The Young Whistler

THE YOUNG WHISTLER
1834-66

by
Gordon Fleming

London
GEORGE ALLEN & UNWIN
Boston Sydney

First published in 1978

ISBN 0 04 927009 5

British Library Cataloguing in Publication Data

Fleming, Gordon Howard
 The young Whistler, 1834-66.
 1. Whistler. James McNeill 2. Painters –
 United States – Biography
 I. Title
 759.13 ND237.W6 77–30588

 ISBN 0–04–927009–5

Printed litho in Great Britain
in 12 on 13 point Barbou
by W & J Mackay Limited, Chatham

For Stella Fleming

With thanks and gratitude

Contents

List of Illustrations

Acknowledgements and thanks for the reproduction of the illustrations are due as follows:

University of Glasgow: 1, 3
Freer Gallery of Art, Washington: 2, 4, 5, 6, 7, 9, 12, 13, 17, 21, 27
New York Public Library, Prints Division: 8, 10, 11, 14, 18, 19, 20
Gallery of Art, Kansas City, Missouri, Collection of William Rockhill Nelson: 15
The Taft Museum, Cincinnati, Ohio: 16
Mr and Mrs John Hay Whitney Collection: 22
National Gallery of Art, Washington (Harrison Whittemore Collection): 23
Addison Gallery of American Art, Phillips Academy, Andover, Massachusetts: 24
Museum of Fine Arts, Boston, Massachusetts: 25
John G. Johnson Collection, Philadelphia: 26
The Tate Gallery, London: 28, 30
The Wadsworth Atheneum, Hartford, Conn.: 29

Acknowledgements

Although I alone wrote this book, and only my wife, my typist, and my publishers saw any of it before publication, I was assisted by individuals and institutions to whom I should like to express thanks.

A grant from the Research Council of my university, the New Orleans branch of Louisiana State University, was useful. The staff members of libraries where I worked were, almost without exception, helpful and courteous, sometimes far beyond what I might reasonably have expected: the Bodleian Library, Oxford (manuscript room and reading room); the British Library, London (manuscript room, newspaper room, print room, and reading room); the Chelsea Borough Library, London; the Fitzwilliam Museum, Cambridge; the Freer Gallery of Art, Washington; the Guildhall Library, London; the Library of Congress, Washington (manuscript division and reading room); Louisiana State University Libraries, in Baton Rouge and New Orleans; the Louvre archives, Paris; the Maryland Historical Society, Baltimore; the Newington District Library, Rotherhithe, London; the New York City Public Library (art division, manuscript division, prints division, rare books division, and reading room); the Pierpont Morgan Library, New York; the United States Military Academy archives, West Point; the University of Glasgow Library (special collections); the University of Paris Library of Art and Archaeology, Foundation Doucet; the Victoria and Albert Museum Library, London; and the Witt Library of the Courtauld Institute, London.

Several individuals, some nameless to me, deserve special mention: the Newington local history librarian whose enthusiasm for Rotherhithe was contagious; several delightful women in the Victoria and Albert Museum who proved to me that you don't have to be stuffy to be English; Kenneth Rapp, at West Point, and Margaret MacDonald, in Glasgow, whose consistent, unfailing, invaluable help was far too extensive for me to specify in detail; and, at my principal base of operations, the New Orleans branch of Louisiana State University, Evelyn Chandler, Clive Hardy, Gregory Spano, and, most particularly, Elizabeth Ashin.

Those to whom I owe personal gratitude include Professor Stephen

Ambrose, who shared with me his knowledge of West Point; E. John Bullard, Director of the New Orleans Museum of Art, who answered numerous questions and offered valuable suggestions; Celia Clarke, of the Royal College of Music, London, great-granddaughter of Seymour Haden's brother Charles Sydenham, who enlightened me on various matters pertaining to her ancestors; Gillian Darley, of Research Unlimited, who was an exceedingly efficient research assistant in London; Michael Franch and F. Garner Ranney, who capably carried out research in Baltimore; Professors Carolyn Jacobs, Marie LaGarde, and Ruth Simmons, who helped me and my translators with certain abstruse questions of interpretation; Sonia and Arto Kouyoumdjian, from the Parisian suburb of Asnières, without whose untiring assistance I could not have completed a major fraction of what needed to be done in Paris and, thanks to them, was done; the late Leonard Levenson, who in response to my requests generously delved into his materials on Whistler which were to be part of the book he did not live to write; Jeremy Maas and Peter Mitchell, London art dealers specialising in the Victorian period, who accepted my questions patiently and answered them cogently; Mrs Nancy Strode, of Amersham, England, granddaughter of Seymour Haden's sister Rosamund, who graciously opened a trunk of documents to which I was allowed free access and which provided information I could not possibly have obtained elsewhere; and Lynne Walker, who in a casual meeting in the British Library Reading Room gave me an invaluable lead to the solution of a vexing problem.

There have also been highly cooperative correspondents: Francis James Dallett, University Archivist, University of Pennsylvania; Ralph S. Emerick, Librarian, Trinity College, Hartford, Connecticut; Jacques Foucart, Curator of Paintings, The Louvre; John K. Hunt, Curator of American Paintings and Sculpture, Metropolitan Museum of Art, New York City; Elizabeth C. Kepple, Librarian, The Stonington Free Library, Stonington, Connecticut; Dorothy Mozley, Genealogy and Local History Librarian, Springfield, Massachusetts; Paul R. Palmer, Curator, Columbiana Collection, Columbia University; Bonnie B. Salt, Harvard University Archives; Judith A. Schiff, Chief Research Archivist, Yale University Library; Mildred Wahlgren, Lowell Historical Society, Lowell, Massachusetts.

The persons with whom I have worked and lived most closely should know that I appreciate their efforts: my research assistants, Diane Dufilho, Kathryn Sublette, and Susan Thorburn; my translators, Christy Beck, Martha Lamb, and Benjamin Sher; my typist, Hannah Rucker; the head secretary of my department, Lynn Godfrey Cunningham, helpful in multifarious ways; my consistently considerate and sympathetic depart-

ment chairman, Seraphia Leyda; my wife and daughter, Mey and Mary Lise, who deserve medals for having endured me during my preoccupation with this book; and the person named on the dedication page, who knows my indebtedness to her.

Finally I am grateful to the following for permission to quote from materials in which they hold the copyright: the University of Glasgow (all writings by Whistler and members of his family); William Heinemann, Ltd (*The Life of James McNeill Whistler*, by Elizabeth and Joseph Pennell); Peter Davies, Ltd (letters by George Du Maurier); William E. Fredeman (letters by Dante Gabriel Rossetti); Imogen Dennis (a letter by Ford Madox Brown); the Maryland Historical Society (Thomas Winans's journal).

A note on translations

Many documents pertinent to this book are in French. Whistler was fluent in the language, which he used when corresponding with his closest friend in early adulthood, Henri Fantin-Latour. In addition to these letters, I have used other French writings: personal reminiscences, reviews of Parisian exhibitions, critiques in French journals. Occasionally I have utilised an existent translation, but most of the material from French sources, including every word by Whistler, has been translated for this volume, and much of it appears for the first time in English. I assembled a team of three translators who were asked to render the French into accurate, readable English, and, for Whistler, accurate, readable, colloquial American English. Passages translated for this volume are preceded by an asterisk, and in each instance I accept full responsibility for accuracy. My translating team worked diligently and conscientiously, and it is a pleasure to express my gratitude and thanks to them: Martha Lamb (chief translator), Christy Beck, and Benjamin Sher. Ms Lamb deserves special tribute, for she was the main translator of Whistler's letters.

The Young Whistler

Chapter 1

NEW ENGLAND
1834-43

The most controversial of controversial artists could not even enter life without causing a dispute. The 1865 Paris Salon catalogue stated that one entrant, James Whistler, 'est né à Boston, États-Unis'. Two years later American art historian Henry Tuckerman asserted in his *Book of the Artists* that Whistler 'was born in Baltimore'. Since the cataloguers' information came from the exhibitors, and Tuckerman had never met Whistler, one might have thought in the late 1860s that Whistler was a proper Bostonian. But Whistler's close friend Theodore Duret, in 'James Whistler', published in the *Gazette des Beaux-Arts* in 1881, and again in 'Whistler and His Work', appearing in the *Journal of Art and Letters* in 1888, assigned his subject's birth to Baltimore. During the interval between his essays, Duret sat for a portrait by Whistler, who said nothing to invalidate this link with Baltimore. In London in 1893, Frederick Wedmore, who also knew Whistler, declared that while other places 'dispute with Baltimore the honour of having given birth' to him 'it is only Baltimore that can fairly claim him'.[1] Duret and Wedmore were supported in America: in the 25 February 1899 *Saturday Evening Post*, George Henry Payne's 'A Living Old Master' began, 'Whistler was born in Baltimore', and this assertion was certified in 1902 by the second edition of *Who's Who in America*.

But this was not the final word. Whistler's body had barely been lowered into its final resting place, in July 1903, when Ernest Knaufft observed that he 'was born – some say in Baltimore, some in Stonington, Connecticut, and others in Lowell, Massachusetts'.[2] And in an important critique of 1905, Léonce Bénédite remarked,† *'Whistler was born in Lowell, Massachusetts . . . and also in Boston, but mainly he was born in Baltimore. For that is the birthplace which he chose.'[3] Not always had he so chosen. His friend H. Granville Fell recalled that 'when the mood took him he would cite alternately Paris or Baltimore as his natal city'.[4] Then in the famous London trial of November 1878 Whistler testified, 'I was born in St Petersburg.' This declaration was not soon forgotten: nearly a

† For an explanation of translated passages preceded by an asterisk see the note on page 17.

quarter of a century later 'born in St Petersburg' appeared in several London obituary notices, and Marion Spielmann, editor of the *Magazine of Art*, in a letter to *The Times* on 15 August 1903, insisted that the artist was born nowhere but in St Petersburg.

Whistler in fact was born in Lowell, Massachusetts, on 11 July 1834, and that year's parish register of St Anne's Church, a small, slate-coloured, square-towered Norman-style edifice at the corner of Merrimack and Kirk Streets, contains this entry: 'Nov. 9. Baptized James Abbott, infant son of George Washington and Anna Mathilda Whistler.' Whistler's birth and baptism were not exactly a state secret: as the Lowell *Morning Mail* observed on 19 July 1888, these facts had been 'many times recorded in the Lowell newspapers'. And the details were accurately entered in the first edition of *Who's Who in America*, published in 1900. The precise birthplace is an attractive, two-storey, colonial-style home on what is now Worthen Street, about fifty yards from a tributary of the Merrimack River. Why should anyone balk at being born in this pleasant dwelling? 'Perhaps through sheer perversity,' someone speculated, 'perhaps by way of furnishing an additional excuse for getting himself talked about . . . Whistler always made a mystery of his birthplace.'[5] Perhaps, however, this was a matter of indifference. In a letter to *The Times*, published on 18 August 1903, Kate Livermore, a woman of 83 who had known him since infancy, recollected, 'When a paper declared that Whistler was born in Baltimore and I asked him why he did not contradict the false statement his reply was, "If any one likes to think I was born in Baltimore why should I trouble myself to contradict such a person? It is a matter of no consequence to me."' To Bénédite, Whistler explained that he was *"born in Lowell by accident . . . and therefore had a perfect right to modify his native place in accordance with his own tastes!'[6] The *Who's Who* modification† might suggest that Whistler enjoyed bantering with those who pried into his personal affairs, as when he answered a model's question concerning his time and place of birth: 'I never was born, my child, I came from high.' (This remark has been quoted often, mainly because it was trumped by the retort: 'I should have supposed you came from below.')

Actually Whistler was neither indifferent to nor jocular about his birthplace. He was ashamed of it. His principal biographers, the Pennells,‡ reported an encounter Whistler claimed had occurred in London's Carlton Hotel. A man supposedly walked up and said:

† For reproduced copies of Whistler's biographical entries in the first two editions of *Who's Who in America*, along with his handwritten alterations of the first entry, see Frank A. Hadley, 'Whistler, the Man, as Told in Anecdote', *Brush and Pencil*, vol. 12 (1903), p. 334.

‡ The most complete, most indispensable book on Whistler is the two-volume biography, *The Life of James McNeill Whistler*, by Elizabeth and Joseph Pennell, an American husband and wife who were Whistler's closest friends late in life.

'"You know, Mr Whistler, we were born both at Lowell, and at very much the same time. There is only the difference of a year – you are sixty-seven and I am sixty-eight." "And I told him," said Whistler. "Very charming! And so you are sixty-eight and were born at Lowell, Massachusetts! Most interesting no doubt, and as you please! But I shall be born when and where I want, and I do not choose to be born at Lowell, and I refuse to be sixty-seven."'[7]

This conversation may have been shaped or even created by Whistler's imagination – he was not averse to inventing episodes – but no one can reasonably question the authenticity of his letter to an unidentified recipient in the winter of 1895–6. This is the relevant passage:

'I came upon a most interesting statement in a large work called "The Genesis of the United States" – compiled from old documents and state papers. Therein is the original grant of land in *Virginia* – by Royal Charter – in the year 1609. There is the full list of all who then went over to Virginia, and among them, is "Francis Whistler, Gentleman" – This is then an earlier ancestor than Willie [James Whistler's younger brother] had as yet discovered. . . . I will acknowledge that my American snobbery is greatly tickled – and the taint of Lowell washed out!!'[8]

Because he lived there for only three years, Lowell has been almost ignored by Whistler's biographers, but since no one's character is fixed, immutable, or unaffected by his environment, and all of one's innate and hereditary traits are constantly shaped, altered, and distorted by the world in which one lives, we should not pass over Lowell or any other Whistlerian residence. Let us then make our visit to the 'taint' of his life, Lowell, Massachusetts.

Situated on an isthmus formed by the Merrimack and Concord rivers, the place which would become Lowell was settled in 1653, but its development was delayed for more than a century and a half. As late as November 1821 a passer-by saw fewer than a dozen houses on the site.[9] Then within fifteen years another visitor called it 'A city which has, almost like Jonah's gourd, grown up in a night'.[10] Lowell's growth had been unmatched by that of any other American community: in 1826, with a population exceeding 3000, it became an incorporated township; and in 1836 it had a municipal charter and 18,000 residents.

The key to its expansion lay in its name, derived from Francis Cabot Lowell, America's pioneer cotton manufacturer: this city had become the centre of the American textile industry. Financial speculators from Boston had formed a corporation, The Proprietors of Locks and Canals on the

Merrimack River, which built a canal to utilise the river's water power, and at once brought on the creation of 'what would today be called a huge company town'.[11]

Nowadays few would go out of their way to see a company town, but in 1836 a resident noted that Lowell had 'become an object of so much interest as to claim the attention of all travellers, whether in pursuit of information or amusement'.[12] Among the visitors two were particularly noteworthy. One was the French engineer-journalist Michel Chevalier, who came to America in the year of Whistler's birth; his travel letters formed the book *Society, Manners, and Politics in the United States*. Two of its thirty-two chapters deal with Lowell, which years later he recalled 'was new and fresh, like a setting at the opera!'[13] He was impressed by 'small wooden houses, painted white, with green blinds, very neat, very snug, very nicely carpeted, with a few small trees around them, . . . fancy-goods shops and milliners' rooms without number . . . vast hotels in the American style' and 'canals, water-wheels, waterfalls, bridges, banks, schools, and libraries'.[14] For Chevalier the city 'with its steeple-crowned factories, resembles a Spanish town with its convents; but with this difference, that in Lowell you meet no rags nor Madonna, and the nuns of Lowell . . . spin and weave cotton'.[15]

Eight years later another transatlantic guest found in Lowell a 'quaintness and oddity of character', something with which he was familiar, for his name was Charles Dickens. American quaintness differed from that of England. It was quaintness rooted in newness:

'In one place, there was a new wooden church, which having no steeple, and being yet unpainted, looked like an enormous packing-case without any directions upon it. In another there was a large hotel, whose walls and colonnades were so crisp, and thin, and slight, that it had exactly the appearance of being built with cards. . . . One would swear that every "Bakery", "Grocery", and "Bookbinders", and other kind of store, took its shutters down for the first time, and started in business yesterday.'[16]

Lowell's newness, and its cleanliness, struck anyone who had seen a European manufacturing city. Although Chevalier at first called it 'a little Manchester', he later acknowledged that the comparison was superficial: both cities produced textiles, but the mills and factories of Manchester, notorious for bad air, bad food, and bad living and working conditions, were very different from those of freshly laundered Lowell. Dickens, who would write scathingly of Manchester in *Hard Times*, visited a Lowell factory 'just as the dinner hour was over, and the girls were turning to their work'. He found them to be 'well-dressed', which 'necessarily

includes extreme cleanliness', and 'healthy in appearance, many of them remarkably so', with 'manners and deportment of young women: not of degraded brutes of burden'.[17]

Were it not for the mills, James Whistler would have been spared his 'taint'. To transport goods rapidly, Lowell's creators turned to the newest form of locomotion, the railway. Construction had begun not long before the arrival of Chevalier, who noted that the Bostonians were 'determined to have something Roman, and their engineers have given it to them and have certainly made the most solid railroad in the world'.[18] Lowell's principal railway engineer was 34-year-old George Washington Whistler.

A civilian for only a few months, Whistler was a military man in a military family. His father and two older brothers had been soldiers, and George, born in 1800 at an army post at Fort Wayne, in 'the North-west Territory', attended the United States Military Academy at West Point, New York, graduating in 1819, twelfth, academically, in a class of twenty-nine. In one subject, drawing, he ranked first, and a classmate reportedly said, 'George Whistler is too much of an artist to be an engineer.'[19] He said 'engineer' rather than 'soldier' because the Academy was then less interested in combat than construction. After the war of 1812 had ended, the USMA might have been called the USEA, for until 1828, when Rensselaer Polytechnic Institute introduced engineering into its curriculum, America's only engineering school was at West Point. The young nation urgently required men to build and improve harbours, canals, and roads, and so George Washington Whistler never fired a weapon at a human being: his army activities included improving the harbour of Salem, Massachusetts, tracing the international boundary between Canada and the United States, and, during his last six years in uniform, working on railways. Late in 1833 he resigned his commission as a major and became supervising engineer on the Boston to Lowell Railroad.

Whistler was brought to Lowell by one Kirk Boott, Jr, who, along with his descendants, was to have a not unimportant effect on the life of James Whistler. The son of a successful merchant who had emigrated from Derby, Boott was born in Boston in 1790 and educated in England at Rugby, and in America at Harvard. In 1818 he became a textile manu-facturer, and because it was he who principally decided on where to centre the industry he was called 'the founder of Lowell'.[20] He moved to the town and until his death in 1837 was its most distinguished citizen. He represented Lowell in the state legislature, and he financed, designed and supervised the building of St Anne's Church which is an exact replica of the church in which he was married, St Michael's, in Queen Street, Derby. During Whistler's residence in Lowell his best friend was to be Boott, and for years the two families maintained an intimate relationship.

Early in 1834, Whistler arrived with a pregnant wife and three children from an earlier marriage. When his first wife died, on 9 December 1827, one of his close friends was William Gibbs McNeill, of Wilmington, North Carolina, a West Point graduate of 1817. Whistler and McNeill were members of an American contingent that studied British railways in 1828-9; they were colleagues on numerous railway projects; they left the army together to continue their association as civilians; and on 3 November 1831, they became brothers-in-law when McNeill's 27-year-old sister Anna became the second Mrs George Whistler.

Anna cared properly for her stepdaughter and two stepsons, but James and his brother William, born on 22 July 1836, were her main preoccupation in Lowell. As she would write in her diary in 1843, 'the training' of her 'little boys' was her 'sweetest employment'.

As for Mr Whistler, he was establishing himself as a railway builder. After dismantling and reconstructing a locomotive imported from the Stephenson brothers, he and his associates began to design their own engines, and on 30 June 1835 a Whistler locomotive made its first trip on America's second complete railway, from Lowell to Boston.[21] When the line was operating publicly, in 1837, Whistler left Lowell to become chief engineer of the Stonington Railroad. He and his family moved to Stonington, Connecticut, where Anna's sister Kate resided. A brief pause in Stonington would be worthwhile if only to try to understand why James Whistler's opinion of it diverged conspicuously from that of his birthplace. He could say nothing good about Lowell, but he never spoke disparagingly of Stonington.

A pleasant, quiet town, with picturesque, tree-lined streets, Stonington juts out on a narrow point into the Atlantic Ocean. Unlike Lowell, Stonington in the 1830s already enjoyed a history. It had been genuinely settled in 1649, and in 1801 it became Connecticut's first incorporated borough. 'Its original settlers', wrote its resident historian, 'were hardy souls who chose to seek life in a new world rather than change their beliefs.'[22] The genesis of Stonington lay in principles and ideals, not financial speculations. In Lowell almost nothing was more than ten years old, but Stonington was permeated with what in America seemed ancient. The very house in which the Whistlers lived, an attractive gable-roofed building on the north-west corner of Main and Wall Streets, was built in 1787, two years before the origin of the American nation, and it was a typical town dwelling. But it was not primarily old houses that reminded Stonington's residents of its past. Again quoting the town chronicler, its inhabitants 'played a part in the development of our Country significant far beyond the size of the community'.[23] In particular there were two occasions the memory of which could not but have left a mark on an

impressionable boy. Twice the little town was the scene of a heroic victory over the mighty British navy.

On 30 August 1775, Stonington had its first chance to repel the forces of His Britannic Majesty. H.M.S. *Rose* landed a foraging party which tried to attack the town, but they were met by local militia, who, suffering one casualty, sent the invaders scurrying back to their ship.

Thirty-nine years later, in August 1814, Stonington celebrated its finest hour. The war of 1812 had not ended, and a squadron of five British ships appeared off the coast commanded by Captain Thomas Masterman Hardy, who had served with Nelson at Trafalgar. With 160 guns at his disposal, Hardy gave the townspeople one hour 'to remove out of the town'. They responded by mustering their defence: a handful of militia and three guns. Five barges of invaders landed only to be stopped by the three American weapons. Repeated landing efforts were no more successful; and when Captain Hardy recognised that Stonington was not Trafalgar, the five British ships sailed away.[24]

The Whistlers arrived at Stonington twenty-six years later, and Anna's elder son surely heard personal, probably exaggerated, recollections of how a tiny group of Americans humiliated the world's most imposing navy. Then there were visual reminders – cannon-balls which had dropped harmlessly in fields, and, in Cannon Square, fifty yards from the Whistler home, two of the defending guns. The Whistler residence itself had been repaired and remodelled because of battle damage.

Resting on an eminence near the end of Stonington point, the Whistlers' home overlooked the beautiful sea which gives the town its picturesqueness and for three years formed a conspicuous part of each day of young James's vision. In those days, far from being a resort community, Stonington was known as a 'Nursery for Seamen'. How many times did the child stand in his garden and gaze at sailing vessels in the harbour and whaling ships departing on journeys of from two to four years, and how many times did he hear mariners tell tales of the great outside world? Could he, like Stephen Dedalus, have been excited by 'the vastness and strangeness of the life suggested to him by the bales of merchandise stocked along the walls', and was it possible that 'a vague dissatisfaction grew up within him as he looked on the quays and on the lowering skies'?

While the boy watched the water, his father and uncle were enhancing their professional reputation on the railway from Stonington to Providence, Rhode Island. Six days a week Mr Whistler worked on the line, and on Sundays, Henry Robinson Palmer remembered from his Stonington childhood, 'the carriage, fitted with car wheels and drawn by a horse, took the Whistler family by rail to the Episcopal church in Westerly, there being no church of that communion in Stonington then'.[25] The Whistler

family, incidentally, increased on 16 July with the arrival of Anna's third son, Kirk Boott.

Away from the railway, Mr Whistler was an amiable, loving husband and father whose favourite hobby was playing the flute, which, acquired in the late twenties, was 'dear to him from many tender associations', as his wife wrote in her diary, and was 'his solace after weariness'. Among the younger Whistlers, one followed in their father's musical footsteps, his first wife's second child, Deborah, a talented pianist and harpist. Whistler's already mentioned drawing talent, which had gained him, briefly, an instructorship in the subject at West Point, and might, his biographer George Vose declared, 'have made him as distinguished an artist as he was an engineer',[26] perhaps would pass down to James. Kate Livermore wrote to Joseph Pennell in 1893, 'He lives in my memory as the beautiful child of two years old, and I can still hear the first words he ever spoke to me at that early age, which were "I'se drawing" as I pushed him out from under his Mother's stand, where he was lying prone with an inch of lead pencil in his hand and two inches of paper before him on which he was "drawing".'[27] This, of course, was written after Whistler had become an internationally celebrated artist, when it would have been only natural to recall a drawing episode and to give it a perhaps disproportionate emphasis.

Whistler's few surviving childhood drawings are unexceptional. A sketch of a duck drawn when he was four, reproduced by the Pennells, shows what might have been done by any moderately talented child.[28] *The Flight of Xerxes*, dated 27 February 1843, owned by the Metropolitan Museum of Art and included as the first illustration in Nancy Dorfman Pressly's fine booklet on Whistler's American art work, is, as Mrs Pressly says, 'awkward and childish' and 'suggests no precocity or particular promise'.[29]

In his early drawings, James perhaps received paternal encouragement, but there can be no doubt concerning the role played by his other parent. Anna Whistler was influential not only because, like most mothers, she was often with her children, but also because she had a personality that led her husband's second biographer, Albert Parry, to characterise her, not unfairly, as 'a power-grasping individual' who 'reached out for power over her family, over friends, acquaintances, even strangers'.[30] As Parry said, she had 'no gift, no ability, no mental superiority. So she used emotion, mainly that of morbid fear: her weapon was the next world.'[31] And her battleground was religion. Anna's perpetual piety will be dealt with later, but for the moment let us note that her sons – but not her stepchildren – were required to memorise one verse of the Bible every day and to recite it the next morning, and that Sunday was totally dedicated to God.

Much has been written on the manifestation of James Whistler's early religious training, ranging from the style of his letters to his disinclination to paint on Sundays, but one phase of life in which Anna influenced her sons has gone largely unnoticed: racial relations, which in James's childhood focused on slavery. This was a troublesome matter for someone who was a devout Christian and also an unequivocal, unapologetic Southerner who, metaphorically, held in her hands a Bible and a slave-whip. Like most Southerners, Anna rationalised the coexistence of Christianity with slavery, as in a letter of 27 April 1853 to an English friend:

'I can witness to the humanity of the [slave] owners of Southern Atlantic states, and testify that such are benefactors to the race of Ham, believing as I have been often led to from my mother's opinions, that the blacks at the South are cared for by Christian owners, being taught from the gospel all their religious indulgencies provided. I take the view that God has permitted this . . . that missionaries might be prepared for Africa, through the religious instruction provided by slave owners in our Atlantic states and that through the colinization [*sic*] it will be effected.'[32]

As Anna Whistler was swayed by her North Carolina mother's opinions, so her sons came under her dominion, and both always regarded themselves as Southerners. James, late in life, insisted: 'I have *a right* to keep my reputation clear – as shall be that of a Southern gentleman.'[33] As a Southern gentleman who had never been south of Maryland he would always speak contemptuously of 'niggers', whom, in his own words, he 'hated as much as any Southerner',[34] and now and again he would refer nostalgically to what he once called 'a little healthy American lynching'.[35] Regarding her elder son, Anna Whistler was answerable for more than discouraging him from painting on Sunday.

Because American railways were being built mainly in the north-east, it was unlikely that Anna would soon return to the South. It was also improbable, because of her husband's vocation, that she would have a prolonged residence anywhere. And in 1840, when Whistler became chief consulting engineer for the Western Railroad, which involved completing a line from Worcester through Springfield to Albany, New York, the family returned to Massachusetts. They would live in Springfield, a city with 11,000 people, the United States Arsenal, and numerous commercial enterprises – cotton factories, paper mills, printing offices, sawmills, gristmills, tanneries, a rifle factory, a sword factory, and a spool factory. One might think, after delightful Stonington, that young James Whistler would be appalled by these surroundings, but he never spoke or wrote deprecatingly of Springfield. For in truth this was not another Lowell.

Like Stonington, Springfield was, for Americans, old, having existed uninterruptedly since 1635, and, as the urban historian Michael Frisch noted, the first settlers established a 'genuine sense of community whose continuity remained undisturbed until the Civil War'.[36] Again like Stonington, Springfield was dominated by water, lying on the eastern bank of a graceful curve of the Connecticut River, one of America's most beautiful inland waterways. Table lands rose by terraces from which one beheld 'a valley four or five miles in width', and a 'river meandering slowly through the whole extent of the view, supplying that additional interest and zest which nothing but water scenery can impart'.[37] The Whistlers lived on Chestnut Street, on the second terrace, and here James first came under the spell of a body of flowing water.

The boy was now also introduced to another influence. Despite its industrial capacity, Springfield was known as 'a New England City of Homes', because of its impressively elegant dwellings on the heights. The best homes were in a small, exclusive district concentrated above the principal thoroughfare, Main Street, notably on tree-named streets – Maple, Walnut, and Chestnut. This realm was governed by 'a traditional, almost patrician social elite',[38] and here one could observe the ultimate in snobbery. An early town historian wrote of the town as it was in 1840:

'. . . the pride of Springfield was its aristocracy – its noted men and ancient families, and fine gentlemen, all of the olden time. There were the Pynchons, the Dwights, the Edwardses, the Chapins, the Blisses, the Burts, the Warriners. . . . Had not Springfield reason to be proud and self-satisfied? She was. Her people were wealthy, aristocratic, and contented.'[39]

On Chestnut Street, less than one hundred yards in length, five homes were occupied by members of families named in this passage, and there were scions of other elitist lines.[40] These men, unlike Lowell's speculators, were repelled by industrial development which would 'cumber and deface their beautiful town with manufactories and fill their streets with greasy operatives and dirty mechanics. . . . It would degrade the place and destroy forever its select society.'[41] But even they could not resist the railway builders, who caused 'the decline of the local artistocracy [which] took its departure never to return'.[42] The change, however, was not immediate: before its flavour had appreciably altered, Jimmy Whistler no longer lived in Springfield.

In 1842, his current assignment approaching completion with total success, George Whistler at the age of 42 was 'in the prime of manhood, and prepared to enter upon the great work of his life'.[43] This 'great work' had its genesis in the year of James's birth, when Nicholas I, Tsar of

Russia, decided that he needed a railway between St Petersburg and Moscow, a distance of some four hundred miles. Since not one rail had yet been laid anywhere within the Russian Empire, the proposal was received by the Tsar's ministers with scepticism, and to demonstrate its feasibility he authorised the well-known Austrian engineer Anton Von Gerstner to build an 18-mile line that would join St Petersburg and the suburban community of Tsarkoe Selo.

This first Russian railway was completed in 1837, and when Nicholas saw it operating flawlessly he returned to his initial scheme. After a thorough preliminary study, he created, in January 1842, a commission to administer the construction of the St Petersburg to Moscow railway. The commission set out to select a supervising engineer, who, because of Russia's limited technical development, would come from abroad. Since the most logical choice, Von Gerstner, had died in 1840, the commission visited Europe, England, and the United States, which had more railway mileage than all of Europe. Its arrival in America, in the spring of 1842, coincided with the completion of the Springfield enterprise, and, after examining this work and interviewing its principal worker, the Russians went home and told the Tsar that 'of all persons with whom they communicated, no one had given them such full and satisfactory information upon all points, or has so impressed them as possessing extraordinary ability as Major George Washington Whistler'.[44]

Tsar Nicholas immediately accorded Whistler 'the highest honor that had come to any American engineer',[45] an offer to become chief consulting engineer of the St Petersburg and Moscow Railroad. The position was more than honorific, commanding what in 1842 was an enormous annual salary, $12,000 (for the period covered by this volume the rate of exchange was approximately five dollars for one pound). Whistler did not deliberate over this once in a lifetime offer, and he left for Russia late in the summer of 1842. His family was to join him the following year. Its composition had changed in Springfield: soon after arriving, Whistler's younger son from his first marriage died; on 27 August 1841, Anna's fourth son, Charles Donald, was born; and on 10 July 1842, just before his father's departure, 4-year-old Kirk Boott died. 'Kirkie left us', his mother recorded in her diary, 'on a beautiful Sabbath morning . . . his hands clasped in prayer and his bright eyes raised in extacy [*sic*] as though he saw what we could not – angelic messengers. His last words were, "Mother I want to go to heaven."'

If Anna now had a favourite among her boys, he was the youngest, who, she later recalled in her diary, 'did not fancy toys, but delighted in flowers, and his hymn book – as he called the nursery rhymes – was in his hand always, for he even took it to bed with him. . . . He never omitted

repeating the Lord's Prayer after Mary [the family servant] any night or morning.' Charles and the other Whistlers led an uneventfully pleasant life until shortly before they were to embark on their journey. James suddenly became ill, 'at the point of death', Anna recorded in her diary, but he recovered, and his mother wrote, 'May God have prolonged his life for a blessing to us!'

In mid-August 1843, a party of seven – Anna, Deborah, James, William, Charles, Mary, and their escort, Mr Whistler's first son, George, who would accompany them for most of the journey and then return to America – left Stonington, where they had been temporarily residing, for their port of departure, Boston.

Chapter 2

ST PETERSBURG
1843–47

When steam was applied to marine propulsion, sea travel was revolution-
ised, and in 1840 the British and North American Royal Mail Steam Packet
Company, later the Cunard Line, was founded with four 1,150-ton, 115-
passenger wooden paddle-steamers that crossed the ocean in a fortnight.
On 16 August 1843 the Whistlers boarded one of them, the *Acadia*, whose
voyage was unexceptional for the Stonington party, except on the 27th,
when the youngest celebrated his birthday. '"Charlie is two years old,"'
Anna wrote; 'he was so pleased to repeat to all who asked how old he
was – he spoke so distinctly.'† Two mornings later the *Acadia* docked in
Liverpool.

Anna's two older half-sisters, Alicia and Eliza, who had stayed in
Britain when their father moved to America, lived in the Lancashire
town of Preston, where the Whistlers spent most of their stay in England.
Upon arriving, they were greeted by a Mrs Hazlewood, whose seventeen-
year-old daughter, whom Anna remembered from her earlier visit to
England, in 1829–30, as a 'sweet girl ... my pet', had died a month earlier.
'I wish I could have shown her to you!' the weeping mother whispered.
'God called her to her heavenly inheritance,' Anna observed in her diary,
and 'we ought to rejoice that she was released from sufferings here & so
soon gathered to His fold.' She apparently did not desire the same release
for her own children, and she especially enjoyed the presence of her infant
son. 'My precious darling Charlie's sweet voice', she wrote, 'was the first
sound that attracted me at the hour of the day. He would come in by
himself to say good morning to his dearest mother', who marvelled at
'how much intelligence this baby discovered', and 'fancied the delight his
father would take in "Kirkie's own Charlie" as that little sainted brother
used to call the baby'.

After two weeks in Preston, the Whistlers went to London, and during
the brief stay James first saw the Thames, from their hotel in Norfolk

† In this chapter, the source of Anna Whistler's quotations is the diary she kept in St
Petersburg. This diary, of which only a few scattered entries have been hitherto published,
is in the Manuscript Division, New York Public Library.

Street, off the Strand, almost overlooking the river. They were to travel on the steamer *John Bull*, and Anna wrote:

'The children were aroused before dawn, my darling baby seemed at once to understand he was going to "father" for he was not the least peevish at being disturbed, tho Mary could not persuade him there was no time to say Charlie's prayers – she found it best to gratify him & let him kneel as usual & repeat the Lord's prayer. As the boatmen rowed us down the Thames by lamplight & starlight how charmed this bright little creature was!'

The *John Bull* took them to Hamburg, and then they rode by carriage to Travemünde, where on Saturday 22 September George left the others after they boarded the *Alexandra*. Soon after this last leg of the voyage had begun, Charlie took seriously ill. Note the differing reactions of his sister and mother: 'Debo was much concerned,' Anna related, 'and longed for a physician. I knew that God alone could bless the means & I felt comfort in believing in His presence.' In retrospect, Anna said that Charlie 'was so gentle & so full of love I ought to have been warned that he was ripening for the skies'. In excruciating pain, he could neither eat nor sleep, and with difficulty 'he tried to kneel down to say "Charlie's prayers" supporting himself by holding to the sides of the berth. "Charlie is too sick to kneel down, say them in bed" which he did, clasping his little hands together as he was wont & repeating every word.'

The morning brought no relief to Charlie, who 'never murmured, but could retain no medicine. The last dose I administered he said gently, "Most done, no medi Mama for Charlie if you please."' These were almost his last words. That evening, Anna recalled,

'he put his cold little hands in my bosom saying, "Charlie's *own* Mama" but neither he or I closed our eyes from the moment we first embarked, as my baby neither fretted or moaned. I was only aware of his increased sufferings by his struggles. . . . My sobs aroused Debo . . . & her cries of distress brought out all the ladies. The steward too ran in. . . . A warm bath he had ready in a few moments & I put my darling in it supposing he was threatened with a fit. Never shall I forget the look of fond recognition from my dying baby's eyes, & as I held him in my arms . . . I wrapped his little body in a blanket which the compassionate stewardess though she could not speak a word of English handed me, & sat down gazing on the angelic expression of my Charlie, for now I realized that his mild eyes could not long be turned to his poor mother, mine were rivetted till his were glazed by death. I pressed my lips in agony to his beautiful brow, then gave up that precious body to stranger hands . . .'

Anna's greatest comfort was knowing that Charlie did not 'go to his bed or rise from it without kneeling down to pray to God in the words which Jesus himself taught us to use'. It was by no means fortuitous that, like Kirk before, he died on Sunday. She told her surviving sons: 'God has called this second little brother to a better world on the sabbath day to impress their minds solemnly on its return every week to keep it holy.'

With her usual composure Anna prepared the body for her husband's eyes. 'It was a privilege', she wrote, 'to hold him in my arms while Mary fondly arranged his beautiful ringlets.' On Thursday the ship docked in Kronstadt, on the island of Kotlin, near the eastern end of the Gulf of Finland, less than fifteen miles from St Petersburg, and Anna learned that corpses could not legally be taken into the Russian capital. Noting that she 'must submit to leaving this that seemed indeed a part of myself', Anna placed the body in the English church, from which it would return to America for burial alongside Kirk. (When news of Charlie's interment reached Anna, she wrote: '... death cannot divide these our two youngest darlings, who loved each other so entirely. They shall mingle! They are one in Christ!')

On the next morning, the 28th, the *Alexandra* entered the Neva River, which separated the two main parts of St Petersburg, and docked alongside the fashionable English Quay, where Whistler waited. As they walked home, Anna relates, 'he seemed to wonder what our nurse had done with him he looked in vain for, but as he would begin with "where is the little one," I abruptly stopped by begging him not to ask questions till he could do so at home'.

Whistler received the sad news in the family's luxurious house, lately the American Ambassador's home, on St Petersburg's most exclusive street, the Galernia, parallel to and immediately beyond the English Quay. Anna anticipated semi-primitive living conditions, but she confessed, 'I encountered fewer difficulties in housekeeping than I had expected. . . . I found every convenience in our kitchens, pantries, etc.' One convenience she had not had since leaving North Carolina was a retinue of servants. In slaveless New England there was only Mary, but now she enjoyed the services of a butler, a cook, a laundress, two housemaids, and a footman. This did not come cheaply: the annual rent was the equivalent of $1,800, and it became apparent that Whistler's salary was not excessive. Nineteenth-century residents of and visitors to St Petersburg habitually remarked upon its expensiveness. In 1843 an Englishman observed with only mild hyperbole that a bachelor 'might just be raised above indigence on £500 a year, and on 800 or a thousand a few of the little comforts of life might be secured'.[1]

A month after arriving, Anna noted that the Neva was closed to navigation and winter had 'suddenly locked every thing in its icy grasp'. The

departure of the season's last ship led the Whistlers' friend John Maxwell to declare, 'The last boat! . . . How many assemble on the pier that day to gaze upon the envied few who are able to escape before the great portals of the Baltic are locked with ice!'[2] Anna and her children would soon comprehend why the departers were envied. A year earlier a *Times* correspondent dispatched some seasonal observations:

'In October the Russians assume fur clothes and keep them in continual wear until the month of April. . . . At 23 or 24 degrees [below zero], constant rounds are made during the night to prevent the police and sentinels from falling asleep on their posts. Should the cold bring on drowsiness, and the sufferer not be able to prevent himself from yielding to its influence, he must perish. At 25 degrees the theatres are closed, and all those who are obliged to go out on foot hurry along with their utmost speed, most anxiously looking at the noses of all those whom they meet in the street. If a sudden paleness – of which intimation is given by any physical feeling – should appear on that part of the face, the passer-by rushes forward, and commences rubbing the afflicted feature of the alarmed passenger with snow, to produce animation. At 30 degrees of cold the police alone go out of doors; entire families shut themselves up.'[3]

From within a warm home, winter could be fascinatingly beautiful. 'St. Petersburg rarely appears to greater advantage', J. G. Kohl wrote in 1843, 'than when the thermometer stands at −35 Fahrenheit, when the sun shines brilliantly in a clear sky, when its rays are reflected by millions of icy crystals. . . . The snow and ice in the streets and on the Neva are white and clean, and the whole city seems clothed in the garments of innocence.'[4] Maxwell took note of the nocturnal beauty: 'The evergreen and ever-silent woodland, hung with white drapery, and the pine boughs tipped with icicles, image forth the realms of the great frost king. Fairy shadows dance across the crystal surface, and the keen air tingles with fairy voices.'[5] Some of the Whistlers appreciated winter's visual attractions, and they all survived its discomforts, and in May the appearance of the year's first ship signalled the arrival of spring, when 'the lively green of the painted roofs and azure star-spangled cupolas of the churches enable the eye again to revel in the long untasted enjoyment of colour, and the river gaily mirrors the palaces that grace its banks'.[6]

In St Petersburg winter was long but spring was short. Because of the intolerable heat the city was 'deserted by all who can afford to leave it early in July',[7] including the Whistlers, who spent July and August in a country villa.

Upon returning in September, they moved into new quarters which

they would occupy for the rest of their stay in St Petersburg, a second-
(or, for Americans, third-) floor flat on the English Quay overlooking the
Neva. The rent was half of what they had been paying, but even this
Anna considered 'extravagantly high'. They had ten rooms, and – a rare
treat in 1844 – a hot and cold shower bath.

George Washington Whistler came to Russia to build a railway, and
he was distracted by neither extreme cold not excessive heat. His pre-
liminary report, envisaging a double-track railway, 420 miles long, to be
constructed in seven years at a cost of nearly 40 million dollars, was at
once accepted by the Tsar. (The line is relatively straight, but the familiar
story of the Tsar taking a ruler and pencil and drawing a straight line
between the two cities is not accurate.[8])

Fifteen or twenty of Whistler's assistants were Americans, and, at his
suggestion, the contract to build 162 engines, 2,500 freight cars, and 70
passenger cars went to the locomotive builders Winans, of Baltimore, and
Eastwick & Harrison, of Philadelphia. 'As soon as it was reported that
the Americans had the contract,' Maxwell wrote, 'a prolonged growl was
heard in the English quarter [of St Petersburg]. . . . That these infernal
Yankees should be insinuating themselves into the Imperial favor, in
defiance of all precautions to the contrary, was almost beyond endurance.'[9]

If Whistler was aware of ruffled English feelings, he was too busy to be
concerned. So totally time-consuming was his job that on 1 August 1844
Anna noted in her diary that he had 'for a wonder staid at home today'. He
was not socialising but 'writing a report upon his late inspection of the
railroad', one of many, usually requiring a fortnight's absence, which
Whistler executed in all kinds of weather.

Whistler's job was obviously not good for his well-being, and Anna's
diary frequently refers to his health. In December 1843, for example,
after a lengthy sledge ride in sub-zero weather, he 'suffered so much from
pain in his chest & cough, my hands & heart have both entirely occupied
with care about him'. When, in March 1846, despite a cold he went 'all
the road to Moscow', he 'was seized by such an alarming attack a few days
after his return . . . that altho Dr Rogers' skill was exercised, we found
nothing to remove the excruciating pain for many days'.

Because of remarkable fortitude, Whistler was not usually in a sick bed,
and Anna could have led a lively social life. Few had better connections
than they, going up to the Tsar himself. The American Ambassador,
Colonel Todd, became attached to them from the moment of their
arrival, when he offered 'the use of his carriage and four greys', and they
could have constantly attended balls, concerts, parties, dinners, and plays,
with the most exclusive members of St Petersburg's most exclusive
society. Yet in March 1845 Anna thus explained a two weeks' hiatus in

her diary: 'There is so little variety in my life that nothing has offered worthy of record.' Her life in St Petersburg was uneventful because she assiduously avoided social, artistic, and intellectual activities. During her first month in this exotic, cosmopolitan city, she left her home, she reported, 'only two or three times except to church'. The first invitation she accepted came from Colonel Todd to visit the Winter Palace, when she 'overcame' her 'disinclination to going into the gay quarter of this showy city'.

Since the Palace was less than 300 yards from her flat, just beyond Admiralty Square, Anna should not have been unacquainted with the 'gay quarter', for it was there that she lived. Although she went in a spirit of self-sacrifice, she was suitably impressed. The enormous structure in a grandiose setting facing the Neva was the Emperor's principal residence and overwhelmed everyone. The rooms 'were so huge that a German guest, General von Gagern, was afraid of being lost in them',[10] and the furnishings suited their surroundings. Despite her alleged aversion to grandeur, Anna was 'very much gratified by all shown us', including a 'staircase [which] appeared to me the grandest I had ever ascended and the suites of rooms of every splendid variety'. She and her husband 'whispered to each other how much we should have enjoyed taking our dear Jimmie through so many attractive objects. He wished so much to be of the party!'

Although he never entered the Winter Palace, James accompanied his parents to the other equally magnificent Imperial dwelling, built by Catherine the Great, the Tsarkoe Selo Palace, which was near the Whistlers' 1844 summer villa. It contained 'rooms completely covered with gold . . . walls and ceilings of glass and amber . . . floors of ebony and mother-of-pearl, and furniture exceeding in value all the treasures of Windsor or Versailles'.[11] The grounds, ten miles in circumference, called 'the most carefully kept in the world', contained 'a theater, a Chinese village, a Dutch and Swiss cowhouse, a Turkish *kiosk*, a summer-house in the form of an Ionic colonnade supporting an aerial garden, planted with flowers, a Gothic building called the Admiralty, a marble bridge with Corinthian columns of polished marble'.[12]

One might think Anna Whistler would be repelled by such ostentation, but in 1844 she went not once but twice to the Palace. In August she rationalised her second visit: 'Debo proposed that we should avail of an invitation from Col. Todd to pass the day at Tsarkoe Selo. . . . I determined to yield to her wishes that we might gratify Aunt Alicia.' (The aunt had arrived to spend a year in St Petersburg.) Her account of this experience stressed the enjoyment of others: 'We had enough in the extensive grounds to interest my Sister . . . and the Chinese bridge with Chinese men & women keeping it delighted our boys.'

Anna's professed reluctance to visit palaces characterised her attitude toward all social life. It was seemingly an ordeal simply to leave her flat, which she did only to appease someone else. She 'felt no wish to go out' late in 1843, 'but had to make the effort occasionally to return calls with Debo'. It was 'a difficult task', she said in February 1846, 'to answer a polite note of invitation to join a party', and when she could not refuse, it was 'a weight off my mind when a party is over'. One obligatory invitation came in the spring of 1845, 'a kind note from the Parsonage reminding us that it was the wedding anniversary of our Pastor', and Anna 'determined not to resist this effort at sociability as I had done all their formal invitations to large parties for I felt we could not expect to receive our Pastor's family under our roof if I always refused their hospitality'.

At the pastor's home, a Mrs Caslett 'took an opportunity of expressing a hope that we should be at her ball next week but I excused myself'. For Anna, a ball typified pleasure, and pleasure was the devil's creation. When she saw Russians enjoying themselves during the Carnival preceding Lent she called them 'poor deluded people' and thought 'how strange their eagerness for amusement because they are to be deprived of it for forty days'. As Easter approached, it was 'shocking' to see 'men at the booths unpacking refreshments of every kind, mead, cakes, fruit, nuts, but above all coloured eggs – banners flying! and all looking as if they rejoiced that the restraint of Lent was taken off'. When she learned in September 1844 that all amusement places would close for six weeks while mourning the death of a member of the royal family, she wrote, 'what a pity they should ever be opened'.

Naturally, Anna was revolted by alcoholic beverages. In July 1844 she wrote, 'Mr Roper dropped in to chat with Debo about the wedding at Tsarkoe & I rejoiced we had not attended as I do not like to be where toasts are given & where the lavish distribution of champagne makes at least innovations upon propriety.' A month later, at an embassy reception, 'The Col. [Todd] proposed drinking the Emperor's health in champagne ... & even I put my glass to my lips tho I invariably refuse, for I did not know if it might be misconstrued into disrespect & for Whistler's sake I went thro the motions.'

Drinking, for Anna, was scarcely worse than dancing. At one social event her obedient stepdaughter sat while others danced. Anna wrote, 'I was so grateful to her when she declined waltzing! I hope she will never yield to her fondness for dancing at the expense of what I conceive to be decorous.'

One person who did not share Anna's view of conventional pleasures was an American woman, Mrs Bodisco, who spent the winter of 1844 in St Petersburg and is prominently mentioned in Anna's diary. She stayed at

the Hotel de Paris and was 'quite a favorite at court & is called the "beautiful American"'. Anna's report of a dinner party at Ambassador Todd's residence deals almost entirely with 'our beautiful young country-woman' who 'wore a green velvet dress with short sleeves, her round fair arms bound round by three bracelets & a weighty necklace of pearls fastened with a very large rich locket of diamonds' and did not 'hesitate to say she likes Russian society better than that of her own country & every night is glad to be in ball rooms or theatre'. When Mrs Bodisco attended the Grand Duke Michael's ball, Anna noted that she wore a dress that had cost $1,000. From a lengthy entry written after Anna's one extended conversation with her, in February, we learn that Mrs Bodisco 'spoke in raptures of the uninterrupted season of pleasure she has partici-pated in at this dissipated court, and said she should never wish to return to her native land if she had her own relatives here – no society in America she says', and that she had 'so little ear for music she did not even recognize our national air Yankee Doodle when played'.

Anna's dissimilarity to Mrs Bodisco is amusingly underscored by a diary entry of March 1845. When an American businessman whom she had see constantly since arriving in Russia visited her, Anna 'was rather astonished at Mr R. seizing me by the hand as an old friend, but probably he was thus eager to meet me only as a countryman'.

Although she supposedly abhorred material possessions, Anna was delighted with a tangible gift from her husband and children on their first Christmas in St Petersburg, 'a most beautiful rose-wood escritoire'. On Christmas morning Whistler

'took an ivory pen handle inlaid with silver with a card of gold pens from the complete Escritoire & presented it to his grateful Annie as his own peculiar gift. I was much overcome! to think I should have been singled out as the favored one of the family group! . . . Whistler pretended to laugh at my childish fondness for my beautiful desk – I never was in possession of any thing I prized so much.'

This effusive response was remarkable only because of Anna's oft expressed disdain for worldly things, which would distract her from that which was eternal. In November 1846, for example, she admonished her-self to 'be weaned from earthly desires that Jesus may become the supreme object'. And in February 1847, as was her wont, she fortified herself with scriptural injunctions: '"Whoso loveth the world, the love of the Father is not in him." Oh do those who indulge in worldly vanities forget the divine admonition "to strive to enter in at the straight gate, & to keep the narrow path? Be ye separate from the world."'

As these random passages suggest, Anna Whistler's life was totally dominated by religion. Her conception of and attitude to God may be illustrated by a typical diary excerpt:

'[August 1845] When I look back upon God's dealings with me they have indeed been such as to cause me to praise Him not only with my lips but in my life! & shall I not devote my all on earth to Him, who hath so mercifully led me for forty years thro this wilderness.'

Death she anticipated with exhilaration. 'How impatient I feel', she wrote in November, 'to be among that happy number!' Lucky are those who die young, who, pure and innocent, will at once join their Saviour. When, in March 1844, she learned that her sister Kate's young son was seriously ill, she declared, 'How thrilling her account of little Georgy's illness! May dear Kate be taught that the children God has given her are from a garden of paradise . . . and lent for her comfort to be recalled at any moment.' Anna rigidly applied this doctrine to herself. In September 1845 she acknowledged that her surviving children had been 'entrusted to my care' and were 'not my *own*, but Christ's, & to be required at my hands!' As for her deceased infants, in April 1845 she told God she could 'rejoice that Thou has early taken some of my little ones from me to dwell with Thee forever!' Whenever Anna heard of a young person's death she moralised. In April 1845 after learning that a 17-year-old girl friend of Deborah in America had been fatally thrown from a carriage, she wrote:

'God has endowed this only daughter with much that might win hearts, & if her Parents led her affections to her Saviour we trust He has taken her to lead theirs to Himself. God does not willingly afflict. We poor blind mortals cannot see His purposes of Mercy thro the clouds & darkness which surround His throne, but if we kiss the rod He will give us also the staff to support us. However sure seem earthly promises to us, they are deceitful. This world is not our home & we must enter Heaven thro much tribulation! God called that Beautiful young flower (we trust to bloom in Paradise) early because He knew it best.'

An instinctive missionary, Anna lamented in June 1844: 'I wish I could speak to these poor deluded [Russian] souls! I'd give all but my own salvation to convert them to Christ.' A month later she declared, 'The great work for each individual . . . should be winning souls to Christ.' Anna practised what she preached. Several Christian organisations gave her tracts in Russian, Finnish, and German, which she distributed whenever and wherever she could, and not always alone. She noted in July 1844:

'Our boys have great pleasure in distributing Tracts on Sunday especially when we observe a knot of idle young men playing or lolling on the grass we pitch out a Tract which they pick up as a prize . . . but the most satisfactory way of distributing them is when regiments are passing to give one to each soldier. . . . This week thousands have in this way been distributed. . . . The word is now abroad in the land! May it produce fruit!'

As noted earlier, Anna Whistler zealously honoured the Sabbath. Indeed, she explained in February 1847, she began the observance even before Sunday had arrived by 'shutting the business & pleasures of the world from [her] family circle Saturday evening', because, she said, 'I cannot but believe it right to do as we pray on the last day of the week, that all worldly cares may be banished from our minds that we may serve the Lord without distraction on His holy day'. On Sunday rarely would she leave home, and then only for a sacred purpose, like visiting an elderly friend in the terminal stage of her illness. On this occasion she saw 'two ladies in a coach in full dress going out to dinner, garlands of flowers on their heads & large bouquets in their hands. Then I thought "she who liveth in pleasure is dead while she liveth."' Sunday social calls were customary, but the Whistlers' friends and acquaintances knew better than to stop at *their* home. As she told an American who, in July 1844, had expressed a desire to see her on Sunday, 'I should welcome my husband's friends every day but upon the Sabbath when I consider myself engaged.'

Not only her husband's friends needed this gentle reminder. Apropos of a Sunday in May 1844, she reported, 'Whistler did propose going out to Tsarkoe Selo to see Col. Todd as he finds little leisure for visiting during the week, but I discouraged him by saying "You know as you spend Sunday so will your work in all the week days prosper or not." ' Although Whistler acquiesced, Anna was not self-deluded. 'Ah how kindly considerate is my husband', she wrote in September 1844, 'in spending his sabbaths thus separate from the world to please me. By & by I trust his own satisfaction will depend upon devoting all the hours of God's holy day to the interests of eternity.' Although he tried to placate her, Anna was troubled by his lack of religious dedication. In October 1846 she asked, 'When shall I have the happiness of seeing my husband kneeling at the Altar to commemorate the death of Jesus who has invited *all* who believe in Him thus to show forth the Lord's death till he come!' Anna never abandoned hope and next month expressed 'gratitude' that 'God has disposed my husband to seek counsel from on high, that he now never travels without his bible as his companion'. She apparently did not entertain the thought that he may have been motivated by a desire to avoid acrimony here below.

No disagreement between Anna and her husband was ever serious,

but the relationship between Anna and Deborah was potentially explosive.

Their divergent temperaments were typified by one slight incident. A clergyman named Williams spent three months of 1844 in St Petersburg, and the two women attended his first sermon. Anna summarised it: 'Mr. Williams' text was "For he was a good man, full of faith & of the Holy Ghost" from which he drew the character of a Christian, compared it with that of a worldly *good* man, moral, benevolent, etc., but remarked no code of morals could satisfy a true Christian which was not based upon faith in Lord & Saviour.' Anna responded, 'Oh my heart flowed with thankfulness to God that such a teacher of righteousness had come to occupy our Pastor's place.' Deborah, however, 'thought him bigotted'.

Deborah was correct. Anna's reports on his sermons show that Williams regarded religion as synonymous with the narrowest, strictest, most fundamental form of Protestantism. And if Williams was a bigot, so was Anna Whistler. Upon observing a servant performing her own religious ritual, in March 1846, she lamented, 'Oh how I wish I could read to her the 48th chapter of Isaiah! . . . Oh when will the true light shine upon the East, where it first dawned!' And Elizabeth Rigby's lately published *Letters from the Baltic* inspired her to write:

'One of her remarks upon the baptismal ceremony in the Greek Church made me laugh. They cross the eyes to express the vow not to look upon evil, the mouth to prevent the utterance of evil communication & she thinks the same charm of the T must be pressed upon the nose, as Russians seem not to be annoyed as others are by the odious smells which infect every avenue to the public.'

Religion underscored one difference between the two women, but in almost every way they were opposites. Deborah, who celebrated her eighteenth birthday on 24 October 1843, thoroughly enjoyed present pleasures, which alone accentuated the contrast between her and her stepmother. Note, in Anna's words, how each reacted in 1844 to a concert: 'Debo and I had some exquisite enjoyment in listening to the choristers of the Imperial Palace, she because the music was so perfect of its kind & I – when I closed my eyes could imagine myself among those who sing heavenly hallelujahs.'

This passage points to one of Deborah's main interests, encouraged and stimulated by her father, whose musical talents went beyond the flute. In September 1844 Anna wrote, 'I have not observed my dear husband so cheerful for a great while. He played accompaniments on the piano, ending with Irish airs on the bag-pipe.' On another occasion, in December 1846,

she told of his delighting a visiting Scotsman 'by imitating the Scotch bag-pipes upon the flute'. Anna looked on Whistler's flute as a mother would regard a child's toy. She found it 'amusing at bed time to see with what care my husband wiped his flute & put it away in its case'. Deborah, on the other hand, understood her father's feelings. On at least thirty-two occasions Anna refers in her diary to Deborah's musical performances. These are typical passages:

'[22 January 1844] [At Ambassador Todd's birthday party] Mr. Maxwell . . . asked Debo if it was too late for music. She sang several songs at his request. . . . When Debo sang Chorrey-Tavayts she surprised Mr Law by her correct pronunciation.'

'[April 1844] Major Tronvillier . . . delights in music & could not resist the temptation of lingering to listen to Debo's harp.'

'[June 1844] Mr. Miller & Curtis arrived to tea, the former . . . is so great an amateur of music he is willing to ride this far at any time to listen to Debo's piano or harp.'

'[June 1845] Mr. Miller made the boys merry as crickets, gave them a lesson in a Highland dance to the quickest time Debo's fingers could move over the keys.'

One of Deborah's St Petersburg highlights was a piano recital, in March 1844, by Clara Schumann. More interesting than Deborah's presence at this concert was Anna's response thereto:

'as my daughter had a fine opportunity for listening to her performance a few days ago when she visited the Smoloff Institution with the Maingays, I I was more chagrined that she went tonight, for I cannot think it consistent with a communicant of our church to give countenance to theatres, but Debo knows my opinion, so I say nothing, only my heart is pained when our views are opposite.'

In April of the following year Anna wrote, 'I am glad the season is over, as my daughter will no longer be tempted into crowded rooms, to keep late hours. She has not been able to resist musical attractions.' Anna disliked secular music, she explained in August 1844, because 'I cannot enjoy what occurs in direct opposition to the warning of our Saviour upon "idle roads".' She did, however, 'delight in sacred music which lifts the heart to mingle in heavenly choirs. Ah if I were Empress of these vast

dominions of Russia I should cultivate a taste for sacred music by prohibiting any other.' If Anna was present when Deborah played for guests, the programme always included sacred music.

Music was not the only area in which Deborah's gifts conspicuously outshone Anna's. Anna learned a mere handful of Russian and French words and throughout her stay in St Petersburg used her children as interpreters. Deborah, on the other hand, mastered languages easily. We have alluded to her excellent diction in singing a Russian song. Her French fluency, Anna noted in August 1844, was 'a great advantage here'. And wishing to learn German, Deborah took lessons from a tutor, faithfully studied the language, and was active in the German Academy and the German Singing Society.

Deborah had a healthy zest for life which she did not conceal, as when, in May 1844, the family visited Tsarkoe Selo palace. Anna noted that 'Debo was the only one who yielded to expressions of delight'. She was moreover wholly devoid of the snobbery that often characterises English-speaking people abroad. In January 1844 Anna reported:

'Debo accompanied Emma Maingay & some other ladies to be a spectator of the wedding festivities of the royal cousin Elizabeth. Her father was rather ashamed that his Yankee girl should condescend to mingle even in a fashionable crowd to be a looker-on upon an assemblage she could not be received in, but his *Indian* pride does not descend to his children.'

Unsurprisingly, Anna's diary shows that Deborah was exceedingly popular:

'[February 1844] Debo is already a favorite in the English circle here.'

'[February 1844] The Ropers came in sociably to tea thinking they might see Debo (whom they love and admire equally).'

'[September 1844] None can admire her as I do always when she mingles among the fashionables here, knowing as I do her power to shine and win attention.'

To her own family Deborah was a constant joy. When James was sick, his greatest comfort came from her visits. And no father was more proud of his daughter than Whistler. When he could spare time from professional duties, he liked nothing better than to be with Deborah – boating on the Neva, escorting her to parties, and promenading on the highly fashionable

Nevski Prospect. Even Anna was captivated by her stepdaughter, calling her, in February 1844, 'a dear, amiable child, dutiful & always cheerful, yielding to her father's views of what is right' and noting in August of the same year 'how unassuming she is compared to other young ladies'.

Deborah was nevertheless a source of concern for Anna, who was fearful, in February 1844, that '*late hours* her health will not keep'. A few days later she revealed that her main anxiety was not for Deborah's physical well-being:

'My dear Debo may compare her rational domestic career with the dissipation of the youth of this gay metropolis & feel satisfied that she may sometimes attend a French play or the Opera without injury to herself, but Oh how much more happy she would be if she found no pleasure in them! . . . I lament that my dear daughter does not realize that she is required by her vows as one of Christ's little flock to "let her light shine" that those who are in error may be led into the way of truth.'

Anna continued to fret about Deborah, and in August 1845 she sighed, 'the future for that daughter presses heavily upon my heart if she should soon be left Motherless!'

When this sentence was written, Deborah was no longer in St Petersburg. Despite her amiability, it seems that she finally found Anna too much to endure. Although the diary constantly speaks of 'my dear daughter' and 'my precious Debo', it reveals a thinly concealed jealousy, and, probably hidden from the writer herself, a feeling of hostility. The entry for 22 April 1845 is perhaps unconsciously self-revealing. Anna was referring to the preceding Sunday, after Deborah and a friend had returned from an afternoon concert:

'Martha Roper spent the rest of the day with Debo, quite frolicsome. The noisy concert has made her quite rife for amusement I fear. In the evening her brother Joseph joined us at tea. I took French leave of the circle while I read to my boys one of McNeill's excellent lectures which he wrote especially for Passion Week upon the sympathies & sufferings of our Saviour. . . . We were just at the close of the lecture upon the treachery of Judas Iscariot when Debo came to say good-night, as Martha has to keep early hours.'

The juxtaposition of Deborah's name and that of Judas Iscariot is, at the very least, strikingly curious.

At the time of this incident, Deborah was preparing to leave for an extended holiday in England, allegedly to improve her health. To be sure,

there are frequent diary references to Deborah's maladies, but they suggest psychosomatic ailments:

'[March 1844] An intense headache confined Debo to the house all Sunday.'

'[April 1844] Alas for my darling daughter's disappointment, she looked so ghost like at breakfast she had to confess herself more unwell than ever.'

'[August 1844] Our dear Debo has been an invalid for several days [with] a general eruption on her skin.'

'[April 1845] It is indeed a grief to me to observe dear Debo so feeble this spring.'

Soon after Anna had written this last line, Deborah raised the question of going to England for a health cure, and when her parents agreed she at once showed a remarkable improvement. On 28 June, Anna wrote, 'I had never known Debo so energetic as she was in efforts to obtain her wish to reach London. . . . Her first & last question night & morning was about steamers for England. . . . At last all was arranged to her satisfaction, the money paid for berth in the Hull steamer, & Mrs Cotton delighted to take her under care.' And then almost on the eve of her departure, an event occurred that made Deborah as eager to remain as she had been to leave. Arriving from America was her brother George. She returned her ticket, and they shared a delightful summer, which, incidentally, marked the arrival of a new stepbrother, born on 29 August, John Bouttatz.

Soon after the birth of Anna's baby, George departed for home, to work for the Winans Locomotive Works. Travelling with him as far as England were Aunt Alicia and his sister. Deborah had felt fine all summer, but in September Anna wrote, 'It had suddenly been decided that we must part from our Debo whose health needed a change.'

With Deborah gone, Anna could concentrate on her sons. As mentioned earlier, her 'sweetest employment' was training her 'little boys', and this continued uninterruptedly in St Petersburg.

The most important part of this training involved religion. The boys, Anna wrote in March 1846, 'have been taught from the scriptures always. May God the Holy Spirit make them wise unto Salvation.' One possible effect of this training might be noted. Anna constantly emphasised the importance of the personal relationship between herself and her sons, and between each of them and God, but she did nothing to develop a proper attitude towards society. They were not taught to be concerned

with this world except as a training ground. It was less important to co-operate with fellow human beings in earthly tasks than to elevate oneself for God. Understandably, a child subjected to such training might grow up without strong social feelings towards other human beings.

Second in importance to religion for Anna was patriotism, and her sons never forgot that they were citizens of the United States of America. 'Oh I can think of no earthly delight to compare with that of our return to our native land!' she wrote as early as February 1844. 'As I anticipate our approach to a sight of its shores within the beautiful harbor of New York or Boston I am afraid of growing too impatient to realize all this fond dream!' On this her feelings never changed.

The boys absorbed religion and Americanism from their mother, but she could not after the first few months supervise their more conventional education. In St Petersburg the usual method of instructing children from well-to-do families was by tutors, from at least two of whom, a Swede and a German, the Whistler boys took lessons until September 1846, when, because their father felt they needed stricter instruction, they became boarding students in Monsieur Jourdan's school. At this moment of James's first separation from his mother, one might examine their personal re-lationship in his childhood. The celebrated attachment of mother and son has sometimes been supported by episodes from St Petersburg, but they should be looked at carefully. In August 1844, when Whistler was on an inspection trip, Anna moved James's bed from the nursery and placed it alongside her own. Her motivation, however, was that he had 'fallen into those habits of late rising in conquence of keeping wake till ten o'clock. . . . I have removed him . . . so that I may manage him.' In June 1845 she gave him 'the polyglott Bible which was his sainted [elder half-]brother Joe's & since his death had been prefered [*sic*] to me to any other, because of the association'. This was done because Anna was worried about her first son and hoped he might 'be aided by the holy spirit to love & to value the unpretending looking volume!' Then there is the often mentioned poem James selected on his tenth birthday and placed beneath his mother's breakfast plate. The text, related by Anna, differs from several published transcriptions:

> They tell us of an Indian tree
> Which howsoe'er the sun & sky
> May tempt its boughs to wander free
> And shoot & blossom, wide & high,
> Far better loves to bend its arms
> Downward again, to that dear earth

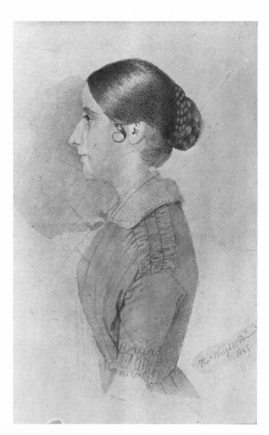

1. Portrait of Anna Whistler, 1845

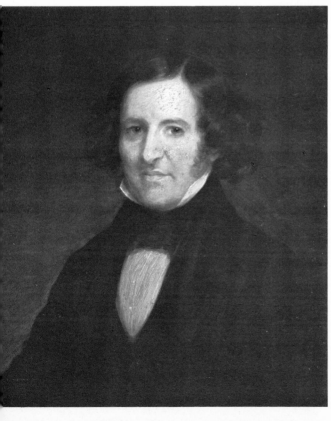

2. Portrait of George
 Washington Whistler

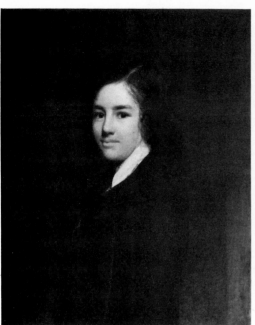

3. William Boxall:
James McNeill Whistler as a child, 1848

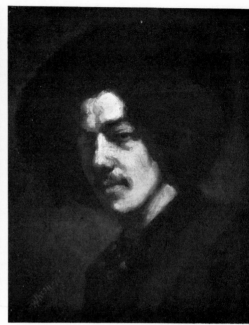

4. James Whistler: Self-Portrait, 1858

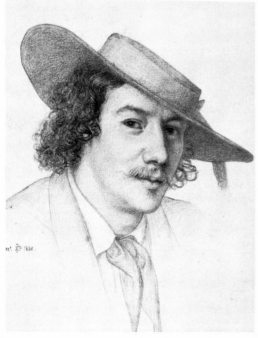

5. Edward Poynter: Pencil Portrait of Whistler, 1858

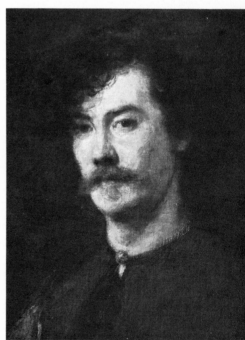

6. Henri Fantin-Latour: Portrait of Whistler, 186

From which the life that fills & warms
Its graceful being first had birth.
'Tis thus, though woo'd by flattering friends
And fed with fame, (if fame it be)
This heart, my own dear mother bends,
With Lov's true instinct back to thee
 On my tenth birth day, your little James.

Before placing undue emphasis on this poem, one should note the relevant diary comment:

'When we assembled at prayers our dear boy came out of his father's office . . . where he had been shut up with his Swedish tutor since six o'clock! at some mysterious employment. It was solved when we went to breakfast. Under each place was a note to each. Mine tho not his own composition as the others were, was so beautifully expressive of love to a mother that I felt . . . quite overcome by the surprise.'

James thus provided a poem for each member of the family, and for the others he composed original works which may have contained as much feeling as the selection chosen for his mother.

Actually Willie was closer to his mother than James. When they left for school, only Willie was noticeably disturbed by the parting. In her initial diary entry on the boys' new life, Anna wrote, 'James reported everything "first rate" even to brown bread & salt for breakfast, quass for dinner.' Willie, on the other hand, could not enjoy anything because of homesickness, and a family friend who visited the boys during their first week at Jourdan's told Anna that 'poor Willie looked very doleful'. In October, after her sons had been home for a weekend, Anna observed, 'Willie & I parted as usual in tears. Dear Jemie may love his home as well, but he is blessed with an elasticity of spirits – which rise above the thoughts which cause his younger, gentler brother to cling to his poor mother. Willie would like school if he could return to us every night.' After the next weekend, Anna 'could not but remark darling Willie's clinging to me, his attention to all I wished', reflecting 'the deeper tenderness which was swelling his heart as the hour for leaving home drew nigh'.

These passages show that whereas Willie was quiet, docile, and dependent on his mother, James was independent, self-willed, and self-contained. With his personality, one would expect James to clash with the school authorities. Surprisingly, three months elapsed before he was reprimanded, when, Anna wrote, he was 'kept in school until night, to write a given portion of French over 25 times as a punishment for having

loitered to chat with a class-mate after their recitation was finished instead of marching back to his seat according to order'. This episode was soon followed by the winter holiday, after which Anna decided not to return her sons to Monsieur Jourdan. In January she explained her decision: '... the experiment has dissapointed [*sic*] my expectations. Any advantage in the way of study has been at too great a sacrifice, that of health most apparent, but I tremble also for morals. I beg their father earnestly, that they remain at home ... where their habits to virtue will be strengthened.' One wonders how much Willie, because of homesickness, and James, because of an aversion to discipline, persuaded her to take this action. In any event, one should note that they were placed in school by their father and taken out by their mother.

Another tutor was engaged, but neither he nor his predecessors nor M. Jourdan nor even Anna provided James with the most important part of his Russian education. His London courtroom declaration that he was born in St Petersburg is not really preposterous, for the trial dealt with artistic matters, and James Whistler the artist was in fact born in St Petersburg.

Soon after arriving, James began to take weekly drawing lessons from Alexander Karetzky, an advanced art student. When he had to miss a session because of illness, in March 1844, it was, Anna said, 'a greater chagrin than Willie's going without him that day'. Next month she wrote, 'At 8 o'clock I am often still at my sewing or reading without a candle & can hardly persuade James to put up his drawing to go to bed while it seems yet day light.' In May when they visited the Tsarkoe Selo palace, 'Jemmie wished he could stay to examine the fine pictures & know who painted them'.

In July 1844 James received his first professional encouragement, from Sir William Allen, of the Scottish Royal Academy, invited by the Tsar to paint a large canvas of Peter the Great teaching peasants how to build ships, who paid one visit to the Whistlers. Sir William's arrival, Anna related, 'made Jemmie's eyes express so much interest that his love for the art was discovered & Sir Wm. must see his attempts. When my boys had said good night the artist remarked to me, "Your little boy has uncommon genious [*sic*], but I do not urge him beyond his application." ' From this single diary reference we cannot know if Allen was just being polite or actually saw potential greatness in James's work.

In St Petersburg most talented art students enrolled in the Imperial Academy of Fine Arts. Modelled on its French counterpart and established in the middle of the eighteenth century, it was located on Vasili Ostrow island and was the largest, most impressive of all European academies, with 'ten times more space than in England would be allowed for the same object'.[13] Its facade, 400 feet long and 70 feet high, adorned with columns

and pilasters, and surmounted by a central cupola with an immense statue of Minerva, faced the Neva directly opposite the Whistler home. On 14 April 1845 young James became one of approximately three hundred students in the Academy. Having done well on the entrance examination, he entered the second of four classes – Karetzky had reached the highest level – 'Drawing Heads from Nature'. The title was a misnomer, for the students, as in most European art schools, copied plaster casts of classical works. James attended thrice weekly, and when examined, on 2 March 1846, he ranked twenty-eighth in a class of more than one hundred and received the top grade, a 'first'.[14]

In dealing with art in St Petersburg, one must mention the Hermitage. Neither Whistler's writings and recorded conversations nor Anna's diary contains a reference to the museum. We should not, however, conclude that he never stepped inside its doors. As an adult he seldom wrote or spoke of specific events in St Petersburg, and his mother by no means penned a complete record of their life in Russia. For her, the absence of Deborah from family devotions would have been more noteworthy than a visit to the Hermitage. Actually it is inconceivable that James would not have gone there. It was near his home alongside the Winter Palace, and can one suppose that he did not persuade his tutor to take him to a museum with sixty paintings by Rubens, forty-one by Rembrandt, thirty-four by Van Dyck, twenty by Murillo, and six by Velasquez?

James Whistler, we may assume, did visit the Hermitage. There would be little point in describing this extraordinary collection but one might mention the first paintings he saw after going through the main entrance. In the 1840s the frontal gallery comprised work of that celebrated painter of nocturnal scenes, the seventeenth-century Dutchman Aert van der Neer. Van der Neer's name inevitably suggests moonlight shining on water, the water of rivers, lakes, and harbours. His Hermitage pictures were representative. A visitor to St Petersburg during James Whistler's first full year there said of them: 'The artist has painted the moon as often as if he had been one of Diana's priests. . . . In general there is the sea, or a lake, or other place of water in the neighbourhood, on which long reflected rays stream far into the dark distance.'[15] We cannot know what James saw elsewhere in the Hermitage, but he could hardly have missed the first objects to strike his eye, Aert van der Neer's nocturnal seascapes.

Lessons from Karetzky, classes in the Academy, and visits to the Hermitage did not encompass everything in St Petersburg that contributed to the making of James Whistler the artist. His growth was influenced by all of his experiences in this remarkable city.

Spectacular illuminations, like van der Neer's pictures, drew attention to the night. A birthday, a christening, a marriage, or any other special

event involving the imperial family called for fireworks or illuminations, as in June 1846, when Anna wrote, 'Yesterday the Empress . . . was welcomed back to St Petersburg. . . . Last night the illumination which my boys have been so eagerly expecting took place. . . . The effect of the light from Vasili Ostrow was very beautiful as we drove along the Quai.'

More important than illuminations was the River Neva. Young James, born within a stone's throw of the Merrimack River, and raised in the constant sight of the Atlantic Ocean and the Connecticut River, now lived in a house that overlooked the magnificent body of water that dominated the city. Almost every visitor eulogised the Neva, 'the real glory of St Petersburg, a scene so vast that all the rest seems little in comparison'.[16] In 1843 an observer stated that at night 'the scene is most striking, when its waters reflect the thousands of lights from the shore',[17] and a decade later the Marquis de Custine recorded his nocturnal response from a vantage point near what had been the Whistler flat:

'I was struck with admiration at beholding one of those effects of light which we see only in the North, during the magic brightness of a polar light . . . its lustre was reflected in the Neva, to whose vast and unrippled surface it gave the appearance of a lake of milk or of mother-of-pearl. The greater part of Petersburg . . . was, under this light, revealed before my eyes; the whole formed a perfect composition of Breughel's. The tints of the picture cannot be described by words.'[18]

How many times did James Whistler gaze upon this scene?

The Neva was magnificent, but the excitement of St Petersburg was on its streets. 'Thanks to its inhabitants,' Custine said, 'this city resembles no other in Europe.'[19] The people had 'a natural perception of the picturesqueness; their customs, furniture, utensils, costume, and figure, would all furnish subjects for the painter, and the corner of every street in St Petersburg might suggest material for a picture'.[20] On the streets and elsewhere, St Petersburg struck most visitors with its contrasts and extremes, displaying in the words of one foreigner, 'scarcely any medium between luxury and want'.[21]

On the one hand there was almost unbelievable opulence. Some people, Maxwell reported, lived in mansions

'with the most costly ornaments and the most luxurious furniture. Jasper and porphyria adorn the walls; columns and pilasters of solid malachite, valued at five and six thousand dollars each, support the sculptured ceilings. Cabinet-makers and upholsters arrive every year from Paris and . . . refit with additional magnificence their great abodes.

'During the winter they are engaged in a constant succession of festivities. . . . Carpets are laid from four-horse carriages and lead from wintry obscurity and bleakness to halls as lustrous and as warm as a southern clime in summer. . . . A hundred menials wait in the anterooms, banquet chambers contain every foreign delicacy, and there is nothing desirable to be bought with gold that is wanting for the pleasure or the comfort of the guest.'[22]

Symbolic of St Petersburg's wealth and luxury was the two-mile-long Nevski Prospect, lined with trees, magnificent buildings, and sumptuous shops with 'an immense variety of edibles and potables, the choicest spices and most expensive wines, delicacies of every kind'.[23] The Nevski Prospect, where Deborah strolled with her father, was 'at once Bond-street, Regent-street, and Palais Royal',[24] and 'if a visitor looked no further and went away with no other than this passing view to remind him of the imperial city, he would say that it was the most magnificent of European capitals'.[25]

One vistor who looked further saw 'slums and rookeries' with 'dirty, squalid brick edifices very closely resembling the "tenement houses" of the lower districts of New York', where a single dwelling 'sometimes sheltered as many as a hundred families'.[26] But nothing more shockingly illustrated the degradation of the lower classes than millions of serfs, with 'no acknowledged rights' and 'deprived of everything by law',[27] for whom 'freezing to death is one of the easiest and least painful which he is ever likely to suffer'.[28] In Tsarist Russia they were indispensable everywhere, and were used in the Whistler enterprise:

'The earthwork was entrusted to a vast army of serfs who in certain years exceeded 50,000 in number. . . . Much of the line traversed marshes, and serfs might spend a whole day waist deep in mud and water. . . . They were badly fed and badly housed and they were liable to be flogged if they complained. . . . Several thousand died during the construction.'[29]

'When I reflect', Custine declared, 'upon the thousand cruelties which . . . take place daily in the bosom of this immense empire . . . I think only of flying.'[30] He prophesied, 'Either the civilized world will, before another fifty years, pass anew under the yoke of barbarians, or Russia will undergo a revolution more terrible than the effects of which we are still feeling in Western Europe.'[31]

Among those not sharing these apprehensions and sensitivities were that devout Christian lady, Anna Whistler, and her first-born son.

In Anna's diary only one sentence, written in January 1846, shows

that she was aware of Russian slavery: 'Whistler and I took our little Willie to church yesterday to attend the funeral services of our old landlord Mr Dury. . . . Willie had noticed the grief of even the poor slaves who were present when their old master's coffin was moved down the aisle.' The following representative passages demonstrate how this gentlewoman viewed the poor people of St Petersburg:

'[April 1844] I shall never be sharp enough for the rogues I have to deal with here, so rare is honesty among the lower classes.'

'[June 1844] What a pity that intoxication should be the besetting sin of the lower orders.'

'[September 1844, written just after moving into their second flat] How glad I shall be when all these work people are done! they are so filthy in their persons! . . . I shudder as their long dirty robes sweep past me and fly from their sheep skins as from contagion.'

As for James, from the beginning he identified with the oppressors. Royal weddings and visits to palaces were important to him, and also, beginning early in 1846, the family ownership of a sledge, which conveyed the status that more recently has been attached to a Rolls Royce. James Whistler was, in short, a thoroughgoing snob. Perhaps the greatest influence in developing his snobbery was the Emperor, Nicholas I, Tsar of all the Russias.

'The name of Nicholas', said a mid-century observer, 'is as inseparable from that of Russia as is the notion of the sun from that of daylight.'[32] And Custine said, 'One neither moves nor respires here except by an imperial order.'[33] Nicholas's appearance suited his position. A young resident foreign artist remarked that he 'is of great height, and is very proud of it – too proud, perhaps, as he has acquired the habit of certain airs, which often give him a strong resemblance to a peacock when about to spread his tail'.[34] Another observer noted that 'His proud, glacial look, stern and penetrating, shows his contempt for mankind and a mystic faith in his omnipotence.'[35]

Despite his arrogance, Nicholas was noted for courtesy and hospitality. Soon after arriving in St Petersburg, Whistler wrote to Anna:

'The Emperor is a very fine looking man, very much like General Scott, but the general never treated me with half the consideration that the Emperor did. There is that about him that enables me at once to enter upon a conversation and tell him all that I know upon the points of his

inquiries with as much ease as I could have talked with any private gentleman. . . . I described to him the whole of the road, its principal difficulties and how they might be overcome. He seemed much interested, often questioned me, and was pleased to say, shaking hands with me, as we parted, "I am sure, sir, you will do it right".'[36]

Young James Whistler heard his father speak of the Emperor, and he occasionally saw the great man, sometimes from close range, for Nicholas regularly walked and rode in public, and his favourite streets were the Nevskí Prospect and the English Quay.

James also saw the Emperor at the celebrated reviews of troops, held in Admiralty Square, sometimes called Champ de Mars, near the Whistler residence. The greatest of these spectacles took place annually in May, the grand review, involving 80,000 marching men. In her diary Anna recorded her impressions of the grand review of 1845:

'Capt. K. had succeeded in obtaining a window for us in the 4th story of the Prince of Oldenburgh's Palace. . . . It is impossible to convey a conception of the effect of 80,000 troops with their field pieces, banners, etc. glittering in the sun shine. . . . We had a perfect view of these beautiful women, the Empress & the Grand duchesses. . . . The troops in their new gaudy uniforms of every hue gave the effect of a vast bed of tulip. The Emperor rode proudly among them. . . . As he received the shouts of the several companions as they passed him in their maneuvres methought he looked too proud for mere mortal & I wondered if he remembered the presence of the King of Kings! for I thought how small was all this array in comparison to the Armies of heaven.'

The review of 1846 was followed by another grandiose event, on 7 July, when the Emperor celebrated his fiftieth birthday and announced the betrothal of his daughter Olga. With Deborah in England, Whistler on an inspection trip, and Willie slightly ill, Anna and James went out alone to see the illuminations. As the crowd surged for a glimpse of the Empress, James had the chance to be his mother's protector. Here is Anna's account of the episode:

'The Empress was passing . . . just as we were beginning our dissipation, but there was no possibility of getting out of the line [and] I was terrified lest the posts from the coaches should run into our backs, or that some horse might take fright or bite us so close were their heads. Jemie laughed heartily at my timidity. He behaved like a man, with one arm he guarded

me & with the other kept the animals at a proper distance. I must confess, brilliant tho the spectacle was *my* greatest pleasure was derived from the conduct of my dear & manly boy.'

The royal wedding occurred later in the month, and, although repelled by vanity and frivolity, Anna devoted more diary space to this event than to any other occurrence. Typically self-sacrificing, she explained: 'The public rejoicings have demanded my participation in my children's interest in the several spectacles.' Her participation, however, seems not to have been under duress, judging from her commentary, of which this is a small fragment:

'I wish I could convey the faintest idea even of the magnificence of the spectacle.... At the entrance gate from the tower was a crown & under it very conspicuous O.K. for Olga & Karl. The gate looked as if composed of diamonds, but all the rest of the upper garden had colored lamps in shape of fruits & flowers, bands of musicians were stationed in the groves & played alternately.... Lines of illuminated wall looking like filagree work of gold & diamonds formed avenues extending in different directions, the principal one from the palace had at the end near the gulf, what looked like an immense gate of brilliants, surmounted by a blazing sun the rays of which enclosed an A for Alexandra in honor to the adored empress.'

A month later came another, more private celebration: '[John] completes his first year today & my heart is overflowing with thankfulness to the Giver. I can reflect upon the gentleness & intelligence of [Charlie] who was taken almost three years ago from my arms to those of his Saviour, and the sprightliness of this one who has been sent to cheer me for that loss.'

This entry would soon appear to be painfully ironic. In late September Whistler left for Hamburg to greet Deborah who, her health restored, was returning to St Petersburg. With James and Willie in boarding school, Anna was alone with her servants and John, 'in excellent health'.

The first diary entry after her husband's departure appears with startling suddenness:

'The house has almost the stillness of the grave & I may while on the watch as sick nurse write of that which has engrossed all my time & thoughts these ten days past. What a shock it will occasion to Whistler & Debo when they arrive to hear all I have gone thro. They will see how near we have been losing our precious little Johnie. The crisis is just past

& . . . we may hope now God will spare us the affliction of having to bury the little one who has the year past caused joy to return to our home circle. . . . Never have I witnessed sufferings so extreme, so protracted in an infant frame.'

The baby received the best possible treatment. The family doctor, an Englishman, called four times daily, joined once a day by a German consultant, for twenty years the principal physician at St Petersburg's children's hospital, who diagnosed John's illness as dysentery.

Anna asked only that the pain be alleviated. 'I dare not pray', she wrote, 'to have his life on earth prolonged if our Infinitely wise & compassionate Saviour designed to take him early to his home in Heaven.' On 15 October Anna recorded the decision: '. . . yesterday at 3½ o'clock in the afternoon our baby's sufferings terminated! His sickened spirit borne on angel's wings no doubt returned to God who had lent him to cheer us & taken him suddenly to warn us "Be ye also ready."' After taking her final look at John, she wrote, 'What a reluctance I felt to be parting from the body I had so much delighted in! As I kissed the beautiful hands, they were as pliable as ever in life, so soft & dimpled! but ah the icy coldness struck to my heart!'

This excerpt underscores a troubling inner conflict for Anna. Since Johnnie was now in paradise, she reflected a few days after his death, she should rejoice:

'May God sancify every affliction to us & Oh may this last stroke loosen our hold upon earth & each succeeding help to prepare us for heavenly joys. . . . How blind & idolatrous that mother who could desire to detain a little one from the Lord of all! Tho I weep let me faint not, but press on daily towards the attainment of a blessed reunion of all I have loved whom God has taken before me to an eternal home.'

Although she tried desperately, Anna could not overcome her distress. Particularly poignant is a passage of November 1846:

'What hard struggles I endure to subdue my selfish grief! Yesterday I was struck by my bereaved friend Mr Nichols' extract in the last letter received from him, "Let power be given – to draw – not them to Earth, but us to Heaven," & I shall endeavor to keep this warning in view, that when painful images of my darling's sufferings pass in review, I may lift my heart in prayer to Jesus to help to keep my thoughts upon the realities of an unseen world. Why should the thrilling tones of my baby's voice as I last heard them expressing the sufferings of that agonizing thirst still cause me to

weep bitterly! It is past & he has forgotten it for the gentle Shepherd leads him to pure streams of living waters.'

Her tribulation, she tried to persuade herself, was a blessing: 'He has enabled me to feel it to be good to enter the cloud of affliction where His glorious presence becomes visible to the mourner who cannot bear the false glitter of this world's joys, but whose soul then sketches its gaze to the realities of Eternity.'

While awaiting Eternity, Anna tended to lesser realities, such as Deborah, who arrived on the day after John's death. 'Our darling daughter', Anna wrote on 29 December, 'much needs more suitable companions to her age than her old Mother. . . . The house must be too quiet, for she seems at times solitary & melancholy.' One hardly thinks of Deborah as solitary or melancholy, but after fourteen cheerful months in Britain it was difficult to live in the family flat, with her father absent during the day and the boys at boarding school. Deborah indeed probably influenced the decision in January to keep her brothers at home.

During the early months of 1847 there were two occurrences which James Whistler would not soon forget.

One episode concerned his father and the railway. Numerous disinterested parties had recognised the greatness of the project. As early as June 1844, *The Times* called it 'an undertaking unparalleled in ancient and modern history'.[37] Emperor Nicholas was properly appreciative and in March 1847 he provided a memorable manifestation of his appreciation. In Anna's words, he

'summoned Whistler to a private audience in an inner apartment, . . . kissed him on each side of his face & hung an ornament, suspended by a scarlet ribbon around his neck, saying the Emperor thus conferred upon him the Order of St. Anne – second class – Whistler, as such honors are new to republicans, felt abashed when he returned with the Count to the large circle in the outer room & was congratulated by the officers generally.'

In retrospect, the medal-awarding ceremony was less significant than an illness that befell James.

In St Petersburg all the Whistlers were indisposed from time to time, but the chief sufferer was James. Throughout 1844, 1845 and 1846 scarcely a month or two passed without Anna mentioning an ailment that had afflicted him. None of them, however, laid him up for more than a few days or a week. Quite different was the illness of 1847.

One morning early in January the family gathered as usual for prayers

but without James, who had come down with an attack of rheumatic fever.

In January, February, and most of March he was bedridden, for six weeks forbidden to move, and in February Anna remarked on his

'murmuring submission to his suffering confinement. The doct. does not yet consent to using his pencil, which is a great privation – but while pain lingers as it still does in his chest, my darling patient himself agrees that his favorite pastime may be injurious. . . . What a blessing is such a contented temper as his. He is so grateful for every kindness, & scarcely ever expresses a complaint.'

One might contrast the ways in which James's mother and half-sister gave him comfort and solace. Anna 'sang hymns', which 'at such seasons are the only welcome sounds to sooth anguish mental & bodily'. Deborah borrowed a book of engravings by Hogarth. This was perhaps the most important single occurrence in James Whistler's life in St Petersburg.

He could not easily handle the volume, but, Anna related, viewing it was an exciting experience:

'We place the immense book on the bed and draw Mr Maxwell's great easy chair close up that dear Jemie may feast upon it without fatigue. I expressed surprise to hear him say yesterday while thus engaged, "Oh! how I wish I were well," & said to him I hoped he was not getting impatient of seclusion. "Oh no Mother!" he answered cheerfully. "I was only thinking how glad I should be to show this book of engravings to my drawing master. It is not everyone who has a chance of seeing Hogarth's own engravings of his originals." & then he added in his own happy way, "And if I had not been ill, Mother, perhaps no one would have thought of showing them to me."'

This was 'the beginning', the Pennells wrote, of Whistler's 'love of Hogarth, which became an article of faith with him'.

Some have been surprised that as an adult Whistler continued as a devotee of Hogarth, but no one should be astonished by the 12-year-old boy's fascination with these engravings. Hogarth is immediately accessible, he is entertaining, and he is an excellent story-teller. Although he was a subject painter, a vast gulf divides Hogarth from the Victorian anecdotal hacks. He was separated from them by vigorous treatment of material, by penetrating powers of characterisation, and by superb gifts of observation and selectivity. And Hogarth learned his art not within stifling drawing academies but on the streets of London. 'There is but one school', he said, 'and that is kept by nature.' Hogarth, in the words of a Victorian

critic, 'led art back to nature, swept away the conventionality of acade-
mies, and placed our English school on the sound basis of truth.'[38] Herein
lies a major reason for his impact on young Whistler. James had been
subjected to conventionalised art training while absorbing St Petersburg's
street scenes, and he seems to have comprehended Hogarth's universality,
realising that, basically, eighteenth-century Londoners did not differ from
nineteenth-century St Petersburgers, and to have distinguished between
the genuine realism of Hogarth and the stylised formalism of academic
genre painters. Because of what the 12-year-old lad gained from Hogarth,
the most important, most fortunate event of his young life was his illness
of 1847.

Whistler's biographers have mentioned Hogarth, but no one has yet
noticed another painter whose work was surely known to and influential
upon young James, a Russian army officer who resigned his commission in
1844 to become a painter in St Petersburg, Pavel Fedotov. A protégé of
Bryulov, the mentor of James's tutor Karetzky, Fedotov died in 1852 after
enjoying a brief period of immense popularity that began with the exhibi-
tion of two paintings at the Academy in the spring of 1847, soon after
James saw the engravings of Hogarth. He achieved the height of his
celebrity in 1848 – when James was still in St Petersburg – with *The
Major's Courtship*, which, resembling Hogarth's *Marriage à la Mode*,
depicts 'an impoverished nobleman courting a rich merchant's daughter –
but [is] confined to one scene, which shows the bride trying to escape
when everything is set for her betrothal'.[39] Fedotov was often called 'the
Russian Hogarth' because of his sense of humour, his dramatic scenes,
and his reliance upon life rather than rules.

'Only a tenth of my work', Fedotov said, 'can be done in the studio,
my principal work is in the streets.'[40] With an observant eye he walked
throughout St Petersburg and 'found his themes in dark damp side-streets
and unkempt corners. . . . Here he sketched ragged beggars, wandering
minstrels with tame performing monkeys perched on their shoulders,
picturesque cab drivers with high hats, and stolid uniformed policemen.'[41]
Fedotov was the first important Russian painter to create realistic street
scenes, and, as Hogarth had done, he introduced a fresh, invigorating
element into genre painting. Since his subjects came from contemporary
St Petersburg, his impact on James Whistler may have been even greater
than that of Hogarth.

Young James may also have been affected by Fedotov's personality.
Before achieving recognition, he painted a picture of a young artist
standing defiantly before his easel, saying, 'No, I won't exhibit; they will
never understand me.' Fedotov often wrote explanations and placed them
alongside his works on exhibition. He was also not above self-advertising

and more than once stood beside a picture to call attention to its merits. It is unlikely that James saw him doing this, but he must have heard of such uncommon conduct, if only from Karetzky. And who can say how these reports might have affected an impressionable 12-year-old boy?

Early in June, Whistler's wife and children visited Anna's sisters in England. Soon after arriving, Anna noted, James suffered what he considered an indignity: 'We reached Scarbro . . . went in the 2nd class carriages tho Jemie's pride was wounded by so doing.' Except for this demeaning experience, the summer holiday was thoroughly enjoyable for him. In Egremont, on the Cheshire coast, he and Willie bathed in the sea; in Liverpool they flew kites, visited a courtroom, and boarded an American ship, where James conversed animatedly with the first mate; and naturally James was constantly drawing. In July while seeing friends in Kirby, Lancashire, near Preston, Anna wrote, 'During our visit Jemie attempted the portraits of even the three servant maids.' This interest in portraiture was not temporary: two months later, after leaving Preston, Anna noted, 'Poor Jemie had left undone much which he applied himself to accomplishing the last day. There was a sketch of Aunt Winnie promised to Miss C——, & a beautiful engraving of Miss Walton long waiting to be copied. He did copy the old hermit at his devotions very correctly, tho he had only a common pencil & foolscap paper.'

James was amiable and well behaved and made a favourable impression everywhere. A typical reaction was that of a Liverpool headmaster at whose school the two boys were briefly pupils. Late in September, Anna wrote:

'Mr Stewart expressed his regret at their removal from his school in the most flattering terms, saying that their example would have been valuable to the other boys. Indeed I had observed . . . our training had enabled Jemie especially to resist temptations among his play fellows, that he had not yielded to their persuasions to deceive their masters & that when he made mistakes, he still had courage to confess his fault.'

The explanation for the boys' enrolment in this school, and their continued presence in England, lay in their half-sister Deborah who among the Whistlers was most permanently affected by the summer of 1847.

After eight months with Anna, Deborah's health again began to fail, and, ostensibly to recuperate, she spent most of the summer in Switzerland with a well-to-do, socially prominent English family from London's Sloane Street, the Hadens. They were five: the widow of a distinguished physician-surgeon, Charles Thomas Haden; two sons, 29-year-old Francis

Seymour and 25-year-old Charles Sydenham; and two daughters, 28-year-old Emma and 27-year-old Rosamund. The Hadens and Whistlers were linked by the 'founder of Lowell', Kirk Boott. Like the Bootts, the Hadens came from Derby, where Charles Thomas's father, Thomas, had been a doctor, an amateur musician, and the city's mayor. Two of his sons, including Charles Thomas, attended Rugby with Kirk Boott, and a daughter, Anne, became Mrs Kirk Boott. Since Boott had been her father's close friend, it was natural for Deborah to be with the Hadens who, like everyone else, at once took a fancy to her. Deborah liked all of the Hadens, and a particularly strong tie developed between her and Seymour, his family's third physician-surgeon, and also a talented painter and etcher. During this summer Seymour and Deborah became engaged to marry.

None of the other Whistlers knew of Deborah's Swiss romance until late August, when, in England, she informed her stepmother, who was quite pleased. Not only were the Hadens wealthy and cultivated, but one of them, Seymour's uncle John Clarke, had been priest-in-ordinary to two reigning monarchs, William IV and Victoria, and in 1846 became Preceptor of Westminster Abbey. She and Deborah sent the news to Whistler, who gave his permission for the match by return post. The wedding was to take place in Preston on 16 October, five days after the father's arrival and eight days before Deborah's twenty-second birthday.

It has frequently been stated that from the beginning Whistler and his elder son disliked Haden. The basis for this assertion is James Whistler's statement late in life to the Pennells: 'I remember that my father came to England specially to see Seymour Haden, and I was with him, and, from the first disliked him. Haden patted me on the shoulder and said it was high time the boy was going to school. Nor do I think my father approved.'[42] Whistler spoke more than fifty years after the event, when serious disagreements had risen between him and Haden. On the face of it, Haden's remark is improbable because the boys had been at school until just before the wedding. Not one word, furthermore, in any contemporary document suggests ill feelings between Seymour Haden and any of the Whistlers. Everyone, on the contrary, seemed delighted with the union.

The wedding ceremony took place in Preston's Old Parish Church, and afterwards Anna responded characteristically to those outside: 'I was annoyed by the rudeness of the crowd pressing upon us as we attempted to get from the church to the carriage. Mr Whistanley [Eliza's husband] expected it & had filled our boys' pockets & his son's with sixpences, but still he cried shame on the English customs while the shower of silver diverted the rude people from us.' The wedding breakfast, Anna recounted, was 'simple & elegant', with 'Debo seated between her father &

Seymour looking the happiest of the happy, not thinking of how soon she was to part from the gentle & indulgent parent but full of fond anticipations of a bright future.' When the couple left for their honeymoon in Wales, Anna wrote, 'Debo bid us good bye without a tear, her eyes shone with happiness'.

The Whistlers at once prepared to leave for St Petersburg. In London they occupied river-side rooms in the Hotel Waterloo, where, Anna noted, they could 'watch the boats passing our window'. She visited the Haden home, an unostentatious four-storey, cream-coloured brick house, 62 Sloane Street at the corner of Hans Street, and she took her sons to Westminster Abbey, where James sketched monuments and 'would have lingered' all day, 'but the Sexton at last hinted prayers would soon begin'. It was 'just as difficult for him to see enough of the Colliseum [*sic*]'. The Colosseum was an exhibition hall and place of amusement in Regent's Park; its attractions included enormous panoramic views of London, a fine collection of classical and modern sculpture, and, in the entrance corridor, prize-winning cartoons from the 1843 Westminster Hall competition. The final London excursion was to St Paul's Cathedral.

Travelling to their steamer, the *Victoria*, gave James Whistler his first contact with London's docks. It was a new experience for Anna to drive 'thro dark narrow streets of the city' and see 'such squallid [*sic*] wretchedness' in this 'district of pollution & crime'. Then there were the men who rowed them to the *Victoria*:

'. . . the Thames boatmen! . . . swearing at each other, seizing our luggage & hurrying us so savagely into their boats in the darkness of the evening I almost trembled, & scarcely expected they would put us aboard the Steamer without pilfering us of some of our articles of luggage, but Whistler did not dispute their unlawful demand for hire, as a lady did who went passenger in the steamer with us, by which she was put on board minus a whole piece of broadcloth etc. for servants' liveries. While she was only intent upon a *fair* settlement, one of the men must have slily slipped back into the wherry this very valuable bundle, for she did not discover her loss until after she had lost all sight of them.'

After slightly less than three days at sea, the *Victoria* reached Hamburg, where Anna noted that her 'boys were making their knowledge of German useful & amusing themselves by putting questions to the people around us'. They went by coach to Travemünde and Lubec, and on 30 October boarded the season's last ship for St Petersburg. The German stewardess had served on the *Alexandra* four years earlier, and Anna reported that 'tho we could not talk together she often kissed my hand & her countenance

expressed that she still retained the tender sympathy for me which the painful circumstances of my first acquaintance with her had elicited'. The voyage was rough, and Whistler, Anna related, 'was ill & felt depressed'.

Early on the morning of 1 November they disembarked on the English Quay ready to begin life without Deborah.

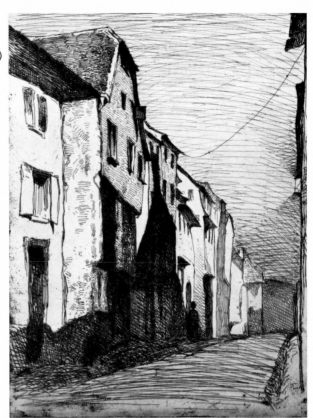

Street at Saverne (From The French Set)

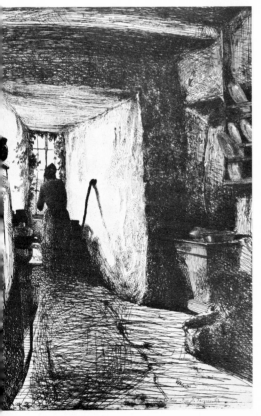

8. The Kitchen (From The French Set)

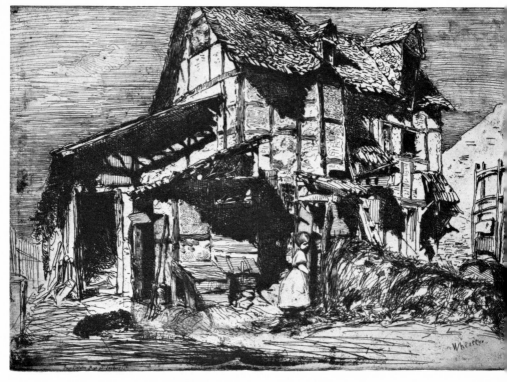

9. The Unsafe Tenement (From The French Set)

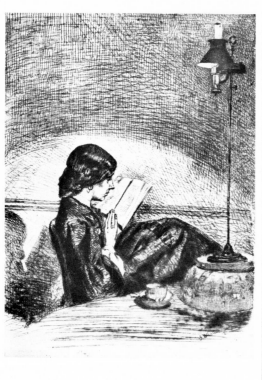

10. Reading by Lamplight (Deborah Haden)

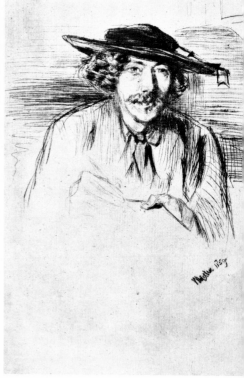

11. James Whistler: Self-Portrait, 1859 (etching

Chapter 3

LONDON
1848-9

After a quiet, dull winter in St Petersburg, a cholera epidemic erupted in the spring of 1848 and intensified with the approach of summer, inducing Whistler, in the beginning of July, to send his wife and sons to England. Because his rheumatic fever had flared up, his parents decided that James would remain there.

Anna and the boys reached Sloane Street on 10 July and were greeted by Seymour. Deborah was upstairs, where Anna found her 'looking better than when she was a bride' and 'even happier now'. The couple, she added, 'are truly one, their tastes the same, perfect harmony & cheerfulness reign. I only missed one comfort in their home, family worship. . . . I trust they will have the wish put into their hearts to raise a family altar.' On her first Sunday in Sloane Street, Anna gratefully related, Deborah proposed religious music, saying, 'I know Mother would like it!' and all the Hadens united their voices in sacred melodies.

After a week in London, Anna and the boys began an extended holiday on the Isle of Wight. James immediately began using a paintbox given by Haden, often, Anna noted, in 'a wide chasm in the cliff where he would fain sketch the waterfall by the hour if I would let him expose himself to catching cold in so damp a shelter'. Soon they were joined by Deborah, and Anna wrote, 'How the boys longed for the loved Sister's coming. . . . She came laden with good things for the boys who had only wanted herself – a beautiful bow & arrows from Seymour to Willie as a birthday gift, a drawing book with paint box purposely for sketching out of doors for Jemie, & a loaf cake for both, besides many nice relishes for our cottage table.' One gift nearly produced a calamity. Deborah took her brothers and two small girls to a field where she crocheted while they played with the bow and arrows. Shortly, Deborah and one of the girls returned hurriedly, each with an alarmingly grave expression. 'They both burst into tears as I addressed them,' Anna wrote,

'& how shocked I was that Debo had been hit by the arrow so close to her eye I shuddered to perceive how narrow the escape from putting the

eye out! Little Anna Maria kept weeping & saying "I did not mean to hurt Mrs Haden, indeed I did not but I could not manage the strong bow." But when all assembled at tea, the eye having been bathed in water & a small plaister covered the wound, then Debo had recovered her composure & comforted the affectionate child.'

Anna knew why the eye had been saved: '"without His knowledge not even a sparrow falleth to the ground," & I love to trace His care of us even in small matters.' Interesting is the implication that the loss of an eye is 'a small matter'.

One current incident shows that even as a boy James Whistler attracted attention. In a shop, Anna reported, one Lady D——

'was fascinated by Jemie's suddenly coming in, glowing with the exercise of mounting from the beach with sketch book in hand. . . . The lady gracefully accosted my boy saying "I have seen you before – last year – were you not at Cheltenham?" "No ma'am," said Jemie returning her smiling courtesies – then at Scarboro! surely it was there? Yes ma'am we were there in June last, for a week, I answered, upon which the lady expressed the hope we should meet again. . . . She said at parting his was a countenance never to be forgotten.'

Since never again would he set foot in St Petersburg, one might mention James Whistler's Russian work. His surviving drawings from this period are mostly included in a sketch-book owned by the University of Glasgow, sixty-eight pages of small one-figure pictures, large multi-figure compositions, sketches inspired by the Bible and ancient history, portraits, and imitations of plaster casts. All of this is historically interesting, but none of it is remarkable.

Although his precocity was not that of a John Everett Millais, James showed an enthusiasm which was not unencouraged. Upon learning of the Isle of Wight drawings, Whistler wrote, 'I'm quite delighted to hear you are interested in sketching landscape – can't you send me a small one – just a sketch, you know I don't expect anything *finished*.'[1] After receiving several drawings, he commented: '. . . the sketches are good [but] you should not forget that I have not seen these places and therefore a few more touches would make them a much better illustration of what you had seen.' Three weeks later, Whistler warned that 'carelessness was wont to be your evil genius – *finish* your work my boy. . . . With your natural talent, and fondness for drawing, had it been accompanied with regularity and perseverance, you would have made much better progress.' The father, incidentally, never expected his son to become a professional

artist. In his letter of 29 September, he advised James to begin thinking of a career. If he wished to enter 'either of the American colleges', he should know Latin and Greek, but then his 'peculiar talents' might be more suited to engineering or architecture. (There were numerous colleges in the United States, but Whistler apparently assumed that James would attend only Yale or Harvard, America's counterparts to Oxford and Cambridge.) A month later the father spoke more directly and counselled his son to concentrate on mathematics.

When he received this guidance, James was attending a fine boarding school, Eldon Villa, in Portishead, whose headmaster, Mr Phillott, was known to Seymour Haden. James enjoyed himself there, for Phillott was congenial and the town was delightful. Situated on the mouth of the River Severn, ten miles from Bristol and about 130 miles from London, Portishead was a pleasant residential community with attractive homes and tree-lined streets. Its location and climate made it a fashionable watering-place, and its magnificent sunsets inspired several paintings by Turner.

After a pleasant term in Portishead, James returned on 15 December to London for Christmas, but, duplicating an experience of St Petersburg, when the holidays ended he did not go back to school. He remained at 62 Sloane Street and became a clergyman's private pupil.

Why did James not continue at Eldon Villa? He was surely not unhappy there, but rather he wanted to live with Deborah – and Seymour. In each of his sister's surviving letters to James in Portishead she wrote, 'Seymour sends his love.'[2] No mere formalism, this signified a bond of affection between the man and the boy. Haden, moreover, could provide James with proper artistic guidance. While he was a medical student in Paris, he had enrolled in a drawing school, and after concluding his formal education he spent the summer of 1843 on a sketching holiday in Italy and returned with water-colour and pencil drawings and half a dozen experimental etchings. Although he had not lately had much time for art, he had not lost interest in the subject. And so James would find that the time he spent in London had great influence on his later professional development. He discussed painting and drawing with his brother-in-law, and visits to museums and galleries exposed him to a large variety of works of art. He became friendly, moreover, with William Boxall, a portraitist who had exhibited steadily at the Royal Academy for twenty-five years, and was eventually to become a Royal Academician, Director of the National Gallery, and a knight.

While in London, Whistler had commissioned Boxall to paint his son's portrait, and this was done soon after James left Eldon Villa. Captivated, like others, by his subject's charm, Boxall took the lad to Hampton Court to see Raphael's cartoons and gave him a copy of the popular, readable

two-volume collection of brief biographies of pre-Renaissance and Renaissance artists *Memoirs of the Early Italian Painters and the Progress of Painting in Italy*, by Anna Brownell Jameson.

Because it was a gift from a famous painter, and was the first such volume that he owned, James eagerly devoured Mrs Jameson's work. A letter to his parents dated 24 January 1849 reported that he had been much impressed by the book. In mentioning his forthcoming trip to Hampton Court he said, 'Fancy being so near the works of the greatest artist that ever was!'[3] This seems clearly an echo of a sentence near the end of Jameson's second volume: 'Raphael stands alone, like Shakespeare in the history of our literature; and he takes the same kind of rank, a superiority not merely of degree, but of quality.' More important than his derived opinion of Raphael was this declaration: 'I hope, Dear Father, you will not object to my choice, viz: a painter, for I wish to be one so *very* much and I don't see why I should not, many others have done so before. I hope you will say "Yes" in your next, and that Dear Mother will not object to it.' Surely it is not coincidental that this assertion immediately followed James's reading of *Memoirs of the Early Italian Painters*. Because his life suggests that Jameson's influence was not temporary, one might note certain passages which probably had an impact on Whistler's personal and artistic development.†

Anna Jameson frequently called attention to the only source of a painter's work, as when she said that Giotto 'went to nature' and 'aimed at the expression of natural character and emotion', and was 'the first painter who "held as it were the mirror up to nature".' The beauties of nature are everywhere for anyone with eyes to perceive. Benozzo Gozzoli, for example, was a fine painter because he 'had such a lively sense of all the beauty and variety of the external and material world' and 'for him beauty existed wherever he looked – wherever he moved'.

Nature inspires a painter, but the interpretation must be uniquely his own. He must be independent and self-reliant, an inventor, an innovator, and, if necessary, a rebel. Giotto 'not only deviated from the practice of the older painters, but stood opposed to them. He not only improved – he changed; he placed himself on wholly new ground.' He was indeed a person with 'little reverence for received opinions about anything'. The only worthwhile evaluation of a painter's work is his own; regardless of outside pressures, he must be true to his ideals. When Ghiberti's fellow Florentines tried to rush him into finishing his bronze doors, he would not be 'hurried into carelessness by their impatience, nor did he contract to finish it, like a blacksmith's job, in a given time'. Cimabue was his own

† Anna Jameson's quotations are from the first edition of her volume, which Whistler read (London, Charles Knight, 1845).

severest critic, and when dissatisfied with a work 'would at once destroy it, whatever pains it might have cost him'. And Michelangelo 'placed his standard of perfection so high, that to the latest hour of his life he considered himself as striving after an ideal excellence which had been revealed to him, but to which he conceived that others were blind or indifferent'.

An artist must be heedless of fashionability, and he must also be wary of popularity, as one may learn from Perugino, 'the most popular painter of his time, a circumstance which, considering that Raphael, Francia and Leonardo da Vinci were all working at the same time, would surprise us did we not know that contemporary *popularity* is not generally the recompense of the most distinguished genius'. Perugino's best work was done when he was true to himself. His worst paintings came when, 'excited by a base and insatiable thirst for gain', he 'aimed at nothing beyond mechanical dexterity, and to earn his money with as little expense of time and trouble as possible'.

Perugino failed as a painter and as a person, and Jameson stressed the relationship between the artist and the man. Giotto thus 'was as independent in other matters as in his own art' and his personality 'had no small part in the revolution he effected'. Certain characteristics of Italy's first master painter would probably not be forgotten by James Whistler. Giotto, he would remember, 'was but little in person' and 'was celebrated for his joyous temper, and for his witty and satirical repartees', one of which was retold: 'King Robert of Naples would sometimes visit the painter at his work, and ... amused himself with the quaint good sense of his discourse. "If I were you, Giotto," said the king to him one very hot day, "I would leave off work, and rest myself." "And so would I, sire," replied the painter, "if I were *you*."'

Perhaps the sentence of Jameson that most immediately affected the 14-year-old boy was one which proclaimed that Masaccio 'was one of those rare and remarkable men whose vocation is determined beyond recall almost from infancy'. Since almost every child has a desire for recognition, does it not seem possible, even probable, that James felt that like Masaccio he was destined to gain fame through art? In any event, to repeat, his desire to be a painter, as 'many others have done before', was expressed just after finishing Mrs Jameson's book.

The response came from his mother:

'It is quite natural that ... you should prefer the profession of an Artist, your father did so before you. I have often congratulated myself his talents were more usefully applied & I judge that you will experience how much greater your advantage, if fancy sketches, studies, etc., are meant for your hours of leisure. I have hoped you would be guided by your dear

father & become either an architect or engineer – but do not be uneasy, my dear boy, & suppose your tender Mother who so desires your happiness means to quench your hopes. Try to enlarge your views by improving your mind first, be governed by the daily direction of dear Sis & Seymour till you can be with Father again.'[4]

This last line is ironic, for 'dear Sis & Seymour' were probably responsible for James's participation in an event which would be more lastingly important to his artistic development than any other occurrence of his boyhood. This was the series of four lectures in February and March, primarily for students of the Royal Academy of Arts, by Charles Robert Leslie. Among the privileged outsiders in attendance was James Whistler.

Leslie was a subject painter who had exhibited at the Royal Academy since 1813, had been a Royal Academician since 1826, and now, in 1848, was Professor of Painting at the Academy. James was surely impressed by Leslie's artistic credentials and, just as surely, by the knowledge that Leslie was born of American parents, had grown up in Philadelphia, and for six months had taught drawing at the United States Military Academy in West Point. Since Leslie's remarks were reprinted in the leading contemporary weekly journal, the *Athenaeum*, and since it is inconceivable that Seymour Haden did not read the *Athenaeum*, young James not only heard the lectures but also undoubtedly studied their text. The lectures could not have come at a more opportune time for him, a year after his introduction to Hogarth and less than a month after completing Jameson's book, and they are so significant that there is almost nothing in his subsequent career that cannot be traced back to them. Since they would be his guide and touchstone, let us briefly consider Charles Leslie's lectures.†

Leslie constantly emphasised art's relationship to nature and the necessity of remembering that 'nothing really excellent in Art is not strictly the result of the artist's obedience to the laws of Nature'. In taking from nature, a painter must be selective, and judicious selectivity truly separates the artist from the craftsman: 'Where Gerard Dow would render, with scrupulous exactness, every wrinkle in the face of an old woman, greater artists, his master, Rembrandt, for instance, would express the character of flesh, and make the head a means of displaying a beautiful effect of chiar-oscuro.' Leslie, however, included a caveat for students: 'In drawing or painting from Nature, there can be little doubt that, until correctness of eye and obedience of hand are attained, the most minute imitation is the best. . . . We should be able to put everything we see in Nature into a picture before we venture to leave anything out.'

† Leslie's lectures were published in the spring of 1848 in four successive issues of the *Athenaeum*: 17 February, 24 February, 3 March, and 10 March.

Nature, Leslie noted, includes human nature, and an artist should carefully observe human beings. To do this, he need not go beyond his immediate surroundings: 'The constant inhabitant of a village may learn far more of mankind, if he be a close and fair observer, than he whose life is spent in traversing the world if he observes not carefully.... Few men ever travelled less than Shakespeare, than Raphael, than Hogarth.' An excellent source of subject matter is a city street: 'Flaxman derived many of his most elegant compositions and single attitudes from the street', Hogarth's 'habits seem to have been anything but sedentary', and, 'when not engaged at his easel, Stothard's time was almost always spent in long walks through the streets of London'.

Stothard walked the streets because good art does not require a noble subject. Unimportant subjects indeed test one's ability: 'the very want of importance enforces the necessity of the greatest possible refinement of treatment. It has been remarked that "we derive pleasure from the works of the best Dutch and Flemish painters in finding how much of interest Art, when in perfection, can give to the most ordinary subject".'

A painter going to nature, Leslie said, need not work at the scene with models: 'Like Hogarth, Stothard rarely had recourse to the model.... The minds of both were so completely filled with imagery collected immediately from Nature, and so vividly was it preserved, that they could at will select and embody on canvas whatever was most appropriate to the subject in hand.' This passage is of special interest because most writers on Whistler have assumed that many years later he first heard about painting from memory.

Not only may the painter work without models; he need not be representational. In a remarkably far-sighted passage, Leslie cited Dutch and Flemish painters as proof that non-realistic pictures may be faithful to nature:

'Of the beauty, the grandeur, and the harmony of abstract forms they had the truest perception.... Their pictures attract our admiration at a distance too great for us to distinguish the particulars of which they are made, and have in them that which would rivet the eye even were they placed upside down. This sense of abstract beauty and grandeur is to be felt but neither described nor analyzed.'

As these lines suggest, the second source of inspiration and instruction is the work of other artists. No one, Leslie said, should imitate another painter, but one should note how others have dealt with nature. Raphael's Hampton Court cartoons, for example, Leslie remarked, 'make me present at the scenes they represent . . . and in the recollection of them I fancy I

have seen the Apostles'. If one imitates, one should be eclectic, for then one learns from many while being the slave of none.

Whether he is influenced by others or simply relies on sensory perceptions, the artist must freely choose his subject even if he be doomed to fail. 'If Art', Leslie said, 'may attempt nothing but with hope of entire success it would be limited indeed.' On this question of success, especially contemporary success, Leslie agreed with Anna Jameson. Great artists are often without honour in their own time. 'There is', he pointed out, 'no evidence of any notice having been taken by Lorenzo of his townsman Da Vinci – and the mighty powers of Michael Angelo, while in their full prime, were allowed to be shamefully wasted during the entire pontificate of Leo.' The best British example of neglected genius, a man who 'could scarcely sell his matchless pictures at the lowest price', was William Hogarth.

Hogarth received more attention from Leslie than any other artist, and for this reason alone James would have absorbed the lectures. Hogarth's genius, Leslie said, was

'peculiarly original, his fire as much kindled from within as that of any other painter of any other age or nation. From his outset he disdained to travel in the high roads of Art, or to avail himself of those directing posts set up by his predecessors; he treads in no man's steps, moves within no prescribed limits and adopts no established combinations. . . . His subjects, his arrangements, his characters, his style, his manner, are all his own, derived immediately from Nature.'

Hogarth's superb employment of colour, moreover, 'instead of interfering, in the slightest degree, with his story or the expression, greatly aids them' and *Marriage à la Mode* beautifully illustrates the 'healthiness of Hogarth's colour as well as his moral sense'.

James could now examine Hogarth's colouring, about which he knew nothing in St Petersburg, and other aspects of his work in the Soane Museum and the National Gallery. Born in Russia, Whistler's enthusiasm for Hogarth developed and matured in London under the guidance of Charles Robert Leslie. That Whistler's respect for Leslie was long-lasting is demonstrated by the fact that the University of Glasgow's handful of surviving books from Whistler's personal library includes one printed volume in English: published in 1858 and inscribed 'James Whistler from his brother George', it was *A Handbook for Young Painters*, by Leslie.

James Whistler owed a great debt to Jameson and Leslie, and there were other current forces nourishing his artistic growth. In St Petersburg, no more than once a year could he see a show of contemporary pictures,

but now in late winter and early spring of 1849, London had six major exhibitions, each with over four hundred works by living artists: in February, the British Institution; in March, the Free Exhibition of Modern Art; in April, the Society of British Artists and the New Society of Painters in Water Colours; in May, the Society of Painters in Water Colours and the Royal Academy. These were only the principal events. The *Athenaeum*'s reviewer aptly began one notice by saying, 'Art Exhibitions are the abounding incidents of the time; and we rise from the examination of one gallery only to answer to the summons of another.' Galleries were not the only sign of the times. Again quoting the *Athenaeum*, 'The growing interest in the Fine Arts is evidenced in the superior illustrations of our periodicals, the improving character of taste in art-manufactures, the establishment of schools for mechanical and artistic design.' Young James surely saw the opportunities for young artists in London.

It would be interesting to know if he attended the Free Exhibition, at Hyde Park Corner, so called because it was freely open to almost anyone who paid the entry fee. Its most celebrated picture marked the public debut of someone who in the not too distant future was to play a strong role in his own life. Here is part of the *Athenaeum*'s critique of this painting:

'It is pleasant to turn from the mass of commonplace . . . to a manifestation of true mental power; in which Art is made the exponent of some high aim. . . . Such a work will be found . . . from one young in experience – new to fame – Mr G. D. Rossetti. He has painted *The Girlhood of Mary Virgin*: a work which . . . would be creditable to any Exhibition. . . . [It] inspires the expectation that Mr Rossetti will continue to pursue the lofty career which he has here so successfully begun.'

If, as is almost certain, James read the review, and if, as is probable, he saw the show, he would have had two antithetical responses: the mass of mediocrity exemplified by most of the 526 works proved that anybody could have a picture publicly exhibited in London, and the praise accorded a young, inexperienced painter with a strange foreign name showed that a newcomer could attract notice if he produced something worthwhile. These lessons he would not soon forget.

While James revelled in London, his family endured the rigours of St Petersburg. In autumn they again faced the dangers of cholera. On 28 November 1848, *The Times* noted that the epidemic 'rages at present with more intensity than in July'; among November's less seriously afflicted victims was Whistler. He should have rested, but, Vose related, 'He would on no account leave his post, nor omit his periodical inspections along the line of the road, where the epidemic was raging. . . . He remained

upon the work through the winter.'[5] For five and a half years he had withstood frightful conditions, but no one's powers of endurance are unbounded. George Washington Whistler reached his limit at 4.30 a.m. on 9 April 1849, when at the age of 47 his overworked heart stopped beating. In a note written the next day William told his brother: ' . . . the last words dear Father said to me were, Good bye, be a good boy.'[6]

Tsar Nicholas informed Anna that her sons could be educated without charge at the Imperial School for pages, but the patriotic American declined with thanks, and within a few days, when the Neva had opened for navigation, she travelled with Mary, Willie, and her husband's coffin on the Emperor's private barge to Kronstadt, where they boarded a steamer for England.†

Mrs Whistler spent three months in Britain with her sisters in Preston and the Hadens in London. For James the high point of this interval was the opening of the eighty-first exhibition of the Royal Academy. He and his family sought out the portrait of a smiling, curly-haired boy, by William Boxall, which the *Athenaeum* called 'fine in expression and beautiful in colour' and 'one of the best achievements here of its kind.' (Its reproduction is the third illustration in this volume.)

Visiting the Royal Academy was the last important artistic experience of James Whistler's sojourn in England. On 29 July he boarded a Liverpool steamer and eleven days later stepped ashore in New York. After six years abroad, the 15-year-old lad was back on native soil.

† Whistler was succeeded by another former American army officer, Major T. S. Brown. On 25 September 1850, the road was opened for limited passenger and freight service, and by 1 November 1851 the St Petersburg to Moscow Railroad was fully operative.

Chapter 4

CONNECTICUT
1849-51

After Whistler's body had been buried in Stonington, his widow and sons settled in another Connecticut town, Pomfret. It has been repeatedly asserted that Anna Whistler inherited an annual pension of $1,500. Had this true been true, she and her sons could have lived in luxury, but in fact she had no pension, and her income came from dividends earned by a modest portfolio of stocks necessarily subject to fluctuations. Were it not for generous friends and relatives, she could scarcely have met minimal expenses, and at all times she had to practice frugality.

In light of the necessity to economise, Anna might have been expected to enrol her boys in one of the state's free common schools, which were rated by many authorities as America's best. Of Connecticut's common schools one educational writer declared: 'We may search the history of every nation and state on the earth in vain, to find another instance where, with only equal means, so much has been done and so great efforts have been made in this noble cause.'[1] Connecticut's common schools, however, were not good enough for some parents, notably those with wealth or social standing. Thus private schools had been established, supposedly 'designed to provide better instruction in language and science than the common schools can do',[2] but also catering to snobbery. Despite Anna's financial plight, her boys would attend a private school. How could someone who objected to riding in a second-class railway carriage share a classroom with children from ordinary families?

Not only would James and Willie go to a private school, it would have to be the right one, which, their mother decided, was Christ Church Hall, in Pomfret.

Located in the north-eastern hills, Pomfret had been commercially prosperous until the railway diverted traffic to river valley towns, and it was now an exclusive residential community and a summer resort where 'society flourished and distinguished guests came from Boston, Providence, and Newport'.[3] The Whistlers lived outside the town in a plain farmhouse where the boys were required to perform menial chores. On Christmas day 1849, the Pennells related, Anna wrote to her mother that her sons had been

'busy all morning bringing in wood for the fiire and listing the draughty doors, though, as a concession to the holiday, she allowed them to lighten their task by hanging up evergreens and to sweeten it with "Stuart's Candy." Part of their morning's duty at other times was, after a snowstorm, to shovel a path from the house to the pigpen and to feed the pig, even if it sent them back with hands blue and cold and their feet frostbitten.'[4]

This was quite a descent from the English Quay and Sloane Street, but as usual James was adaptable and uncomplaining.

In one realm Anna Whistler's household routine was unchanged: the day began with scriptural recitations and ended with devotional services. The boys went along with their mother and usually obeyed her, but they were sometimes difficult to control. In her diary on 22 May 1850 she confessed to being 'greatly disturbed this afternoon by my boys' indolence & resistance to my authority' and a week later she noted that 'they have both been very indifferent in attention to me this week'.† James's inattentiveness was not confined to home: on 14 June Anna wrote: 'Jamie sent home from school in consequence of irreverence at prayer in the morning.'

This was neither James's first nor last early arrival from school. Christ Church Hall's headmaster, the Reverend Roswell Park, was a West Point graduate who was an effective teacher and a strict disciplinarian. James's classmate Emma Palmer remembered him as 'one of the stiffest and most precise of clergymen who dressed the part most punctiliously'.[5] Park's clothing, she recollected, gave James a chance to gain attention:

'One day Whistler came to school with a high, stiff collar, and a tie or stock precisely copied from Dr. Park's. Of course the school-room was full of suppressed laughter. The reverend gentleman was very angry, but he could hardly take open notice of an offence of that sort. So he bottled up his wrath; but when "Jimmy" gave him some trifling cause of offence, the Rev. Dr went for him with a ferrule. The school was in two divisions – girls sitting on one side of the large hall, and the boys on the other. Jimmy went round back of the girls' row, and threw himself down on the floor, and the Dr followed him and whacked him, more, I think, to Jimmy's amusement than to his discomfort.'[6]

Jimmie was mischievous and constantly in trouble, but he was also pleasant and likeable. Emma Palmer said he was 'one of the sweetest, loveliest boys I ever met, and he was a great favorite'.[7] She recalled his

† The brief diary from which this passage was taken is not the document referred to in Chapter 2; it is held in the Library of Congress.

'pensive, delicate face, shaded by soft brown curls, one lock of which even then fell over his forehead' and his 'somewhat foreign appearance and manner, which aided by his natural abilities, made him very charming'.

His most conspicuous natural abilities, wit and drawing talent, were sometimes combined:

'One day he was drawing a caricature of Dr Park who noticed that the boys were convulsed over something and going softly behind them, he surprised Jim as he was putting the finishing touches to his picture. When he saw it, he could hardly help laughing, even if it was of himself, but he told Jim to present himself to be ferruled, as such a breach of discipline could not be tolerated. But in an instant two or three boys jumped up and said they would take Jim's punishment for him, or he could ferrule them all. So it was compromised, and Jim got off with a few strokes.'[8]

Drawing and geography, which included making maps, were James's only good subjects. One classmate, Ellen Louise Chandler, who under her married name, Moulton, become a popular writer of verse and children's stories, recalled his maps as 'at once the pride and the envy of all the rest of us – they were so perfect, so delicate, so exquisitely dainty in work-manship'.[9] Maps and caricatures were only part of his art work, which included portraits of classmates, delineations of observed incidents, and literary illustrations.

These drawings show Charles Leslie's influence. Following the advice to look to his immediate environment, young Whistler drew classroom scenes, as well as a humorous portrayal of a road mishap which 'depicted an old country-woman, with bandboxes, bundles, and bird-cage all mixed in inextricable confusion, and labelled "H-awful H-accident",'[10] and a more serious water-colour, probably done from memory, *A Fire at Pomfret*. The literary illustrations have the exactitude and imitativeness that Leslie recommended for beginners. Although not exceptional, these pictures, as Nancy Pressly said, show a certain 'imaginative independence'.[11]

After eight months in Pomfret, James spent the spring holiday with Anna's older brother, William Gibbs, in Brooklyn. On the day of his departure, 3 April, she wrote in her diary, 'My heart sank at losing sight of my dear James.' On the next day she owned that she had been 'pleading' for her 'absent boy continually when alone in [her] chamber' and on 5 April she lamented, 'My anxiety renewed for . . . my precious Jemie. I felt my helplessness.' The diary contains similar plaintive entries until 20 April, when James returned.

If Anna was devastated by seventeen days without James, how would she feel about a prolonged absence? This question is not academic, for

early in 1851 he took a step which might separate him from his mother for the better part of four years. He resolved to become a cadet at the United States Military Academy.

The USMA's admission requirements then were disarmingly simple. There were no competitive examinations; entering cadets were merely required to be 'over sixteen and under twenty-one years of age' and 'at least five feet in height and free from any deformity, disease, or infirmity which would render them unfit for military service'.[12] In fact, however, it was not easy to become a cadet, for appointments were controlled by politicians. In 1843 Congress stipulated that each congressional district was entitled to one cadet, appointed by the Secretary of War on the recommendation of the congressman. Additionally, ten 'at large' appointments, with no residency requirements, were made by the President, mostly to sons of army officers, who seldom lived in one place long enough to gain political influence. It is not certain when James decided on an army career, but we know when the first step was taken to bring this about. Appointments were given in March to those who would enter West Point in June, and on 19 February 1851 George Whistler wrote to Secretary of State Daniel Webster and requested a Presidential appointment for his elder half-brother. Few applicants could have had better family credentials than James Whistler, whose father, uncle and, more recently, cousin Joseph Nelson Whistler, class of 1846, had been West Point graduates. Webster responded favourably, and unsurprisingly one of President Millard Fillmore's 'at large' appointees was Whistler.

In the 1850s an American army cadet was virtually shut off from the outside world. West Point was accessible only by boat up the Hudson River from New York City, and except for one summer vacation a cadet spent his entire career at the Academy. Was Anna Whistler heartsick at parting from James for four years? On the contrary, she probably encouraged him to become a cadet. In the USMA archives, a typewritten document, a 'Brief Biography of James Whistler until He Left the United States Military Academy', states: 'At the insistence of his Mother, James Whistler secured a nomination for an "At Large" appointment as a cadet.' This is not really surprising. Anna had frequently expressed a wish for her first son to follow in his father's footsteps, and her desire was strengthened by his undisciplined behaviour and determination to become an artist. Her plan of action undoubtedly received aid and encouragement from West Point graduate Roswell Park.

If Anna's attitude is understandable, is it not strange that her independent, rebellious son agreed to enrol in a military academy? Only in retrospect. His boyish resistance was expressed in schoolroom pranks, motivated mainly by a desire to attract notice. He had been raised in a

family steeped in military traditions, and he had spent his adolescence in the military atmosphere of St Petersburg. And perhaps subconsciously he wished, finally and unequivocally, to cut the umbilical cord.

Most important, perhaps, of Whistler's motivations lay in the character of West Point. In 1851, America's three most illustrious schools of learning were Harvard, Yale, and the United States Military Academy. Catalogues for Harvard and Yale reveal that an undergraduate's necessary annual expenses, exclusive of clothing, pocket money, and travel, came to about $210, well beyond the reach of Anna Whistler. An education at West Point, on the other hand, cost nothing. This did not mean that its students came from poor families. 'Appointments were coveted, and usually secured,' Morris Schaff, a graduate of 1862, recalled, 'by the sons of the leaders in business, political influence, and social standing,'[13] and 'the corps of cadets came nearer to being an aristocracy than any rank in government or society.'[14] A more recent commentator, Stephen Ambrose, agrees that 'the Corps did constitute an aristocracy. They tended to come from families of importance, for it did a politician little good to select a boy whose parents could not help him in the next election.'[15] In 1858, for example, the Corps contained 'a Washington from Virginia, a Buchanan from Pennsylvania, a Breckenridge from Kentucky, a Huger and a Mordecai from South Carolina, a du Pont from Delaware, and a Hasbrouck and a Vanderbilt from New York'.[16] In 1862 a prominent senator, Benjamin Wade of Ohio, called West Point 'a closed corporation', 'exclusive', and 'aristocratical'.[17] For Wade, these were words of condemnation, but not for a lad who had almost rubbed shoulders with the Emperor of Russia.

Before gaining admission to the Academy, an appointee had to be examined physically, and also orally, to certify that in accordance with a congressional Act of 1812 he was 'well versed in reading, writing, and arithmetic', and so at the end of May James Whistler went by train to New York City to board the boat that would take him to West Point.

Chapter 5

WEST POINT
1851-4

In order to provide seclusion from distractions, the founders of the United States Military Academy settled on a remote site 53 miles north of New York City on the west bank of the Hudson known as West Point. Towering 150 feet over a 160-acre plain, West Point bends the winding river into its sharpest curve and is enclosed at the rear by sharply rising, cedar-covered hills. 'For a military academy', an early observer wrote, 'no spot could be more appropriate, from its situation, its salubrity, its scenery.'[1] And Charles Dickens called it 'the fairest among the fair and lovely Highlands shut in by deep green mountains and ruined forts', whose beauty and freshness were 'exquisite indeed'.[2]

Upon arriving on 3 June, Whistler was not given time to contemplate the scenery. A non-commissioned officer at once escorted him and other newcomers to the plateau, where surrounding the drill field were the academic hall, chapel, hospital, library, cadet barracks, and the Hotel West Point. This last building, known as Cozzens' Hotel after William Cozzens, the first lessee, along with the boat landing, provided cadets with a link to the world from which they had come. Though he would not be examined until 20 June, Whistler was assigned to a section of prospective cadets and sent to the barracks where his military career began with the shearing of his cherished long black curls.

After two and a half weeks of an informal introduction to the army, Whistler and the others marched to the academic hall, where first they were examined physically. Although classmates mentioned his near-sightedness, it could not have been considered serious, for Whistler passed the examination. Next he faced the Academic Board, comprising the heads of all departments. Morris Schaff, who had been a mid-century cadet, recalled that 'it was a formidable reality to youthful eyes. They were sitting at small desks, arranged in a crescent; the heavy bullioned epaulettes of the military staff, and the brass buttons on the deep blue, scholastic dress-coats of the professors proclaimed the dignity of the solemn array.'[3] Another former cadet, Edward Hartz, remembered them as 'the most rigid, cold, and merciless looking set of men I ever before

beheld. They seemed so much oppressed by the weight of dignity that rests upon them, that a kind look was a stranger to their faces.'[4] Actually, as Ambrose explained, 'Congress insisted on keeping the entrance requirements at an absolute minimum',[5] and Schaff and Hartz found their apprehensions to be unwarranted. Schaff 'wondered ... that any boy who has had a fair training at a common school should have failed to pass it'.[6] Although a dozen of Whistler's fellow appointees failed this easy examination, it could not trouble someone who had studied in Russia and England and had lately been a pupil of Dr Roswell Park. And so James Whistler received a conditional six-month appointment as a cadet. If he completed the first term and passed the mid-year examination, the appointment would become permanent and he would be sworn into the United States Army.

Before the academic year started in September, Whistler and seventy other conditional appointees underwent a two months' summer encampment which would take them across the line between civilian and military life – a line such that 'there is no boundary in this world like it in its contrasts',[7] and which had the effect of '*putting the stamp* of the soldier upon him'.[8] The cadets lived during this encampment in uncomfortable tents with little relief from heat, cold, or rain; they slept on a hard floor; and they continually drilled and performed other military exercises. This was all part of a design whose objective was to instil in them the mental and psychological attitudes of the military mind. Constantly emphasised was the concept of discipline, which they were told was the pivot on which an army operates, and which involved literal, unhesitating, total obedience. The West Point philosophy was succinctly stated by its most famous nineteenth-century superintendent, Colonel Sylvanus Thayer, who said, 'Gentlemen must learn it is only their province to listen and obey.'

Despite everything, the cadets were ruled by a spirit of camaraderie. Their cheerfulness was due greatly to their own high opinion of themselves, a belief cultivated by their superiors. 'Day after day,' Ambrose noted, they heard that 'they were the best, the cream of the crop, members of the elite Long Gray line.'[9] They believed they were an exclusive group, superior to everyone who was not a cadet or an officer. This posture of superiority to outsiders was balanced by internal feelings of equality. All were treated alike. They wore the same clothes, ate the same food, and withstood the same discipline. 'Had any cadet shown the least acknowledgment of his social superiority,' Schaff observed, 'he would have met the scorn of the entire battalion.'[10] The cadet corps was a true democracy, or meritocracy, where wealth and social distinction meant nothing and achievements meant everything. As a contemporary writer said, West Point's 'honors are awarded only where the title to them has been fairly earned by diligence and merit'.[11]

Punishments also were awarded when earned. A USMA regulation stipulated that 'Any Cadet who shall disobey a command . . . or behave himself in a refractory or disrespectful manner, shall be dismissed, or otherwise less severely punished, according to the nature and degree of his offence.'[12] Dismissal for a single offence was extremely rare. Almost always cadets were 'less severely punished' with demerits, whose number hinged on the nature of the infraction, ranging from 'mutinous conduct' (ten demerits) down to such transgressions as 'shoes unshined' and 'late to dinner' (one demerit). When a cadet's total number of demerits exceeded one hundred for a period of six months or two hundred for an academic year, he was subject to dismissal.

Most West Point cadets have been awarded demerits, but there have been exceptions. Robert E. Lee, it has often been observed, did not receive a demerit during his four years at the Academy, but he was not, as sometimes suggested, unique. Lee did not stand alone even in his class of 1829, among whom two others, including the top graduate, Charles Mason, had a spotless record.

James Whistler, it soon became clear, would not join Mason and Lee. At the summer encampment he behaved properly for more than a fortnight, and then on 17 July he was 'absent from tattoo', the late evening formation, for which he received three demerits.† On the next day he was given three demerits, one for each of three offences: he was late at breakfast, late in joining the ranks of the supper mess parade, and late in falling in at the inspection of the yard detail. Six more times before the end of the month Whistler was penalised, for 'Laughing at drill' (two demerits); 'Gazing about in ranks at evening parade' (one demerit); 'Late at breakfast' (one); 'The rear of his tent not properly policed at morning parade' (three); 'Habitually gazing about at roll call' (one); and 'Inattention in ranks at drill' (two). In August, his total matched that of July, and thus, before attending his first class, Whistler had collected thirty-eight demerits for twenty-three offences.

Whistler's misconduct was rarely mentioned by classmates later when recalling this first summer at West Point. A typical recollection is that of his future room-mate, Henry Lazelle, who met Whistler on a rainy day in July 'when his bright sunny face peered through the opening of my tent . . . asking if he might come in. He spent hours repeating the stories of his reading, and in describing with gleeful interest the various characters in them so graphically that one would know them if met on the street.'[13] He was also remembered for his artistry. 'During the cadet encampment,' another contemporary reminisced, 'Whistler's skill as a draftsman first

† All cadet demerits are recorded in the *United States Military Academy Register of Delinquencies*, in the archives of the Academy.

attracted general notice. He was fond of making pen-and-ink sketches on camp stools, on the flaps of tents, and some very beautiful heads decorated these unconventional canvases; and he would also occasionally make pen-and-ink drawings in the "autograph albums" which it was the custom for cadets to keep.'[14]

On the last day of August the encampment ended, and Whistler and his fellows became the first class of plebes† to move into the newly con-structed three-storey cadet barracks. The accommodation was not luxurious. The cadets lived two to a room, 14 by 22 feet, and the furniture consisted of an iron bedstead, a table, a straight-backed chair, a lamp, a mirror, a mattress, a blanket, and a washstand. The wardrobe closet contained sixteen items of clothing for each cadet, and the time and place for the use of every article was governed by strictly enforced regulations.

Rules on clothing formed a small part of the living code. There were many other decrees, one of which, not long enacted, obliged cadets to 'bathe in the new barracks once a week, not oftener, without the Super-intendent's permission. Cadets desiring to bathe more than once a week are required to get a permit in writing.'[15] The bathing order did not trouble Whistler, but he quickly ran foul of another rule compelling cadets to 'have their hair trimmed close'. His first recorded delinquency in the barracks was assessed on moving-in day: 'Sept. 1. Hair not cut during month of August. 1 demerit.' As Lazelle recalled, Whistler's hair created a lasting problem:

'At West Point, Old Joe, the negro hair cutter, was never known to smile or deviate from "regulations". Once a month cadets were obliged to have their hair cut by him. This was a great worry to Whistler, who disliked to part with pretty locks; so he would try by cajolery and flattery to have Joe let up a little on the length of his hair. But in this he was never successful. Joe would stop his shears in the midst of a remonstrance and say, "Mr Whistler, do you want me to cut your hair according to regulations or not?" Of course this put an end to the argument, and Whistler would come back to our room, look in the glass and swear at Joe.'[16]

During the first week of the term, Whistler continued to commit minor acts of delinquency. He was cited five times, including an episode recorded by the Pannells:

'The cadets were out early one morning. . . . It was very cold and raw, and Jimmy, finding a line of deep ditch through which he could make a retiring movement, got back into college and his warm quarters unper-ceived. By an unfortunate accident a roll-call was held that morning, Cadet

† First-year students at West Point are called 'plebes'.

Whistler not being present, a report was drawn up sending in his name to the commanding officer for being absent from parade without the knowledge or permission of his instructor; the report was shown him, and he said to the military instructor: "Have I your permission to speak?" "Speak on, Cadet Whistler." "You have reported me, sir, for being absent from parade without knowledge or permission of my instructor – well, now, if I was absent without your knowledge or permission, how did you know I was absent?" They got into terms after that, and the incident was closed.'[17]

Subsequent biographers have mentioned this as a youthful example of the Whistlerian combination of wit and humour. What it really illustrates is either Whistler's love of embellishment or the unreliability of later accounts of earlier escapades. The occurrence took place on 4 September 1851, for only then, according to West Point's authoritative *Register of Delinquencies*, was Whistler absent from a morning parade. It is never 'cold and raw' at West Point in early September, and since the Register indicates that he was 'Absent from 9½ o'clock parade', he was not 'out early'. And the incident was not closed, for he received three demerits for his absence and, four days later, another one for 'Not rendering an excuse for absence of 4th'.

'From the 15th of March to the 1st of November,' the regulations stipulated, 'there shall be a military drill every day when the weather is favorable.'[18] The cadets drilled, drilled, drilled. Sometimes the drilling ended with a parade, 'when the entire battalion in full dress passed in review to the lively accompaniment of the band'.[19] Cadet Whistler's drill field and parade conduct could not be called exemplary. On twenty-two occasions he was late at a parade, inspection, or drill, and twenty-three times he was marked down for inattention. Six times he was punished for laughing and five times for talking in ranks. Additionally, he was penalised for swinging his arms while marching; raising his hands; failing to take his place promptly; unsteadiness; carelessness; not coming to order properly; and changing ranks without permission. His weapons were troublesome: he was set down four times for not carrying his musket properly, and he was cited for not seizing his musket at the shoulder in coming to order, for not throwing up his gun properly, and for not going through the manual correctly at parade. In light of his later sartorial fastidiousness, it is interesting that he was cited for wearing his fatigue jacket without buttons; having his cap out of uniform; having his cap strap under his chin; wearing his waist belt slovenly; wearing shoes out of uniform; wearing his military dress improperly; having no shirt collar at drill; having his shoes not blacked at inspection; being not properly

shaved at morning inspection; and 'wearing a scarf at artillery parade'.

Some cadets, one should remember, spent four years at West Point without once stepping out of line. Although Whistler repeatedly violated rules, he always knew how he stood regarding possible dismissal. Since plebes were new to the system, a third of their first-term demerits were written off. Thus during these six months they could collect 149 demerits and remain in good standing. Whistler's first-term total was 137 – high, but not too high. His individual monthly accumulations suggest that he knew how far he could go. He received nineteen in July, nineteen in August, thirty-eight in September, and thirty-eight in October. Thus with two months remaining his total stood at 114. How did he perform during the last two months? In November he got fifteen demerits, and in December only eight, three of which came on the last two days, when he knew he was safe. Although Whistler might draw close to the danger line, he was careful to stay on the right side.

Our discussion has centred on military affairs, but during the school year the largest share of a cadet's time was devoted to matters academic. A plebe studied three subjects – English, mathematics, and French – and a class in each subject met daily from Monday to Friday for, respectively, four, three, and two hours – that is, nine classroom hours a day for the three courses. Also, on alternate days they received instruction in the use of small arms. As to the difficulty of the work, a writer in 1854 accurately described a West Point career as 'severer by far than any other educational course in our land'.[20] The present-day authority on the USMA, Stephen Ambrose, said of West Point in the 1850s,

'the course of studies was so rigorous that only those with outstanding ability or excellent preparation could stay in the school. . . . Cadets who had been to other colleges before coming to West Point were amazed at how much they were expected to know and how well they were required to know it. Students back home, one of them wrote, "have not the faintest idea of what hard study is." . . . West Point, he claimed, covered more ground in one month than the ordinary college did in three, and the level of work was higher. Cadet Henry Du Pont found West Point at least twice as difficult as the University of Pennsylvania, which he had attended for a year before coming to the Academy.'[21]

Although they complained, most cadets appreciated West Point's academic advantages. A typical comment was that of Emory Upton, writing to his sister in 1857: 'Few have the facilities offered for getting an education which I have, and not to take advantage of these privileges would be most foolish.'[22]

Classroom instruction was conducted in sections of about twelve students, at first organised alphabetically, and then, three or four weeks later, rearranged according to merit. All sections of all courses used the same methods: everyone was subjected to a rigid oral examination every day. Probably in no other college or university in the world were students so constantly tested. They received grades every day, ranging from a maximum of three to a minimum of zero, and the various daily grades formed the basis for weekly standings which were posted every Monday evening after dinner. Because of the importance of one's comparative position which ultimately would determine who would get the best professional assignments, the weekly posting of grades 'helped reinforce the spirit of competition that was so marked a feature of cadet life. . . . The principle of pure competition, fighting for higher standing and rank, permeated every aspect of Academy life.'[23]

Gaining high grades depended mainly on memory, and memorising took time, as did nine or ten hours a day in class, and drills and parades. From reveille at five o'clock (1 April to 1 November) or six (1 November to 1 April) until taps at ten, a cadet had virtually no time to himself. And his life was not easy, for he was subjected to discomforts to prepare him for his career. He lived in rooms that were cold in winter and hot in summer; he had little or no recreation; he wore uncomfortable clothing; and he ate food fit for a prisoner. In addition to everything else, he was lonely and isolated. George McClellan, who was to gain fame in the Civil War, voiced the sentiments of countless other cadets when he wrote to his sister in 1842 that he felt as 'much alone as if in a boat in the middle of the Atlantic. . . . Not a soul cares for, or thinks of me – not one here would lift a finger to help me'.[24]

One cadet, however, despite an early life of luxury, rarely complained. As in a sick-bed in St Petersburg or a classroom in Pomfret, James Whistler displayed what Julian Hawthorne called a 'uniform superiority to his environment, be that environment what it may'.[25]

Far from muttering about West Point's arduousness, he gained a reputation for idleness. When James's half-brother George visited the Academy in September 1851, his room-mate Lazelle remarked on his laziness,[26] and later Lazelle called him 'one of the most indolent of mortals'.[27] Here, as seen by Lazelle, was Whistler during the evening study period:

'We sat facing each other, an iron table on which there was an oil lamp between us. After an abstracted study of an hour or so I would look up, and almost invariably see the youthful Whistler, his head supported by one hand, fast asleep. He would rouse up for a little while, but the instant the

half-past nine drum sounded [tattoo, the signal to prepare for sleep] his bed was down and he was very soon in it.'[28]

Whistler was not always snoozing when he should have been studying; Lazelle noted that 'many hours during the day and evening, with lessons in prospect, he whiled away the time drawing sketches of cadets and various other phenomena'.[29]

Whistler's 'indolence' was partly a pose, but it was convincing. As Gamaliel Bradford said, 'Because he . . . pretended to work lightly and carelessly, people thought him idle.'[30] Other cadets, even his room-mate, were taken in. West Point's *Register of Delinquencies* helps to explain why he was considered lackadaisical and lazy. During the first term he was cited five times for being late for breakfast, three times for being late for dinner, twice for being late for reveille roll-call, and once for being late for Sunday church roll-call. Twice he received demerits for 'continued inattention during recitation at English studies', and once for being inattentive in his mathematics class. As on 1 September, again on 1 October and on 1 November, his hair was not properly cut. (On 1 December, when he was concerned about his demerit total, his hair was satisfactory.) Perhaps his most intriguing current delinquency occurred on 16 October when he collected three demerits for 'Leaving the room where he had been visiting, by jumping from the window'.

All of these offences create a consistent, unified picture, but on 14 October he received a demerit for a seemingly insignificant infraction which is in fact exceedingly important and stands apart from the others: 'Not turning in library book at proper time.'

The USMA catalogue for 1850–2 reveals that it had a modest library, with 14,477 volumes. Rarely was a cadet required to use a library book, and never during his first two years at the Academy. He had to gain permission from an officer to obtain a book, which could be done only on Saturday afternoons. Library borrowing rules hardly concerned many cadets, least of all plebes, who could barely keep pace with the prescribed curriculum. Whistler, however, on his first Saturday in the barracks, 5 September, took out a volume, and in October and November he visited the library on five consecutive Saturdays to borrow books, and again on 29 November and 13 December, only two weeks before the mid-year examinations.†

Most of the library books dealt with military, scientific, and historical subjects, but it was not these that interested Whistler. On 5 September, he

† Books borrowed by Whistler at West Point are recorded in the *Entry of Books Issued to Cadets on Saturday Afternoons, 1851–1853*, an unpublished document in the Academy library.

borrowed Volume 3 of Scott's Waverley novels, which he renewed on
11 October and again on 18 October. On 25 October he selected Volume
37 of the *Knickerbocker Magazine*; on 1 November, Volume 6 of the
Waverley Novels and Volume 2 of *Chambers's Miscellany*; on 8 November,
Butler's *Hudibras*; on 29 November, Volume 2 of the *International Maga-
zine*; and on 13 December Goldsmith's *The Vicar of Wakefield*.

Whistler's library treks are noteworthy in the light of frequent assertions
that he disliked reading. Luke Ionides, a friend of the fifties and early
sixties, said, 'He did not read very much.'[31] Mortimer Menpes, who knew
him later, stated, 'I never saw him read a book,'[32] and then declared, 'I
cannot imagine Whistler quietly reading.'[33] His biographers have generally
accepted this notion of the non-reading Whistler, but if reading was
repugnant to him, would he, in his first term at West Point, when class-
mates were labouring night and day to stay in the school, have made on
eight occasions a special effort to borrow books unrelated to anything
covered in his courses? His West Point contemporaries knew of his feel-
ings about reading. One classmate, William Averell, said, 'Whistler was
unique, not only because there was no one like him in our class, but also
because he had no equal in art or in the quick and vivid perception and
appreciation of the best literature.'[34]

In selecting books, especially novels, he probably remembered Charles
Leslie's advice on the use of literature by painters. Literature, he had said,
may be helpful to a painter if approached properly. Reynolds, for example,
'read Richardson with interest, because his mind was instinctively turned
towards Painting more than to any other pursuit'. Stothard also read with
the eye of a painter, and in his *Canterbury Pilgrims* 'the personages of
Chaucer pass before our eyes as if they were shown to us by a painter
contemporary with the poet'. To turn to Whistler's current reading, West
Point's set of the Waverley novels was the 1850 Boston edition, of which
the twice renewed Volume 3 is *Guy Mannering*, Part I, and Volume 6 is
The Antiquary, Part II. It may seem odd that Whistler pored over Part I
of *Guy Mannering* without reading Part II, and that he began *The Antiquary*
with Part II, but not if he was reading with the eye of a painter. Since the
story is of no importance for its own sake, does it matter where one begins
or ends one's reading?

One interesting Whistler borrowing is Volume 2 of *The International
Magazine*. (The full title is *The International Magazine of Literature, Science,
and Art*. Volume 2 includes issues from December 1850 to March 1851.)
We cannot be certain of what he read, but we can make an educated
guess. Among light fiction and such articles as 'Ireland in the Last Age',
'John James Audubon', 'The Ghettos of Rome', and 'Egypt under the
Pharaohs', an item of January 1851 is the only one which would obviously

have struck Whistler's eye, the essay 'Art-Unions: Their True Character Considered'. The anonymous writer discussed American 'art-unions', lotteries in which lucky ticket holders won original works by contemporary artists. Established to benefit artists and to expand public knowledge and perception of art, the union actually, according to the author, encouraged quantity of production and mediocrity. The article ended with a passage that Whistler would remember:

'Artists must learn . . . to control their own affairs, and . . . they must not think of trusting their interests to the keeping of those not of their profession, and entirely uneducated in art, and who consequently cannot be qualified to discharge so delicate a duty with judgment and fidelity. . . . Let artists depend more upon private sales of their works to those who can appreciate them for a just remuneration, than upon the deceptive offers which chartered schemes may hold out to them. They will then, by their worth and their artistic merits, build up about them a solid body of friends and patrons, of whom nothing but death itself can rob them. . . . They cannot just suppose that permanent success and a distinguished name can be attained through any other channel than by honesty and excellence in their works.'

About a month after reading this article, Whistler confronted his first big academic hurdle when, on 2 January, he took his semi-annual examination, an oral test held in the library before the Academic Board. Of the seventy-one conditionally accepted cadets, permanent appointments were recommended for sixty, including Whistler. Late on the afternoon of 2 January he signed papers pledging him to eight years of military service, four as a cadet and four as an officer, if he completed his work at the Academy. Then he swore 'that I will support the Constitution of the United States, and bear true allegiance to the National Government; that I will maintain and defend the sovereignty of the United States paramount to any and all allegiance, sovereignty, or fealty I may owe to any State, county, or country whatsoever'.

On the next day Whistler celebrated by collecting twelve demerits. He was late for reveille (one demerit), was out of bed after taps (three), and, the first of only three such occurrences during his cadet career, he committed an eight-demerit offence. (Never was he dealt the maximum penalty, ten demerits, given for 'mutinous conduct'.) The infraction was 'Playing cards after taps'. Classes for the new term had not yet begun to meet, and it is surely understandable that Whistler and his room-mate chose to play cards. Unfortunately, they were caught. Here is the official report, signed by the Commandant of Cadets: 'Cadets Whistler and

Lazelle are charged with playing cards, 11 p.m. They were discovered by Capt E. K. Smith sitting at the table, in their room – with playing cards scattered over the table. Cad. Whistler had cards in his hands. No cards were observed in Cad. Lazelle's hands – although the reporting officer is under the impression that he had them in his hand when he entered the room.'[35] Lazelle also received eight demerits for 'Attempting to conceal cards from the Inspecting Officer'. He later recalled the incident and Whistler's role in it: 'He loved frankness, truth, and honor. . . . We knew that the offense was a serious one . . . and considered whether we could properly ask that the report should read, "cards in possession", a lesser offense, instead of "playing cards", as we were not playing when the inspector saw us. Whistler said, "No, *we had been playing*," so we faced the music.'[36]

The *Register of Delinquencies* suggests that during this second term Whistler changed one of his regular habits. He was late for dinner on 2 February but was not to repeat this offence until 9 January 1854, and then he would again be late for dinner on 16 January, 10 February, and 20 February 1854. Between February 1852 and January 1854 Whistler was not uncustomarily punctual, for he continued to be late for reveille, breakfast, drills, parades, and tattoo. In those days cadets could eat their dinners off the base, and for a time Whistler used this opportunity to obtain tasty food. His new dining-room was in the home of an army officer's widow, Mrs Thompson, who lived near the barracks and fed twelve cadets. 'It was a great privilege', a former boarder recalled, 'to obtain a seat at [her] table, for at that board were luxuries unobtainable at the general mess.'[37]

After gaining the privilege, Whistler nearly had it taken away by Mrs Thompson herself. Concerning this there are two published explanations. One, obtained from Whistler late in life, was provided by the Pennells:

'One balmy evening . . . Whistler was discovered by Mrs Thompson, leaning over the rear fence, engaged in an animated discourse in the French language with her pretty French maid. Mrs Thompson, in a severe tone, inquired his business there at that hour. Whistler promptly replied: "I am looking for my cat!" . . . The absurdity of Whistler's answer deprived it of all turpitude, but the old lady, between amazement and anger, nearly had a fit [and] she gasped out: "Young man go 'way!" . . . Of course poor Whistler took no more meals at Mrs Thompson's.'[38]

This story is highly improbable. No evidence corroborates the presence within Mrs Thompson's home of a French maid. Even if she did exist, it is inconceivable that Whistler would converse with her during evening

study hours. Earlier he had received five demerits for being absent from his room for three minutes during the study period, so is it likely that he would chat within easy hearing range of the barracks? The Pennells' report is just another illustration of the unreliability of Whistler's recollections.

The more probable version of the incident was recounted by Thomas Wilson, a cadet of the mid-fifties, and by Gustav Kobbé, who learned of the details from Whistler's classmate Alexander Webb (who in the Battle of Gettysburg gained his nation's highest military award, the Medal of Honor). Here is Kobbé's account:

'One day the cadets conceived the idea of having a little sport at their landlady's expense. The first cadet who came to table said, as he sat down: "Good evening, Mrs Thompson. There is a cat on the roof of your house." The second cadet repeated the remark, except that he varied it by saying: "There are two cats on the roof of your house." Each cadet added a cat until, when Whistler, the last to arrive, sat down, he said gravely and with much concern, "Good evening, Mrs Thompson. There are twelve cats on the roof of your house."

'During the next meal, Whistler, whom the landlady rightly suspected of having instigated the joke, found under his napkin a billet, notifying him that his presence was no longer desired. . . . After dinner he planted himself in front of a portrait of her late lamented, which hung in the parlor, and appeared lost in admiration of it. When he heard the widow entering, he began descanting, as if to himself, yet loud enough for her to hear, upon the virtues of the deceased, winding up his exclamation, "To think that West Point should have produced such a man, and that we have his portrait here to remind us of what we ourselves may attain to!" This touched the widow so deeply that Whistler was re-established in her good graces and – the mess.'[39]

Although no longer 'late at dinner', Whistler kept his record of delinquencies at its customary level and during the second term earned eighty demerits. He also continued his outside reading. He borrowed a collection of Thomas Hood's poems, Swift's *Tale of a Tub*, three volumes of Scott, a miscellany entitled *Wide, Wide World*, and, for the second time, Volume 37 of *Knickerbocker Magazine*. He perused most of these works presumably in search of painting subjects, but he was probably otherwise motivated when reading *Knickerbocker Magazine*.

Knickerbocker was a popular American journal, and Volume 37 covers the first four months of 1851. As with the *International Magazine*, we cannot be positive of what attracted Whistler to this journal, but again

one piece stands out as important enough to induce him twice to carry out this heavy volume. It appears in January, a pseudonmyous poem of nineteen four-line stanzas, 'An Artist's Studio'. The first part describes the artist in his riverside studio, a 'lofty room . . . clothed with mystic spell', which 'was his resting place of joy':

'The inner shrine of one whose brow the stamp of genius bore
And who the laurels of his fame with child-like meekness bore.

'I touched his easel and his brush; I saw his colors laid:
Those simple implements of art, they made me half-afraid;
For with such trifling means alone, to bid their visions glow,
Appelles, Zeuxis, Raphael, wrought wonders, long ago!'

On a wall 'hung a canvas broad and high', and eight stanzas describe the picture, depicting Pilgrims on the *Southwell* in Delft-Haven bound for Southampton. Students of American colonial history will remember that the *Southwell* was to be the first ship bearing colonists to the New World, but it proved unseaworthy, and its passengers boarded the *Mayflower*. The detailed description points to a precise painting, a mural of 1843 in Washington's Capitol rotunda, the famous *Embarkation of the Pilgrims*. The painter was Robert W. Weir, West Point's Professor of Drawing. The plebes who survived their final examinations would be his students in September. Whistler's absorption in this literary selection suggests that already he may have been less strongly attracted to an officer's uniform than to an artist's smock.

His interest in drawing uncurtailed by West Point's curriculum, Whistler found time for sketching. He became friendly with the Professor of Chemistry, Jacob Whitman Bailey, at whose home he often spent a Saturday or Sunday afternoon drawing the earliest of his many portraits of girls, in this instance Bailey's daughter Maria, better known as Kitty. They were done before the summer of 1852. On 28 July, Bailey, his wife, daughter, and son William were aboard the steamer *Henry Clay* in the Hudson River when it was destroyed by fire. Among those who perished were Mrs Bailey and Kitty.

During the spring of 1852 Whistler also drew the cover design for a piece of sheet music entitled *Song of the Graduate*. Showing a newly commissioned second lieutenant giving a farewell handshake to a friend who is still a cadet, it presents an accurate delineation of an incident from life. Soon after completing this drawing, during the first week of June, Whistler took his initial final examinations, and although his performances

were not outstanding, he did well enough to become a yearling.† This is a capsulisation of his first year record:[40]

SUBJECTS	CLASS STANDING
Mathematics	47
English Studies	41
French	9
Order of General Merit	42

The last number, representing his overall class standing, was derived by averaging four marks – the three academic subjects and conduct – with mathematics given double the value of each of the others.

The new yearlings spent July and August in an encampment, and during the first twenty-eight days Whistler collected no fewer than sixty-four demerits. For the last three days of the month, however, he committed no punishable offence; the explanation of this subdued behaviour probably lies in the date of the accident that took the life of Kitty Bailey, 28 July. August was better than July, for he got only twenty-four demerits. But with a total of eighty-five, he would have to limit himself for the rest of the year, the entire first term, to fourteen demerits if he wished to ensure his position at West Point.

During his summer Whistler drew many sketches, including caricatures, of fellow cadets, which sometimes reflected Hogarth's influence, as in a series of four pen and ink drawings entitled *On Post in Camp*. The 'First half hour' shows a cadet standing by a tree, musket on his shoulder. In the 'Second half hour', with musket lowered, he leans against the tree, checking his watch. In the 'Third half hour', he sits with his back to the tree. The 'Last half hour' finds him beneath the tree asleep.

For the autumn term there were two additions to the Academy: a new mess hall and a new Superintendent, a colonel in the Corps of Engineers, Robert E. Lee, than whom no one at West Point has ever been more universally praised. 'It has never been our fortune', remarked a writer on the Academy in 1854, 'to know a more noble-souled, high-toned, considerate and scrupulous man than Colonel Lee.'[41] Half a century later, a retired officer recalled, 'Every Sunday morning Colonel Lee visited our quarters; he would bow and say, "Good Morning, young gentlemen," and then glance around the room, and sometimes make kindly inquiries . . . especially when one of the occupants had been ill.'[42]

Colonel Lee's kindliness would soon be extended to Whistler, or more accurately, Whistler's mother. She has not yet been mentioned in this chapter because, as during his nine months in England, James was getting

† Second-year students at West Point are known as third-classmen or 'yearlings'.

along nicely without her. (Early in August 1851, Anna Whistler paid her only visit to West Point while her son was there, when, accompanied by William, who was about to enter a school in Springfield, Massachusetts, to prepare for Yale, she stayed in Cozzens' Hotel.) If he was homesick at West Point, his feelings are unsupported by documents or recollections. Anna, now living in Scarsdale, New York, endured the separation with her usual stoicism. In September she bid farewell to William, who was entering a new school, St James's in Baltimore – to prepare for Columbia rather than Yale – and on the 24th, a few days after William's departure, she sent a request to Colonel Lee:

'Though my son ... has not earned a furlough and I know the regulation requires his fulfilling two years at the Military Academy before a visit to his home, perhaps under present circumstances you may consider it his duty to relieve an invalid and widowed mother the exertion of visiting him to exchange adieus previous to embarking for England for absence of nearly a year in the hope of regaining health.

'The 14th of Oct. is the day for the steamer's sailing ... and if in accordance with Col. Lee's judgment next week may be granted for a visit to his home the favor I trust will be an incitement to his application to study throughout his term at West Point.'

She particularly asked 'that his leave of absence include one Sabbath the memory of which may comfort a lonely voyager'.[43] Although the request contradicted USMA regulations, and Whistler's demerit total now stood at ninety-four, Lee dispatched this reply on 28 September:

'I have received your application for a leave of absence for your son. ... Under the circumstances I have concluded to grant it, but regret that I cannot extend it to the length you desire. It is very important to him at this period of his course that he should omit no part of it, & ... every lesson he loses will be disadvantageous to him. I trust however for the sake of the pleasure he will receive & give, he will make the necessary effort to recover his ground.

'He will leave here Friday next, in time to reach New York for the $5\frac{1}{2}$ o'clock train – which will carry him to Scarsdale by 7 p.m. on condition that he returns here by 7 p.m. Monday 4th Oct. ... This will enable him to spend the Sabbath with you ...'[44]

Whistler was now enrolled in four courses: mathematics, three hours daily; English, two hours; French, two hours; and drawing, two hours

daily for half the term and one hour for half the term. He also participated in a cavalry class for two hours on alternate days. Class standings would be determined on the basis of 6½ points: mathematics, 3 points; French, 1; English, 1; Conduct, 1; Drawing, ½.

Although contributing little to a cadet's class standing, drawing was not regarded lightly at the Academy. At a time when photography was in its infancy and aerial reconnaissance only a dream, this art, which involved maps and sketches of fortifications and battlefields, was indispensable to an army. Recognising its value, West Point's authorities provided good drawing facilities and good teachers. A distinguished English visitor in 1854 described the drawing hall: 'It was lofty, and well lighted and ventilated. Each student had his separate seat and desk. Opening into the hall was a large room, on one side of which were hung up coloured figures and landscapes, copied by the students from the first-class prints on the opposite side.'[45] Nearby were 'Statuary and Picture Galleries, the former being chiefly filled with plaster casts for drawing models, and the latter containing an exhibition of paintings, drawings, etc., executed by cadets, besides a full-length portrait by Weir of Colonel Thayer.'[46]

'Weir', Professor Robert W. Weir, had taught at West Point since the year of Whistler's birth. Like his predecessor, Charles Robert Leslie, he was a distinguished painter who had excelled in several areas of his art, including portraiture and landscapes. He was conservative rather than innovative, and he was painstakingly careful and methodical. Before beginning *The Embarkation of the Pilgrims*, he

'put months of study perfecting every detail in order that it should conform to absolute historical fact. His notebooks are filled with data, with sketches of heads, of costume and accessories. The figures are studied with special reference to the types of character they represent. . . . No pains were spared in making this painting true in historical accuracy, in insuring the correctness of every detail.'[47]

Robert W. Weir clearly would not tolerate careless work.

The yearling drawing course encompassed, officially, 'Elements of the Human Figure, . . . Landscape with pencil, . . . Landscape in India ink, and elements of Topography with pen, pencil, India ink and colors'.[48] Weir filled in the details in his Outline of Instruction:

'1) Geographical signs; 2) topographical delineation of rocks and hills, wild and uncultivated ground; rivers, lakes, marshes; 3) formation of letters; 4) course of topography with brush laying flat, broken and blended tints, shading mountains, rocks, trees, and other objects. 5) the course in

freehand work begins with outline drawings of human figure and outline drawings from Flaxman and Retzsch.'[49]

Since the first basic step in an artist's education is learning to draw, one should readily comprehend the value of this course to a potential painter.

Weir soon recognised the superior talents of one yearling of 1852, who probably mentioned with proper emphasis the poem he had read in *Knickerbocker Magazine*. Even without calling attention to himself, Whistler would have stood out. According to the centenary history of West Point, cadets had been 'for the greater part wholly deficient in any, even the most rudimentary, instruction in drawing. . . . It was therefore necessary that instruction should begin at the illiteracy in this subject.'[50] How, then, could Weir not have noticed the work of Whistler? General Thomas Wilson, Whistler's contemporary, recalled:

'The models which cadets copy when they enter the drawing-class at West Point are known as "topographical conventional signs". They illustrate the mode of depicting, with pen and ink, the various topographical features of a country, such as water, hills, trees, cultivated ground, etc. In a much shorter time than seemed possible, Whistler had finished the copy of the model given to him, and his work was most exquisite, far surpassing the model itself in accuracy and beauty of execution. Professor Weir then brought from the picture gallery a large painting containing many figures, and directed Whistler to prepare a board with drawing paper, and copy this picture with pen and ink.'[51]

Another future general, Alexander Webb, worked alongside Whistler and recounted that one day while he

'was busy over an India ink drawing of a French peasant girl, Weir walked as usual from desk to desk, examining the pupils' work. After looking over Whistler's shoulder, he stepped back to his own desk, filled his brush with India ink and approached Whistler with a view of correcting some of the lines in the latter's drawing. When Whistler saw him coming, he raised his hands and called out: "oh, don't sir, don't! you'll spoil it!"'[52]

Although 'this was dangerously near to subordination, Weir merely smiled, and walked back to his desk without making the intended corrections'.

Whistler's talent, and Weir's encouragement, aroused the animosity of one of the professor's assistants, Lieutenant Smith. This led to a confrontation, described by Wilson:

12. Finette (etching)

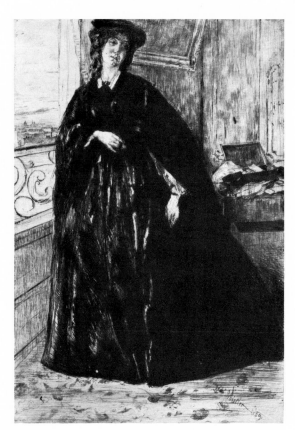

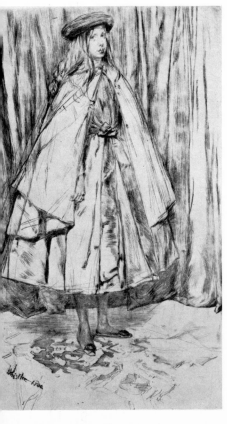

13. Annie Haden (etching)

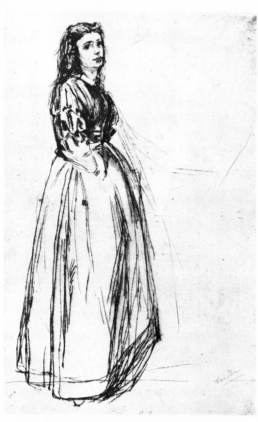

14. Fumette Standing (etching)

15. Gustave Courbet:
Portrait of Joanna Hiffernan

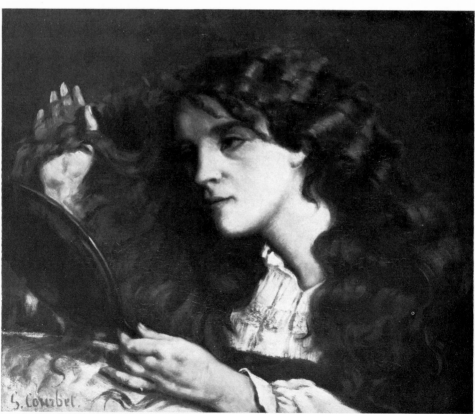

'Whistler was painting in water-colours from a picture representing the interior of a cathedral, with monks and nuns scattered about. Behind the tonsured head of one of the monks Whistler had painted a shadow; Lieutenant Smith, in making his rounds of examination of the work of the students paused at Whistler's head, and said very audibly:

' "Your work, sir, is faulty in principle. What is the meaning of that shadow? There is none in the model, and you should know better, for by no principle of light and shade could any shadow be there. Why, there is nothing to cast it." Without saying a word, Whistler filled his brush, and with one sweep of it he threw a cowl over the head of the monk. He had painted the *shadow* first. Lt. Smith walked quietly away, without a word.'[53]

Since obviously his academic position would never be high, Whistler was no threat to his contemporaries, who admired his proficiency in a course that contributed half a point to his class standing. 'When at work,' wrote Day Allen Willie, who had talked with several of his fellow cadets, 'he was always the center of a knot of boys attracted to him by the instinctive knowledge of his talent.'[54] General William Averell, a classmate, recalled that 'he would wriggle and twist about his work like an animated interrogation point'.[55] And Wilson wrote:

'He would fix his eye near a position of the model, and then proceed to copy it, upon his drawing board. He never drew any outline of the work he was copying. He seemed to work at random, and in this instance he displayed one of his favorite tricks, which was to draw first, say a face, from the model, then a foot, then the body, skipping from one part of the picture to another, apparently without keeping any relation of the parts. But when the picture was completed, all the parts seemed to fit in together like a mosaic, and it was a complicated piece of work.'[56]

Whistler drew whenever and wherever he could; he especially enjoyed doing humorous and satirical sketches suggested by life around him or by his reading. Another general who had been a classmate, George Ruggles, remembered his 'keen sense of the ridiculous. In the recitation-room, at church, and almost everywhere, the ridiculous incidents of a situation would strike him, and he would sketch, in a second or two, cartoons full of character and displaying the utmost nicety of appreciation of its ludicrous points.'[57] Among his literary inspirations, the most important was Charles Dickens. Whistler's yearly borrowings included *Barnaby Rudge*, *Martin Chuzzlewit*, *David Copperfield*, *The Old Curiosity Shop*, *Nicholas Nickleby*, *Oliver Twist*, and *The Pickwick Papers*. Dickens's effect on Whistler was not temporary. Joseph Carr, who knew him late in life,

remarked that 'when he wanted a quotation to heighten the sarcasm of any biting sentence it was happily chosen, and most often . . . taken from Dickens, whose humour appealed to him.'[58] Inexplicably, another friend of his adulthood declared that 'Dickens he could find no excuse for at all,'[59] and this assertion has been taken seriously by subsequent writers. Whistler also borrowed at this time three more Waverley novels, *The Arabian Nights*, and *Rejected Addresses*, a book of verse by the minor nineteenth-century poet James Smith whose closing section, 'Humorous Poems', quasi-Dickensian character sketches such as 'The Culprit and the Judge', 'The Milkmaid and the Banker', 'The Auctioneer and the Lawyer' and 'The Bank Clerk and the Stable Keepers' probably suggested ideas for comic drawings.

Although he was experimenting with pen and pencil, one medium in which Whistler showed no interest was landscape art. Because of his later work, this unconcern with West Point's breath-taking scenery may seem surprising. The explanation is that his subsequent outdoor pictures involved close-range observations, whereas to appreciate West Point's surroundings one needs good vision. Because he was near-sighted, Whistler would usually ignore that which lay beyond his immediate perspective.

Even had he been able, it seemed unlikely that Whistler would continue for long to enjoy West Point's vistas. As we have noted, by the end of September he had collected ninety-four demerits, and if his total had risen to one hundred by 31 December he would have faced dismissal. He could, if necessary, control his behaviour, but to expect him to receive no more than five demerits in three months would be to ask for a miracle. Actually, he behaved remarkably well, acquiring only twenty-two demerits, giving him on 31 December a total of 116. And yet he was not dismissed. We can only speculate, but there are several possible reasons for the reprieve. More than half of his demerits had been accumulated in the first month of the encampment; during the academic year, especially after visiting his mother, he appears to have tried to conform to regulations. During these last three months this habitually unpunctual lad was only once cited for lateness; his demerits were mostly for spontaneous actions. Probably also Professor Weir, a member of the Academic Board, spoke favourably of his best student. Finally there was Robert E. Lee, a personal acquaintance and admirer of Whistler's father, who had the discretionary power to forestall his dismissal. It seems likely that Colonel Lee called Whistler into his office and elicited from him a pledge to control his behaviour. In any event, he was permitted to take his mid-year examinations, all of which he passed.

Supporting the suggestion that Whistler promised to behave himself is

his record of conduct during the next term. His total number of demerits for this six-month period stood at eighteen, convincingly demonstrating that if he so desired Whistler could do what was right.

The first half of 1853 was uneventful until late in May. On the 26th, Colonel Lee wrote to the recently returned Anna Whistler, staying with her brother in Brooklyn, 'I regret to inform you that your son . . . is quite sick. He was taken this day week with an attack of rheumatism and went into Hospital, where he has remained under the treatment of the Surgeon. He does not suffer much pain, but his attack does not yield to remedies, and the Surgeon has this morning informed me that he fears his lungs are seriously involved.'[60] Four days later Whistler took a medical leave of absence. In New York his ailment was diagnosed as endocarditis, and on 3 June Anna Whistler informed Lee that their doctor 'judged it extremely imprudent that James should return for the examination'.[61] He went on convalescent leave, and his year-end examinations were postponed. He received no mark in mathematics or French, but Professor Weir excused him from the examination and ranked him number one in drawing.

On 28 August a healthy Whistler returned to West Point and, after picking up a demerit for 'Reporting for duty . . . with long hair', passed his examinations and in a class reduced to forty-eight members was rated '32 in General Standing'. Despite extracurricular activities, he ranked above a third of his classmates who had survived two years at West Point. In the beginning of the first year, it may be remembered, the class numbered seventy-one.

When they reached the second class (that is, the third year), cadets enrolled in three academic courses: chemistry, whose relative importance was one point; drawing, one point; and 'Natural Philosophy', three points. They also received tactical instruction – infantry, artillery, and cavalry. Everyone agreed that West Point's most difficult year was the third because of the course in 'Natural and Experimental Philosophy', the Aristotelian term for physics, taught by Professor William Bartlett, often called the Academy's most brilliant nineteenth-century student. A graduate of the class of 1826, he was ranked number one for each of his four years, and he never received a demerit. He had been, or would become, the author of books on acoustics, optics, astronomy, mechanics, and molecular physics; and during a partial solar eclipse in 1854 he was to be the first person in America to use photography for astronomical measurements. His course, which met for three hours daily, covered in depth and breadth 'Mechanics . . . Statics . . . Dynamics . . . Hydrostatics . . . Hydrodynamics . . . Magnetism, Electric Magnetism, Light . . . and Astronomy'.[62] After completing this course cadets found their last year at West Point comparatively easy.

The Natural Philosophy class met in the morning, and then Whistler gained relief every afternoon in the drawing hall. Weir thus summarised his second course: 'Landscape is taken up under the following heads: 1) measurement; 2) form: simple and compound; 3) aerial perspective; 4) light; 5) different scales; 6) drawing in tinted paper; 7) use of brush (sepia); 8) coloring; 9) finished drawings from standard works.'[63] We need not belabour the obvious value of this course to James Whistler.

During September 1853 Whistler received more demerits than in any other month, seventy-three resulting from thirty-two offences. He was cited on each of the first eleven days, which, added to the last two days of August, created a string of thirteen consecutive days with demerits. On the twelfth he somehow escaped punishment, and then he began another streak of eight days with demerits. If only he had stepped out of line on the twelfth he would have established what surely would stand as an unbeatable cadet record, twenty-two consecutive days with demerits. Including seven acquired during the last four days of August, Whistler accumulated eighty demerits in twenty-seven days. Since he surely could not again hope for leniency from the Superintendent, he would have to restrict himself to nineteen demerits in ninety-nine days if he wished to remain at West Point. So what happened? He was cited three times for a total of seven demerits. His conduct from 24 September until the end of the year shows that James Whistler could control his demerits as easily as water flowing from a tap.

During the autumn of 1853, when James Whistler was behaving surprisingly well, William Whistler, unsurprisingly, was proceeding diligently in *his* studies. On 3 October he enrolled in Columbia College, New York, and pursued the following course of study required of all freshmen:[64]

'Horace's Odes, Epodes and Satires; Virgil's Georgics, Ovid's Fasti; Cicero's *de Senectute* and *de Amicitia*, Cicero's *Oration for Muraena*; Dalzell's *Collectanea Graeca Majora*, Lucian; Latin Composition in prose and verse; Greek and Roman Antiquities; Ancient History and Geography; The German Language; Algebra; Elements of Plane Geometry; Geometry of Straight Lines and Triangles, Theory of Parallels; Doctrine of the Circle, Measure of Angles, Geometry of Polygons; English Grammar; English Composition.'

So, it would seem, both of Anna's sons would be kept busy. Anna, incidentally, lived from November until February at 220 14th Street, in order to be near William. (Situated in Lower Manhattan, Columbia was then more convenient to 14th Street than would be its present campus on Morningside Heights, which was not occupied until 1897.)

No tales of current escapades concerning William have survived, but in the spring James was involved in what might be called a Dickensian episode, of which the official record is an entry in the *Register of Delinquencies*: '29 March. Not taking gallop at the proper pace. 2 demerits.' Here, reported by Kobbé, are two classmates' recollections of what underlay this notation:

'General Webb says that it was not unusual at cavalry drill for Whistler, a sorry horseman, to go sliding over his horse's head. On such occasions Major Sacket... would call:
' "Mr Whistler, aren't you a little ahead of the squad ?" '
'Adjutant-General George D. Ruggles ... also refers to Whistler's habit of parting company with his horse during drills.
'In the first mounted drill in the riding academy in which Whistler took part, he had a hard horse. The instructor ... gave the command: "Trot out!"
'At this command Whistler, who had journeyed from the withers to his croup and back again several times, tumbled in a bundle into the tanbark. He lay for a moment without movement. The dragoon soldiers, who imagined him seriously injured, ran to him and picked him up, to carry him to the hospital; but he told them to let him down. Major Porter... called to him from his horse: "Mr Whistler, are you hurt ?"
'Whistler, leisurely drawing off his gauntlet and brushing the tanbark away from his hips, replied, "No, Major! but I do not understand how any man can keep a horse for his own amusement!"
'There was in the squad a horse named Quaker. This horse ... had thrown the most expert riders in the cavalry detachment. ... One day ... this horse fell to Whistler, who coming up blinking with his myopia, said: "Dragoon, what horse is this?" The soldier answered: "Quaker, sir," and Whistler replied: "My God! He's no friend." '[65]

If horses stimulated amusing adventures, a frozen river led to one of Whistler's three most serious cadet infractions commemorated by this entry in the conduct register: '18 February 1854. Off cadet limits, skating on river in neighborhood of Buttermilk Falls. 8 demerits,' It is fascinating to contemplate the normally unathletic Whistler demonstrating this highly risky interest in skating. He was not accompanied by another cadet, for the *Register of Delinquencies* reveals that he alone was punished for the offence. But surely, in perpetrating a transgression whose seriousness was exceeded only by 'mutinous conduct', he did not skate alone. His companion, perhaps, was the 'heroine' of his three-page fragmentary essay, written in 1854, on his West Point career.[66] She was

'a beauty by Jove! the belle of the Point! Dear me how fond we were of each other – at least if any thing like faith can be put in our own affectionate demonstrations, and warm vows of strong and lasting love – I don't wish to be mawkish, but mon cher, she had those large languishing deep black eyes, that would excuse even the most cold blooded misanthrope or most thoroughly blasé in being guilty of an enthusiastic burst of admiration – and such beautiful, *really* beautiful rich red lips, that you must pardon a reminiscence, even though you find it dull and stupid to read – which, by the way, you haven't the slightest right to do, and now that it has occurred to me, I shall in future ignore your very existence, not offering you the faintest consideration, but stopping or going on, annoying or boring you, and pleasing myself without any reference to an impertinent intrusion of friend of the family, or morning acquaintance who picks up things on the table.

'Où en suis-je? where have I strayed to? voyons – oh! I was at charming little "Em's" delicious lips – not a bad resting place either – parole d'honneur! and when I last heard her "Goodbye" I was "right sorry" to leave them!'

The essay thus came to an end.

Apart from this skating incident, Whistler's conduct during most of the second term of his third year followed the usual pattern, and with his customary sense of timing, he paced himself well. By the end of May he had 189 demerits, but during the first nineteen days of June he collected only five, and so, if he restrained himself for the rest of the month, misbehaviour would not prevent advancement to the first class. Let us now examine the record for five days in June 1854.

Whistler began 20 June by reporting late for breakfast and receiving two demerits; then without permission he dashed out of the mess hall before breakfast had ended and gained two more demerits. On the next day he reached the forbidden 200 mark by being late at reveille. On 22 June, he was late for breakfast (one demerit); he carried his musket improperly (two); and while serving on guard he was absent from his post (four). On the 23rd he got six demerits by being absent from dinner roll call and not appearing until after 3.30 p.m. Finally, on the 24th he received his final demerits, five for crossing the sentinel's post at 2.18 a.m.

It is difficult not to conclude that Whistler's conduct was to ensure his dismissal from West Point. But why? After three years at the Academy, and, more immediately, after nineteen days of highly controlled behaviour, why did he suddenly throw off all restraint and commit flagrant, easily detectable infractions? In order to answer this question, we should examine his academic record for the year.

Of the more than eighty initial appointees in June 1851, forty-two remained to take final examinations three years later. As expected, in drawing Whistler was again first. In Moral Philosophy, he was ranked 39. Although near the bottom of his class, he nevertheless passed the course universally regarded as the most difficult and most demanding in the Academy. In chemistry, however, he was rated 'Deficient'.

The most famous moment in Whistler's West Point career occurred during his chemistry examination. Asked to discuss silicon, he supposedly asserted, 'Silicon is a gas,' causing his interrogator to end the questioning by saying, 'That will do; Mr Whistler,' The episode was concluded years later when Whistler declared, 'If silicon had been a gas, I might have become a general.' That his military downfall was due to silicon has been dutifully reported by writers on Whistler, many of whom have also attributed his chemistry failure to the burning of the *Henry Clay*. Here is a typical comment:

'Whistler was completing his third year when an unfortunate accident determined his fate. Professor Bailey . . . had a firm conviction that any cadet who was nearing completion of the first three years, and had not displayed any congenital weakness debarring him from a commission should not be hindered in his upward course to a diploma because of a slight lack of chemical knowledge. While on the steamboat *Henry Clay* . . . Professor Bailey and his family were caught in the explosion and burning of that boat. The Professor's family was wiped out and he was left to care for their burial and to mourn their loss.

Meanwhile, Lieutenant Caleb Huse was in charge.'[67]

And so, we are told, but for a steamboat accident Whistler would have been a first classman, and, presumably, an officer. In fact, as we have seen, the disaster occurred in July 1852, nearly two years earlier. No new instructor was introduced into his chemistry class, and no one was responsible for his deficiency but himself.

Whistler's failure, it seems, was deliberate. Clearly he was capable of completing West Point's curriculum. As Lazelle said, 'with his memory and alert mind, he could easily have graduated with honor'.[68] Why then should he intentionally fail? For two reasons: he did not wish forever to be subject to military discipline, and, because of personal goals, he was no longer motivated to become an officer. The first reason is self-evident, but the second may deserve amplification.

It would be incorrect to say that between 1851 and 1854 Whistler's goals had changed. In 1854 as in 1851 his ultimate objective could be expressed in one word: superiority. Like most ambitious people he wished

to gain pre-eminence among his peers. He may never really have expected to achieve this by means of West Point, but for want of an alternative, and perhaps because he had not yet made up his mind on the matter, he stayed for three years. Then as the second class final examinations drew near, he probably made the irrevocable decision. He would not be an officer in the Army of the United States. Consider what he would have achieved by remaining at West Point. The graduating class, a nineteenth-century observer explained, was divided 'into three sections, accompanied by a recommendation from the Academic Board to the Secretary of War, that the first may be assigned to any corps that they may elect; the second to any corps except the Corps of Engineers; and the last to the Infantry and Cavalry branches only'.[69] Whistler would certainly finish in the bottom third of his class, and it would be rhetorical to ask how he would accept a post in the infantry or cavalry after seeing the desirable positions go to others. Even if he chose an army career, 'under ordinary circumstances he could expect to be a second lieutenant for five or more years, a first lieutenant for ten years, and a captain only when he reached middle age'.[70] Need one inquire if these expectations would satisfy James Whistler?

West Point graduates, however, were not required to stay in the army beyond four years, and they were well prepared for another vocation. Along with Bartlett, one of the Academy's two most eminent faculty members was Dennis Mahon, Professor of Civil Engineering, and, as in the days of Whistler's father, West Point continued to produce the nation's best civil engineers. But James Whistler's reluctance to become an army officer was probably exceeded only by his disinclination to be an engineer. Since his father had been a famous practitioner of the profession, how could he gain distinction in his own right as an engineer? Would he not always be 'George Whistler's son'? In one sphere of activity, however, he might make a name strictly on his own merits, a field in which he had consistently outdistanced his contemporaries. Therefore he renounced soldiering and engineering and committed himself to art.

A cadet who wished to leave the Academy before graduation, practically speaking, had to be dismissed for deficiencies in conduct or scholarship. Conduct meant demerits, and it would have been easy for Whistler to go beyond 199. But, as noted, until 20 June he carefully remained within bounds. He probably felt that a bad conduct dismissal carried a certain stigma, and he would not want to disappoint Colonel Lee, who had always treated him well. But most important was his mother, who as recently as 29 May 1854 had expressed displeasure over reports on his conduct and admonished him that his 'revelry and popularity at the academy had been won at the expense of the good opinion of their

friends'.[71] How could he face her if he were dismissed because of mis-behaviour? He would have to fail academically.

Because of its notorious difficulty, and its importance to a cadet's standing, one might think that the obvious course to fail was Natural Philosophy. Actually this class probably provided a challenge for Whistler; it would be an accomplishment to pass the most demanding course offered by the nation's most demanding institution of higher learning. Bartlett, moreover, had been a friend of Whistler's father, and Anna's letters to James regularly mentioned the professor and his family, to whom she nearly always sent best wishes and, on at least one occasion, some peaches. Because of this closeness to Bartlett, Whistler would have been ashamed to fail his course. If the foregoing speculations are valid, he turned his attention to chemistry, which, contrasted with natural philosophy, was considered easy. During his chemistry examination, it is possible, even probable, that Whistler was purposely flippant. This would explain why someone who had mastered the intricacies of Professor Bartlett's course might say that 'silicon is a gas'.

Examinations were completed by the end of the first week in June, and for a fortnight Whistler behaved properly, presumably awaiting a notice of dismissal. But it never came. 'Any Cadet found deficient at the annual examination,' the regulations stated, 'shall not be admitted to the next class; and if, in the opinion of the Academic Board, his deficiency is to be attributed to incapacity or want of application, his case shall be represented to the Secretary of War, to the end that he may be discharged.'[72] The Academic Board evidently did not make the fatal recommendation. Professor Weir was surely Whistler's advocate, Professor Bartlett probably also spoke in his favour, and the Superintendent was not unfriendly to him. Since, as we shall soon observe, his classroom performance prior to the examination had been satisfactory, he would apparently have another chance to be examined in chemistry.

If the 'good news' arrived on the 19th, it would explain Whistler's erratic behaviour of the next five days. His impulsive departure from the morning mess hall cannot be explained rationally if he had wished to remain at West Point. The appropriate dismissal order was issued, and before the end of the month James Whistler was a civilian. In his fragmentary essay of 1854, Whistler wrote:

'After a brief but brilliant career as a military man, when I served my sweet Fatherland through three years of fun, folly, and Cadetship at West Point, it was discovered, that the sphere, whose limits are determined in the Academic Regulations, was entirely too small and confined for one of my elastic capacities; so, upon the recommendation of the "Board",

my trunk was packed . . . my "grey changed for the blue", or rather for a buff colored shanghai which had been brought by a newly arrived "Plebe" of fashionable pretensions, and in return for which I made him happy with my "shell jacket".'

Before Whistler departed, Lazelle recalled, 'Professor Weir advised him to continue his work, telling him that if he would do so a great future was before him.'[73] Lazelle also noted that his room-mate's parting levity was superficial: 'He felt very keenly the mortification and self-reproach of failure, especially as its consequences involved others.'

Most important of the 'others' was of course his mother – whose letters often began 'My own dear Cadet' – and because of her, on 1 July, he posted an extraordinary document to the Secretary of War, Jefferson Davis, which until now has remained unpublished and might be called the first of Whistler's celebrated 'literary' letters:

'The returns made to your Department recently from the Military Academy place me on the list of those recommended deficient in Chemistry. . . . I wish to point out to you that I have been found deficient without sufficient cause . . . and consequently beg you to allow me to be re-examined. . . .

'In the first place, Sir, you will see, should you notice my marks in this subject, received in the section room . . . indicate a good knowledge of the course; and indeed on some portions you will see a series of *perfect* recitations, where I have received for *two or three weeks* running, the *maximum standard*. . . . Now Sir, my mark for the year being 130·6, my average mark for each day is 2·2, which undoubtedly shows any thing but deficiency, and as an officer on the Point acknowledged, *is above the general average to prove proficiency*. Now more than this, is the great fact of *my having been transferred up* during the year from the fourth section [the lowest, academically, of the sections into which the class was divided] . . . to the 3rd section, *on the knowledge of my course* that I had displayed on my recitations, thereby proving a proficiency in it that ought to have prevented my being recommended deficient in June. At the examination I certainly did not do well, but that ought not to be sufficient to show a deficiency, for after all, that is only one recitation, and any man is liable to fail upon it, and at the same time know infinitely more about the subject than one who happens to do splendidly before the Board. . . . If I had done badly all the year and *then* failed at the examination it would be a different thing, but as I have already said, my average mark is 2.2! You must see Col. Davis that my case is a fearfully hard one – after remaining at West Point for *three long* years to be so suddenly discharged, and that on a *secondary* study, which I had done well in and stood well on, and in which I had *not*

the most remote idea of the possibility of my being found [deficient]. . . . Now I know Sir, that you say that I have been found deficient in Conduct also, but if you would examine the list of my demerit, you would see none of them are for grave offenses, but for things that in themselves were neither vicious nor immoral, and indeed I feel convinced that had I passed in Chemistry, my demerit would have been all removed, as was done in the case of a great many others. At any rate Sir, let me beg you to grant *me this re-examination, without reference to my demerit*, so that even if eventually I am to leave West Point, let it not be because I was found deficient in what I feel myself proficient, and only asked to be examined upon, to prove that I ought not to have suffered this horrible disgrace.

'Besides I know that afterwards I can certainly have my demerit removed and then I *am sure* of graduating in one year more! . . . Let me beg you again Sir, to remember of what vital importance this matter is to me, and that after three years spent at the Military Academy, all my hopes and aspirations are connected with that Institution and the Army, and that by not passing, all my future prospects are ruined for life. . . .'[74]

A remarkable performance, this perhaps served its purpose of appeasing Anna Whistler.

Jefferson Davis referred the letter to Brigadier General Joseph Totten, the Army's Chief Engineer, who in turn sent it to Colonel Lee, who acknowledged that Whistler's classroom work had been satisfactory but said the examination 'was considered a complete failure' and then declared, 'I know of no claim he has for a re-examination over any others.' Concerning the demerits, Lee could not understand 'his belief in the practicability of its reduction except the indulgence that has hitherto been extended to him'. He concluded, 'I can therefore do nothing more in his behalf nor do I know of anything entitling him to further indulgence. I can only regret that one so capable of doing well should so have neglected himself & must now suffer the penalty.'[75]

Totten's report to Davis stated that Whistler's 'request for a re-examination ought not to be granted. And also that independent of his deficiency in Chemistry, his deficiency in Conduct required his discharge.' Davis had the last words on Whistler's application:' For the reasons given not granted.'

Before taking leave of West Point, one might mention a matter, inherently trivial, that has assumed some importance because of its persistent treatment by writers on Whistler. They have insisted that at West Point he adopted his mother's family name 'McNeill' as a replacement for 'Abbott'. In point of fact, the boy who arrived at West Point as James Abbott Whistler left with the same name. The Academy archives, his

current correspondence, and recollections by comrades are without a shred of evidence to support the contention that a name change occurred at West Point, and for at least seven years after his dismissal he was James Abbott Whistler.

Whistler left West Point, but West Point never left Whistler. When he 'recalled his early years', his confidante of the nineties, Elizabeth Pennell, wrote, 'it was over the West Point period he sentimentalized. Time glorified the Academy [and] it became his standard of conduct.'[76] One of the first copies of his first book, appearing more than twenty-five years after his departure, went to the Academy inscribed: 'From an old cadet whose pride it is to remember his West Point days'.

WASHINGTON
1854-5

From West Point, Whistler went to Scarsdale, where a neighbour remembered him 'sitting very quietly in a dark corner of the piazza'.[1] He had not come to stay, for, he later remarked, 'it was hardly a moment for the return of the prodigal to his family or for any slaying of fatted calves'.[2] It was also not the time to speak of art. His immediate course of action was clear: he had to go to work.

Getting a job was not, however, a matter of urgency, for Whistler spent half of July and all of August drifting in a leisurely way about the north-east. One person whom he saw was his former room-mate. On 16 August, Lazelle wrote to him: 'My dear little friend you cannot imagine the delight I took in your letter and with what pleasure I acquiesced in your wish at the prospect of once more seeing your face together with your body here once more.'[3] At least one other West Point acquaintance wanted to see him, apparently without success. On 2 September, Anna wrote to an unidentified recipient:

'Do not let it alarm you fair stranger that the widowed mother of James Whistler ventures to advise you of his absence and to offer a few reflections, prompted by the truest regard for you. I judge not harshly of the inexperienced in the world's allurements, not doubting present amusement is blinding you to further mortifications if persisted in. It has so happened that two of your billet doux have been opened by me. The first in the twilight was supposed to be directed to myself. The W. Point post mark and a lady's caligraphy [sic] easily explains my error. When I returned from a week's excursion I gave it him, and his laughing assurance that his returning the compliment should end the correspondence satisfied me. My delicacy was alarmed for one of my own sex. I saw James had merely been indulging in the gratification of his vanity, his natural fondness for ladies society and your being a West Point belle explained all. I did not lecture my son, but depended upon his ready promise to end the affair – so natural in a youth's teens! but so imprudent and culpable if continued. Probably you have no mother! Make a friend of me, for I have

trained a daughter to *rejoice* in the restraints maternal love put upon inexperienced years. I excuse the *past* in this flirtation of James. The temptation is so irresistible at West Point. James has *devoted* his attentions to a Stonington belle every day, for it is his way! but in another month he will find as much fascination in other bright eyes, some kindred spirit will meet him in every place. He has now gone to Washington and is going to take up a post with the U.S. Coast Survey, and he will not be able even to visit West Point. He left here on his second trip to Washington a fortnight ago, and was visiting friends in Pennsylvania when last I heard. Consequently your last hurried note was handed me.'[4]

In several instances Anna seems to have trifled with the truth. Her explanation of how she happened to open the letters from this 'West Point belle', perhaps 'Em' of the fragmentary autobiography, is unconvincing, and nothing indicates that he had been seeing a 'Stonington belle'. He had not, furthermore, gone to Washington but was now in Baltimore. This had been his obvious destination, for Baltimore was the home of the Winans Locomotive Works. The Whistler-Winans intimacy harked back to 1828, when George Washington Whistler and Ross Winans, who had begun to build locomotives, were members of the American delegation inspecting British railways. Fifteen years later, as we saw, Winans, recommended by Whistler, started working for the Tsar. Because the Winanses lived near their factory in suburban Alexandroffsky, they infrequently saw the Whistlers in St Petersburg, but their friendship with Anna continued in America. In the early fifties, Ross's son Thomas took over the family establishment, and in Baltimore he built a palatial mansion which he called Alexandroffsky. Anna was an occasional house guest, and she received from Winans more than hospitality. On 18 October 1853, his journal reveals, he 'gave Mrs Whistler $500.00'.[5] He also helped Anna's second son, advancing him $20 or $25 every month during his time at Columbia. Since satisfactorily completing his first collegiate year, William had been working at the locomotive works. Winans's concern for Anna and William was based on more than gratitude and shared experiences in Russia, for on 1 June 1853 his only sister Julia married his business partner George Whistler. Thus was it certain that young James would go to Baltimore.

His delayed arrival was probably assisted by Winans, whose journal shows that on 14 July James received $35.00, and one week later $25.00. When his money had been dissipated, James went to Baltimore, early in September, and moved into Alexandroffsky, a virtual palace surrounded by dozens of trees on an estate enclosed by a wall supposedly to protect the strait-laced from the sight of nude statues. In October, Anna followed

James to Baltimore, but lived a couple of miles from the estate at 176 Preston Street, a pleasant dwelling in an upper middle-class neighbourhood.

James had presumably come to Baltimore to work in the Winans Locomotive Works, 'the largest individual enterprise of the kind in the country'.[6] James was offered an apprenticeship with promising expectations, but he had no interest in being a railway man. When he visited the factory, an employee recalled, he spent his time

'loitering in his peculiar *bizarre* way about the drawing office and shops.... We all had boards with paper, carefully stretched, which Jem would cover with tentative sketches to our great disgust, obliging us to stretch fresh ones, but we loved him all the same! He would also ruin all our best pencils! sketching not only on the paper, but also on the smoothly finished wooden backs of the drawing-boards.'[7]

Art, not locomotives, engaged Whistler's thoughts in Baltimore, and, as at West Point, his pictures were often inspired by Scott and Dickens. His surviving work, contained in an album owned by the Metropolitan Museum of Art, includes three scenes from novels he had read at West Point, Scott's *The Monastery* and Dickens's *Barnaby Rudge* and *Dombey and Son*.

Whistler enjoyed living in Alexandroffsky, and he liked Baltimore. With a population of nearly 160,000, it was the first comparatively large American city in which he had lived, and, as his life would demonstrate, James Whistler was a denizen of cities. Although Baltimore was called ugly, its ugliness was picturesque, and its narrow streets and crooked alleys with rows of small houses with white steps and red brick fronts probably reminded him of Preston and some sections of London.[8]

Although in fact Baltimore was a border city, mid-way between North and South, all of Whistler's later Southern pretensions were based on his brief residence here. On the crucial racial question, the city's sympathies were pro-Southern. Few Baltimoreans had a direct interest in slavery, and the non-white population was not large – 16·79 per cent of the city was black and 1·74 per cent were slaves[9] – but most whites were pro-slavery and against anti-slavery legislation. Black residents were kept in their place: educational opportunities were limited, and ordinances restricted their freedom. Most of Baltimore's slaves worked as household servants, some at Alexandroffsky. For James Whistler, the Winans mansion was like a southern plantation, complete with bowing, smiling 'darkies' at his beck and call.

Whistler could not forever live like a Southern gentleman. As might be

expected, maternal pressure brought the good life to an end. On 30 October Anna wrote 'accusing him of having preferred the luxury of the Winanses' home to that of his own and of having succumbed to pleasure and indolence. She told him to pack his bags and come to where she was living.'[10] James packed his bags, but he did not move to Preston Street. On 6 November, Winans wrote in his journal: 'Jas. Whistler – $10.00. He left to take service at Washington.'

Unlike thriving Baltimore, Washington was a sleepy town of 50,000, mostly transients. Whistler secured living accommodation in a modest boarding-house at the corner of E and 12th Streets, less than half a mile from the White House, and after settling down he went to Capitol Hill, where on the west side of New Jersey Avenue, between A and B Streets, he found the offices of the Coast Survey, whose director, Captain H. W. Benham, had been a friend of his father and would place him in a suitable position.

Founded in 1807 as the government's first technical bureau, the Coast Survey existed as such until 1878, when it became the United States Coast and Geodetic Survey. It created detailed maps of the entire coast of the country, its shore line, ocean and ocean bottom, and islands, tidal rivers, harbours, bays, capes, lagoons, headlands, lighthouses, and beacons. Since the coast covered five thousand miles, this was an immense undertaking. And it was important for a nation with 20,000 ships annually entering and leaving its ports, and another 10,000 engaged in coastal activities. Operations were coordinated to achieve the ultimate goal. Hydrographers examined the waters to learn of the depth and configuration of the sea bottom and movements of currents and tides, and topographers recorded the character and prominent features of the shoreline. Their findings were given to the map-makers, who produced the finished product.

Two offices dealt with maps, the Drawing Division and the Engraving Division. Cartographers in the Drawing Division took material from the field workers and drew the maps. Since a faulty detail could cause a navigational disaster, absolute accuracy was essential, and creating a nautical map sometimes required weeks or months. The engravers would then 'take the reductions of the draftsmen, and ... effect a faithful transfer of these embryo charts',[11] which was reproduced and distributed to mariners.

Whistler was hired as a draftsman in the Drawing Division. He told the Pennells that he was paid $1.50 a day, but like other recollections this is inaccurate. According to the Washington Directory of 1854, no *per diem* government employee got less than $3.00, and no salaried draftsman received less than $800. A later official of the Coast Survey, quoting a contemporary memorandum on Whistler, noted that because of absences

17. The Music Room

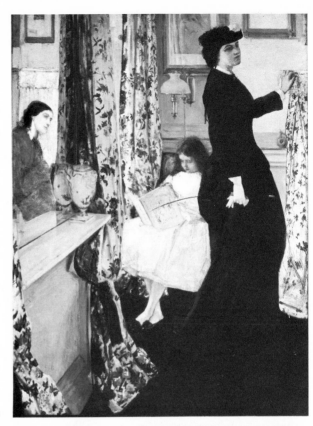

16. At the Piano

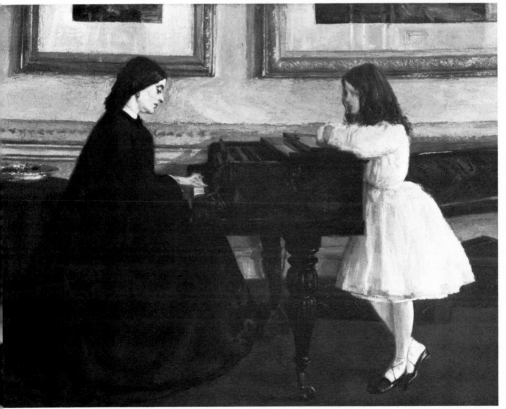

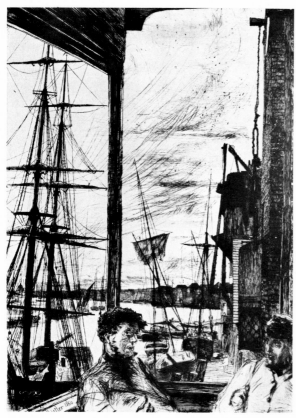

18. Rotherhithe (From The Thames Set)

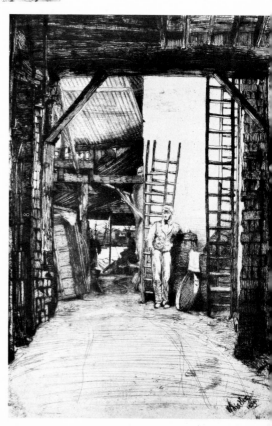

19. The Lime-Burner (From The Thames Set)

'two days were deducted from his monthly pay for time lost',[12] implying that he was not a *per diem* employee, but was probably paid the customary annual salary of a beginning draftsman, $800.

It was soon apparent that the job could not satisfy a James Whistler. His co-worker John Ross Key wrote, 'The accuracy required . . . was not to Whistler's liking, and the laborious application involved was beyond his nature, or inconsistent with it.'[13] As Duret said, 'the restrictions of topography appeared to him as insupportable as military discipline'.[14]

Whistler was sometimes absent without cause, and although the hours were undemanding, from nine to three, he was often late. When questioned about his tardiness, he later replied, 'It was not I arrived too late but the office opened too early.' Once Captain Benham asked another drafts-man, named Lindenkohl, to visit Whistler on his way to work and stress the importance of punctuality. Lindenkohl later recollected that he had

'called at Whistler's lodgings at half past eight. No doubt, he felt somewhat astonished at this early intrusion, but received me with the greatest bon-homie, invited me to make myself at home and promised to make all possible haste to comply with my wishes. Nevertheless he proceeded with the greatest deliberation to rise from his couch and put himself into shape for the street and prepare his breakfast, which consisted of a cup of strong coffee brewed in a steamtight French machine, which was then a novelty; and he also insisted upon treating me with a cup of coffee. We made no extra haste on our way to the office, which we reached about half past ten. . . . I did not repeat the experiment.'[15]

In December, Whistler was transferred to the engraving division, where Benham hoped he would find the work more interesting. This was a significant shift, for it introduced Whistler to a new art. Key witnessed his baptismal performance:

'I introduced him to the men in [the engraving] department. Mr McCoy, one of the best engravers in the office . . . went over the whole process with us – how to prepare the copper plate, how to put on the ground, and how to smoke dark, so that the lines made by the point could be plainly seen.

'For the first time since his entrance into the office, Whistler was intensely interested. . . . He seemed to realise that a new medium for the expression of his artistic sense was being put within his grasp. He listened attentively to McCoy's somewhat wordy explanations, asked a few questions, and squinted inquisitively through his half-closed eyes at the samples of work placed before him.

'Having been provided with a copper plate . . . and an etching-point, he started . . . his first experiment as an etcher. I watched him from the moment he began his work until he completed it, which took a day or two. At intervals, while doing the topographical view, he paused to sketch on the upper part of the plate, the vignette of 'Mrs Partington' and 'Ike', a soldier's head, a suggestion of a portrait of himself as a Spanish hidalgo, and other bits, which are the charm of the work.

'After he had finished etching, I watched him put the wax preparation around the plate, making a sort of reservoir to hold the acid, as McCoy had instructed. Then he poured the acid on the plate, and together we watched it bite and bubble about the line, as with a brush he carefully wiped the line to prevent the refuse accumulating and biting unequally. . . . Finally we went to the basement, where the printer washed the plate, and an impression was then taken on Whistler's first etching.'[16]

In the Engraving Division, Whistler was occupied with the coast of southern California. After completing two plates of the coast line near Santa Barbara, his interest began to waver. Clearly his career in the Engraving Division would not be long.

The early days of 1855 saw changes in the lives of both of Anna Whistler's sons. By 15 January, William had left Baltimore and resumed his studies, at Trinity College, Hartford, Connecticut, where he enrolled as a pre-medical student and joined Delta Psi, then Trinity's only fraternity. Soon after William had left for Hartford, Anna received a letter from James saying that he would leave the Survey. This letter has not survived, but Anna's reply dated 1 February suggests that his departure would not be entirely voluntary. After beginning, 'My own dear Butterfly!' – perhaps the earliest written linking of James Whistler and the insect with which his name would become associated – she wrote:

'Donald [a family friend in Washington] told me your apologies had been accepted at the Coast Survey office and that you would henceforth be punctual and faithful in attendance upon your duties there. . . . I cannot give you an idea how your foolish course is undermining my health, *my heart* cannot but be the repositor of hopes disappointed, of promises un-fulfilled. . . . You must not distress me by despising your present field of employment . . . persevere till your year is fulfilled. It will be impossible without ruin to our little stock that you go to Europe (as you seem to cherish hopes) and that Willie return to College which he is preparing by daily hard study to do. Only give me time to recover the losses I have sustained, by trying retrenchment, to start Willie and then put in your claim to my self denial.'[17]

She ended by mentioning the possibility of moving to Washington and asked, 'What think you?' From this letter we learn that James had apparently agreed to stay a year at the Coast Survey, that he was thinking of going to Europe to study art, and that Anna was again stretching the truth, for William, we have seen, had settled in Hartford more than two weeks earlier.

In her next letter, on 15 February, Anna told her son – with questionable veracity – that her stocks had devalued to the point that she was bankrupt. This news could not affect James's employment: three days earlier he had resigned from the Coast Survey.

Whistler spent only three months at the Survey, but they were valuable months, for it was then that he properly learned how to etch. His assigned etchings, naturally, did not embrace all of his Washington art work. One official at the Survey recalled that

'any odd moment he could snatch from his work he was busy in throwing off his impromptu compositions on the margins of his drawings or plates; odd characters such as monks, knights, beggars, seemed to be his favorites. He was equally skillful with pen and ink, pencil, brush and sepia . . . and often I was struck by the facility and rapidity with which he evolved his intentions – there never was the shadow of a dilemma or even hesitancy.'[18]

His colleague Key also remembered his 'clever, droll, or humorous sketches, made without effort on the margins of map failures, or on bits of paper, which he kept on his table'.[19] These drawings, Key noted, were not confined to paper: '. . . the wall along the stairs leading down to the superintendent's room was covered by Whistler with pencil-sketches of soldiers fencing, soldiers on parade, at rest, or in action and various little heads. He frequently stopped on his way up or down to correct or add to these drawings.'[20]

Whistler's drawings were memorable, as was his personality. 'I retain a more vivid recollection of his sojourn', said a fellow worker, 'than that of any other draftsman. . . . There was something peculiar about Whistler's person and actions quite at variance with the ordinary run of my experience.'[21] He was remembered partly for physical reasons: 'There was something striking in Whistler's appearance, I might say something fascinating, which was sure to attract attention anywhere. . . . His face of almost girlish beauty and the fairest complexion he carried somewhat after the rebellious style of Beethoven or Liszt.'[22] Lindenkohl recalled 'an elegant figure with an abundance of black curly hair, soft lustrous eyes, finely cut features, fair complexion, well shaped hands, and a graceful tournure. I thought him about the handsomest fellow I ever met.'[23] He

concluded that 'sensitiveness and animation appeared to be his predominating traits'.

Everyone considered Whistler friendly and likeable. Key could not 'remember ever seeing him ill-natured or in a bad temper' and 'never knew any one to say an unkind word of him'.[24] Key also remarked on another familiar trait: 'One of the draftsmen was then in the habit of taking long walks to sketch the woods and to fish in the streams near the city. I often went with him, and did my best to persuade Whistler to join us, but he could not be induced to make the exertion. He was the most indolent young man I have ever known. This was evident in social life, as well as in business relations.'[25] In Pomfret, in West Point, and now in Washington, Whistler cultivated the posture of indolence. When he joined the Engraving Division, he was hardly slothful when working on his first etchings. As time passed he grew not lazy but bored, and his disinclination to go on a rural excursion was due simply to his distaste for the country. The picture of James Whistler fishing in a country stream would be more droll than his most ludicrous caricature.

Key's statement that Whistler led an indolent social life is strange, for hyperactive social intercourse was probably a principal reason for his professional unpunctuality. 'It was amazing', he told the Pennels, 'how I was asked and went everywhere – to balls, to the Legations, to all that was going on.'[26] Here, unlike some of his other reminiscences, Whistler was speaking truthfully, for his assertion is supported by corroborative testimony. A functionary of the British legation, for example, remarked that in society 'Whistler was thought witty and paradoxically amusing'.[27] One celebrated incident involved an official of the Russian legation, probably the Minister himself. Kobbé, after talking to an American army officer who had been stationed in Washington, thus reported the episode:

'The Russian Minister had been very kind and polite to him, and, desiring to reciprocate, Whistler invited him to dinner. The invitation was accepted, and Whistler said he would call in a carriage at the appointed time, which he did. As they were driving off Whistler asked the Minister if he would object to stopping at a store on the way, to which the Minister replied that he would not. After stopping, Whistler returned to the carriage with several paper bundles and resumed his very interesting conversation. Presently he asked the Minister if he would mind stopping a moment at the market. This was acceded to, and more paper parcels were added to the collection.

'They then drove to a lodging house, and Whistler, taking his paper bundles conducted the Minister to a room in the attic, where he invited him to a seat in a comfortable chair in a cozy corner. Having requested

further permission, he pulled out a gas stove and the necessary saucepans, and cooked and served an excellent dinner, with an appropriate accompaniment of wines of approved vintage, coffee, and cigars. . . . At the conclusion of the affair he sent his guest home in a carriage.'[28]

Because it is difficult to conceive of even Whistler thus consorting with America's top Russian diplomat, some versions of the story identify the official as Edward de Stoeckl, chargé d'affaires at the legation, who, it has been alleged, was a friend from St Petersburg. Perhaps there was a de Stoeckl who knew the Whistlers in Russia, but his name appears nowhere in Anna's diary, and in any event Whistler's guest was probably indeed the Minister. The relevant Washington directory reveals that The Envoy Extraordinary and Minister Plenipotentiary of the Russian Empire was Alexander de Bodisco. Is it not likely that this gentleman was married to the 'beautiful American' of Chapter 2, who, Anna related, lived a life of luxury and attended the most glittering social events, but whose presence in St Petersburg was both temporary and unexplained. Mrs Bodisco behaved like a prominent diplomat's wife, and if she and her husband were now in Washington it would explain why a young apprentice draftsman was frequently present at exclusive social occasions.

Whistler's 'tout ensemble', an anonymous fellow worker said, 'had a strong tinge of Bohemianism which suggested that his tastes and habits had been acquired in Paris, or more concisely speaking, in the Quartier Latin'.[29] Although a Bohemian, Whistler, in Key's words, 'had no bad habit, and did not smoke'.[30] Billiard playing was not, according to Key, a bad habit, for he and Whistler often visited a billiard parlour, and Whistler usually lost. Congenial and outgoing, Whistler nevertheless, Key observed, did not cultivate 'any intimate friendships with those whom we met at the billiard-room or in his office'.[31] He was not a Bohemian out of the pages of Henri Murger. Indeed, contrary to what has often been said, nothing indicates that he was influenced by *Scènes de la vie de bohème*. Actually, although he surely knew of this well-known book, it is improbable that he ever read it. James Whistler did not need encouragement from Murger to become a Bohemian. Too independent to be thus influenced, he was perfectly competent to create his own life pattern. His conduct in Washington was a carry-over from West Point, but now he was not subject to effective external discipline.

After leaving the Survey, Whistler remained in Washington for a couple of months because he enjoyed the social life and wished to avoid his mother. He now did his first serious painting, a portrait of one Annie Denny, which long ago disappeared. Writing to her son early in April, Anna Whistler mentioned Thomas Winans's interest in this portrait, and

Winans invited James to return to Alexandroffsky: 'Bring on your *easel* and brushes and I will find you a face to paint here, that will ease your pocket and give you practice – and perhaps fame.'[32] Winans knew that 'fame' would stimulate Whistler, and as for easing his pocket, there is this journal entry: 'April 21. J. Whistler, $50.00.'

A few days later Whistler was in Baltimore. Although he had enjoyed himself in the nation's capital, he would never look back to it nostalgically. For various reasons he could not become attached to Washington. It was a small, rootless city; he worked at a dull job; and he had no close friends. Then there were other matters, rarely mentioned, which affected him. According to the leading specialist in this period of Washington's history, the late Constance McLaughlin Green, 'after 1850 vandalism, arson, prostitution, thievery, robbery, and assault worsened every year'[33] and shootings and stabbings became daily occurrences. Even worse for Whistler than the lawlessness was the treatment of black residents, which differed markedly from that of Baltimore. 'So passionate an abolitionist as Dr Gamaliel Bailey of the *National Era*', Constance Green remarked, 'believed Washington's record in handling race problems in the mid-50s better than that of many northern cities [and that] speech was as free here as in the North and toleration rather greater. As the editor who first published *Uncle Tom's Cabin*, he had reason to know.'[34] A year before Whistler arrived, Myrtilla Miner, a white woman from New York, established on New Hampshire Avenue a high school for black children, hitherto unthinkable for a Southern city. Her supporters included Harriet Beecher Stowe and her brother, the eloquent foe of slavery, Henry Ward Beecher. 'Miss Miner's work', Green said, 'made so wide an impression that in 1857 ex-Mayor Walter Lenox accused her of stirring up trouble by educating colored children beyond their station in life and giving them better schooling than white children could get.'[35]

Whistler was happy to return to Baltimore, where 'niggers' knew their place. He again lived in the Winans mansion, and now no one spoke of working on locomotives. Even Anna – who, the Winans journals reveals, was 'loaned' $500 on 17 May – realised that James was committed to art. His work at this time included his first lithograph, *The Standard Bearer*, done in collaboration with a noted Baltimore artist, Frank Mayor, and signed and dated July 17, 1855.

Soon after finishing the lithograph, Whistler began preparations for leaving the country, for then any American who wanted to become an artist, and could afford it, studied abroad, preferably in Paris. On 30 July James's half-brother George agreed to send him $350 a year,[36] and on the same day Thomas Winans wrote in his journal: 'Loaned Jas. A. Whistler 450.00. . . . George W. Whistler will settle it – Jimy Whistler left for New

York previous to his starting to Europe.' Among his parting presents was probably the book mentioned in Chapter 4, Charles Leslie's *Handbook for Young Painters*.

After a month in New York, James Whistler boarded the ship that would take him again across the ocean and to the start of a new life.

Chapter 7

PARIS, I
1855-9

On 10 October, Whistler reached London, and, he told his mother, he enjoyed his reunion with Deborah and Seymour, a man distinguished for 'looks and cleverness'.[1] He stayed with them until 2 November and then left for Paris in a first-class railway carriage. Upon arriving at the Gare de Boulogne (now the Gare du Nord), he did not have to tell the cabman where to go, for in this city of 1,200,000 there was only one section for a newly arrived student, the Latin Quarter, and, if decently dressed, only one specific destination. 'If a student have two hundred francs a month,' said an English resident of Paris, four years before Whistler had come, 'he lives probably in the Hotel Corneille.'[2] Everybody in the Latin Quarter knew the Corneille. In the *Paris Sketch Book*, Thackeray in 1840 advised students to 'cross the water forthwith, and proceed to the Hotel Corneille'; the Scottish artist Thomas Armstrong, Whistler's Parisian contemporary, recalled that 'most of the men I have known who studied in the Quartier Latin . . . had lived in it'[3]; and thirty years after Whistler's arrival an English guidebook advised 'all those who wish to examine the peculiarities or enjoy the pleasures of student-life, without hesitation, [to] adopt the Hotel Corneille as their head-quarters'.[4] And so Whistler began life in Paris at the shabby six-storey building alongside the Odéon, which Armstrong called 'dingy, mean-looking, and dirty, inside and out', whose residents were 'a noisy crew, singing and shouting to their friends below from open windows',[5] and whose only note of distinction was a bust of Corneille in the dining room.

Whistler arrived, deposited his luggage, and went out to enjoy Paris, which seemed to exist just for artists. Five days before he left London, the *Athenaeum* noted that in Paris 'art in some shape or another appears on all sides; it forms the principal occupation of a very large portion of the inhabitants, and a prominent source of pleasure to the remainder: the whole city is, in fact, one immense studio.' It constantly attracted painting pupils from everywhere: in 1855 Whistler's fellow immigrants included Degas, Camille Pissarro, and Frederick Leighton. They arrived in an exciting artistic year, the year of the Exposition Universelle – 5,000 works

by 2,000 artists, which the *Illustrated London News* called 'the most remarkable collection of paintings and sculpture ever brought within the walls of one building' – and the year when the two largest Salon galleries housed retrospective exhibitions of Ingres and Delacroix.

Ingres and Delacroix! 'All the young painters', the Goncourt brothers had written in their journal in the early forties, 'turn toward those two men whose names are the two cries of the war of art.' The war had slackened by 1855, but they were still, at least nominally, twin pillars of the French art world.

Ingres was *par excellence* the painter of classicism. 'Draw lines, young man,' he told the youthful Degas, 'and ever more lines. This is the only way to become a good artist.'[6] Ingres was the master of his lines, but most of his followers came to 'regard paintings merely as colored drawing',[7] and produced work that was dull and unimaginative.

Had there been no Ingres, there might have been no Delacroix, who replaced the lines of classicism with the colours of romanticism. Delacroix, capsulised, was 'a careless draughtsman, but prolific in invention, vigorous in conception, intensely dramatic, master of chiaroscuro and colour, and a determined enemy of conventionality and cold classic correctness'.[8]

Delacroix was a rebel, but only against Ingres and classicism. Neither he nor his followers were true revolutionaries; rather than beginning something new, they were, in their own eyes, returning to past greatness, to Veronese, Titian, and Rubens. Ingres and Delacroix each felt that he was carrying on and working within traditions and conventions which neither wished to upset; and while using different sources for subjects – Ingres and his followers relied on the classics whereas the romanticists turned to the Middle Ages and the Orient – both ignored the world of which they were a part.

In 1855, Ingres and Delacroix were France's 'grand old men' of painting, receiving homage at the Salon. Nobody honoured their followers, however, whose work was characterised by predictable mediocrity. The retrogression was a sign not just of the disciples' inferiority but also of contemporary conditions. 'In the 1850s', a pair of recent historians observed, 'one might as well ask for the moon as to be allowed to be oneself. Not that way were reputations made in the world of painting. All the successful men were successful in proportion to the degree in which they were able firmly to suppress originality and to give the public what it wanted.'[9] As Charles Baudelaire had lamented, the mid-fifties were dominated by 'the undisputed sway of the "neat" in painting – the pretty, the silly, the intricate – and also those pretentious daubs which, though representing a contrary excess, are no less odious to the eye of a true

amateur'.[10] A picture's most important attribute was its subject. Since a painting almost had to tell a story, 'the Salon painter was a narrator first and a painter second' and any Salon of the late forties and fifties would be crammed with 'imitations of every picture that had ever made a Salon success, warmed over and hopefully served up again.'[11]

In these dull days, French art was ripe for a genuinely revolutionary change. In 1845 Baudelaire prophesied the character of this change: 'the true painter will draw from everyday life and make us see and understand . . . how great and poetic we are in our ties and polished and high-buttoned boots.'[12] Ten years later, one month after Whistler had touched down in Paris, Fernand Desnoyers, writing in *l'Artiste*, spoke directly to the artists themselves: 'Do not write or paint anything except what is, or at least what we see, what we know, what we have lived.'[13] His article was entitled 'On Realism', and this was the magic word that embodied a meaningful alternative to classicism and romanticism. Soon after the appearance of Desnoyer's essay, Edmund Duranty founded a review called *Réalisme*, and in the initial issue he implored artists to 'create what you see!'[14]

Several talented artists had already concluded that their own world was visually interesting. Three names that spring to mind are Corot, Daumier, and Millet. Each depicted what he saw. Corot saw trees, fields, and animals; Daumier saw Parisian streets; Millet saw toiling peasants. All three broke with the past, but they did not pose a threat to the establishment. Corot was even praised by traditionalists, 'for he was a most imaginative artist with a strong poetic turn of thought.'[15] Daumier was not taken seriously by the authorities because he was only an illustrator. Millet was reprimanded for his commonplace subjects, but, quiet and unobtrusive, he was not subjected to a concentrated attack.

Corot, Daumier, and Millet were gentle realists who did not stir up waves in official waters. Very different was one of their contemporaries whose relationship to realism approximated that of Ingres and Delacroix to classicism and romanticism. His name was Gustave Courbet.

Courbet became notorious at the Salon of 1850-1 with his enormous depiction of a peasant burial ceremony, *Burial at Ornans*. One of his biographers related:

'No words could adequately describe the astonishment, the consternation, the alarm, the rage that greeted this imposing composition. The inner circle of aesthetic officialdom was thunderstruck. . . . The people . . . are real human beings untouched by the make-believe of conventional idealisation. . . . The result was a deafening uproar of protest. A typical entry . . . was that of the critic of the Journal des Débats who concluded

that "Never, perhaps, has the cult of ugliness been practised more frankly".'[16]

Courbet revelled in publicity and with succeeding pictures continued to shock the authorities. In 1856, Théophile Silvestre said that in six years Courbet 'had made more noise in the city than twenty celebrities would know how to'.[17] His noisiest outburst came in Whistler's first year in Paris.

When three of his dozen paintings sent to the 1855 Salon were rejected, Courbet angrily recalled them all and did what was then almost unheard of: he erected a pavilion, and with forty paintings and four drawings held a one-man show. An entrance sign proclaimed 'le Réalisme', and the catalogue declared that his artistic purpose was 'to translate the manners, the ideas, and the outward appearance of my age as I perceived them, in a word, to create living art'. Baudelaire and one or two other critics liked the show, but a more typical response was Eugène Loudun's: 'Courbet is trying to represent people . . . as ugly and coarse as he finds them. . . . There is nothing noble, pure, or moral, in the head that controls his hand.'[18]

Unsuccessful critically and financially, Courbet's show of 1855 was nevertheless significant for calling attention to the movement known as realism. What was Courbet's 'realism'? How did it differ from Ingres's classicism and Delacroix's romanticism? The dissimilarity was not in technique or style, but solely in the choice of subject. Courbet replaced classical and romantic subjects with those from contemporary life. The one tenet of his critical doctrine which set him apart from Ingres and Delacroix was that paintings should be faithful reproductions of what the painter had seen with his own eyes.

Since Courbet was neither the only nor the first realistic French painter, why was he alone scandalous, and why was his name most closely attached to the movement? One answer lies in the size of his pictures: huge, fully detailed paintings could hardly avoid attracting notice. Then there was Courbet's personality. Loud, vulgar, argumentative, egotistical, he liked to exasperate his adversaries, and thus was he motivated to hold his 1855 show with its provocative entrance placard and catalogue. Courbet's significance, however, went beyond sound and fury: more than anyone else he established the principle that a legitimate fountainhead for artists is contemporary life.

Although Courbet's influence was extensive, Parisian art teachers of 1855 seemed as oblivious of him as of Delacroix. French art education was rigidly governed by the principles of Ingres. The famed École des Beaux-Arts, on the Rue Bonaparte, was for advanced students; young

men and women received their initial training in those establishments which formed the foundation of French art education, the ateliers. Each atelier was supervised by an experienced painter, and while differences existed among them, they all prepared students for the École, and, teaching in the shadow of Ingres, they all emphasised drawing. Of the Parisian ateliers in the mid-fifties, the best known were those of Ary Scheffer, Thomas Couture, and Charles Gleyre.

Scheffer was a famous painter whose pictures fetched high prices. His atelier, in the Rue Chaptal, was the most rigid in stressing design over colours, and this alone would have discouraged Whistler from enrolling there.

Couture was renowned mainly for one picture, *The Decadence of the Romans*, painted in 1847 at the age of 30. His atelier on what is now the Rue Victor-Massé, was comparatively large, and in 1855 his students included a young man who had been with him since 1850, Edouard Manet. Less traditional than most teachers, Couture 'taught an entirely original method of painting which assumed the role of dogma', and his disciples became a 'cult . . . bound to their master through mutual admiration'.[19] Although he was the person who could best prepare pupils for the École, Whistler was too independent for his atelier.

With Scheffer and Couture ruled out, it was almost inevitable that Whistler would go to the Rue Vaugirard and the atelier presided over by the 49-year-old Swiss painter Charles Gleyre.

It has been conventional to speak condescendingly of Gleyre. He has been called pedantic and inflexible, and detractors have often cited Monet's recollection of an experience with him:

'. . . he sat down . . . and looked attentively at my production. Then he turned round and . . . said to me: "Not bad! not bad at all, but it is too much in the character of the model – you have before you a short thick-set man, you paint him as short and thick-set – he has enormous feet, you render them as they are. All that is very ugly. . . . Young man, when one draws a figure, one should always think of the antique." '[20]

One should remember that Monet stayed with Gleyre after this episode, and that his other pupils included Sisley, Renoir, and Bazille. An unyielding pedant could not have attracted and retained men like these.

Gleyre was in fact a good painter and a good teacher. As an artist it was said that he *'took as much care with his painting as an honourable man does with his conduct'.[21] He also was noted for his independence: one contemporary called him *'this painter of originality, who mouths no shibboleths, confines himself to no formula, refuses to join any school'.[22]

His independence kept him from becoming an Academician or a teacher at the École, and provoked a quarrel with the French establishment, because of which he had not exhibited in France since 1849.

Meticulousness and individualism also characterised Gleyre as a teacher. He was, to be sure, a classicist who adhered to Ingres's principles and accentuated drawing, but he was not intractable. He simply would not tolerate carelessness in drawing, nor in any other facet of a student's work. Although he considered it less important than drawing, he did not neglect colour. He had indeed devised his own way of fashioning a palette. He felt that a painter should prepare tones and harmonies before-hand; thus freed from this mechanical task, he or she could paint spontaneously. Whistler learned from Gleyre this method of forming a palette, which he never abandoned, just as he learned to use black as the basis for all tones. Another element of Gleyre's teaching has gone unnoticed by writers on Whistler. Albert Boime observed, 'He encouraged his pupils to sketch from memory and advised his pupils, after making studies of the live model in the atelier, to reproduce from memory at home.'[23] This instruction reinforced what Whistler had heard from Leslie.

As a teacher Gleyre was noted for leniency. Renoir, who acknowledged that 'under Gleyre I learnt my trade as a painter',[24] said that his master possessed 'little instinct for domination'[25] and 'had the merit of leaving his students alone'.[26] Gleyre actually, Renoir recounted, 'did not even have any preferences in subject matter and let his students paint what they wanted'.[27] Pupils often mentioned Gleyre's encouragement of originality. Charles Clement recalled that he repeatedly warned, 'do not draw on anyone's resources but your own'[28] and Frederick Bazille owned that 'if I ever achieve anything, I shall at least be able to boast that I have not copied anyone'.[29]

Gleyre's studio was more pleasant than many other ateliers. Nineteenth-century French art students were notoriously uncouth and rowdyish. The Italian artist Jean-François Raffaelli, who was in Paris slightly before Whistler, called them 'wretched fellows, most of them coarse and vulgar, [who] indulge in disgusting jokes [and] sing obscene songs. . . . And never, never . . . is there a discussion about art, never a noble word, never a lofty idea. Over and over again, this dirty and senseless humbug, always filth.'[30] A few years after Whistler's departure from Paris, one of his countrymen observed that French art students' conversation was 'brutal and disgusting . . . while their manners . . . are in keeping with their language'. A young American who 'refused to submit to their insulting demands [was] set upon en masse . . . and kicked in the face as well as the body, producing severe injuries'.[31] Nothing like this occurred at Gleyre's studio. When asked if there was hazing there, Whistler replied,

'Very little. If a man was a decent fellow, and would . . . take a little chaff, he had no trouble.'[32]

Gleyre's students worked in two rooms, one for the study of plaster casts and one for the live model. Usually they were alone, but twice a week the master called. Bazille, who entered the atelier in 1862, told his parents that on his visits Gleyre had 'a word with each pupil, correcting his drawing or painting. Every now and then he assigns the subject of a composition.'[33] In the novel *Trilby*, one of Whistler's fellow students, George Du Maurier, described the atelier, which he called 'Chez Carrel'. Among the pupils were

'graybeards who had been drawing and painting there for thirty years and more, and remembered other masters . . . younger men who were bound to make their mark, and . . . others as conspicuously singled out for failure. . . . Irresponsible boys, mere *rapins*, all laugh and chaff and mischief – *blague et bagout Parisien* [Parisian jokes and glibness]; little lords of misrule – wits, butts, bullies; the idle and industrious apprentice, the good and the bad, the clean and the dirty (especially the latter) – all more or less animated by a certain *esprit de corps*, and working very happily and genially together, on the whole, and always willing to help each other with sincere artistic counsel if it was asked for seriously.'

The English painter Val Prinsep, who worked at Gleyre's, agreed that the students 'were much as those Du Maurier describes'.[34]

Although influenced by Gleyre more than he would admit, Whistler was not faithful in attendance or prompt in completing assignments, and he became known as a fun-loving idler. 'In those days,' his English contemporary Joseph Rowley recalled, 'he did not work *hard*.'[35] Another English student, George Boughton, who reached Paris soon after Whistler had left, said he 'began to hear of the previous set of such students who "had lived the life" there . . . and among such names that of "Jimmie" was enthusiastically prominent – more for wild student pranks, however, than for any serious studies'.[36] Boughton heard mainly from other Englishmen, and it was Englishmen who created and spread the notion that in Paris Whistler played rather than worked. One of them, Du Maurier, popularised this idea with Joe Sibley, a character in *Trilby* based on Whistler. (Joe Sibley appears only in the first publication of *Trilby*, in *Harper's Magazine*. Because of Whistler's protests, his name and nationality were altered, and in the published volume he became 'Antony, a Swiss'.) Sibley was an 'idle apprentice, the king of bohemia' . . .

'Always in debt . . . vain, witty, and a most exquisite and original artist;

and also eccentric in his attire (though clean), so that people would stare at him as he walked along – which he admired! But he was genial, caressing, sympathetic, charming, the most irresistible friend in the world as long as his friendship lasted.'

Let us examine, for their relevance to Whistler, the components of Joe Sibley.

Whistler would have accepted the title 'king of bohemia'. Why, he might have asked, should one study in Paris without becoming a bohemian, and no other outsider more readily fitted into the life of the Latin Quarter. As Duret said, he 'adapted himself to it so completely that he had from the first been considered by his comrades as one of themselves, without his foreign origin being in any way remarked'.[37] Part of this easy adaptability came from his facility with the language, gained in St Petersburg, but mostly it was a matter of temperament. This young man who in England had insisted on travelling first class enthusiastically joined his French comrades in student restaurants where 'the lowness of the prices [was] almost alarming'.[38] The most popular was the Café Fucoteau, in the Rue de la Harpe, where, a contemporary diner remarked, 'from 4 to 6 p.m. more than 800 students take their meals [and] spend not more than 16 or 18 sous for each meal'.[39] The conformable James Whistler was as much in his element at Fucoteau's as on St Petersburg's Galernia or London's Sloane Street.

At Fucoteau's, Whistler's companions were usually male, but no Parisian bohemian lived with men alone.

Whistler's first inamorata was one of those uniquely Parisian creations, a grisette,

'so fair, so fresh, so young, so slim, so active, smiling, merry and easily-content . . . true, authentic, easy, careless, reckless, gladsome, frolic-some. . . . What would that beardless race, which forms the honour and glory of our colleges, be without her? . . . Not a young man who lives in Paris . . . but has won the heart of one of these pretty little Countesses of the Rue Vivienne.'[40]

Whistler's grisette, named Éloise but called 'Fumette', read poetry, and, known behind her back as 'La Tigresse', she was hot-tempered. Once, after neglecting her, Whistler returned to their lodgings and found his drawings transformed into small scraps of paper. He first wept and then, atypically, went out and got drunk. Before long, he and Fumette separated, and eventually she emigrated to Argentina.

Second to grisettes in the hearts of Parisian students were cancan

dancers, mainly those who performed at the Closerie des Lilas, sometimes called the Jardin Bullier, on the Boulevard Saint-Michel. Everyone in the Quarter went to the Closerie, and Whistler, after parting from Fumette, established a liaison with a dancer known as 'Finette'. She was more restrained and cultivated than her predecessor, but her tenure with Whistler was no longer. She also left Paris, going to London to dance for English audiences. (The illustrations in this volume include reproductions of etchings of Fumette and Finette.)

Although little is known of them, Fumette and Finette were the only Parisian women romantically linked with Whistler who can be identified. Luke Ionides, a young English friend, said that Fumette 'was desperately in love with Jimmy'[41] but he was not interested in forming an attachment with her or Finette. He was playing the game of bohemianism, and one rule stipulated that a player must have an affair with a grisette and a cancan dancer.

To return to Joe Sibley, he was 'always in debt'. Whistler was often in debt, but of how many students cannot this be said? And life in Paris, rarely cheap, was especially costly in the fifties. On 24 September 1856, a *Times* correspondent reported: 'Paris has became within the last three or four years one of the most expensive capitals of Europe. . . . The commonest necessities, bread, meat, and wine are exorbitantly dear, and as to house rent it is something fabulous.' In the summer of 1855, Frederick Leighton, looking for a studio, told his mother, 'I shall have great difficulty in finding one, and shall have to pay about 1500fr. per annum unfurnished.' A few days later, 'after great trouble and manifold inquiries,' he took *the only* studio that at all suited me, and for that I give unfurnished 150 francs a month'.[42]

For most of his stay in Paris Whistler had no studio of his own, and he never had one like Leighton's. Nor did he ever live in a domicile like that cited by *The Times* to illustrate high rents, a medium-sized third-floor flat on the Rue de Rivoli for 10,000 francs per year. He always resided in the Latin Quarter, but never for long in one place. After the Corneille his lodgings included Madame Lalouette's pension in the Rue Dauphine; a little hotel he enjoyed with Fumette in the Rue St Sulpice; a furnished room at 1, Rue Bourgon-le-Château, near St Germain des Près; a room at 2, Rue Campagne-Première; a sixth-floor room on an unnamed street which he shared with an impecunious art student named Ernest Delannoy; and the place where he was found by an American friend of his mother visiting Paris, 'in a little back street, up ten flights of stairs – a tiny room with brick floor, a cot bed, a chair on which were a basin and pitcher – and that was all!'[43] Whistler's guest reported that they 'sat on the cot, and talked as cheerfully as if in a palace'. Whistler was not disturbed by tem-

porary poverty. As a Frenchman said, *'If he had allowed himself to worry about how he would survive in Paris, he would never have crossed the ocean.'[44] He often showed his carefree attitude toward impoverishment, as when pawning his jacket on a hot summer afternoon to obtain money for an iced drink. When admonished for recklessness, he replied: 'But it is warm!'

One cause of Whistler's financial difficulties was his generosity. Ionides said, 'If he had money in his pockets, he spent it royally on others.'[45] Also, he knew that his indigence would never endure. The compact with George guaranteed an income, and at irregular intervals he received gifts from Thomas Winans. Also he occasionally dashed across the Channel to Sloane Street to see his sister and brother-in-law, and, probably, to get financial help. Whistler could afford to be indifferent to his 'poverty', which like a grisette and a cancan dancer, was required of a Parisian bohemian.

Harking back to Joe Sibley, he was 'eccentric in his attire, so that people would stare at him as he walked along – which he adored!' With some exceptions, such as Courbet, French artists and art students, contrary to popular belief, did not dress eccentrically. As a historian of the period said, 'by the 1840's and 1850's the artist was more intent on expressing his conflicts in a spiritual manner than on showing off by means of superficial eccentricities of dress'.[46] Whistler's physical appearance, however, was consciously conspicuous. Armstrong, for example, wrote:

'I have a most vivid recollection of my first sight of Whistler . . . for his appearance, at all times remarkable, was on that occasion most startling. . . . I remember the exact spot at the corner of the Odéon Theatre where I first caught sight of him. . . . It was in the warm weather of August or September, and he was clothed entirely in white duck (quite clean too!), and on his head he wore a straw hat of an American shape not yet well known in Europe, very low in the crown and stiff in the brim, bound with a black ribbon with long ends hanging down behind.'[47]

Like Du Maurier, Armstrong mentioned cleanliness, a matter of importance to Whistler. A French admirer remarked, *'the idea of elegance always haunted him. During his humble beginnings in Paris he washed his own clothes, but he always dressed impeccably.'[48]

Finally on Joe Sibley, he 'was genial, caressing, sympathetic, charming; the most irresistible friend in the world'. This judgement accords with virtually every evaluation of Whistler's personality. *'[He] was then', Henri Fantin-Latour recalled, 'quite happy and truly amiable; his vanity was good-natured. He would laugh about it himself.'[49]

Fantin-Latour and his countrymen understood Whistler better than did his English friends and acquaintances, who recognised his wit and amiability but were just as sure of his indolence. This raises the question of Whistler's relationship with the English in Paris, and the allied matter of the English life style, topics which have not often been discussed, but, in light of some of his later attitudes, should not be overlooked.

If only because of their common language, Whistler knew numerous Englishmen, four of them quite well: Armstrong, Du Maurier, Thomas Lamont, and Edward Poynter. He briefly shared living quarters with Lamont and Poynter, and he frequently visited the quartet in their studio at 33 Rue Notre Dame des Champs. Whistler saw them continually, and yet, Armstrong told Elizabeth Pennell, he 'was never wholly one of us'.[50] This is reminiscent of Captain Marlow's refrain in *Lord Jim*, 'he was one of us'. Because in an alien land he was a proper Englishman, Conrad's Jim received the recognition that could never be accorded the American Jim.

The English youths could no more accept Whistler to their bosom than they could the natives of Paris, from whom they remained aloof – even though Du Maurier was fluent in French and Poynter spoke the language well. Armstrong recollected their happiest evenings, when 'we made a descent into the middle of Paris and treated ourselves to British food and drink at a little place in the Rue Royale . . . where the roast-beef and mutton, the boiled potatoes, and the beer and gin, were excellent and cheap. . . . Here we had very jovial evenings.'[51] Need one ask what Whistler would think of a jovial evening with roast mutton and boiled potatoes? This seeking out of an English restaurant – in Paris, of all places – illustrates not only English aloofness but also English insularity and the all-too-often English disinclination to adapt to other people's ways of doing things. In an English restaurant one could be certain that a separate knife would be provided for butter and that, above all, no one's hands would touch the food, for the English obsessiveness about handling food was as prevalent then as now. 'We were none of us real Bohemians,' admitted Armstrong, 'for we had those behind us in England who would have come to our help if we had been in dire necessity.'[52] Whistler also was bolstered by well-heeled people, but this did not prevent him from plunging into the life of the natives. The English inability to adjust to life in the Latin Quarter was due not to their money but to an inherent national deficiency. 'English people are too serious and always take everything to heart,' reported a nineteenth-century American in England. 'Their ways of living, their thoughts and general habits, nay, even their manner of dressing, are thoroughly peculiar to them. It is not that they take their pleasures sadly . . . but it is that even in the midst of pleasure their natural taciturnity does not leave them and even pleasure

will be taken from a practical, analytical philosophical point of view.'[53] Instead of taking pleasures as he did, *à la parisienne*, Whistler's English friends spent their leisure hours exercising. Late in the afternoon they lifted weights, boxed, fenced, and practised gymnastics. Whistler, Armstrong reported, 'would laugh at us and say . . . "Why the devil can't you fellows get your concierge to do that sort of thing for you ?" '[54]

If Whistler was baffled by their exercises, they could not understand his behaviour: frequenting dance-halls, living with grisettes, and cultivating 'no-shirt' friends, so called because they were allegedly too poor to own a shirt. How, they wondered, could he be serious about art? Artistically as well as socially, they were conventional and circumspect. 'They sincerely believed,' Du Maurier's principal biographer, an Englishwoman, observed, 'that all that was necessary to become a good artist was the requisite number of attendances at the atelier, complemented by work of their own along the same lines. . . . They were in Paris to learn the craft of painting, rather than to question its basic principles.'[55] From their point of view, Whistler's absences from his atelier and his failure to carry out the master's assignments proved that he was not an earnest student.

One may strikingly contrast Whistler with his British counterparts by following Du Maurier's precedent and setting him against Edward Poynter. In *Trilby*, Poynter was Lorrimer, the 'industrious apprentice', introduced immediately after Joe Sibley, the 'idle apprentice'. A man 'of precocious culture, who read improving books, and did not share in the amusements of the Quartier Latin', Lorrimer 'spent his evenings at home with Handel, Michael Angelo, and Dante. Also he went into good society sometimes, with a dress-coat on, and a white tie, and his hair parted in the middle!' As for Poynter himself, a contemporary remembered that in his student days he was 'diligent in attendance, faultless in discipline, eager and painstaking in following the instructions given'.[56] For Poynter there was no short cut to success. To be an artist, one had to work, work, work.

Although they once shared a room, could Edward Poynter understand James Whistler? At the banquet preceding the first Royal Academy Exhibition after Whistler's death, in 1904, Poynter, then President of the Academy, said of him, 'I knew him well when he was a student in Paris – that is, if he could be called a student who during the two or three years when I was associated with him, devoted hardly as many weeks to study. His genius, however, found its way in spite of an excess of natural indolence of disposition and love of pleasure.' This is Whistler the art student according to the Gospel of Edward Poynter. Having focused our sights on his personal activities, let us now determine whether indeed Poynter 'knew him well' by examining the artistic side of James Whistler's student days in Paris.

Chapter 8

PARIS, II
1855-9

If diligence is measured by obedience to prescribed procedures, Whistler's British friends rightly charged him with indolence. He did not regularly report to Gleyre's, he did not always follow directives, and eventually he stopped attending altogether. But this hardly made him unique. 'After mid-century,' Boime noted, 'independent artists who attended Academic ateliers stayed on long enough to learn their métier, and then they left to pursue their careers through other . . . procedures [because] spontaneity and originality took the ascendance over thoroughness and perfection.'[1] The rigid instruction at the ateliers, even at a comparatively lenient one like Gleyre's, could easily lead an independent-minded student to rebel. After all, ateliers prepared pupils for the École, which, because it 'turned out conformist painters by the dozen',[2] necessarily stifled individuality.

Whistler's departure from Gleyre's, then, was not extraordinary. Actually, in Paris it was recognised that art students needed to work alone, for which there existed on the Île de la Cité the Atelier Suisse. Established by a former model named Suisse, it was a large studio where for a small fee anyone could paint or draw a living model without instruction or guidance. One could compile a Who's Who in French Painting from those who used the Atelier Suisse: Ingres, Delacroix, Courbet, Manet, Monet, Pissarro, and Cézanne. One artist, however, who never worked there was James Whistler, who, it seems, was too individualistic to be part of any group, even an informal one. Then, too, he agreed with Alfred Stevens that 'cramped studios produce cramped work'.[3] His real studio could not be less cramped: it was the world in which he lived.

The streets where he walked, the restaurants where he ate, the ballrooms where he danced – they were his studio. For him play and work were inextricably joined because play was work, and work was play. The perceptive Stevens knew, what Poynter and his friends could not understand, that 'an artist is always at work, even when he is doing nothing'.[4]

Whistler had become part of the realistic movement, the 'new school', in the words of *l'Artiste*'s reviewer of the 1848 Salon, 'composed of young people whose lives are lived outside the studio'.[5] Interestingly, long before Courbet gained notoriety an adherent of this doctrine was Charles Gleyre, who, a biographer noted, *'when in Rome spent most of his time looking around and dreaming'.[6] Later he 'advised Renoir and Monet to work outside the studio in order to make serious progress'.[7] Perhaps he spoke similarly to Whistler.

While zealously guarding his independence and individuality, Whistler appreciated the work of other artists, past and present. 'Respect for the great traditions of art', the Pennells said, 'always remained his standards: "What is not worthy of the Louvre is not art," he said again and again.'[8] And not only in the Louvre did he see fine paintings. In 1857 the city of Manchester organised an 'Exhibition of Art Treasures' whose *pièce de résistance,* gathered from all over Britain, was a collection of about 900 paintings by old masters and a similar number by modern artists. Whistler visited this exhibition, and to finance his trip he audaciously approached a man to whom he was already in debt. Armstrong recalled, 'I enquired if he had repaid the eighty francs the gentleman had lent him not long ago. "Well, no," replied Jimmy, "I haven't, but I don't think he expected it. Anyway, I'll go to see him and explain, and I'll ask him if he thinks I ought to ask him to lend me this money for the Manchester journey." '[9] Naturally he got the money.

Properly impressed in Manchester, Whistler returned to Paris where only a river separated him from the world's greatest permanent collection of art. For painters and painting students, the Louvre was not a museum: it was an integral part of their lives. At the Louvre, John Rewald remarked, they could 'choose their own masters, could erase the traces of their one-sided education and find in the works of the past a guidance congenial to their own taste', and it 'became a healthy counterbalance to the instruction at the *École*.'[10] Even Courbet said that at the Louvre he had 'studied the art of the old masters and of the modern'.[11] Stevens, in his own way as independent as Courbet, agreed that 'the great masters in the Louvre must be studied and understood' but warned that 'the painter must never seek to *imitate* them'.[12]

This last admonition applies to a practice which in Whistler's day had been traditional for two centuries. *'Everyone copied at the Louvre', said Léonce Bénédite, 'in order to penetrate masterpieces, analyze them, understand them, or simply to pour out one's admiration.'[13] Except for Monet and Sisley, the copyists included all the artists who would be called Impressionists, and, from time to time, James Whistler.

His contemporaries remembered Whistler copying Ingres's *Angelica,*

Boucher's *Diane at the Bath,* Couture's *Decadence of the Romans,* and Veronese's *Marriage Feast at Cana.* Only once, however, did he officially request permission from the authorities to copy a painting, an action unmentioned by previous writers on Whistler. The Register of Copyists in the Louvre archives reveals that on 28 February 1857 he sought leave to copy Pierre Mignard's *La Vierge à la Grappe,* a Raphaelesque picture of a Virgin holding a cluster of grapes from which the child in her lap helps himself. Whistler presumably had a special interest in this work, but his unofficial copying was done mainly for money. When Armstrong noted that his *Angelica* 'was not a bit like that of Ingres, for it was done in a thin, transparent manner, with no impasto and hardly enough paint to cover the canvas', and reproached Whistler for stinting on paint, 'he replied that the price he was to be paid would not run to much more than good linseed oil for he was to have only 100 francs apiece for the copies'.[14]

Whistler did not especially enjoy copying, but it was not irksome and was sometimes a lark. A French acquaintance, Henri Oulevey, recalled that once he 'helped himself to a box of colors, and, when discovered by its owner, was all innocence and surprise and apology: why, he supposed of course, the boxes of color were there for the benefit of the students.'[15] There were other amusing episodes involving Whistler in the Louvre, but they were less important than an apparently commonplace occurrence in the autumn of 1858, meeting Henri Fantin-Latour.

Born in Grenoble in 1836, Fantin-Latour had lived since 1841 in Paris; at the age of 15 he entered the studio of Lecoq de Boisbaudran and two years later enrolled in the École des Beaux-Arts. He was a familiar sight in the Louvre, *'almost as well known', Bénédite remarked, 'for his copies as for his own pictures'.[16] The Register of Copyists lists more than a dozen pictures, by almost as many painters, for which Fantin gained permission to copy, and informally he sketched many others. When Renoir was a beginner at Gleyre's, Fantin told him, 'The Louvre! there is only the Louvre! You can never copy the masters enough.'[17]

Although Fantin was 'a shy reserved man [who] did not easily make friends and dreaded seeing new faces',[18] he was captivated by Whistler. After speaking with Fantin, Bénédite described their first encounter:

*'For some time he had been noticing a young man, dressed rather eccentrically, whose alert head was adorned by hair that was beautifully long and curly and covered by a large hat, who would wander about in the halls. Fantin did not like him much. Then one fine day the young man in the large hat casually stopped behind Fantin's stool and eagerly admired the copy. They talked and argued, acquaintance was quickly made, and the two young men soon became the best of friends.'[19]

Their relationship, begun that afternoon, Fantin later told Joseph Pennell, was *'continued that evening at the Café Molière'.[20]

As everyone knows, nothing more typifies Paris than its cafés, as ubiquitous in the 1850s as today. Among those frequented by artists were the Taranne, the Fleurus, the Brasserie des Martyrs, the Brasserie Andler, and the Molière, and their democratic character permitted Whistler to mingle freely with his artistic superiors. Before and after meeting Fantin, he encountered various current or future luminaries in the French art world. Three are worth special mention.

Félix Bracquemond was only a year older than Whistler, but, like Fantin, a much more experienced artist. Outgoing and gregarious, he talked to whoever would listen. His current enthusiasm, and recent discovery, was Japanese art. He expatiated at length on the subject, and Whistler would remember what he had heard.

The young Belgian Alfred Stevens was already the premier painter of Parisienne, the refined, graceful life of French society, but he was no ordinary genre painter. He wrote, 'In painting, the subject is of minor importance. A picture should need no explanation.'[21] For Stevens the subject was only a means to draw out that which was of primary importance, the colour harmonies. Like Bracquemond, he planted seeds in Whistler that in due time would blossom forth.

Bracquemond and Stevens influenced Whistler, but the man who had the greatest sway over him was Gustave Courbet.

Much has been said of Courbet's artistic influence on Whistler, but the elder man's personal effect on the younger has gone largely unnoticed. This topic deserves more than a perfunctory glance, for perhaps without Courbet we would never have had, in the form in which he appeared, the later legendary Whistler.

For ten years Courbet had lived and painted in the Quarter, at 32 Rue Hautefeuille, and his favourite haunt, two doors away, was the Brasserie Andler, where he was cock of the roost. (Sometimes he crossed the river and held forth at the Brasserie des Martyrs, in Montmartre.) Although Whistler never spoke of Courbet's Brasserie performances, understandably if he received therefrom the pattern for his own conduct, he certainly saw the master in action. Since Courbet's behaviour was consistent through the years, recollections of others provide an accurate picture of what Whistler observed.

Courbet 'enjoyed "showing off" in public, and when he had an audience he would talk, laugh, and sing.'[22] Like the later Whistler, he had *'a resounding laugh, as he filled the Parisian bar-rooms with his quips and sallies'.[23] Although jovial, he also had a temper that was 'likely to explode at slight provocation' and 'he could not tolerate or even admit the

existence of a living rival in his own field'.[24] An acquaintance of Courbet, writing less than fifteen years after Whistler had left Paris, recalled one of his earlier utterances, which was well known in the Quarter: '"There," said the master of Ornans, "there's a work of *your* Velasquez," and placing one of his compositions beside the old canvas, cried triumphantly, "Eh bien, doesn't that beat all the Velasquez in the world?"'[25] Could this have been the origin of a famous Whistler witticism?

Courbet was one of the most boastful figures in the history of art. A fine contemporary biographer declared that *'the soul of Narcissus has chosen his being to sojourn in his latest transmigration through the ages. ... No one is capable of offering him a tenth the compliments which he addresses daily, morning and evening, to himself.'[26] Anyone who disagreed with him would be demolished with ridicule: *'Courbet cared not a hoot for the Beautiful! If some stray aesthetician had pronounced this word before him, he would have been met with one of those extraordinary fits of laughter, causing, for at least three minutes, the windows of the brasserie to shake.'[27]

Because of what it reveals and foreshadows, the report of one colourful incident might be worth reproducing:

*'One day I witnessed a scene where Courbet's vanity displayed itself with a candor that was truly amusing. It was in 1861, the year in which the painter Lambron, a pupil of Flandrin [!], had just exhibited his *Undertaker's Mutes*, then causing quite an uproar.

'In a café near the Luxembourg . . . I saw a heavy, stout man enter, respectfully followed by a callow and almost beardless youth. They were in the midst of a conversation.

'"Monsieur Courbet," the young man said, "permit me to offer you a beer."

'"A beer? Willingly, my boy."

'They sat at a table which was near mine. Courbet asked for his pipe and settled down comfortably. He rested his body on one chair, which groaned painfully, his soft hat on another, and his legs on yet a third. The beer was brought to them, and the conversation continued. . . .

'"Have you seen Lambron's picture, Monsieur Courbet?" asked the young man.

'"Who is that, 'Rambron'? Who is that? You say?"

'"Lambron, Monsieur Courbet."

'"Oh, well, yes, 'Mambron'. Don't know him.† Oh! wait a minute. You mean that pretentious ass, right?"

† Courbet's contempt comes out powerfully in the French when he insistently refers to Lambron as a 'ça', that is, a neuter object, a mere thing.

'"Yes. How do you find that 'pretentious ass', Monsieur Courbet?"

'"Why, he stinks, my boy. He doesn't exist. One doesn't speak about *that*. That's nothing but a blockhead, nothing but filth, pure shit."

'"Nevertheless, Monsieur Courbet, there are those who believe that he is your pupil."

'"The idiots! . . . What can you expect France to become with such ignorant louts as these?"

'"It is certain, Monsieur Courbet," said the neophyte in a tone of obsequiousness, "that he doesn't have your skill or knack, your dash, your . . ."

'"It's not only that, my boy. Look here, the difference between this 'Gambron' and myself. Do you really want to know, in plain words, what it is?"

'He swaggered self-importantly in his chair, which gave out repeated squeals. . . .

'"The difference is simply that that animal has nothing in his belly, while I have something in mine: that's all there is to it."

'"Yes, yes, and then everyone can see well enough that he has not a single idea on art, while you . . ."

'"It's got nothing to do with ideas or theories. That's nothing but hogwash. Your 'Lampron' has nothing in his belly, while I have something in mine. That's all. . . . Look here, let's suppose an imaginary situation, to make you see what I mean. Let them throw me into prison and tell me, 'My boy, you won't get out of here till you have created the *Captive* of Michelangelo.' I would answer, 'Give me a mallet, a chisel, and a piece of marble, and I'll eat my hat if it doesn't come out better than the one in the Louvre.' Why?"

'"Why, Monsieur Courbet?"

'"Because I have something in my stomach! That's all there is to it."

'The young tyro listened, overwhelmed with admiration.'[28]

The narrator concluded by remarking, *'Echoes from the Café Fleurus, from the brasserie on the Rue des Martyrs, as well as the house of Andler could repeat many a conversation of this sort.'[29] Had he not wished to appropriate them for his own use, several such scenes could probably have been reconstructed by James Whistler.

Whistler's relationship with Courbet was one-sided, and his acquaintance with Bracquemond and Stevens was slight and superficial. Very different was his alliance with Fantin-Latour.

A shy, introverted person, for whom, Elizabeth Pennell said, 'a monastic cell would have been the appropriate background',[30] does not sound like a potential intimate of James Whistler. Yet they developed a sincere,

meaningful friendship which for Whistler was unparalleled and for each of them was beneficial. Whistler learned about art from Fantin, who in turn gained reassurance and sound advice. Contrary to popular opinion, Whistler could be generous with compliments. As a later friend said, 'He knew how to comfort, not by flattery, but by encouragement.'[31]

When he met Whistler, Fantin's only close friend was a poverty-stricken art student from Burgundy, Alphonse Legros. On that memorable evening at the Café Molière, Fantin introduced Whistler to Legros, and an instant *rapport* was established among the trio, who soon called themselves a 'Society of Three'. This was not a formal organisation, not a miniature Pre-Raphaelite Brotherhood. Mrs Pennell said, 'No special bond held them together, no definite formula of faith. . . . They were innocent of mission or doctrine, their comradeship based solely upon their respect for tradition and desire for each to do the best that was in him in his own way.'[32] She implied that as Frenchmen Whistler's new friends could better comprehend him than could his English comrades: 'Fantin and Legros appreciated Whistler from the start, loved his gaiety, admired his work. Because he was the gayest of men most people refused to believe that he was the most serious of artists. These two friends could understand his combination of gaiety and seriousness.'[33]

It is not quite true that they were 'innocent of doctrine'. Fantin and Legros were ardent disciples of Lecoq de Boisbaudran, a teacher noted for his emphasis on cultivating one's memory, and they surely discussed his ideas with Whistler, who almost certainly read Boisbaudran's booklet of 1847, *The Training of the Memory in Art*. Since this 'memory method' was to be employed by Whistler on some of his most famous paintings, it might be pertinent to note some of the points raised by Boisbaudran, keeping in mind that Whistler had already heard of memory-painting from Leslie and, probably, Gleyre.

By memory Boisbaudran meant not something unthinking and rote-like, but what he called 'stored observation', to supplement, not supplant, intelligence. Cultivating one's memory is not a clever trick; it is an essential adjunct of painting, without which 'innumerable subjects are entirely beyond us. How else can animals, clouds, water, rapid movement, expression or passing effects of colour be recorded?'[34] Students with a well-developed memory, Boisbaudran observed, 'became more exact and intelligent in their ordinary work from the model'[35] and 'were able to draw for a longer time, without the least loss of accuracy, before they needed to look at it again, which proves that their impression was better observed and was retained for a longer space of time'.[36]

In perhaps his most important passage, Boisbaudran emphasised that no conflict should arise between memory and imagination, which

'are so closely linked that imagination can only use what memory has to offer her. . . . How much more productive then must the imagination be when nourished by a cultivated memory, for it has at its service a store of material richer both in quantity and in variety, yet absolutely precise. We may be sure then that memory training is a great stimulus to artistic creation by ministering to and reinforcing the imagination.'[37]

With his two friends, Whistler trained his memory in streets and cafés, and he would never forget the ideas of Boisbaudran.

Fantin and Legros were intolerant of indolence, and their acceptance of Whistler as a colleague should demolish the notion that he was a loafer. The best argument, however, against the 'idle apprentice' theory lies in Whistler's work in Paris.

Like many art students, he usually carried a drawing pad, upon which he depicted various aspects of Parisian life. Four typical drawings were auctioned at Sotheby's on 15 December 1971, realistic sketches of persons who could be seen at any time on almost any street of the Latin Quarter. These drawings, neither remarkable nor unusual, are what might have been expected from an advanced student. The same cannot be said of Whistler's work in another medium.

Whistler reached Paris in the midst of a revival of etching. Dormant since Rembrandt's death, the art captured the interest of Delacroix, Daubigny, Corot, Millet, and the man principally responsible for its rejuvenation, Charles Meryon. In 1846, after a ten-year naval career, Meryon began studying art, and because he was colour-blind he turned to etching. Between 1850 and 1854 he created his masterpiece, *Les Eaux-fortes sur Paris*, a series of superb views of the streets, bridges, quays, and, above all, the buildings of Paris. These etchings, aptly called 'the greatest . . . since Rembrandt's',[38] gained their creator little remuneration, for even at a price of one franc apiece few were sold. Meryon lived in penniless obscurity, and in 1858 he entered a mental institution where he remained until his death ten years later.

Although he was personally unrewarded, Meryon's work was not unrecognised, and herein was his legacy. Discriminating artists saw and admired his prints and realised what could be achieved in this neglected medium. Despite assertions to the contrary, Whistler, like the others, was influenced by Meryon. Twenty years later, indeed, he would do in Venice what Meryon had executed in Paris. Even if he had not been personally affected, Whistler was indebted to Meryon for helping to resurrect a medium admirably suited to a person of his own temperament and talents.

For several reasons Whistler was attracted to etching, not least of which was its comparative freedom. The etcher, one commentator noted,

'must be a law unto himself. Only under that condition can he get any result which is worth while.'[39] Because of its freedom, etching is 'the most intimate, the most personal of all mediums of pictorial art',[40] permitting, indeed compelling, the practitioner to be selective and suggestive, and thus has it been called 'the art of all others which permits an artist to be recognized by what he omits'.[41] Etching was ready-made for an independent, freedom-loving youth, who, moreover, had been trained in its techniques.

In 1857 Whistler returned to the art from which he had been absent for two years, and, Armstrong reported, tried to convert his British friends and

'suggested that we should all get plates and try our hands. It was decided that each should choose his own subject, and that prints should be sent to some literary person in England and he should build from them a story for publication to be called "Plawd", a word composed of the first letters of our names – Poynter, Lamont, Armstrong, Whistler and Du Maurier.'[42]

Whistler, Poynter, and Du Maurier completed their work, but Armstrong and Lamont did nothing, and the scheme was abandoned. The two etchings of Poynter and Du Maurier comprise everything done in this medium by the gaggle of industrious Britishers during their entire sojourn in Paris. What about the 'idle apprentice'? As an etcher what did he do beyond contributing to the abortive project? If we look at the record, it will show what his French friends knew, that, in the words of the Pennells, 'he worked as prodigiously as he played'.[43]

For a time during 1857–8 Whistler rented a small studio in the Rue Campagne-Première, where he had a hand press and pulled his own prints, hardly the conduct of an idler. Unlike Meryon's, most of these etchings present human beings, usually friends and acquaintances, ranging from Fumette and Finette to Bibi Lalouette, the young son of the proprietor of Lalouette's Restaurant, a favourite with students. The picture of Bibi is a delightful depiction of childhood, and the several representations of Fumette and Finette notably demonstrate the effectiveness of the Whistlerian combination of work and play. Of his principal picture of Finette (reproduced in this volume), standing before a window, it has been said that 'in the whole range of modern art you will not find such a Parisian type of the late fifties more truthfully or more interestingly portrayed'.[44]

Whistler created what Duret called *'a painter's etchings', with 'that liberty of allure, that unexpectedness which is found only in the products of artists who handle the etching needle and the paint brush with equal ease, and indifferently use all means to produce their vision'.[45] Painters

appreciated his work, he discovered in the Café Molière, when, Fantin later recalled, '*he showed his first etchings, and got his first admirers'.[46] Several of the etchings resulted from the most comical episode in the life of young Whistler.

Late in the summer of 1858 Whistler was invited by a friend from Gleyre's to visit the Alsatian town of Saverne, and since he happened to have money in his pocket he accepted the invitation and persuaded the young French artist Ernest Delannoy to accompany him on a journey that would include Saverne as one stop. They travelled by train to Nancy, Lunéville, Saverne, and Strasbourg, and by Rhine boat to Cologne, where they discovered they had spent their money. 'What shall we do?' asked Delannoy after their first night in Cologne. 'Order breakfast,' Whistler replied. The only American consular official in Cologne was away on holiday, and no one else was available for help, and so they wrote to various people who might provide relief and waited for what they were sure would be a prompt answer. The Pennells reported:

'Every day they would go to the post office for letters, every day the officials would say "*Nichts! Nichts!*" until they got to be known in town – Whistler with long hair, Ernest with a brown holland suit and a straw hat now fearfully out of season. The boys of the town would be in wait and follow them to the post office where, hardly were they at the door, before the official was shaking his head and saying "*Nichts! Nichts!*"'[47]

After waiting for ten days,

'Whistler took his knapsack, put his plates in it and carried it to his land-lord. . . . He said he was penniless, but here were his copper plates in the knapsack on which he had set his seal. What was to be done with the copper plates, the landlord asked. They were to be kept with care, Whistler answered, and when back in Paris he would send money to pay the bill and the landlord would send his knapsack. Schmitz [the landlord] hesitated, while Whistler and Ernest were in despair over trusting such masterpieces to him. A bargain was struck after much talk. The landlord gave them a last breakfast. Lina, the maid, slipped her last groschen into Whistler's hand, and the two set out from Cologne, with paper and pencils for baggage.'[48]

The foot journey, Armstrong recalled, 'was made memorable . . . by the inimitable way in which Whistler related their adventures. There never was such a raconteur, I verily believe.'[49] He did not soon tire of the tale, for George Meredith, whom he first saw nearly three years later,

called Whistler's account of the trip 'impayable' (priceless).[50] A letter to Deborah written upon arriving in Paris may convey some idea of how the story sounded. Whistler said that when he saw her he would recount

'how the first night I made a portrait in pencil . . . for a plate of soup . . . how I remembered the Good Samaritan and the pouring of oil on wounds, how I went thro' agonies and accepted gratefully a piece of chandelle from a kindhearted comb-maker . . . how we walked 22 miles in one day, and then I was unable to move out of the way of a mob of hooting Prussian children such as the Prophet Elijah would certainly have set all the wolves in his power upon . . . how for a *glass of milk* had to make the portrait of one of my tormentors – the ugly son of the woman who took our *only two groschen* for a bed which she made with an armful of straws, and for the pillow a chair overturned, which was violently withdrawn the next morning at dawn, so that the consequent bump of the head on the ground might awaken us . . . how for another portrait, we had a piece of black bread and an egg, the white of which went to heal my bruised feet . . . how sunnier moments were also on our road – how we came upon a fair – how I there made a portrait of "butchers, bakers, candlestickmakers!" – for five groschen a piece – that is a little more than fourpence ! !'[51]

These sketches illustrate Whistler's artistic integrity, for, he said, 'I did my best – and each one of the eighteen portraits was a drawing such as Seymour would have been pleased to come from my hand.' Whistler and his friend received a loan from the American consul at Aix-la-Chapelle and the French consul at Liège, from which town they rode to Paris, arriving at four in the morning.

Whistler ended by saying, 'We have clear consciences and can hold up our heads, for during this extraordinary journey we have worked very hard – have made more progress than we could have made otherwise in three times the number of months.' Herein lies the significance of the Alsatian trip: it led to Whistler's first published work of art and established him as a man of real talent.

The response at the Café Molière to his work and the ensuing encouragement from Fantin and Legros stimulated Whistler to go to the Rue de la Huchette and approach the noted printer of etchings who had collaborated with Meryon, August Delâtre. Delâtre liked what he saw, and the result was *Twelve Etchings from Nature* – a baker's dozen including the frontispiece – generally called *The French Set*.

These etchings are not really a set since nothing ties them together except their common stimulus, 'nature'. They were not even all created in France: *Annie* and *Little Arthur*, portraits of Whistler's niece and

nephew, were etched on a visit to London. Five of the others are Parisian, and five plus the frontispiece came from the journey. The catholicity of the group attests to Whistler's breadth of vision. The subjects include children (in addition to the London etchings, the frontispiece shows Delannoy surrounded by Alsatian youngsters); a sensitive portrait of his first mistress, seen from the front, sitting and bending forward (*Fumette*, not to be confused with *Fumette Standing*, shown in this volume); an impecunious old woman in the doorway of her shop (*La Vieille aux Loques*); a young woman sitting under a parasol (*En Plein Soleil*); a farm-yard in Lorraine (*Liverdun*). Then there are the three chosen for inclusion in this book. They depict a dilapidated farmhouse (*The Unsafe Tenement*); a narrow, lamp-lit street, Whistler's first nocturnal scene (*Street in Saverne*); and the *chef d'œuvre*, a splendid combination of realism and suggestiveness, whose blending of light and shade is inevitably reminiscent of the Dutch masters, *The Kitchen*.

No one could have been more excited about *The French Set*, and more helpful to Whistler, than Seymour Haden. He went to Paris to see it and managed its publication in London. Whistler showed his appreciation by dedicating the work 'A mon vieil ami Seymour Haden'. To meet publishing costs, fifty copies, at two guineas each, had to be sold, and Haden guaranteed twenty-five subscribers. As for the others, Whistler looked westward to his mother.

During his absence from home, James did not write regularly, or even frequently, to his mother, who on 7 May 1858 noted that while Deborah wrote every fortnight, three months had passed since she had heard from her elder son.[52] Fortunately she had a devoted second son. After a year and a half at Trinity College, William left in May 1857 without a degree, and began an informal medical apprenticeship under Dr James Darrach in Philadelphia, in whose home mother and son lived together. After a year with Dr Darrach, William was ready to start his formal professional education. The *Medical Matriculation Book 1850–1861* of the University of Pennsylvania lists the names of those who became students during these years, and this is one entry:

> '1858, October 5th. William Whistler
> Town: Philadelphia. State: Pennsylvania
> Preceptor: J. Darrach
> Number of Course: 2d'

The last line indicates that William enrolled as a second-year student, his advanced standing coming from his apprenticeship and a high score on the entrance examination.

William was a diligent student, and he also took good care of his mother, who continued to live with him. Anna's dependence often emerges from her correspondence. On 17 October 1858, for example, suffering from defective vision, she wrote to her friend James Gamble:

'If my Willie were here as he usually is on Sunday, at my side, he would be my eyes in devotional reading. . . . But the medical course of lectures and study keep Willie so confined he needs country air, and, among so exemplary companions of his own age, to relax his mind and invigorate his frame. He was sorry at leaving me alone, to be gone two nights!'[53]

Soon Anna heard from her other son, with news of his etchings and a request for American subscribers. She knew where to turn. A statement in Glasgow's Whistler collection reveals that Thomas Winans sent a draft for £63 in exchange for 'etchings', presumably thirty sets. Since he had recently completed a sumptuous country home, called The Crimea, to go with his town house Alexandroffsky, this purchase hardly strained his finances.

Whistler's etchings were praised by knowledgeable people, and they brought him a small income, but etchings and drawings did not gain an artist a reputation or financial security. These came from paintings, and so during his last year in Paris Whistler began seriously to paint. Picking up a brush, however, did not mean putting away his needle. As Duret said, he 'cultivated the two arts in parallel. . . . The etcher and the painter form constantly the double aspect of his personality.'[54]

Sometimes Whistler treated one subject in both media, for example La Mère Gérard, an aged, nearly blind flower seller who stood outside the Bal Bullier with whom Whistler frequently chatted. The man who less than fifteen years later would exhibit the world's most famous picture of an elderly woman saw her artistic possibilities, and she sat for two pictures, an etching in *The French Set* and one of his first oil paintings, a portrait of a white-capped, white-haired old woman. Shortly before or after *La Mère Gérard*, Whistler encountered an indigent, superannuated pedlar of crockery, whom he persuaded to sit for forty sous, and the result is a fine study of an old man smoking a pipe, now in the Louvre. These paintings of old people are good, but Whistler's best oil portrait of the period was of a young person, himself. This head and shoulders view (illustration 4) shows a fine self-awareness.

'The true artist', Stevens said, 'strikes the keynote in the dawn of his work.'[55] The three portraits give some indication of the future Whistler, but the first real keynote of his career was a painting he began late in 1858 on a visit to London.

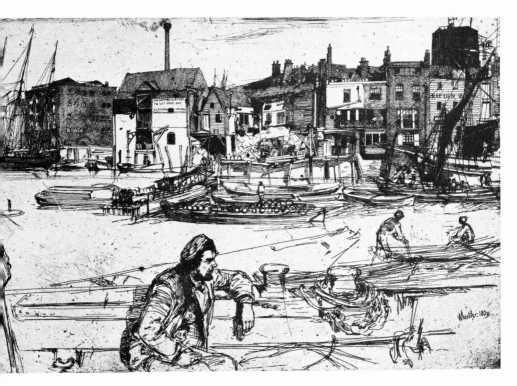

20. Black Lion Wharf (From The Thames Set)

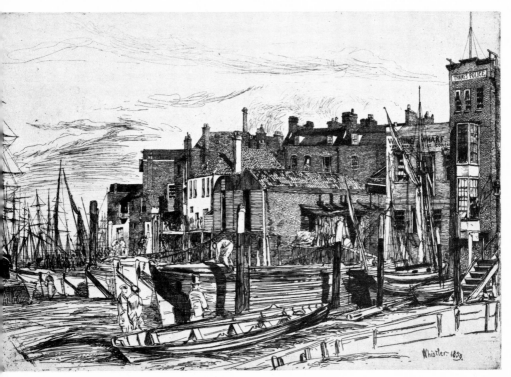

21. Thames Police (From The Thames Set)

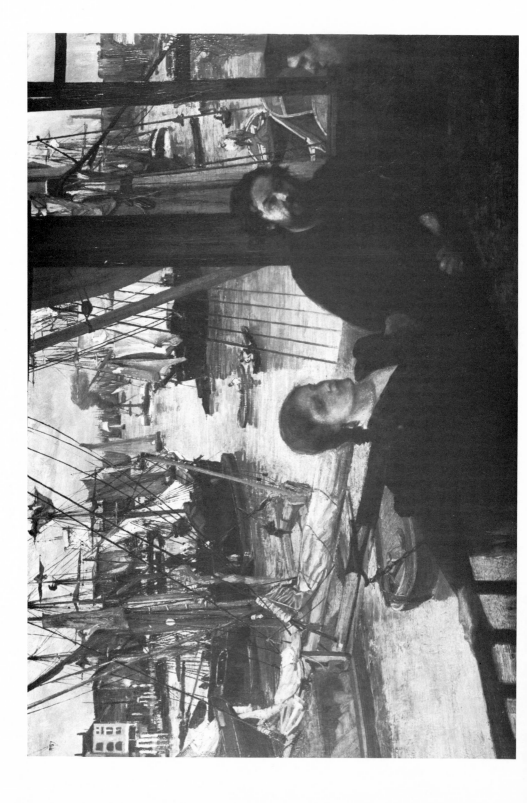

Whistler had already etched all of the Hadens – Seymour, Deborah, Annie, and Arthur – and now in the music room of 62 Sloane Street he launched into his first family painting, *At the Piano*. The subject is simple: a black-dressed woman, modelled by Deborah, plays a piano, while a girl in white, posed by Annie, leans on the instrument, listening meditatively. This sounds as trite as any of hundreds of other genre pictures produced on both sides of the Channel, but the treatment is outstanding.

Fine in itself, *At the Piano* is even more interesting as a harbinger of things to come, a painting which 'foreshadowed Whistler's whole career as an artist'.[56] There is, in the first place, what can only be imagined in our reproduction, a beautiful combination of colours: the black dress of the brunette woman, the white dress of the blonde child, the dark green cello case, the red carpet, the red scarf on the table, the blue and gold porcelain cup, the white-grey background with sea green and gold bands. Although some time was to pass before Whistler used the term, this was his first 'harmony'. But there is more to the picture than colour. Note the splendid portrayal of Annie, the first in the line of creations which have made James Whistler perhaps the English-speaking world's finest painter of children. Note also the skilful use of horizontal lines, his first employment of a device which would become a Whistlerian trademark. The greatness of this picture, however, lies not in the colours, nor the lines, nor even the child, but in the integration of all elements: colours, lines, pianist, piano, listener, background, cello case, porcelain cup. Everything joins with everything else; nothing is irrelevant or superfluous. It is like a completely realised sonnet where not a syllable could properly be removed or added. If the picture suggests a Keatsian sonnet, it may also conjure up a passage from Keats's greatest ode:

> Heard melodies are sweet, but those unheard
> Are sweeter . . .

One wonders if Deborah, excellent musician though she was, ever played to the 'sensual ear' as well as she does in this painting.

Whistler finished *At the Piano* in Paris early in the spring of 1859 and submitted it for exhibition at the coming Salon. Because of their role in mid-century art, as well as the early career of Whistler, one might pause for a glance at the biennial exhibitions of the Salon.

In 1857 the Salon had gained a new exhibition site, the large building on the Champs-Elysées used for the 1855 Exposition, but the Salon itself was anything but new. Established in 1673, it had held exhibitions uninterruptedly, in good and bad times, under revolutionary and reactionary governments. Its purpose was to provide artists – native and foreign,

beginners and veterans – with a public opportunity to display their best work. Over the years the Salon had become increasingly prestigious, and never had it been, nor would be, more influential than in the middle of the nineteenth century. Most artists exhibited as much and as often as possible at the Salon, because, practically speaking, in nineteenth-century France only there could they gain recognition. With few Parisian dealers and private sale-rooms to give worthwhile exposure to pictures, all painters except the very famous depended heavily, sometimes for their very survival, on the Salon. Unfortunately it had gradually veered from its original purpose and by the end of the first third of the nineteenth century had become a gigantic spectacle. As Ingres said, it was 'a picture shop, a bazaar in which the tremendous number of objects is overwhelming, and business rules instead of art'.[57] Ingres abstained from the Salon for twenty years, but this was an unaffordable luxury for lesser luminaries, especially beginners, for whom the Salon was not the most important place, it was the only place.

In the nineteenth century, Salon juries of admission were notoriously hard on artists whose work was unconventional. 'If a generality is ever safe,' John Canaday said, 'it is safe to say that for several decades beginning around 1850 the men controlling the Salon were all but blind aesthetically, and all but sadistic in their persecution of any painter who fell out of line with their goosestep.'[58] In 1859, John Rewald said, 'refusals actually reached such proportions that the artists organized a protest in the vicinity of the *Institut de France*.'[59] The rejections included Manet's first submission, his *Absinthe Drinker*, and the principal entries of each of 'The Society of Three'. Two Whistler etchings were accepted, but turned away was *At the Piano*.

The 1859 Salon, judging from contemporary notices, would have been better if some accepted works had been replaced by pictures like *The Absinthe Drinker* and *At the Piano*. Early in his lengthy review, Baudelaire said:

'The first time that I set foot in the Salon, I met one of the most subtle and best-regarded of our critics, and to my question, he replied, "Flat, mediocre; I have seldom seen so dismal a Salon." . . . [After] a general inspection, I saw that he was right. It cannot be doubted that mediocrity has dominated. . . . So many successfully-completed platitudes, so much carefully-laboured drivel, so much cleverly-constructed stupidity and falseness. . . . It would seem that littleness, puerility, incuriosity, and leaden calm of fatuity have taken place of ardour, nobility, and turbulent ambition.'[60]

The *Gazette des Beaux-Arts* was founded in 1859, in time to review the

Salon. Basically conservative, the *Gazette* was sympathetic to the establishment, but its initial reviewer felt constrained to say that

*'one question . . . must be resolved before the Salon of 1861. . . . It is our opinion that entrusting the Académie des Beaux-Arts with the infinitely delicate responsibility of pronouncing final judgement upon the admissibility of works presented for exhibit is the most unfortunate idea in the world. . . . The law of its organization has condemned the Académie eternally to the opinions of yesteryear. . . . The French school keeps changing its look . . . yet the Académie des Beaux-Arts keeps on the defensive; it asks for time to reflect, and even more time to understand. . . . As an institution taught by the past, the Académie is a poor judge of experimental works. . . . It is, as it were, a church, and, as such, it is inevitably led to treat new forms of sculpture or painting as orthodox associations have always treated heresies. . . . Let the victims of the jury be consoled with the knowledge that there is nothing dishonourable in seeing one's name added to the glorious list of those who have succeeded in winning fame and recognition despite rejection by the Salon.'

Normally, the victims could only accept this dubious consolation, but in 1859 not all of them had to retire meekly with a whimper. Among those angered by the jury's high-handedness was the owner of a small gallery on the Rue Saint Jacques, François Bonvin. A genre painter with a small following, Bonvin had first exhibited in the Salon ten years earlier and was represented in the current show. Although treated favourably himself, Bonvin was *'indignant at the decision of the jury and resolved, in his own way, to render justice to the beginners'.[61] His 'own way', in 1859, was astonishing: he sponsored in his gallery a show for some of the rejected painters, including Fantin and Whistler, and he invited friends to see their work. The guests included Courbet, who, although arrogant and self-centred, often encouraged struggling young painters. The picture at Bonvin's which most forcibly struck his eye, and which he extolled with extravagance, was *At the Piano*.

Bonvin's exhibition was a milestone for James Whistler: it ended his apprenticeship and began his professional career. His studies had ended, and he would soon cross the Channel to reside in London. As for his three and a half years in Paris, the Pennells properly observed that 'his pictures and prints were truly amazing in quality and quantity for a student who, Sir Edward Poynter would have us believe, worked in two or three years only as many weeks'.[62]

One final matter: in Paris, 'he was always known to us', Armstrong recollected, 'as James Abbott Whistler.'[63]

Chapter 9

LONDON
1859-61

Not long after Bonvin's show had opened, Whistler moved to London. Although some have questioned his wisdom in leaving Paris, there were good reasons for taking this course of action.

An anonymous contemporary writer, quoted by Whistler himself, offered one motive for the change: 'In Paris he was one of many, though he would be at peace in France, that peace would not be unattended with a certain comparative obscurity. Inconspicuous solitude would not have had the same charm for him.'[1] Others have seized on this notion that Whistler went to London because he could more easily gain attention there than in Paris. Actually he had had no difficulty in being noticed in Paris or anywhere else, but a more basic objection to this contention is that its advocates nurture the belief that Whistler was more of a *poseur* than an artist. Significantly, proponents of this proposition have generally been Englishmen, who even now find it difficult to understand James Whistler the American.

Whistler's principal personal reason for settling in London was a family one. During his Parisian residence he frequently crossed the Channel and visited 62 Sloane Street, where he maintained excellent relations with all the Hadens. 'Seymour was pained', Anna told Gamble, 'to see him not taking care of his health and coaxed him into consenting to spend the winter in their home.'[2] This was in 1858-9, when he painted *At the Paino*. Upon returning to Paris, he wrote to Deborah: '. . . my stay with you and Seymour has done me an immense good in my art.'[3] This would have been true if only for *At the Piano*, but he had done more than this. He had revived Haden's dormant interest in etching, and the brothers-in-law spent many hours together with their needles, exerting a healthy influence on each other. During this winter, Haden turned out nineteen plates, mostly landscapes. While his work was original and individualistic, there can be no doubt whence came his rekindled enthusiasm. 'The most important personal factor in Haden's development as an etcher', the principal commentator on his work said, 'was the emulative genius of Whistler.'[4] Because of his stimulating personality, Whistler was urged to

remain in London. As early as 5 December 1858, Anna told Gamble that Seymour and Deborah were 'exerting all their energies to make him prefer London for his work to Paris.'[5]

The Hadens provided more than one reason for Whistler's decision to live in London. Seymour had gained distinction in his profession – in 1857 he had become a Fellow of the Royal College of Surgeons – and he would have helpful connections. Then there was Seymour's brother-in-law, Rosamund's husband, John Calcott Horsley, one of England's foremost living painters, who had exhibited forty-three pictures in nineteen exhibitions of the Royal Academy, England's equivalent of the Salon. In 1855 he had been elected an Associate of the Royal Academy, Britain's second highest official artistic honour, and when there was a vacancy he would probably receive the ultimate accolade by becoming one of the forty Royal Academicians. The Horsleys lived in Tor Villas, Campden Hill, Kensington, where one neighbour was the quintessential Pre-Raphaelite, Holman Hunt, and so Whistler did not see much of them during the winter, but the advantages of having them in the family were self-evident.

Although personal motivations were important, Whistler moved mainly for artistic reasons. In this connection, one might note an article in the February 1857 issue of *La Revue des Deux Mondes*, 'L'optique et la Peinture', in which the eminent physicist Jules Janin summarised for landscapists certain recent discoveries in optics. After studying lighting conditions with optical instruments, Janin concluded:

'... artists should paint only ... when the light out of doors was diminished. If they painted, for example, at twilight, or sunset, in the early morning, in fog or haze, during storms and overcast skies, they would not need to use such intense light contrasts as when painting a bright clear sky – at times of day just indicated, the limited range of their palette would correspond to what was actually observed.'[6]

From this essay, a conversation piece in artists' cafés, Whistler perhaps drew a heightened awareness of the potentialities of foggy, hazy London.

If Haden, Horsley, and Janin played a role in Whistler's move, they were elements contributing to his most basic motivation. His goal, as always, was to gain success, which he realised could be done more quickly in London than Paris.

Paris was more competitive, not just because of its young artists – Monet, Manet, Degas, Pissarro, Fantin-Latour, Stevens, etc. – but because of limited opportunities to display one's wares, one significant exhibition held in alternate years. In London, the annual showing of the Royal

Academy was as prestigious as the Salon, and, as noted in Chapter 3, five or six other organisations held at least one large yearly exhibition of contemporary art, to say nothing of the numerous shows in private galleries and exhibition halls. In London it would seem difficult for a talented painter to go unrecognised.

London also, to quote an artist writing in the early sixties, provided 'a more extensive and better-paid employment for painters than has ever been known in any period of history or any century'.[7] Mindboggling prices were paid for pictures. Less than a year after Whistler moved, Holman Hunt got £5,500 for *The Finding of Christ in the Temple*, and two years later William Frith was paid £5,250 for *The Railway Station*. Frith and Hunt, to be sure, were established artists, but John Everett Millais when 20 was paid £350 for *The Carpenter Shop*, and Frederick Goodall when 21 earned £400 for *The Marriage Feast*. What about freedom to paint as one pleased? Could an artist earn money and retain his integrity? The four paintings cited do not definitively answer these questions. In *The Railway Station*, as in everything he did, Frith gave the public what it wanted, but no one was more true to his principles or faced greater adversities than Hunt, who spent ten years on the *Temple*. Goodall's *Marriage Feast* is pleasant and non-controversial, but Millais's picture was a *cause d'exécration* which Dickens called 'the lowest depths of what is mean, odious, repulsive, and revolting'. The four works, however, share a common characteristic: each contains an easily understood subject.

The mid-century painter's first duty was to find a topic, which might have to be carefully guarded. With some exaggeration, Whistler later recalled that at this time 'Artists locked themselves up in their studios – opened the doors only on the chain; if they met each other in the street they barely spoke. Models went round silent, with an air of mystery. . . . Then I found out the mystery: it was the moment of painting the Royal Academy picture. Each man was afraid his subject might be stolen.'[8] Subjects predominated because they met the demand of important purchasers. 'From about 1840,' a recent historian observed, 'patrons of modern art had changed and the buyers no longer belonged to the nobles and landed classes but were the prospering manufacturers. . . . From about 1847, the great northern manufacturers appeared as buyers [and] used their pictures for adornment of new and empty houses.'[9] These culturally unsophisticated men bought pictures they understood, and London dealers did their best to please, often competing furiously with each other. In 1859, for example, they gathered 'on the Academy steps before its doors opened on the first day, in their eagerness to have first pick of the treasures within'.[10] It is thus no wonder that pictures fetched good prices.

Returning to our question, in that situation could a painter retain his integrity? The answer is a qualified yes. Working within the framework of a clearly definable subject, a painter had considerable latitude, perhaps more than in any other country. William Rossetti, no establishmentarian, remarked in 1855 that 'the English school' was

'the most hopeful in Europe [and] the most open to new impressions – the most free in receiving, the least fettered by dogma or preconception in applying them. . . . It maintains a certain independence, and looks round, not through authorized spectacles, but with clear eyes. It is, on the whole, unsectarian, and willing to trust its own impulses, and to learn of nature through the eye rather than receive traditions of her through the ear.'[11]

The group to which Rossetti belonged, the Pre-Raphaelite Brotherhood, could support his statement. Outrageously denounced in 1850, they were when Whistler reached London eminently respectable. And none of them, not even Millais, had yet conspicuously compromised his principles. But then a concomitant of Pre-Raphaelite art was telling a story.

Unfortunately, as William Rossetti often observed, few painters took advantage of the opportunity to be truly creative. In his preface to the second edition of the *Lyrical Ballads*, Wordsworth said he had 'abstained from the use of many expressions, in themselves proper and beautiful, but which have been foolishly repeated by bad Poets till such feelings of disgust are connected·with them as it is scarcely possible by any art of association to overpower.' Wordsworth's words of 1800 apply to English painting of half a century later. What had been fresh and original became enfeebled and deadened through repetition. A critic of 1852 noted 'how the passion for imitation seizes upon the body of artists. A new vein is no sooner opened, than it is worked with as much eagerness as the diggings in Australia. . . . We allude to . . . the perpetual reproduction of subjects that have happened, in the first instance, under the treatment of a master hand, to hit the popular taste.'[12] Illustrating this generalisation was that summer's exhibition of the Royal Academy:

'When the spectator enters in 1852 he discovers little else than a reflection of 1851. The collection may be better, or it may be worse . . . but in its general features it is as nearly as possible the same. He finds the same sheep and cows glassed in the same water or browsing under the same trees – the green lanes . . . are reproduced without the slightest variation . . . the evening shadows fall on the same upland, with a cottage on the left and a clump of autumnal foliage on the right – inexhaustible Vicars of Wakefield gather about him as thickly as ever – there is no end to the

marine curiosities minted after the original patterns, the fishermen coming home or going out, the bits of the Rhine, the Dutch beaches and the Mont St. Michels – the same overwhelming gallery of portraits, with a strong likeness in the faces and costume . . .'13

One reason for this lack of originality, paradoxically, lay in the manifold opportunities for British artists. With so many walls to cover, people incapable of a fresh thought could have pictures shown because space had to be filled. Even good painters were tempted to be imitative and repetitive. Why labour to create a thing of beauty when a pot-boiler as readily sold for as high a price?

These remarks of 1852 could have been inspired by the ninety-first Exhibition of the Royal Academy, still attracting crowds to its home which, when Whistler arrived, was shared with the National Gallery. The *Illustrated London News* said it 'seldom ranges above mediocrity'; the *Morning Post* saw 'a predominance of the mechanical and imitative over the spiritual and imaginative'; and *The Times*'s reviewer wanted to forget 'an enormous proportion of the canvases, which are appropriated to overpowering masters of city companies, tremendous young cavalry captains, expensively got up mothers and elaborately grouped families, full-length provincial nobodies, and simpering illustrations of some life-size Book of Beauty'.

All of this mediocrity emphasised the need to encourage anyone with a spark of originality. For such a person the outlook was not bleak. When Whistler appeared, the author of a current essay declared:

'. . . it will be strange if some great artists do not rise above the level of their less-gifted contemporaries. The best hope of eliciting artistic eminence arises from the wideness of the area of competition. In times when art was at a low ebb, many an inglorious Raffaelle may have died unknown. But now . . . any rising ability is more sure of recognition and success. . . . We must make up our minds, therefore, to the patient endurance of a vast amount of mediocrity if only we may hope for some splendid exceptional works of genius. But the object of all lovers and critics of art should be to search for, and to encourage, when they find them, any signs of remarkable progress.'14

The year of 1859, it would seem, was a good one for Whistler to start his English career, which began when, probably urged by Haden, he sent two etchings to the current Royal Academy Exhibition which were accepted. Now that he had made his debut, he settled down as a British artist.

After a brief spell with the Hadens, Whistler went to Newman Street,

a short extension of Cleveland Street, which had once been favoured by painters (in 1826 five of the forty Royal Academicians worked there, and in 1849–50, Number 70 had been occupied by Dante Gabriel Rossetti). Long before 1859, the well-known artists had left, and studios were available for a low rent. Whistler took one at Number 72, where he lived and worked alone until early in 1860 when he was joined by Du Maurier. For reasons to be explained, Whistler was often gone, and Du Maurier wrote to his mother in June, 'I am now in Jemmy's studio . . . for which I pay 10/- a week, unfurnished, but Jemmy has left me his bed, his sister's sheets and towels, two chairs, a table and lots of wonderful etchings to adorn the walls, besides the use of a dress suit and waistcoat, quite new (when he doesn't happen to want it himself).[15] The two of them, Du Maurier remarked, 'pull together capitally dans le monde – no rivalry whatever, both being so different, Jemmy's bons mots which are plentiful are the finest thing I ever heard; and nothing that I ever read of in Dickens or anywhere can equal his amazing power of anecdote.'

Everyone at this time spoke well of Whistler. Rossetti's friend George Boyce kept a journal, and in March 1860 he wrote, 'Met a gallicized Yankee, Whistler by name, who was very amusing.' The versatile painter George Boughton, Whistler's almost exact contemporary, recalled the early sixties as 'the real "Jimmie period". He was then at his very best . . . on his favourite friends his most sunny and affectionate nature was lavished.'[16] Another artist, Arthur Severn, remembered that

'towards the end of the evening, there used to be drowning yells and shouts for Whistler, the eccentric Whistler! He used to be seized and stood up on a high stool, where he assumed the most irresistibly comic look, put his glass in his eye, and surveyed the multitude, who only screamed and yelled the more. When silence reigned he would begin to sing in the most curious way, suiting the action to the words with his small, thin, sensitive hands. His songs were in *argot* French, imitations of what he had heard on low cabarets on the Seine.'[17]

These performances occurred most memorably on Sunday evenings in the Brixton home of the wealthy merchant Alexander Ionides, father of Whistler's Parisian friend Luke, where, Du Maurier noted, Whistler quickly became 'the pet of the set'.[18] There, as everywhere else, he was usually the centre of attention. An excellent raconteur, 'he would', a friend said, 'keep the company in fits of laughter with his amusing stories, told as only he knew how'.[19] He was rarely serious: this was a time for fun, and if anyone started a sober discussion he would turn it into something humorous. Writing to his mother in September 1861, Du Maurier said:

'I must tell you a very funny thing [Whistler] said to Rosa Major . . . he wore her pork-pie (that was the evening he got so drunk); afterwards it appears, Rosa Major found that somebody had spat in the hat and didn't wear it any more; and the other day she gave it to him, saying that he might have it as it had been spit in, and thinking that he would be much ashamed, but he took the hat quite delighted, and said: – "By jove, Miss Rosa, if that's the way things are to be obtained from your family I only regret I didn't spit in your hand!" '20

The Ionides circle had not led Whistler to forget Legros and Fantin-Latour. Late in 1859 he paid a flying visit to Paris, and, seeing them in dire straits, invited both to London, where he said much money could be earned. Legros left at once and began working in Whistler's studio. Whistler then wrote to Fantin:

*'My dear child, for you are a child! and the most naive child I know! To think that you are so unhappy over a pile of cretins! while your force is herculean. But, my friend, let yourself go – I am acting in your behalf. Sneeze on the whole world and shake it off! If you only knew! But you are rich! You are a prince and surrounded by all the luxury I know you dream of. Come Fantin, come! come! come! The brother-in-law [Haden] has sent you money. It has been long enough that you have been receiving small sums for reproducing other peoples' masterpieces. Simply come – straight to my place. You will find here everything to continue the profit and the wealth that have begun for you. [This is a reference to several commissions that Whistler had gained for Fantin.] Everything is waiting for you, easel, color box! Everything! I am not exaggerating at all, Fantin, when I tell you that Alphonse [Legros] does not put brush to canvas without immediately making a thousand francs! Never under 800! The same for me!! In the space of three or four weeks he has made about eight thousand francs!!! So, dear Fantin, the same for you as well! . . . Write by return post to tell me that you are coming! so that I can meet you at the train!'21

This letter reveals a neglected side of Whistler's personality, his generosity, which, with friends, was limitless. But helping others also stimulated his ego. When impoverished friends visited households like those of the Ionides and Haden families, and received commissions, they were eternally grateful to their benefactor. A more altruistic, untainted munificence was that of Seymour Haden, who sent passage money to Fantin, and perhaps Legros, and provided them, and also Ernest Delannoy, with living accommodation. He purchased their pictures – originals and copies –

gave them liberal commissions, and introduced them to other patrons. His actions, far from being part of an ego trip, were those of a man genuinely interested in helping young persons of talent.

Fantin went to London and thoroughly enjoyed his stay there. It was, a biographer observed, 'a great and wholesome change, restoring his health and spirits wonderfully. Letters to his parents are full of the wonders of London, the comfort of the houses, the remarkable dinners he went to.'[22] London was a fine city, but only to visit, and, despite Whistler's entreaties, at summer's end Fantin returned to Paris.

During 1859 and 1860 only one facet of Whistler's character was revealed in Kensington and Brixton. As mentioned earlier, he was frequently gone from Newman Street, sometimes for prolonged periods. Where was he during these absences? Where else but along the river? He was in the least refined section of the metropolis, the dock area of Wapping and Rotherhithe. In Brixton, Kensington, and Mayfair, Whistler played, sang, and joked. In Wapping and Rotherhithe, he talked seriously and worked.

A more striking contrast than that between the docks and genteel London could scarcely be imagined. Even Du Maurier, the most cosmopolitan, least conventional of Whistler's British associates, told his mother in October 1860 that Whistler was 'working hard and secret down in Rotherhithe, among a beastly set of cads and every possible annoyance and misery'.[23] The 'cads' of Rotherhithe, on the Surrey side of the river, and Wapping, on the opposite bank, were all associated with shipping, for these communities serviced the port of London, which extended four miles below London Bridge and accommodated more than two thousand ships. After staying briefly in Wapping, Whistler moved to Rotherhithe – the two were joined by the Thames Tunnel, built in 1843 for pedestrians and carriages and now used by the Metropolitan Line of the London Underground – and lived in the Angel Inn, at Cherry Gardens, with a comfortable balcony overlooking the river.

No place was more historically bound to the Thames than Rotherhithe, which for centuries had been preoccupied with shipping. With a population of about 25,000 in 1860, it was an insular settlement, cut off from outsiders. As its historian explained, Rotherhithe was 'apart from the main stream of the life of the metropolis by reason of its area occupying space enfolded by one of the numerous bends of the river, so that the main thoroughfares and great railway lines passed the southern fringe of its boundaries and left the parish itself almost untouched'.[24] Rotherhithe and Wapping were virtually unknown to 'respectable' Londoners, who, it was correctly said in 1862, were 'better acquainted with what skirts the canals of Venice than with what stands on the banks of the Thames'.[25]

Strangers in the docks saw only superficialities. In 1863, Nathaniel Hawthorne viewed Wapping and Rotherhithe from a river boat, and his reaction, if not his eloquence, was typical:

'The shore is lined with the shabbiest, blackest, and ugliest buildings that can be imagined . . . insomuch that, had I known nothing more of the world's metropolis, I might have fancied that it had already experienced the downfall which I have heard commercial and financial prophets predict for it. And the muddy tide of the Thames . . . is just the dismal stream to glide by such a city. . . . We landed in Wapping, which . . . turned out to be a cold and torpid neighborhood, mean, shabby, and unpicturesque, both as to its buildings and inhabitants.'[26]

Occasionally an observer penetrated beneath the veneer of the lower Thames and could describe what he saw. No one was better acquainted with or more revolted by London's squalor and ugliness than Henry May-hew, but the docks drew from him this response, which first appeared in a book when Whistler lived in Rotherhithe:

'As you enter, the sight of the forest of masts in the distance, and the tall chimneys vomiting clouds of black smoke, and the many coloured flags flying in the air, has a most peculiar effect. Along the quay you see, now men with their faces blue with indigo, and now gaugers, with their long brass-tipped rule dripping with spirit from the cask they have been probing. Then will come a group of flaxen-haired sailors chattering German; and next a black sailor, with a cotton handkerchief twisted turban-like round his head. Presently a blue-smocked butcher, with fresh meat and a bunch of cabbages in the tray on his shoulder; and shortly afterwards a mate with green paroquets in a wooden cage. Here you will see sitting on a bench a sorrowful-looking woman, with new bright cooking tins at her feet, telling you she is an emigrant preparing for her voyage. As you pass along this quay the air is pungent with tobacco; on that it overpowers you with fumes of rum . . . and shortly afterwards the atmos-phere is fragrant with coffee and spice. . . . The jumble of sounds . . . blends in anything but sweet concord. The sailors are singing, boisterous nigger songs from the Yankee ship just entering; the cooper is hammering on the casks on the quay; the chains of the cranes, loosed of their weight, rattle as they fly up again; the ropes splash in the water; some captain shouts his orders through his hands . . . and empty casks roll along the stones with a heavy drum-like sound.'[27]

'Who says that all this movement is ugly?' asked another beholder of

the scene. 'At every turn there is a sketch. Every twisting or backing of a cart; every shifting of the busy groups suggests a happy combination of lines and shades [and] picturesque studies by the score.'[28]

James Whistler surely seconded these sentiments; he agreed with Alfred Stevens that 'True artists have a weakness for the beauty of ugliness.'[29] He wandered along wharves and poked into alleys, where no proper Londoner would be caught dead or alive. Without fear or hesitation he walked wherever he pleased as always harmonising with his environment. He examined warehouses, taverns, barges, and deep-sea vessels, all of which was a vividly beautiful manifestation of modern life. He differed from earlier painters of the Thames – Claude de Jongh, Wenceslaus Hollar, Canaletto, William Marlow, Samuel Scott, Constable, and Turner – who watched the river from Richmond, Henley, or Chelsea. Whistler was a pioneer, like Hogarth, Fedotov, and Courbet. And, although he would have stubbornly denied it, he *'looked at the banks of the Thames as Meryon had seen the banks of the Seine between the high buildings of old Paris . . . and with that curious, intelligent, and shrewd eye which immediately perceived whatever is picturesque in any thing'.[30]

In June 1860 the *Builder* commented on one shortcoming of London's art exhibitions:

'It is remarkable that so little use has been made of the decidedly picturesque and striking scenes which are presented in metropolitan everyday life. . . . If modern English painters would but glance at the metropolis with artistic and philosophical feelings, many works would be produced from everyday life, which would amuse, instruct, and improve the present age, and have a very high value in times to come.'[31]

When these words were written, James Whistler, an American, was doing what his English counterparts had disdained to attempt. In Rotherhithe, isolated from distractions, he worked with a brush and a needle.

As in Paris, he began with the needle and produced *A Series of Sixteen Etchings of Scenes on the Thames and Other Subjects*, popularly called *The Thames Set*.

Although not issued as a group until 1871, these etchings were done mainly in 1859 and 1860, and, presenting a highly detailed, realistic picture of life 'below bridge', they form a genuine 'set'. They were much praised by Whistler's professional contemporaries. Du Maurier said they were 'most magnificent',[32] and Holman Hunt, who rarely liked Whistler's work, called them 'admirable'.[33] For William Rossetti, they displayed

'a marked propensity for shore-life, river-life, boat-life, barge-life –

everything which hints of old wharves, jetties, piers, rigging, bow-windows overlooking reaches of the peopled stream, and that class of hard-fisted, square shouldered, solid and stolid faced men, on whom the odour of tar and of tobacco is equally incorporate. . . . It is a little curious that the artist, of all artists past or present, who has an intuition of the opportunities which Thames scenery offers for the purposes of art should come to us from a birth-place across the Atlantic, and a studio across the Channel.'[34]

Rossetti prophesied, 'The fogs, beauties, and oddities, of our river, just as it stands before us now, bid fair to become Mr Whistler's *specialité*.'

The Thames etchings selected for reproduction here are *Rotherhithe, Black Lion Wharf, Thames Police* and *The Lime-Burner*.

The set's most carefully detailed piece is *Rotherhithe*. Note the mariners' faces, the masts and rigging, the warehouses, and, most particularly, the bricks on the right. These details, not there for their own sake, as one often feels of Pre-Raphaelite art, combine to create a maritime atmosphere, and 'one feels, looking from the large open window of the tavern out-house . . . through the rigging down the river, that one may fancy the sound of breakers'.[35]

None of the other Thames etchings has been as consistently praised and reproduced as *Black Lion Wharf*. Again a profusion of details – wharves, schooner, landing stage, warehouses with minutely detailed roofs, and fully elaborated windows and balconies – coalesce into oneness.

Thames Police brings us closer to Wapping's wharves, one of which, at the extreme right, provided the title, and shows also a typical river work scene.

The Lime-Burner presents one of the land-based workers necessary to the maritime industry. This interior scene is linked to the others by the archway through which one catches a glimpse of the river.

'Serjeant Thomas has bought Jimmy's etchings,' Du Maurier wrote in 1860, 'and is exhibiting them – does all the printing and advertising, and gives Jimmy half.'[36] A lawyer who owned a print shop at 39 Old Bond Street, Thomas had reprinted *The French Set* and now was selling the Thames etchings for one and two guineas each. They were not bestsellers – no etchings were – but they gained Whistler some recognition.

On the Thames, Whistler also worked with his brush and in 1859 began his first important river painting, *Wapping*.

It is easy to turn from the etchings to *Wapping*, painted on the precise locale, the Angel Inn balcony, where *Rotherhithe* was etched. In a letter to Fantin written while *Wapping* was in progress, Whistler discoursed at length on his painting, saying, in part:

*'I would like to have you here before a picture that I am counting on very much. This is how it looks. [Whistler drew a pencil sketch of it.] There, I don't know if you'll make head or tail of it. I'll try to explain it. First, it is from a balcony on the second floor [first floor, in British usage], looking out on the Thames. There are three people: an old man in a white shirt – the one in the middle who is looking out the window; next, on the right, in the corner, a sailor in a cap and blue shirt . . . who is talking with a girl.'[37]

As important as the figures was the background. *'The sky', he wrote, 'is very real, and boldly painted. You can see a corner of it through the window panes – clever, huh? Up closer, there is a row of big ships, one of which is unloading coal, and, all along the window, the mast and yellow sail of a lighter, and just opposite the girl's head . . . is the bowsprit of a big ship with ropes and pulleys crossing the entire painting.' Whistler ended by saying, 'Ssshh! Don't talk to Courbet about it.' Why? Surely nothing would have offended Courbet. Perhaps he wanted it to be a surprise, or, if he failed, he could keep Courbet in ignorance of it.

Wapping was the most difficult thing Whistler had attempted, and he told Fantin, *'I want particularly to have you here, so we could discuss it.' Legros was there, modelling for the young man, but he could never replace Fantin as a confidant. Nor did Whistler confer with British friends; Armstrong recalled that he did 'not then care to have people about or to let any one see too much of his methods'.[38] A major stumbling block was one of the figures. *'The girl', he told Fantin, referring to her painted expression, 'has a superlatively whorish air' and 'is awfully difficult to paint.' He explained:

*'You know, I have painted her three times, and I don't want to get tired; moreover, if I fool with her too often, I shall never have time to finish it. Believe me, I have managed to put an *expression* there. Now be quiet, mon cher, a real expression – ah! if I could describe the head to you, the head – the hair, the most beautiful you have ever seen! It is a red, not golden, but *copper-colored* – everything one dreams of in a Venetian girl! a yellow white skin, or golden if you wish, and with this famous expression I am telling you about, an air of saying to her sailor, "That's O.K., old chap, I've had others!" You know, she winks her eye and makes fun of him. All of this is *against* the light and consequently in a half-tone which is horridly difficult. But I do not think I shall repaint her. Her throat is uncovered, her blouse can almost be completely seen and, mon cher, is painted very well.'[39]

As one might guess, Whistler's interest in his model was not just artistic. An Irish woman, Joanna Hiffernan (not Heffernan, as her name has

often been spelled), she was, and would be for some years, his mistress. According to Luke Ionides, they met while Whistler was working in Newman Street, which sounds probable since a letter of Du Maurier in March 1862 gave the address of Jo's sister as 69 Newman Street. All we know of her father Patrick is that he was a drifter and called Whistler 'me son-in-law'. We know even less about her mother; a couple of lines in Du Maurier's March 1862 letter to his mother refer to 'the death of [Whistler's] mother-in-law: about which he was quite sentimental, and very much afraid that the bereaved widower, Joe's Papa, who is an impulsive & passionate Irishman, will do something to disgrace Joe's sisters'.[40]

Jo obviously was physically attractive. (In this volume she is depicted in *Wapping*, *The White Girl*, *The Little White Girl*, and the portrait by Courbet.) She apparently had little education, but she was intelligent, sensible, good-humoured, and a sympathetic, devoted companion to Whistler. In some ways she resembled Rossetti's long-standing mistress, Lizzie Siddal, although Jo, unlike Lizzie, was neither neurotic nor hot-tempered. Rossetti moreover eventually married his mistress. Whistler never married, or thought of marrying, Jo, mainly because, like Rossetti, forced into matrimony after an intimacy of more than ten years, he was temperamentally unsuited for marriage. He was selfish and preoccupied with his own welfare, and, while always treating Jo with deference and courtesy, he would not take on marital responsibilities.

Whistler was not ashamed of Jo; she was constantly with him and known to all his friends, including Seymour Haden, who was now en-thusiastically etching and in late 1859 visited Whistler in Rotherhithe and did three Thames pieces, *Thames Fishermen*, *Egham*, and *Egham Lock*. As Malcolm Salaman noted, the two men responded differently to the river:

'For Whistler the appeal was paramountly the active human interest of London's great waterway, with the functional individuality of the various river-craft and the men that plied them, the peculiarly local character of the wharves and riverside houses; for Haden it was chiefly the riparian landscape of the upper reaches . . . that called his needle to the copper.'[41]

Since Haden's interest was landscape, and Whistler's was people, the brothers-in-law sometimes collaborated. In *Trees in the Park*, bearing both names, the trees are Haden's, and a girl standing among them was done by Whistler. *Sub Tegmine*, etched in 1859 in Greenwich, also with two signatures, shows a pensioner sitting in the park: the man was Whistler's, the trees were Haden's.

At this time, Whistler was always welcome at 62 Sloane Street, which he frequently visited, but not with Miss Hiffernan. Early in 1860 he

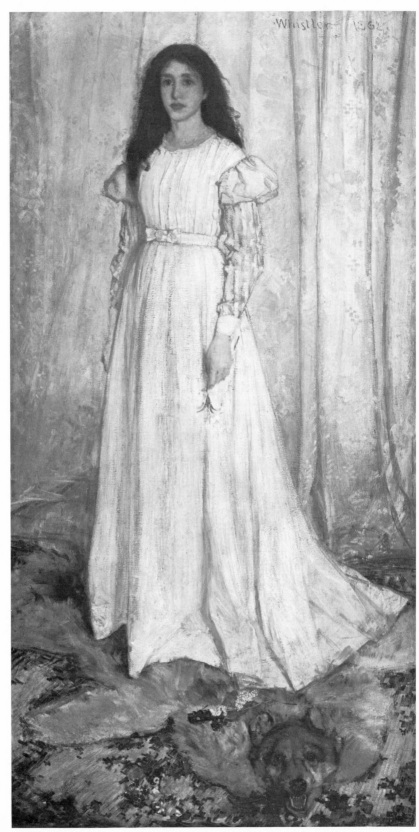

The White Girl

24. Old Battersea Bridge

25. The Last of Old Westminster

spent some time at the scene of the *Piano* picture and completed his second major painting, *The Music Room*. (With his multi-faceted artistic personality, Whistler could simultaneously work on river etchings, a Thames oil painting, and a Kensington interior scene.)

The Music Room is an artistic cousin of *At the Piano*. On the right stands a woman in a riding costume; behind her a girl sits reading a book; and to the left a young woman's face is seen in a mirror. (This last face is Deborah's, the girl is Annie, and the standing woman was modelled by Isabella Boott, a niece of the founder of Lowell.) Nothing indicates the relationship of the figures, and the picture is without narrative content. Originally it was to be named *Morning Call*, which would have explained what is now inexplicable; altering the title removed all traces of a 'story'. Later Whistler would call it *Harmony in Green and Rose*, and he also might have labelled it an 'arrangement', for he created a fine scheme of colour harmonies and spatial arrangements. *The Music Room*, as one would hope from a young painter with a developing talent, surpassed *At the Piano*. The accessories are excellent, and the details are remarkable. 'For complete representation of objects,' Kenyon Cox said, 'this picture was perhaps Whistler's high-water mark.'[42] He asked, 'Was it because he felt in such a picture as this the still-life was, in a manner, better than the figures, that he never makes so much of it again?' The answer lies in Whistler's work on the Thames. His attention to detail in the river subjects carried over to Sloane Street: the almost photographic representation of *Rotherhithe*'s bricks is matched by the curtains of *The Music Room*. The details did not, however, as Cox implies, lead Whistler to neglect his figures. The standing woman is excellent, and Annie is even better here than in the *Piano*. 'Examine the little girl,' exclaimed an enthusiastic viewer, without hyperbole, 'and ask yourself if, in any modern painting, you know of a figure more exquisitely observed or more exquisitely embodied and realised.... Other painters have the quality of elegance and distinction, but this goes a point beyond, because it is, or seems, unstudied, unconscious, spontaneous, genuine.'[43]

As a middle-aged woman, Annie recollected Whistler painting *The Music Room*:

'It was a distinctly amusing time for me. He was always so delightful and enjoyed the "no lessons" as much as I did. One day ... I got tired ... and suddenly dissolved into tears, whereupon he was full of the most tender remorse, and rushed out and bought me a lovely Russian leather writing set, which I am still using at this very moment! ... We were always good friends, and I have nothing all through those early years but the most delightful remembrance of him.'[44]

Before Whistler had finished his second major painting, the first one caused some excitement. It was accepted for hanging at the British parallel to the Salon, the 1860 Exhibition of the Royal Academy.

Founded by Royal Charter in 1768, the Academy included forty full members – painters, sculptors, and engravers – Royal Academicians, entitled to place 'R.A.' after their names, and twenty associate members, 'A.R.A.s', from whom vacancies among the R.A.s were filled. To become an R.A. was to gain Britain's premier artistic honour, but a cumulative list of Academicians is conspicuous for numerous nonentities and the embarrassing absence of such names as Ford Madox Brown, Edward Burne-Jones, John Cotman, David Cox, Old Crome, Peter de Wint, Benjamin Robert Haydon, Holman Hunt, William Henry Hunt, John Linnell, John Martin, William John Muller, Dante Gabriel Rossetti, and Alfred Stevens (the English Stevens). For such omissions, and for other reasons, the Academy was repeatedly assailed, yet throughout the Victorian period it flourished. Despite other art societies, the R.A. had no real rival. In the fifties and sixties to have one picture badly hung at the Academy meant more than half a dozen well hung elsewhere. London had many exhibitions, but only one Exhibition, which opened on the first Monday in May and continued until the end of July. Its ostensible purposes were to give exposure to the best contemporary art and, with the entrance fee of one shilling, to gain revenue to support the Academy. Its significance in fact went beyond these goals. Some of the flavour of a typical Victorian Exhibition may be gained from an article, selected almost at random, by Margaret Oliphant:

'There is no public event which creates . . . so much interest throughout all classes . . . as the opening of the Royal Academy Exhibition. . . . From all corners of the country, people who are rich enough to pay a yearly visit to London reckon this one of their inducements and even the hastiest excursionist . . . thinks it necessary to take a hurried glance at "the pictures". No book, or at least no season of books, so to speak, ever receives the discussion, the attention, the public notice which the Exhibition does. At every dinner table, at every summer assembly . . . it is in everybody's mouth. Every one takes an interest, more or less understanding or ignorant, in the periodical show. From ten o'clock till six the rooms are thronged with an interested eager crowd, enduring dust, heat, and fatigue with more placidity than in any other haunt. . . . It would scarcely be possible to find a more thoroughly representative crowd than this. . . . Fashion in wondrous apparel . . . fine young men about town, and uncouth striplings from school; country people, city people; men from clubs, women with schoolroom parties; connoisseurs and speculators . . .

make up a crowd which is more instructive than the art which attracts them. . . . To almost all of these the Exhibition is an article of faith. To miss it for a year would be worse than many a little moral peccadillo. . . . Even to delay the first visit to the Academy shows an indifference which few persons claiming to be refined or educated would like to be accused of. . . . A certain latitude may be allowed about going to church, but about going to the Academy none is possible.'[45]

To turn from social to artistic matters, it is fair to say that the R.A.s were more equitable and tolerant than their colleagues in Paris. The selecting and hanging were done by a Council consisting of the President of the Academy and eight other members, four of whom retired each year not to return until every other member had served. A constantly changing Council was more likely to accept innovations than a permanent body, especially since a regulation stipulated that new members, those closest to the outside world, would sit on the Council during the first year after their election. Although, inevitably, complaints arose about rejected and badly hung pictures, the Royal Academy was perhaps more impartial than any other similar organisation. Certainly no one could reasonably have charged the Council with being unfair or vindictive to the once-rebellious Pre-Raphaelites, whose pictures were generally accepted and well hung.

In 1860 the Academy decided, in the interests of good hanging, to accept fewer works than usual – about 1,100 instead of the customary 1,500 or so – and this certainly improved the show's appearance. The *Morning Post* noted that 'pictures are not piled on top of one another from floor to ceiling, where in recent years many were beyond the vision of any animal with a shorter neck than a giraffe's'. The new admissions policy seems not, however, to have improved the quality of the exhibition. *The Times*'s reveiwer could not find 'any work or works of surpassing merit or of striking novelty either in aim or achievement', and the *Illustrated London News* remarked that 'mediocrities are as abundant and as conspicuously displayed as ever'.

Fewer admissions, in the words of *The Observer*, 'cut off all chance of exhibition from many a struggling artist', but two who did not suffer were Seymour Haden and James Whistler. Haden submitted two etchings – *Egham* and *Kensington Gardens* – and they were accepted. (The name under his pictures and in the catalogue was 'H. Dean.') As for Whistler, five etchings were admitted – *Monsieur Astruc, Black Lion Wharf, The Lime-Burner, The Thames from the Tunnel Pier*, and an unnamed portrait – and, most important, the painting rejected by the Salon was taken and, Armstrong reported, 'hung in a very good place on the line'.[46] (A picture

'on the line' is approximately at eye level.) Whistler benefited from the exclusionary policy: fewer works in a generally mediocre show increased his chances of gaining attention.

At the Piano, Ionides recalled, 'was received with great enthusiasm by many of the artists. Watts said that as far as it went, it was the most perfect thing he had ever seen.'[47] When speaking of pictures painted by others, Holman Hunt was laconic, but he acknowledged that *At the Piano* was 'a striking example of frank manipulation and wholesome but not exhaustive colour'. [48] Hunt's friend John Everett Millais was more effusive. Du Maurier told his mother, 'The other day at a party [Whistler] was introduced to Millais, who said: "What! Mr Whistler! I am very happy to know you – I never flatter, but I will say that your picture is the finest piece of colour that has been on the walls of the Royal Academy for years." '[49] Du Maurier himself called it ' out and out the finest thing in the Academy'. Thackeray, more knowledgeable in the visual arts than most novelists, was reported to have 'admired it beyond words, and stood looking at it with real delight and appreciation'.[50] George Boughton, still a student in Paris, returned for a holiday and later recollected:

'. . . though I saw the Exhibition several times, that one picture is the only thing I brought vividly away in my memories of the show. . . . I have thought of that enraptured child as part of one's joy of life. It was the quiet air of that dim room, filled with ripples of soothing melodies, that one could almost hear; and the two quiet figures were living and breathing in that atmosphere that was as clear and limpid as if it had been sunlight instead of quiet shade.'[51]

Finally, Du Maurier told his mother that Sir Charles Eastlake, President of the Royal Academy and Director of the National Gallery, 'took the Duchess of Sutherland up to it and said "There ma'am, that's the finest piece of painting in the Royal Academy." '[52]

Praise from one's associates is enjoyable, but, at least in Victorian times, it bore less on a young artist's success than the verdict of professional reviewers. Although London's daily newspapers and many weekly journals carried one or more notices of the annual Exhibition – the *Athenaeum* and *The Times* might run six or seven – space was available for only a small fraction of the works, and it was unlikely that an unknown painter's first picture would receive any mention. Whistler, however, suffered from no neglect. In 1863, the *Morning Herald* recalled that the 'picture entitled "The Piano" made a sensation three years since'. For the artist it was a pleasant sensation. The *Morning Advertiser* spoke of 'a half-finished performance, but [with] singular force and truth, although

it merely displays a lady at a pianoforte with a lilting child looking on'. The prestigious *Athenaeum* gave it a good position in the third notice:

'Mr Whistler's "At the Piano" is a sketch and of the wildest and roughest kind, yet shows a genuine feeling for colour, form (in spite of a recklessly bold manner of drawing), a splendid power of composition, and lastly design, – which evince a just appreciation for nature that is very rare amongst artists. . . . If the observer will look for a little while at this singular production, he will perceive that it "opens out" just as a stereoscopic view will – an excellent quality, due to the artist's feeling for atmosphere and judicious gradation of tone.'

This writer even mentioned Whistler's other entries, hung in the notorious Octagon Room, where one could hardly see anything, calling them 'an admirable series of etchings', As for the journalistic monarch, *The Times*, a young man in his first Exhibition would be unrealistic to expect one brief sentence in the last notice, but in 1860 the following appeared in *The Times*'s second notice:

'The name of Mr J. A. Whistler is quite new to us. It is attached to a large sketch rather than a picture, called "At the Piano". . . . In colour and handling, this picture reminds one irresistibly of Velasquez. There is the same powerful effect obtained by the simplest and sombrest colours – nothing but the dark wood of the piano, the black and white dresses, and under the instrument a green violin and violoncello case, relieved against a greenish wall, ornamented with two prints in plain frames. Simpler materials could not well be taken in hand; but the painter has known what to do with them. With these means he has produced what we are inclined to think, on the whole, the most vigorous piece of colouring in this year's exhibition. The execution is as broad and sketchy as the elements of effect are simple; but if this work be the fair result of Mr Whistler's own labour from nature, and not a transcript or reminiscence of some Spanish picture, this gentleman has a future of his own before him, and his next performance should be curiously watched.'

After reading this, Whistler could not have been much disturbed by less favourable remarks, such as Walter Thornbury's characterisation of the picture as 'a feverish dream of playing the scales in purgatory – (distemper); yet not without some sickly grandeur'.[53]

While speaking of reviews, one should not overlook the most celebrated Victorian critic of the fine arts, John Ruskin. During each of the five preceding years, Ruskin had issued a pamphlet known as *Academy Notes* and evaluated those paintings which deserved 'particular praise or censure'.

Unfortunately these tracts terminated in 1859; it would be interesting to see what, if anything, Ruskin would have said about *At the Piano*.

One reason for interest in Whistler's painting was that before the show opened it had been seen, liked, and bought by John Phillip, R.A. A Scot, Phillip had acquired the nickname 'Spanish' because after visiting Spain in 1851-2 he painted popular pictures of Spanish subjects in the spirit of Velasquez. (One wonders if *At the Piano* reminded *The Times*'s reviewer of Velasquez because he knew it had been bought by the man whose work among all British painters was most reminiscent of the Spanish master.) During the fifties Philip painted brilliant Spanish pictures, and he was a court favourite. He sold pictures to the Queen in 1853, 1854, 1855, and 1858, and his current principal work on exhibit was *The Marriage of the Princess Royal*. In 1857 he was elected an A.R.A., and in 1859 he became a Royal Academician. A young artist could hardly have chosen a better admirer of his first exhibited painting. Years later, Whistler recalled that Phillip had

'looked up my address in the catalogue, and wrote to me at once to say he would like to buy it, and what was its price? I said that in my youth and inexperience, I did not know about these things, and I would leave to him the question of price. Phillip sent me thirty pounds.'[54]

Phillip could afford the price: according to William Rossetti, at about this time he sold a dozen paintings done recently in Spain for £20,000.[55]

The reception accorded *At the Piano* startled those who considered Whistler an idle apprentice. 'We, his friends,' Armstrong wrote, 'were amazed at his sudden and unexpected success.'[56] Upon returning to Paris, Boughton said: 'The students were much surprised to hear that his Girl at the Piano had a place on the line at the Academy and had been purchased by John Phillip, R.A. and was making a talk in the big city.'[57]

Before the Exhibition closed, Whistler received news from home: William had graduated from medical school, was a resident physician in Howard Hospital, Philadelphia, and was betrothed to Florida B. King from the state of Virginia. Along with family tidings, he learned that delegates to the Republican Party's national convention in Chicago had chosen as their presidential candidate Abraham Lincoln. If Lincoln were elected, the Southern states almost certainly would secede from the Union, and secession would mean civil war. How might this affect a young American in good health with three years of training at West Point, one who had sworn allegiance to the United States of America but sympathised with the states which would be seceding? He could only hope that his countrymen would have the good sense to reject Lincoln.

In the meantime Whistler dismissed from his thoughts these faraway matters and concentrated on art. With money from his inheritance and occasional 'loans' from the Winanses, he could work as he pleased. Du Maurier wrote enviously that he was 'doing anything he likes, while my subjects are cut out for me'.[58] Whistler continued to be active in two media. In 1860 he completed the *Thames Set* and produced several other fine etchings, such as *The Miser*, *Soupe à Trois Sous*, and, most notably, signed and dated 'Whistler 1860', *Annie Haden*. It presents 11-year-old Annie in front of a curtain, her long hair falling about her shoulders, wearing a round hat, long cape, and full skirt, and, in the third state, reproduced in this volume, standing in slippers on a patterned carpet. Everything is superb: the hat, the hair, the cape, the slippers, the carpet, the curtain, and, above all, Annie's delightfully saucy expression which, ever so slightly, reflects her impatience and anticipates the great oil painting of the seventies, *Cicely Alexander*. James Laver, who was not given to extravagance, called it 'one of the great portrait etchings of the world'.[59] Whistler's own opinion was unambiguous. On the second state proof owned by the New York Public Library, he wrote 'one of my very best', and Edward Kennedy, compiler of the definitive portfolio of his etchings, said, 'Whistler told me that if he had to make a decision as to which plate was his best, he would rest his reputation upon "Annie Haden."'[60] Artists are not always reliable judges of their work, but here one cannot quarrel with Whistler. *Annie Haden*, one might suggest, is to his etchings what *Cicely Alexander* is to his paintings, his finest achievement, and, furthermore, it may well be the world's greatest etching of a child. (This opinion holds for the third state, clearly the best of the three.)

We cannot be sure of the exact date of *Annie Haden*, but we know precisely when Whistler worked on his next completed painting, *The Thames in Ice*, because of its initial title, *The Twenty-fifth of December 1860, on the Thames*. This gloomy scene of several men working on an anchored ship in the ice-bound river was done quickly, perhaps in no more than three days, one of which was Christmas. Painted from the balcony of the Angel Inn, it demonstrates a Courbet-like realism, and also something new. As Denys Sutton said, 'For virtually the first time he may be seen really enjoying the atmospheric qualities of the Thames.'[61] The picture may be contrasted not only with Whistler's other river work but also, strikingly, with the etching of Annie Haden. The Thames etchings and the unfinished *Wapping* are lively and buoyant, *Annie Haden* is cheerful and happy, but *The Thames in Ice* is a picture of unrelieved gloom. The Pennells said of its creation that 'for an Idle Apprentice, it was a curious way of spending Christmas Day'.[62] It was also curious subject for the most festive day of the year. Perhaps it reflected Whistler's inner feelings.

One is reminded of the passage in *In Memoriam* when Tennyson refers to the first Christmas after Hallam's death:

> A rainy cloud possess'd the earth,
> And sadly fell our Christmas-eve.
>
> At our old pastimes in the hall
> We gamboll'd, making vain pretence
> Of gladness, with an awful sense
> Of one mute Shadow watching all.

Like Tennyson, Whistler probably felt disinclined to go through the pretence of celebrating Christmas in Sloane Street, and so he went down to gloomy Rotherhithe. He too felt a 'mute Shadow' watching over him, that of the newly elected President of the United States, Abraham Lincoln.

The election meant secession. Indeed, although Whistler did not know it, already, five days before Christmas, South Carolina's legislature had adopted an Ordinance of Secession. And after secession? What else but war, war in which Americans fought Americans on American soil. So is it strange that on Christmas Day Whistler preferred the Angel Inn to 62 Sloane Street? His current feelings may explain the rapidity with which he dashed off the painting as opposed to his agonising efforts on *Wapping*. He sold it to Haden for the absurdly low price of ten pounds. James Whistler was in no mood to haggle over a purchase price.

Preoccupation with overseas events affected Whistler through the early months of 1861, and he produced almost nothing. When the time came for submissions to the R.A. Exhibition, Haden entered five etchings, all of which were accepted, but Whistler offered only his Parisian portrait *La Mère Gérard*. This small picture – less than one-tenth the size of *At the Piano* – was badly hung and mentioned by only two major reviewers. The *Athenaeum* called it 'a fine, powerful-toned and eminently characteristic study of an old woman's head' which 'contains admirable qualities of real art of the best executive order'. The *Telegraph* deemed it 'fitter to be hung over the stove in the studio than to be exhibited at the Royal Academy, and yet replete with evidence of genius and study', and declared, 'If Mr Whistler would leave off using mud and clay on his palette and paint cleanly, like a gentleman, we should be happy to bestow any amount of praise on him, for he has all the elements of a great artist in his composition.' This reviewer then corrected an earlier oversight. Failing in 1860 to mention *At the Piano*, he now called it 'an eccentric, uncouth, smudgy, phantom-like picture of a lady at a pianoforte with a ghostly-looking child, in a white frock looking on'.

If he read these words, Whistler was not much affected. Far more

important than art notices were overseas dispatches of recent months. By the end of January seven states – South Carolina, Georgia, Florida, Alabama, Mississippi, Louisiana, and Virginia – had seceded, and early in February their delegates met in Montgomery, Alabama, and formed a provisional government, calling themselves the Confederate States of America, and elected a president, Jefferson Davis. A month later came the inauguration of Lincoln, who still hoped for a peaceful solution of the dispute. For about six weeks conditions were relatively peaceful – although the original seceding states had been joined by Texas, Tennessee, Arkansas, and North Carolina – and then in mid-April the Confederates bombarded Fort Sumter in Charleston harbour, and Lincoln issued a call for volunteers. The point of no return had been reached: shelling Fort Sumter meant war. One ancillary effect of all this must have had special meaning for Whistler: on 20 April Colonel Robert E. Lee, deciding that his conscience could not let him fight against the South, resigned his commission in the American army and became commander of Virginia's contingent in the Confederate armed forces. The early war news could only have been painful to Whistler. Although Maryland was a non-seceding slave state, it was the site of the first hostilities. It lay between the Northern states and Washington, and Massachusetts soldiers passing through Baltimore angered some residents, resulting in bloodshed on the streets and the stationing in Maryland of an army of occupation to keep communication lines open. What, Whistler surely wondered, was happening to his family and friends in the city to which he felt most closely attached, besieged Baltimore? Then came more personal news. His brother William, encouraged by his Virginia wife, had become a medical officer in the army of the Confederacy.

Early in June, Whistler collapsed and for more than a month was bedridden in Sloane Street. His illness has never been satisfactorily diagnosed, but it seems as if the malady was psychological, caused by prolonged worry and feelings of guilt that a West Pointer should be living comfortably in London while his brother, without one day of previous military experience, was a uniformed officer on active duty. Part of Whistler's tribulation probably sprang from the question of which side, had he returned, he would have joined, the Union, to which he had sworn allegiance, or the Confederacy, which commanded his emotional attachment.

The illness served its purpose. After weeks in bed, he obviously could not fight. And when he had recuperated there probably would be no need to do so because most people predicted a quick Union victory. Meanwhile he needed a holiday, and early in autumn Whistler and Jo left for the coast of Brittany.

FRANCE AND LONDON
1861-2

Whistler envisaged Brittany as the prelude to a winter in Paris. He could afford it: in addition to his usual pecuniary sources, he was earning money. Du Maurier told his mother in April 1861, 'Fancy Jimmy's first set of etchings, a dozen (the whole set sold for 2 guineas), brought him in £200 and he has just sold the 12 plates for another £100.'[1]

Not inclined to country life, Whistler stayed in Brittany just long enough for two pictures. One was an etching, *The Forge*, which he included in the *Thames Set* even though it had nothing to do with the river. Although this scene in a blacksmith's workshop has interestingly innovative lighting effects, it is less important than the oil painting originally called *Alone with the Tide*, now known as *The Coast of Brittany*.

Showing a rocky beach, a blue sky, white clouds, and, among the rocks, a sleeping young peasant woman, *The Coast of Brittany* has been regarded as the painting 'in which [Whistler's] study of nature seems to have been most continuous and most literal'.[2] This was a continuation of his Thames *modus operandi*, but the painting is more than a mass of details. Just as the etchings convey the spirit of the river below bridge, *The Coast of Brittany* is permeated with the atmosphere of a desolate beach. Du Maurier told his brother that "There is not one part of the picture with which he is not thoroughly satisfied',[3] and thirty-seven years later, writing to Kennedy, Whistler called it 'a beautiful thing – blue sea – long wave breaking – black and brown rocks – a great background of sand – and wonderful girl asleep'.[4]

After *The Coast of Brittany* was finished, Whistler and Jo were off to Paris.

He could not escape the Civil War even if he shunned the newspapers, for his mother's letters were filled with war news. One letter detailed the horrors of the first Battle of Bull Run, on 21 July, a Confederate victory demonstrating that the war would not be short, and explained why William was a Confederate: 'Ida has made Willie a thorough secessionist, thus verifying the saying "a man forsakes all for his wife." '[5] As for herself, Anna declared, 'Truly *I* know no North, *I* know no South,'

While William Whistler was in the midst of American hostilities, James Whistler, for the first time, and without apparent cause, had also become belligerent. Upon reaching Paris, he had his first recorded violent encounter. Du Maurier told his mother of 'a fight between Jimmy and a Hackney coachman, one round, all three events for Jim, which was impayable.'[6] Whistler then quarrelled with Ernest Delannoy, his companion on the Alsatian trip, with whom hitherto he had never exchanged a cross word.

Avoiding the Quarter because, Du Maurier said, he was 'no longer Bohemian',[7] Whistler settled in Montmartre, on the Boulevard des Batignolles, where, with Jo as his model, he began what would become one of the century's most celebrated paintings, *The White Girl*.

Whistler's picture was to be a life-size portrait of a woman in a white dress, standing on a white skin, in front of a white curtain. The only colours would come from the woman's red hair, the blue in the floor matting, and a few flowers. A study in 'white on white', it was, in 1862, extraordinary. On nothing did he ever work more diligently and painstakingly. Through the winter he spent every day on it, usually from eight until late afternoon. He knew that it was a landmark, signalling his break with realism; without literary, historical, geographical, or social connotations, it would, like music, impart a direct experience. It is a fine example of 'pure painting', for despite attempts to do so, no one has successfully created a·'story' for it or found in it any 'meaning'. It is simply the representation of a graceful figure in a white dress with a fascinating face. Perhaps, as some have suggested, she is in a trance; perhaps, as others have said, she has just lost her virginity; perhaps she is merely bored. Whatever story one sees in the expressionless face is in the mind of the beholder.

In February, with Jo, Whistler spent four days in London, where he was to meet his always helpful and generous etchings dealer, Serjeant Thomas. 'I wrote to the old scoundrel,' Whistler told Du Maurier, 'and he died in answer by return of post – the very best thing he could do!'[8] Du Maurier commented, 'he considers himself well out of that business, the Thomases junior being easy to manage.'

Early in April, Whistler and Jo returned for good to London, where *The White Girl* would be sent to this year's Exhibition. Arriving only a few days before the deadline for submissions, with the picture still unfinished, Whistler had not a minute to spare. Writing on 9 April to his American friend George Lucas, Jo explained, 'Jim is so very much occupied that he has no time to write himself, therefore he desires me to write for him to you.' Yet two days earlier, on reaching London, he had had time to write to Edwin Edwards, a Middlesex lawyer and art patron

who had bought several of Fantin's recent flower pictures. He spoke of 'the satisfaction it would give [Fantin] if one of his "nature montes" were sent to the Academy this year', and said, 'if you have time and can manage to send the one you would consider the most important he would I know be very much pleased.'[9] (Perhaps the request was too late, for Fantin was unrepresented at the Exhibition.) Whistler wrote from 62 Sloane Street, indicating no change in relations with Haden, who as juror for the British section of fine arts in London's second International Exhibition chose four prints from the *Thames Set*, which, except for several illustrative plates by George Cruikshank and selections by members of the Etching Club, were the only original etchings on exhibit. (Haden himself would have one entry at the R.A.)

After two or three days in Sloane Street, Whistler joined his mistress, but not in Rotherhithe, probably because after a winter in Paris she could hardly live 'below bridge'. The real Joanna Hiffernan was not the ethereal creature of *The White Girl*. In February, Du Maurier told his brother that she was 'got up like a duchess, without crinoline – the mere *making up* of her bonnet by Madame somebody or other in Paris had cost 50 fr.'[10] In May, Du Maurier disclosed that Whistler 'is in his furnitures somewhere with Joe, qui devient de plus en plus insupportable et grande dame I am told . . .'[11] A *grande dame* did not belong in the Angel Inn, and so she and Whistler settled temporarily in Chelsea, in a brick cottage at 7A Queen's Road (now Royal Hospital Road), which William Rossetti said was one of a group of 'quite old-fashioned houses, of a cosy, homely character, with small fore-courts'.[12]

Whistler awaited the opening of the Exhibition, which was not outstanding, for, as the *Illustrated London News* remarked, the show contained 'very small leaven of invention, few original thoughts, and little elevation of aim'. The writer added that 'the greatest artistic achievements completed this year are elsewhere'.

Art was indeed thriving beyond Trafalgar Square. Daniel Maclise's imposing *Interview Between Wellington and Blücher* hung in the House of Lords. A small Haymarket gallery housed a single picture, with an admission fee of one shilling – which 86,000 people would pay – by Britain's most popular painter, William Frith – the panoramic view of the new terminus in Paddington, called simply *The Railway Station*. Another small gallery, Moore, McQuin, and Co., at 25 Berners Street, was showing Millais's *Carpenter Shop*, which twelve years earlier *The Times* had found 'plain revolting' and the *Athenaeum* 'a pictorial blasphemy'. Now occupying an honoured place in a fashionable West End gallery, it was described by the *Illustrated London News* as 'remarkably original, both in its technical qualities and the mystical rendering of an imaginary incident

in the early life of the Saviour . . . unquestionably one of the most mem-
orable pictures in the contemporary history of British art'.

Moore, McQuin, and Co. had no monopoly of contemporary art on
Berners Street. Nearby at No. 14, Matthew Morgan's recently opened
Berners Street Gallery was holding its first show and the principal work
was *The White Girl*. Yes, it had been rejected by the Academy. Whistler
was nevertheless well represented in Trafalgar Square: two paintings –
The Thames in Ice and *The Coast of Brittany* – and one etching, *Rotherhithe*,
hung there. They were politely received. The *Athenaeum*, for example,
mentioned all three, seeing in *Rotherhithe* 'rigging as solid as Rembrandt
could give it', calling *The Thames in Ice* 'broad and vigorous', and finding
The Coast of Brittany to be a 'scene of wild wood and limpet-covered rock
sunk in sand, the half saturated look of which last is perfectly expressed'.

Much more important to Whistler than these accepted pictures was
his *magnum opus*, about which he had had apprehensions. In her April
letter to Lucas, Jo noted that 'the White Girl has made a fresh sensation –
for and against. Some stupid painters don't understand it while Millais
for instance thinks it splendid, more like Titian and those of old Seville
than anything he has seen – but Jim says that for all that, perhaps the
old duffers may refuse it altogether.'[13] Why did the comparatively
broadminded Royal Academy turn down a painting which everyone
now recognises as a masterpiece? One consideration was its size. Seven
feet by three and a half, it required two and a half times the wall space of
The Coast of Brittany, and nearly six times that of *The Thames in Ice*. As a
large single figure, it was doubly vulnerable, for as Stevens said, 'A picture
of a single figure is ruthlessly criticised, whilst a more complex subject is
let off more easily.'[14] Finally, an arrangement of white on white was almost
as startling in 1862 as a realistic scene of the child Jesus had been in 1850.

As he had done three years earlier in Paris, upon receiving his notice of
rejection Whistler went to a small independent gallery. Interestingly, the
Athenaeum gave considerably more space to *The White Girl* than to his
pictures at the Academy. The following appeared in its 'Fine Arts Gossip'
column for 28 June 1862:

'A new Exhibition has opened . . . with the avowed purpose of placing
before the public the works of young artists who may not have access to
the ordinary galleries. . . . The most prominent is a striking but incomplete
picture, *The Woman in White*, which the catalogue states, was rejected
at the Royal Academy. Able as this bizarre production shows Mr Whistler
to be, we are certain that in a few years he will recognize the reasonable-
ness of its rejection. It is one of the most incomplete paintings we ever
met with. A woman, in a quaint morning dress of white, with her hair

about her shoulders, stands alone, in a background of nothing in particular. But for the rich vigour of the textures, one might conceive this to be some portrait by Zoccherro, or a pupil of his practising in a provincial town. The face is well done, but it is not that of Mr Wilkie Collins's "Woman in White".'

This elicited the first of Whistler's 'letters to the editor', published on 5 July, more restrained than those for which he would become famous: 'May I beg to correct an erroneous impression . . . in your last number? The proprietors of the Berners Street Gallery have, without my sanction, called my picture "The Woman in White". I had no intention whatsoever of illustrating Mr Wilkie Collins's novel; it so happens, indeed, that I have never read it. My painting simply represents a girl dressed in white standing in front of a white curtain.' Two weeks later the 'Fine Arts Gossip' included this item:

'Mr Buckstone, of the Picture Gallery in Berners Street, writes to say . . . that Mr Whistler was well aware of his picture being advertised as "The Woman in White", and was pleased with the name. "There was no intention," Mr Buckstone adds, "to mislead the public by the supposition that it referred to the heroine of Mr. Collins's novel; but being the figure of a female attired in white, with a white background, with which no-colour the artist has produced some original effects, the picture was called 'The Woman in White' simply because it could not be called 'The Woman in Black' or any other colour."'

The erroneous name and its association with Wilkie Collins were not easily separated from this picture: as late as 1867 the *Daily News*'s art critic while writing on that year's Exhibition said, parenthetically, 'It is some years now since Mr Whistler exhibited his "Woman in White" – a somewhat claptrap title to assume for his picture from a literary celebrity.'

Whistler's displeasures of 1862 were not confined to London. In Paris, on the Boulevard des Italiens, the Martinet Gallery, owned by the painter-etcher Louis Martinet, where Manet had begun to exhibit in 1860, was hosting the first public showing of *The Thames Set*. In an essay published in April in the *Revue Anecdotique* and reprinted in September in *le Boulevard*, Baudelaire wrote: 'the other day a young American artist, M. Whistler . . . was showing a set of etchings, subtle and lively as improvisation and inspiration, representing the banks of the Thames; wonderful tangles of rigging, yardarms, and rope; farragoes of fog, furnaces, and corkscrews of smoke; the profound and intricate poetry of a vast capital.'[15] Whistler could hardly have asked for more, but perhaps because of events

overseas – on 1 June, Robert E. Lee became commanding general of the Confederate forces – he was unreasonably sensitive. Upon receiving Fantin's cutting of the second printing of Baudelaire's notice, Whistler responded: *"They do better articles in London! Baudelaire says many poetic things about the Thames and nothing about the etchings themselves!"[16] If he expected sympathy, he was disappointed. Elizabeth Pennell wrote:

'Fantin did not encourage Whistler in his misery over the failures and disappointments of the summer, did not condole with him on the lack of personal praise in Baudelaire's appreciative criticism. He wrote a straightforward letter. . . . He played the judge and pronounced judgment: *"Whistler aime trop la réussite."* [Whistler likes success too much.] Whistler accepted it humbly, gratefully. He knew that Fantin would not write anything except what he thought the truth.'[17]

If the summer of 1862 was artistically vexing for Whistler, it was also a happy period when he became friendly with the Dante Gabriel Rossetti circle. After his wife's death in February 1862, Rossetti left his Blackfriars flat and in October moved into Tudor House, facing the river at 16 Cheyne Walk. Already he and Whistler were friends. On 28 July 1862 George Boyce's diary mentions a housewarming party at 77 Newman Street for Rossetti's disciple Algernon Swinburne: 'Spent the evening at Swinburne's. . . . Present: D. G. Rossetti, Whistler, Val Prinsep, Ned Jones, and Sandys. Whistler gave humorous vent to a lot of comic stories.' (Prinsep was a painter influenced by Rossetti. 'Ned Jones' is better known as Edward Burne-Jones. James Sandys was an illustrator and painter.) Ten days later, Boyce wrote: 'went to Whistler, 7a Queen's Road, Chelsea. Found there Gabriel Rossetti, Swinburne, Poynter, and Chapman. Whistler's "Joe" was present, a handsome girl with red hair and altogether fine colour.' (George Chapman was a portrait painter.)

One might speculate on cross-currents of influence passing between Whistler and the Rossetti circle. Whistler's first 'pure painting' hung in Berners Street when he became friendly with them, and one might suppose that he voiced his ideas on 'pure art'. Among Rossetti's associates, Whistler exerted the strongest influence on the impressionable Swinburne, whose critical theories were affected by this new friendship. The *Spectator* for 6 September 1862 contained a review-essay, 'Charles Baudelaire: les Fleurs du Mal', anonymous but in fact written by Swinburne. This passage is from the first paragraph:

'. . . the poet's business is to write good verses, and by no means to redeem

the age and remould society. . . . The mass of readers seem to think that a poem is the better for containing a moral lesson or assisting in a tangible and material good work. The courage and sense of a man who at such a time ventures to profess and act on the conviction that the art of poetry has absolutely nothing to do with didactic matters at all, are proof enough of the wise and serious manner in which he is likely to handle the materials of his art.'

Replace 'poem' and 'poetry' with 'picture' and 'painting' and these lines could have come directly from James Whistler.

Whistler and his friends were practising and preaching art for art's sake in 1862 while he worked in a medium far removed from this doctrine. He produced six magazine illustrations to accompany contemporary literary works. His feelings about this come forth in the postscript of a letter to Edwin Edwards: 'I've been guilty of something in *Once a Week*!!!!'[18] Since this was the golden age of illustration, when virtually every artist was drawing for books and magazines, usually for £9 per picture, and since most of his friends were doing it, Whistler inevitably got into the act. The 1862 volume of *Once a Week* – one volume of one journal – contains twenty-seven illustrations by Charles Keene, twenty-three by George Du Maurier, twenty-three by John Everett Millais, seven by Edward Poynter, six by James Sandys – and four by James Whistler. Whistler's illustrations, single-figure drawings of young women, are good, and his manipulation of lines is not unlike that of some of his better etchings. His other two drawings appeared in Volume 3 of *Good Words*, and all six were reproduced in the first volume of the Pennell biography. These illustrations moved one admirer to 'regret that he did not more frequently draw for reproduction by the wood-engraver'.[19] It would have been out of character, however, for him to have done more. Like Rossetti, who rarely illustrated, he had too much creative originality to be a prolific accompanist of other people's ideas, and never again was he paid for an illustration.

The £54 earned from illustrating contributed to Whistler's relatively healthy finances, and in October he and Jo left on a trip to Spain. He was supposedly going to Madrid to see in the Prado in all its glory the work of the currently most fashionable old master. *"When I see you again,' he told Fantin, 'I hope to be able to describe the Fileuses and Prise de Breda!!!'[20] On the eve of departing, he wrote:

*"You must be anxiously waiting for my trip to Spain. . . . I will be the first one who can look at Velasquez for you. I will tell you all about it, I'll tell you everything. . . . Also if there are photographs to be had, I will bring

some back – as for sketches, I hardly dare attempt it. If I have the nerve, I may try. You know, that glorious painting cannot be copied – it must carry you off – oh, mon cher, how he must have worked!'[21]

This seems unambiguous, but let us not jump to conclusions too quickly. Velasquez may have been just an excuse to travel. Perhaps he left because English newspapers were keeping him too uncomfortably close to the American Civil War, or possibly he just needed a holiday.

Whistler and Jo went by train to Southampton, crossed over to Cherbourg, and then travelled to Biarritz, within ten miles of the Spanish border – where they stopped. After covering nearly three-quarters of the distance to Madrid, Whistler lost the zest to go further.

After crossing the border once, for part of one day, Whistler told Fantin:

*'Yesterday we were in Spain, yes, mon cher, in Spain! In the most ravishing little gem of a city or town that you can imagine. Fontarabie is its name – but – there are too many buts in this country – but *impossible* to stay there without speaking Spanish or Basque! It was the most unheard of thing to see the complete change in customs, faces, houses, everything, just by crossing a little stream. A matter of twenty minutes! In Behobie it is still French, and at Fontarabie it is completely Spanish! The houses are covered with green balconies, as in poor pictures, filled with pretty brown girls taking on a chocolate color all day long. The Spaniards of the Opéra-Comique in the street, and many others who are completely national in their berets and red shirts – and the children, what a swarm, wild and looking like little Turks. *No one* understands *a single word* of French, and they don't give a damn.'[22]

Ostensibly because nobody spoke French or English, Whistler returned to Biarritz and never again set foot on Spanish soil. The man who had spent his boyhood in St Petersburg, and would eventually pass a year in Venice and take four trips to Holland, was uncomfortable in Spain because he could not speak Spanish or Basque! Yet some people insist that he was irresistibly drawn to Velasquez!

After his brief incursion into Spain, Whistler returned to Biarritz and stayed there. With plenty of free time, he wrote long letters to Fantin.

*'The waves are so solid!' he exclaimed; 'and then in the middle, great billows come breaking on the separated rocks which you see *in* the sea.' He had one memorable experience in the water:

*'I almost drowned the other day. . . . I was carried off by a ferocious current which dragged me into the reefs, and if it had not been for my

model . . . I would have been carried out of here stiff. The sea was enormous! The sun was setting. Everything was getting ready for the event. I saw the earth going away, a wave of fifteen feet absorbed me, I drank a ton of salt water, went through so as to be swallowed up by a second one twenty feet high in which I turned over. Swallowed in a third one, I swam, I swam, and the more I swam the less close I got! Ah dear Fantin, to feel that your efforts are useless! and the spectactors who say to themselves, "But this man is having fun and must be awfully strong." I cried, despaired. I disappeared three, four times. Finally they understood! A fine fellow, a railroad man, came running and rolled over twice on the beach. The swimmer (my model) heard the cries, came galloping along, jumped into the sea like a Newfoundland dog, and the two held me. Enough!'

This was the most frightening event of Whistler's holiday, but there were other continuing difficulties. Artistically, Biarritz was exasperating. In one letter he wrote: *'I have had awful luck! Rain, rain, and rain, or the stupid sun without any reflection and a sea so flat you want to spit in it. I feel almost demoralized . . .' On another day he complained: *'I am languishing horridly. The weather is diabolical. . . . Each time it rains I must wait three days for the soil to dry before working. What luck, huh? Ah, the countryside!' He complained: *'I make such little progress. The big canvas is perhaps good enough in its arrangement, but it all goes so slowly I am despairing.' His slowness reinforced his belief in memory painting: *'My picture drags. I do not work fast enough! I seem to learn so little! Moreover painting from nature done outside can only be large sketches. It does not work. An end of a flowing drape, a wave, a cloud, it is there one minute and then gone for good. You put down the true and pure tone, you catch it in flight as you kill a bird in the air – and then the public asks you for something finished!'

Whistler was convinced of the folly of going away to paint:

*'Precious time is wasted. There is the arrival in the unknown country, models to train, natives who pose only with much coaxing; finally there are weeks before the painting is in the works. And then it is so far to go. It rains so much here. In the future, my dear Fantin, I shall swim in closer seas. . . . It seems to me that an interior in the country, near London or Paris, would make me happy, with a big room for the studio, then a bedroom, a small living room, etc.'

This suggests that from the beginning his terminal goal had been not the Prado but the sea of Biarritz.

Whistler did not complete his large canvas, about which we know little, but he did paint an interesting small oil picture, *The Blue Wave: Biarritz*. A sequel to *The Coast of Brittany*, it shows two large waves, beneath a greyish sky, breaking on a rocky shore. Much discussion has centred on Courbet's possible influence on this painting. Those denying it have noted, with questionable relevance, that the Frenchman's principal seascapes came later. Bénédite, who knew the work of both painters well, said, *'The Blue Wave has . . . absolutely Courbet's constant vision; it shows the same way of viewing a sight, and it has the same palette and colors.'[23] Whistler himself, referring late in life to some of his pictures, told his sister-in-law, 'They are all going to America, except my Courbet.'[24] His 'Courbet' was *The Blue Wave*.

After a few weeks in Biarritz, with one small picture completed, Whistler was happy to leave, and he and Jo returned to London. Before departing, he gave Fantin a novel reason for not taking the short south-ward journey to Madrid: *'I am postponing my trip until next year, and then you will come with me. It will be the greatest happiness! It will be a sacred pilgrimage, and nothing must stop us from taking it. Think of the fun we'll have examining those masterpieces together. That is a thousand times better than going alone! Therefore let's swear on it!' This is splendid Whistlerian rationalisation, and if ever again he asked Fantin to accompany him to Spain, his request seems unsupported by documentary evidence.

There is a final sidelight of the Biarritz trip. One of the letters, variously signed, ends *'Your devoted friend Jim McN. Whistler', perhaps his earliest nominal employment of 'McNeill'. Since Fantin obviously knew what 'McN.' represented, the name may have been annexed during the preceding winter in Paris. Whistler's tentative adoption of 'McNeill' at this time was possibly stimulated by the Civil War and his feelings of guilt for being a bystander. The McNeills had been Scottish warriors, and adding the name may have been psychologically good for him. If he could not be a fighter, he could at least have a fighting name. And so when he returned to England he was in a transitional state between James Abbott Whistler and James McNeill Whistler.

Once in London, Whistler naturally proceeded to the Thames, and on this occasion went to live near Westminster Bridge. The old stone structure, immortalised in Wordsworth's sonnet, was being replaced by an iron span which was nearly finished. Whistler at once found a subject and worked in the lodgings of the landscape painter Walter Severn. Severn's younger brother Arthur occasionally watched and later recorded his recollections:

'He was always most courteous and pleasant, and it was most interesting

to see him at work. The bridge was in perspective, still surrounded with piles, for it had only just been finished. It was the piles with their rich colour and delightful confusion that took his fancy, not the bridge, which hardly showed. He would look steadily at a pile for some time, then mix up the colour, then holding his brush quite at the end, with no mahlstick, make a downward stroke and the pile was done. I remember once his looking at a hansom cab that had pulled up for some purpose on the bridge, and in a few strokes he got the look of it perfectly.'[25]

As this account makes clear, the subject of *The Last of Old Westminster* is not the dismantling of the old bridge on the left, but the removing of the scaffolding from its replacement. Although it is realistic – with the workers beneath a background of warehouses, domes, chimneys, and the trees of Lambeth Palace Park (all of which was obliterated by the construction of St Thomas's Hospital) – the realism, as in the etchings, is thinly coated with a personal interpretation. It is a vigorous, lively painting, and one can sense Whistler's pleasure in being back in London.

Now Whistler intended to cease roving. For the first time in his adult life, he settled in a fixed place of residence, facing the river just above Battersea Bridge. The acceptance of a latchkey to his new home was a sign that his inner turmoil over events in America had ended. The American forces, northerners and southerners, would have to get along without him. He had decided to be an artist on the Thames.

PARIS AND LONDON
1862-4

'The choicest bit of London,'[1] American novelist William Dean Howells
said of Chelsea when he visited the British metropolis in the early sixties.
A native writing at about the same time in the *Illustrated London News*
called it London's 'most picturesque spot'. They, and other contemporary
enthusiasts, were not speaking of the whole borough, then a community of
63,000. It was not the King's Road which Chelsea's devotees savoured.
And it was certainly not its slums. Yes, Chelsea had slums, some of
London's worst. On one street, ironically named Paradise Walk, a recent
historian reported:

'Grimy ragged children swarmed, and several families were crammed
into four-roomed hovels. . . . Even more sinister was Jew's Row, a
labyrinth of narrow courts and passages between Burtons Court and
Lower Sloane Street. Here were filthy lodging houses and thieves'
kitchens, and . . . prostitutes crouched together on the curb to hurl insults
at passers-by or set upon some unwary traveller and pick his pockets.'[2]

The first woman with whom Holman Hunt fell in love, Annie Miller,
came from this environment. She lived with her family in what Hunt told
his fellow Pre-Raphaelite F. G. Stephens was 'the foulest of courts –
infested by vermin'. The Millers, Hunt said, 'were filthy and covered with
vermin' while Annie, 'allowed to prowl about the streets using the coarsest
and filthiest language', was 'in a state of the most absolute neglect and
degradation'.[3] The Annie Millers of Chelsea were ignored by those who
spoke of its beauty and picturesqueness. They saw Chelsea on the River
Thames.

In one respect riverside Chelsea has been unaffected by the passage
of time. Cheyne Walk's charming red-brick houses with white window
frames, deep verandahs, tall railings, and wrought-iron fences, behind
small gardens, have not changed and were spared by wartime bombing.
Otherwise the scene in 1863 was vastly different from what it is now. It was
altered by the building of the embankment, completed in 1874, and the
coming of the automobile.

In the sixties, Chelsea's main thoroughfare was the river, crowded with a variety of boats, 'from chunky, russet-sailed Thames barges and clanking paddle steamers to skiffs, wherries, racing shells and on special occasions the stately barges of the City Companies'.[4] Like the European cities with which it was often compared, Chelsea could best be seen from one of these boats. In 1871 a passenger going down river described what he saw:

'Beyond Battersea Bridge the tiled houses begin at once; the footways along the banks are sternly stopped, and we begin to see those charming slopes and swards, those snatches of old houses playing hide and seek with us between the trees.... As we glide on and draw in to shore, we observe a shaded walk, sheltered by the two rows of tall trees ... and beyond them a background – a cosy row of red brick houses – an old-fashioned terrace, of bricks of Queen Anne's special hue, with twisted iron railings and gates in front. At the edge of the road in front of the trees is an irregular wooden railing, against which loungers rest. Below them are boats drawn up. . . . We land and find ourselves on Cheyne Walk.'[5]

Upon landing he would have stepped on to 'a picturesque path under stately trees that seemed like the edge of a Dutch canal and had an atmosphere of the time of William and Mary'.[6]

Whistler knew that the river front would not for long remain unchanged: already, in the interest of 'progress', Parliament had appropriated money for an embankment. But, fortunately for him, the English do not habitually move with haste, and for another decade riverside Chelsea would remain a painter's haven.

'Chelsea does not breed artists,' a later resident said, 'she adopts them; but they would die for her.'[7] Preceding Whistler to the riverside were Turner, John Martin, Maclise, and a handful of Pre-Raphaelites. They were artists, and they had the temperament for Chelsea. 'If you have not that temperament,' another later resident said, 'Chelsea isn't for you; try Hampstead or Streatham or Bayswater.'[8] The Chelsea temperament was sometimes misunderstood. A borough historian wrote:

'There is a prevalent opinion that Chelsea is the British counterpart of the Quartier Latin, but the resemblance is only superficial. The Quartier Latin and respectability are poles asunder; its population does not only never think of respectability, but it does not know what it is. Parisian Bohemians have no use for it. . . . Chelsea is not in revolt against morals or anything else; for the most part it is quiet, law-abiding, and hard-working.'[9]

In Chelsea, another of its intimates said, 'the studio is not a squalid garret. Rodolphe writes light verse for "largest circulations". . . . Marcel . . . is poor in so far as he dines for two shillings instead of five. . . . There is a *vie de Bohème* at Chelsea, but it is a *Bohème* of coffee and liqueurs and Turkish cigarettes.'[10] Whistler, who, it will be remembered, skipped the Latin Quarter on his recent Parisian sojourn, was temperamentally suited to Chelsea.

His new home, 7 Lindsey Row (now 101 Cheyne Walk), once formed part of an early seventeenth-century mansion, Lindsey House – named after its principal owner, the Earl of Lindsey – which in 1760 was divided into five dwellings. Number 7 is a narrow three-storey house, thirty yards above Battersea Bridge, which, slanting towards the water, commands a splendid, far-reaching upstream view of the river. The house was surrounded by contrasts. The immediate environs, in the words of a contemporary, had 'all the air of a continental scene',[11] but a few doors up the river bank looked not unlike that of Rotherhithe, with water stairs, wharves, warehouses, and boat-builders' jetties and shanties. And about four hundred yards westward was the favourite pleasure ground for London's lower half of society, Cremorne Gardens.

Downstream, just beyond the bridge, was Tudor House, the new home of Dante Gabriel Rossetti, whose spacious accommodations he shared with his brother and Swinburne. Rossetti's circle of friends liked Whistler's work – Swinburne revered him as the world's greatest living artist – and their enthusiasm would perhaps be converted into guineas. The grandson of Ford Madox Brown, Rossetti's closest friend, and, chronologically, the first English Pre-Raphaelite painter, told of coming 'upon a circular that Madox Brown had had printed, drawing attention of all his old patrons to the merits of Whistler's etchings, and begging them in the most urgent terms to make purchases because Whistler was "a great genius"'.[12] Rossetti also helped. On 1 February 1863, he wrote to one of his patrons, the Newcastle lead merchant James Leathart:

'I once recommended a picture (Inchbold's) [James William Inchbold, a landscapist influenced by the Pre-Raphaelites] which I know has grown on you more and more in liking. I am inclined therefore just now to do the same in another instance which I am sure would have the same result with you, as it has had now with myself, having got to know the picture well through near neighbourhood with the painter. I allude to Whistler's 'Breton Coast Scene' [*The Coast of Brittany*] . . . which is a work really quite unsurpassed in many qualities both of truth and pure colour. . . . Whistler is willing to sell it for 80 guineas, which is a decidedly moderate price. . . . I have such a hearty admiration for the high qualities of style and

use of nature in Whistler's works, and am so well aware that they have not yet met with their deserts from purchasers that I am induced thus a second time to suggest a possible purchase to you.'[13]

Leathart did not take the picture, which was bought late in the year by Whistler's half-brother George.

In other ways, Whistler was to be helped by a former Rossetti associate, F. G. Stephens, one of the original seven Pre-Raphaelites, who in 1860 became art critic of the *Athenaeum*.

Whistler's new friends did not separate him from the past. He still occasionally saw Poynter and Du Maurier; and for a time he and Jo shared 7 Lindsey Row with Legros, who had settled in London. In the spring of 1863 Whistler and Legros made their first trip to Holland. Most accounts of the journey imply that they travelled alone, but they had a companion who probably paid for most of the expenses, Seymour Haden.

Before departing for the Continent, Whistler wrote to Fantin from '62 Sloane Street'. Dated 23 March, the letter said, in part, *'My dear friend, I am coming! I am coming to your house next Sunday. . . . I am staying in Paris one day. I'm bringing *The White Girl*! I shall unroll my canvas and frame it in your studio, so we can see it together before sending it to the Salon. . . . It will be such a great pleasure to consult you about it.'[14] Whistler was not sanguine about his painting. Bénédite reported that on reaching Holland *'he sent word to Fantin to ask Martinet to exhibit *The White Girl* . . . "if it is refused as I suspect"'.[15]

In Holland, Whistler rhapsodised over Rembrandt's *Night Watch*; he saw, in The Hague, several of his etchings in an exhibition; and he etched the fine *Amsterdam, from the Tolhuis*, a maritime scene, with wharves, warehouses, and sailing boats. He also wrote to Fantin:

*'Six weeks from now I will have you with me in London doing the kind of painting you like and receiving gold and bank notes for it. . . . It is probable that we will pass through Paris, and we will take you by force – for it is absolutely imperative that you have English guineas as we [Whistler and Legros] do. You must have your fortune made – and we will have you make it in spite of yourself. Don't think we are kidding. Everything is already decided and arranged.'[16]

Before he could drag Fantin away, Whistler confronted more immediately personal artistic matters.

Upon returning home, he stepped into a furore. Henry Holiday, who worked on the fringe of the Pre-Raphaelite circle, recalled that 'the rejections [by the R.A.] this year were of so extraordinary a character,

and the show of the work on the walls so poor, that there was a general storm of indignation at the total want of judgment, and apparently of justice, shown by the council. Holman Hunt wrote to me that there ought to be an exhibition of some of the chief of the rejected works.'[17] As Holiday, a rejectee, prepared to collect his picture, Whistler appeared and

'expressed himself characteristically. Glancing round when he entered, he went straight up to my picture and said, with a sort of cry of indignation, "Do you mean they rejected *that*?" And his language was free on the subject. I had not met him before, but he shook hands warmly and pitched into the R.A. in a way that did me good.

'Old Redgrave [Richard Redgrave, an R.A. since 1851 who had had many official responsibilities in British art circles] came in at this moment. He made the best case he could for his colleagues ... and said, "You know they can't hang everything that comes in higgledy-piggledy." "Why," exclaimed Whistler with vehemence. "What do you call your present exhibition, isn't that higgledy – and particularly *piggledy*?"'[18]

Whistler was not a disinterested party. He had six etchings in the show (five from the *Thames Set* and a recent portrait of Jo), but two of three paintings had been rejected. He was so angry, Du Maurier told his brother, that he threatened to mutilate his accepted painting, *The Last of Old Westminster*: 'Jimmy swears he's going to take a penknife and cut his picture out of the frame.'[19]

Whistler did not cut his picture, perhaps because he could not find it, for, as Du Maurier reported, it was 'down on the ground'. Most of the reviewers, however, saw it and liked it. Mentioning it in the first notice, *The Times* called it a 'remarkable river-side subject ... full of rude force and directness'. In the *Athenaeum* Stephens also reviewed it early and chided the Academy:

'Below the "line", where the crinolines scour its surface, hangs Mr Whistler's artistic and able picture. ... A comparison of the artistic qualities of this boldly executed work with what we have seen in those by Mr Roberts† will show, if it be needful to do so, where the last fail altogether in Art, and are little else than misrepresentations of fine themes. One glance at Mr Whistler's reading of the softened, warm grey of a London sky, so feelingly rendered here, and so beautiful in truth as it is, will satisfy the student that the artist has found something Mr Roberts's

† David Roberts, an R.A. since 1841, was a prolific painter of architectural subjects and at the 1863 Exhibition showed two scenes of St Paul's viewed from the river.

black and white and blue give no idea of. The streaming-motion of the river as it goes past the piles, its many and subtly-hued surface, the atmosphere among the piles, their solidity, so deftly given without toil, the aerial beauty of the removed shore, are such that, if the Hanging Committee had given a moment's thought to them, it would have put this picture where it ought to be, in an honourable position.'

Other reviews were briefer but generally favourable. The *Art Journal* called it 'an original subject well carried out'. The *Spectator* said, 'Mr Whistler's dashing sketch deserves notice. As a sketch it is very good. For anything else, the greater part of it, especially the water, is far too stenographic.' The *Morning Herald* remarked that 'although a very slight sketch [it] represents the subject well'. *The Observer* deemed it an 'excellent work' in landscape, and for *London Society* it was a 'clever sketch in oil'.

Those who called the picture a 'sketch' implied that it was not finished and that Whistler had not taken sufficient pains with it. The *Illustrated London News* spoke directly to this point: 'Few but professional artists will appreciate the indications of power here; and we would therefore say that, since the painter would have us believe he can do so well with so little pains, he would show more respect to himself, his art, and the public by trying to do better.' These were the first notes of a charge that would become much louder in later years.

Whistler's etchings were also badly hung, in the infamous Octagon Room, near those of 'H. Dean' (Haden, with three etchings in his fourth successive Exhibition). Only one reviewer, the *Athenaeum*'s Stephens, mentioned them, and again he reprimanded the Academy:

'The artistic importance of etchings . . . has been overlooked by the hangers. . . . Thus, in the dismal Octagon Room are placed some of the exquisite dry-point productions of Mr Whistler, whose fame the Royal Academy ignores by placing the marvellous plates that measure five inches by eight or so, at the top of the room, one hangs where the sun comes to ruin its delicacy, even if it could be seen at all, – another [*The Pool*] is in the shade, equally high, a third [*Monsieur Bequet*] broad as a Rembrandt, is down on the floor. Like the last are placed Mr H. Dean's dry-points, which are only inferior to Mr Whistler's works. If anything can match the injustices and absurdity of this it would be for the Royal Academy to ignore etching altogether.'

It would be interesting to know if Stephens discovered 'H. Dean' on his own, or had been briefed by Whistler.

If there was turmoil in London, it was a tempest in a teapot compared to what was happening in Paris.

On 12 April, Parisians learned that three-fifths of 5,000 paintings submitted by 3,000 artists had been rejected by the Salon's jury, an action that many called a 'massacre'. Louis Martinet was deluged with requests to exhibit rejected works, and on 15 April he announced that he would try to sponsor such a show. Since, unsurprisingly, one of the rejects was *The White Girl*, Whistler wrote, care of Fantin, to Martinet, *'I would like to exhibit in your Salon du Boulevard. It would be very kind of you, if there are any formalities to follow, to consider this as my authorization to have the picture sent from the Palais de l'Industrie.'20

Martinet's gallery was too small for an exhibition of this magnitude, but because of the fervour something had to be done. Something was done, and it was unprecedented. On 22 April, Emperor Napoleon III visited the Palais de l'Industrie, and after examining some rejected pictures he ordered Count Nieuwerkerke, president of the Salon Jury, to hold an exhibition of rejected works alongside the regular Salon. Two days later the official *Moniteur* stated:

'Numerous complaints have reached the Emperor on the subject of works of art that have been refused by the jury of the exhibition. His Majesty, wishing to leave the public as judge of the legitimacy of these complaints, has decided that the rejected works of art be exhibited in another part of the Palais de l'Industrie. This Exhibition will be elective, and artists who may not want to take part will need only to inform the administration.'21

When he learned of the Emperor's announcement, Whistler, in Amsterdam, wrote to Fantin, also rejected, *'My dear Fantin! It is enchanting for us, this exposition of the rejects! Certainly I will leave my picture there, you too. It would be foolish to take them out and put them in Martinet's. Therefore, do not give him that authorization I sent you, tear it up immediately.'22 Most of the other rejected artists also went along with the new exhibition, and the Salon des Refusés, as it was called, represented the work of more than 1,200 people, including Jongkind, Bracquemond, Legros, Pissarro, Monet, and Cézanne. From one standpoint the show was a success: its attendance equalled that of the regular Salon. Many, perhaps most, of the visitors, however, came to be entertained. The English critic Philip Hamerton described their mood and behaviour: 'On entering the exhibition of refused pictures, every spectator is immediately compelled . . . to abandon all hope of getting into that serious state of mind which is necessary to a fair comparison of works of art. That threshold once past, the gravest visitors burst into peals of

laughter.'[23] It would not seem as if the pictures were sufficiently comical to provoke this mirth. Perhaps viewers were eager for relaxation after seeing the Salon proper (one had to go through the Salon to reach the Refusés), or perhaps their reaction was pre-conditioned: rejected pictures must be bad, which only fools would exhibit, so why not laugh?

How did the moulders of opinion react? Some ignored the show. In the *Moniteur*, Théophile Gautier's twelve notices on the Salon did not include one word on the rejects. Maxime du Camp wrote a long article on the Salon for the *Revue des Deux Mondes* and added a brief non-committal note on the Refusés without mentioning anyone by name. Of those who reviewed the exhibition, critics on both sides of the Channel were generally negative. Ernest Chesneau called it the 'Salon of the Van-quished',[24] and Martinet, who might have been expected to be friendly, said it was an 'exposition of comics'.[25] English critics took special joy in ridiculing a French show. The *Illustrated London News* said:

'The ironclad in self esteem, the hippopotamus-hided in egotism have accepted the Imperial boon. Rope enough has been given to them, and they have hung themselves. . . . The spectator asks with amazement who on earth the people can be who have executed these prodigious "mulls"? The only rational conclusion to be arrived at is that all the sign-painters who have thought themselves above the representation of sausages and slices of melon on wineshop door-jambs – all the clockmakers' apprentices, fired with emulation by the study of pictorial pendules – all the executants of "spotted girl" and "cow with two heads" cartoons for the shows at fairs – all the Zouaves who have relieved the tedium of garrison duty by scrawling caricatures of battle-pieces – and all the lunatics in Charenton who have been permitted the use of pencil and palette . . . have dispatched their achievements to the Palais de l'Industrie.'

The Times asked, 'Where are the friends of these artists? Was there no one to say "Don't send your picture into the Exhibition; wait till you can do better" and then later, the advice refused, and the picture rejected, was there no one to counsel the artist not thus to advertise his failings?'

Truly, a mass of rubbish hung among the Refusés, most of which had been properly rejected. But not all of it. In the *Gazette des Beaux-Arts*, Paul Mantz wrote:

*'. . . since talent always speaks louder than mediocrity, the good paintings in the annex escape the attention of competent judges all the less because they are surrounded by poorer ones. This is not to say that the Salon of the rejected does not include many silly things, many, sad to say, ludicrous

specimens contrary to the most essential laws of art . . . but there are to be found there also works of an honorable and serious nature, and frankly it is not there that the jury ought to have placed them.'

Among the latter works, the most widely discussed were Manet's *Le Déjeuner sur l'herbe* and Whistler's *White Girl*.

Le Déjeuner sur l'herbe could not but attract attention because this picture of two fully dressed men picknicking with two naked women had been denounced by the Emperor. Some reviewers agreed with him. Philip Hamerton called Manet a 'wretched Frenchman' whose picture was 'of the class which lead to the inference that the nude, when painted by vulgar men, is inevitably indecent'.[26] The French critic Louis Étienne wrote, *'A commonplace trollop, as nude as is possible, shamelessly struts between two dandies who are dressed and wearing neckties, as much as is possible. These two characters look like schoolboys on vacation, committing an enormous crime to make themselves men; and I vainly search for what this not very fitting puzzle can mean.'[27]

Le Déjeuner sur l'herbe was notorious for reasons which had no bearing on the fame of the one picture which aroused more notice than Manet's work, *The White Girl*. Fantin did not exaggerate when he told Whistler that his picture had *'certainly caused the biggest sensation'[28] in the show.

Whistler was greatly concerned about the journalistic treatment of *The White Girl*. He wrote to Fantin, Bénédite related, and *'eagerly inquired if "Graham's Figaro had been good," and asked about the Gazette des Beaux-Arts, and Théophile Gautier, and he would very much like to know what they were saying about it at the Café du Bade.'[29] Fantin responded:

*'Now you are famous. Your picture is very well hung. You have won a great success. We find the whites excellent; they are superb, and at a distance (that's the real test) they look first class. Courbet calls your picture an apparition, with a spiritual content (this annoys him) . . . Baudelaire finds it charming, exquisite, absolutely delicate. Legros, Manet, Bracquemond, De Balleroy and myself, we all think it admirable.'[30]

*'The artists', Duret said, 'were struck by its range of colour' and recognised 'the work of a man born a painter, endowed with an absolutely correct vision' in a painting with 'a form as the subject, and at the same time a combination of white tones which could be called an arrangement in white.'[31]

The admiration of *The White Girl* was not confined to fellow artists. A number of important reviewers also liked it.

Wilhelm Burger-Thoré said, 'The image is rare, conceived and painted like a vision,'[32] and Ernest Chesneau felt it 'reveals superior picturesque qualities, an imagination amorous of dreams and poetry'.[33] In his booklet *The Salon des Refusés*, Fernand Desnoyers wrote:

*'The most unique, most interesting painting is Whistler's *The White Girl*. . . . It is both simple and fantastic; her face has a tormented and charming expression which immediately catches one's attention. There is something vague and profound in the gaze of a girl whose beauty is so unique that the public does not know whether to call her ugly or pretty. This portrait is vibrant, remarkable, fine, and one of the most original paintings to pass under the eyes of the jury.'[34]

Paul Mantz's extremely important review in the *Gazette des Beaux-Arts* gave *The White Girl* far more space than any of the other Refusés:

*' "The White Girl" is . . . a bit peculiar; but we would indeed reveal our ignorance of the history of painting if we dared to pretend that Mr Whistler is an eccentric when, on the contrary, he has precedents and a tradition that one should not ignore, especially in France. What is his picture about? About a young lady who, arranged in white from head to toe, stands out against a white curtain. I don't know whether Mr Whistler has read the life of Oudry as told by the Abbé Gougenot, but he could have learned there that the clever master sought on many occasions to group, as the historian says, "objects of different whites," and that he exhibited at the Salon of 1753 a large painting "representing against a white background diverse white objects, including a white duck, a napkin of damask linen, porcelain, cream, a candle, a chandelier of silver, and paper." These associations of analogous nuances were understood a hundred years ago by everyone, and the difficulty which would baffle more than one master today passed then for child's play. In searching for a similar effect Mr Whistler continues therefore in the French tradition. . . . Yet he was perhaps wrong to dot the carpet on which his charming phantom is walking with blue tones; he has stepped there not only beyond the boundary of his principle, but almost beyond the boundary of his subject, which is nothing more or less than a symphony in white. . . . Mr Whistler's work radiates a strange charm, and for us it is the choice specimen in the heretics' salon.'[35]

In appreciating *The White Girl*, the French critics were well ahead of the general public. Étienne, who, we noted, denounced Manet's picture,

said of Whistler's: *'The ignorant people laugh when they pass in front of this painting; I understand that it is execrated, but I defy any being slightly imbued with artistic feeling not to stop and think before this austere young woman . . . standing proudly on an animal skin.'[36] In his novel *The Masterpiece*, Émile Zola referred to the public laughter: ' "The Woman in White" . . . was rarely without her group of grinning admirers digging each other in the ribs and going off into fits of helpless mirth.' As Bénédite said, *'We cannot now imagine that the public laughed at it.' He then pointed to the causes of the hysteria:

*'It came from the relations of tone upon tone, the arrangement placed very high on the canvas, with the figure posed in the background and the wide perspective rising from the ground, which has been used so often since Whistler. It came from the fact that these effects were then totally new; they have been repeated so many times that we no longer perceive the newness.'[37]

It is therefore especially to the credit of those critics of 1863 who could see greatness in *The White Girl*.

For Whistler the Salon des Refusés was a landmark. He had gained his first fame and notoriety, which was not limited to France. He told Fantin, *'Christ, if you only knew what effect this novelty has created here. They are all quite disgusted, the Horsleys and the others, to think that *The White Girl* is so well accepted in Paris after being so poorly treated here.'[38]

Before the summer ended, Whistler gained a less publicised tribute from Amsterdam. Readers of 'Fine Arts Gossip' in the 18 July issue of the *Athenaeum* learned that

'Mr Whistler has received at the Exhibition of the Fine-Arts at The Hague, a gold medal, one of three medals awarded to foreigners, for his beautiful etchings, some of which have been seen at the Royal Academy this year. After the manner in which his works were hung here, it must be some consolation to know that their merit has been recognized in Holland, a country possessing the traditional right to judge of such work and glory in the fame of Rembrandt.'

He immediately informed his mother, who told Gamble, 'The gold medal . . . came with a flattering letter from the president of the Academy of Fine Arts. There was an inscription too, on the massive gold medal with James Whistler's name in full, how encouraging!'[39]

Anna Whistler's happiness over her son's success was shared by two

young men with whom he became friendly soon after moving into Lindsey Row, Henry and Walter Greaves.

One of the most prosperous of the Chelsea watermen, attached to the wharves and boat-building facilities above Battersea Bridge alluded to earlier, was Charles William Greaves of 9–10 Lindsey Row. He had often rowed for Turner on sketching excursions, and though not a cultivated man had encouraged one of three daughters, Eliza, to become an accomplished musician and two of three sons, Henry and Walter, to become good amateur painters. The more talented of the brothers, Walter, painted at least one masterpiece, *Hammersmith Bridge on Boat Race Day* (now in the Tate Gallery), which may have been done when he was only 16. It has been traditionally dated 1862, but some viewers have contended, partly because of the clothing and women's hair styles, that the picture must have been created eight or ten years later, after he had met Whistler. But regardless of when Walter Greaves painted *Hammersmith Bridge*, the picture demonstrated a talent which, to a degree, he shared with his brother, and brought them and Whistler together. Walter told of their initial meeting: 'One day we were painting on the river bank, when Whistler, whom we knew by sight as a neighbour, came upon us and watched us at work. He said suddenly, "Come over to my place," and we went there and he showed us his work. . . . I lost my head over Whistler when I first met him and saw his painting.'[40] The brothers seized the chance to be friendly with a now famous painter, and he welcomed the presence of a couple of satellites. The three of them developed a camaraderie, but it was always understood who was the leader and who were the followers. 'For many years,' Walter related, 'we saw him nearly every day. We attended to all the work of his studio, mixing his colours, stretching his canvases, preparing the grey distemper ground he used to work on, and painting the mackerel-back pattern on the frames. . . . Besides this we helped to paint the inside of his home. . . . Of course, we never got so much as a shilling for what we did, but we never minded that.'[41] Additionally, since Whistler's interest in the river was as great as ever, they gladly rowed him wherever he wished to go by day or night. He 'would start with them in the twilight', the Pennells reported, 'and sometimes stay on the river all night . . . drifting into the shadows of the old bridge, or else he was up with the dawn, throwing pebbles at their windows to wake them, and make them come and pull him up or down stream.'[42]

Whistler's domination over them was total. In the words of Tom Pocock, principal chronicler of the Greaves family, 'the brothers took to dressing like Whistler in dark, wide-brimmed, low-crowned hats set at an angle or with the brim turned up. Henry grew a tuft of an "imperial" below his lower lip as Whistler had, and Walter affected coloured ties and gloves as

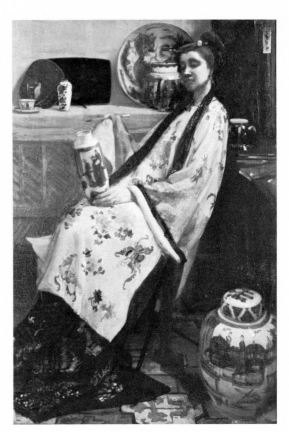

26. The Lange Leizen of the Six Marks

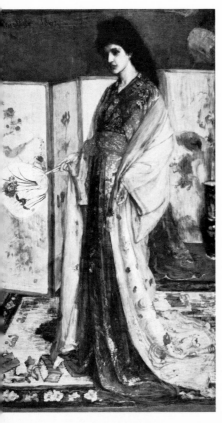

27. La Princesse Du Pays de la Porcelaine

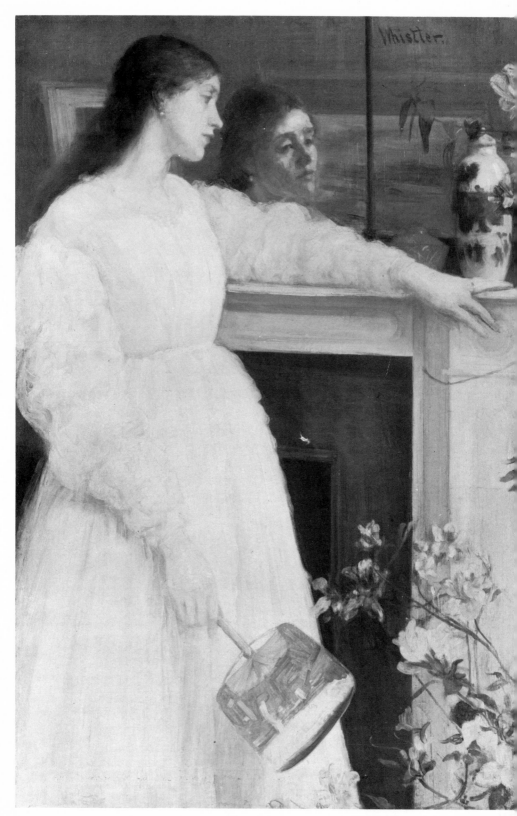

28. The Little White Girl

did Whistler.'[43] Because of their closeness to him, the Greaveses, although not particularly articulate, provided occasional glimpses into facets of Whistler's personality. Walter, for example, recollected for the Pennells 'how Whistler would have a passing hurdy-gurdy in the little garden in front of the house to play for a quarter of an hour or so, because he liked music. "He was a rare fellow for music," Greaves said, and he and his brother would play for hours in the evening while Whistler danced.'[44] Walter also remembered that Whistler 'always reviled Turner'.[45] Curiously, in light of his earlier idolatry, Whistler developed a hatred of Turner's work which would be lifelong. An early documentation of his changed attitude appears in a letter of February 1862 from Du Maurier to his brother:

'You should have heard Marks [Murray Marks, an Oxford Street art dealer who specialised in antiques and china] tackling Jim at Jeckell's [Thomas Jeckell, an architect] the other night about Turner. Jimmy owned he couldn't see much in Turner. . . . Hence a long discussion, in which Jimmy pitched into Turner for being so particular about being mounted. . . . Marks with great indignation: "Particular! why he'd leave his pictures in his court yard to be pissed against!" – Jimmy: "Well, that accounts for some of the damned peculiarities we're obliged to swallow!" '[46]

Once a worshipper of Turner why did Whistler now hate his work? Who knows? Perhaps he had carefully revised his assessment of Turner's work, but perhaps his judgement was less professional than personal, possibly tinged with annoyance, envy, even jealousy, which may have been heightened after meeting the Greaveses and hearing them extol the virtues of the man who had known their father. Whatever the reason, Whistler would never again say a kind word about J. M. W. Turner.

Whistler was friendly with all of the Greaveses, 'a sort of Peggotty family,' he called them. He often visited their home, where 'after supper', Pocock related, 'Walter or Henry would strum on the piano and Whistler would prance round the room with one of the girls in a dance that was part-waltz, part can-can, or sing comic plantation songs.'[47] As in Washington, the Latin Quarter, and Rotherhithe, so now in the home of a Chelsea boat-builder he could without condescension perfectly accommodate himself to his environment.

Whistler continued to maintain good relations with Haden, who from an upper window of Lindsey Row etched *Battersea Reach* and *Whistler's House, Old Chelsea*. Whistler himself was not doing much etching because of painting commissions. As Du Maurier told his brother in February 1864, 'The Greeks are a providence to Jimmy and Legros, in buying their

pictures.'[48] At this time Boyce noted that 'Whistler has begun two pictures of the Thames, very good indeed.' One was *Battersea Reach* (probably the version in Washington's Corcoran Gallery), and the other was *Chelsea in Ice*. Part of the latter was done in the presence of a studio guest who wrote: 'During a very sharp frost of a few days, ice was passing as we looked out upon the Thames. He could not resist painting, while I was shivering at the open window.'[49] The writer was Anna Gibbs McNeill Whistler.

Although long threatened, the arrival of Whistler's mother came with startling suddenness. *'All of a sudden in the middle of the affair,' he told Fantin, 'my mother arrived from the United States! General upheaval!! In about a week's time I had to empty my house and purify it from cellar to attic, look for a buen retiro for Jo, an apartment for Alphonse [Legros, still staying in Lindsey Row], go to Portsmouth to meet my mother. If you could see the state of affairs! Affairs! up to my neck in affairs!'[50] The most urgent affair involved Jo, who at once moved into separate lodgings. Living quarters were perhaps the least of the problems surrounding Jo at this moment, probably the worst time for Anna Whistler to turn up. Joanna Hiffernan, it seems, was in an advanced state of pregnancy.

Jo's pregnancy is one of the most speculative matters in the early life of Whistler. Walter Greaves and one of his sisters told the Pennells that she gave birth to Whistler's son during his residence 'at No. 7',[51] that is no later than early 1866, when he left 7 Lindsey Row for good. Certainly Jo became pregnant before Anna arrived, and several signs point to the present time. What did Whistler mean by saying that his mother had come 'in the middle of the affair'? In the middle of what affair? Then there is Whistler's highly praised etching of late 1863, *Weary*, a full-length portrait of Jo in a voluminous skirt resting in an easy chair, obviously fatigued. Why was the woman who had stood tirelessly day after day for *The White Girl* now exhausted when she was not working? In February 1864, Du Maurier wrote to his brother: 'I am told that Jim stands in mortal fear of Joe, and that he is utterly miserable; I met him lately and he certainly wasn't very nice to me, and seemed to have grown spiteful and cynical et pas amusant du tout. I fancy the Joe is an awful tie.'[52] Was Whistler 'miserable' and Jo 'an awful tie' just because she had to make way for Anna? If Jo were pregnant, everything – Whistler's panic at hearing of his mother's arrival, the oblique passage in the letter to Fantin, the etching, *Weary* and the treatment of Du Maurier – fits into a consistent pattern. Also, for a spell we hear nothing of Jo in Whistler's writings or in those of his friends and acquaintances. As for the child, a Greaves daughter recalled: 'a carriage came one day, and French nurse, baby and all, got in and went to Paris.'[53]

Jo's putative pregnancy and his mother's arrival disturbed Whistler only temporarily. Nothing could for long keep him from his work. In her February letter to Gamble, Anna said: 'He is so pressed for time because of a picture now on his easel that he can neither read nor write for his mother.'[54] He was working on two principal Thames paintings.

One current picture, *Old Battersea Bridge* (the first of two paintings with this title), commissioned by Alexander Ionides, would not be finished and exhibited until 1865, but because of its close relationship to recent work it is appropriate to deal with it now.

The Battersea Bridge of Whistler's tenancy at 7 Lindsey Row was a narrow, wooden, nineteen-span structure completed in 1772. It had always been hazardous. At one time people had fallen off because of inadequate protective railings, and its closely-set piers had often been struck by boats and barges. Because of its dangerousness, many had repeatedly argued that it should be replaced. But even had it been the world's safest bridge, some would have wanted it torn down because of its appearance. In typical comments, mid-Victorians called it 'an ugly edifice'[55] and 'one of the most horrible constructions which one can imagine'.[56] On 31 May 1862, a leading architectural journal, the *Builder*, referred to it as 'a criminal of the first water' which too long had 'encumbered the earth, or, rather, the water, with its baneful presence' and thus 'deserved condemnation and destruction'. Another observer deemed it 'a sad contrast, in every respect, to the elegant structures that now span the river', and hoped 'there will soon be erected another one in its place – one that will be an ornament to Chelsea, Battersea, and the metropolis'.[57]

One dissenter from these views was James Whistler, who ignored the 'elegant structures' while producing two major paintings and at least one etching of Battersea Bridge. Again he found beauty in what others considered ugly. His current representation shows a group of watermen, a barrel-laden barge, the bridge itself with waggons, vans, and pedestrians, and, in the background, homes and factories of Battersea. It is natural to compare this with *The Last of Old Westminster*. *Battersea Bridge* has more tightly unified details, possesses a finer atmospheric quality, and, probably, is the better picture. (The reader of this volume will find the paintings reproduced together.)

Some years later, when the old bridge was about to be replaced by the present structure, a writer for an art magazine thanked Whistler for preserving the beauties of the doomed span. Its end, she said, 'comes like the death-knell of the old charm of this part of the river. Cumbrous as it is, it is far more in harmony with its surroundings than any stone bridge, however massive and handsome, can ever be.'[58] This passage

indicates why Whistler was attracted to Chelsea's old wooden bridge and relinquished the newer erections to Monet.

During these early months of 1864, as he began one painting of the Thames, he was finally completing another picture of the river which he had begun in Rotherhithe in 1859 – *Wapping*.

Before Mrs Whistler reached London, Rossetti and several of his friends wrote to James Leathart about *Wapping*. On 4 November 1863 Ford Madox Brown said, 'You may remember that I thought very highly of Whistler's picture, and I still think it would enhance the value of your collection. . . . I only saw the picture once and by night, but I don't think I can be much mistaken.'[59] On 9 December Rossetti told Leathart, 'The Thames picture is still unsold, and . . . I find its price is 300 guineas. It is the noblest of all the pictures he has done hitherto, and is *the* one for your collection.' On 25 February 1864, the Scottish poet-painter William Bell Scott, another member of the Rossetti circle, added his endorsement: 'The picture has extraordinary power and distinctness at a distance and would be so distinct among all the pictures you have in that room that all would be benefited.'

Leathart made an offer, but it was too late. On 25 April 1864, Scott informed him that Whistler 'sold his picture to an American for £350'. The purchaser was Thomas Winans.

Whistler sent *Wapping* to the Academy, where it was accepted, well hung, and, as Whistler's first public exhibit since the Salon des Refusés, was an object of great interest.

The Times's first notice was a general discussion of the show, and when, in the second notice, it turned to specific works, Whistler was mentioned first:

'There are no pictures in the Exhibition showing more unquestionable power, accompanied by an almost defiant eccentricity, than the two by Mr Whistler. [For reasons that will be clear, Whistler's second picture will be discussed later.] The painting of the Thames and its various river craft . . . could hardly be surpassed for force and truth. If Velasquez had painted our river, he would have painted it something in this style. It is a pity that this masterly background should be marred by a trio of grim and mean old figures. There are noble-looking merchant sailors and fair women even among the crowd of Ratcliff-highway. But it is Mr Whistler's way to choose people and things for painting which other painters would turn from, and to combine these oddly chosen materials as no other painter would choose to combine them. But even such power as Mr Whistler's does not excuse his defiance of taste and propriety. He should learn that eccentricity is not originality, but the caricature of it. . . .

Mr Whistler has so much power, we think it a thousand pities . . . when he can draw so well . . . to give us figures as repulsive and unfinished as those in his balcony.'

The Times set the tone for the response to *Wapping*. The *Telegraph*'s critic wrote:

'There are some obvious faults . . . the foreground figures are carelessly painted and unpleasant. . . . But there is nothing in the whole exhibition which approaches these pictures [*Wapping* and Whistler's other entry] in one of the rarest and finest gifts which an oil painter can possess. They have a truth of relative tone in the colouring which seems almost perfect and this truth has been gained, not by elaborate handling, but at once. Every touch has been laid in without correction, but laid in, so far as correctness of tone goes, for ever. Hence in the river view the effect of atmospheric gradation, the clearness in the midst of the perplexity of ships and buildings have been attained with a success which when we compare the means with the result, is simply marvellous.'

The *Art Journal* declared:

'. . . . within the picture, which seems true to the very life seen on the spot, sits a repulsive company, the centre figure a man of desperate ugliness. The choice of a subject so repellent deserves censure. Nothing can redeem characters thus completely sunk in vulgarity. However, it is but just to acknowledge that in the painting of the river and the craft floating thereon, Mr Whistler has shown singular power.'

The *Builder* praised Whistler's 'rare appreciation of colour', but asked 'why did he spoil his exquisite view of the Thames, painted with incomparable force and luminousness, by the introduction of meaningless and ugly figures?'

Not everyone found the figures repulsive. In *Fraser's Magazine*, William Rossetti said:

'Never before was that familiar scene so triumphantly well painted. Everything is literal, matter-of-fact – crowded, dispersed, casual. It has all been seen and fixed by a pictorial genius, and so expressed with a sort of tart gusto and immediately curious perfectness that – so far as the sole purpose of artistic record is concerned – it need never be painted anew.'

Stephens wrote in the *Athenaeum*: 'Mr Whistler gives an incomparable

view of the Lower Pool of London [which] will commend itself to all lovers of art who are competent to enjoy its *chiaroscuro*, tone and the fidelity of treatment which the craft of the painter has made poetical.'

Wapping, formulated down river in 1859, was the last embodiment of an earlier phase of Whistler's career. Accompanying it to Trafagar Square was a picture startlingly dissimilar. If *Wapping* ended something old, its companion began something new.

LONDON
1863-5

When the American Commodore Matthew Perry and the Emperor of Japan signed a trade treaty on 31 March 1854 in Yokohama, their action was to have monumental repercussions in the art studios of Paris and London. The pact ended Japan's isolation from the West, which began receiving shipments of products, including works of art. Japan, to be sure, had not been totally cut off from the rest of the world. For three hundred years the Dutch had maintained a post on a Japanese island, and a trickle of art objects filtered back to Europe. Two London exhibitions in the early fifties showed specimens of Japanese art: a small section of the 1851 International Exhibition, in the Crystal Palace, and, three years later, the first completely Japanese show in the West, consisting of furniture, in the gallery of the Old Water Colour Society in Pall Mall East. While these pieces were on display, the American Commodore and the Japanese Emperor put their signatures to a piece of paper, and floodgates opened. Japanese merchants outdid one another in sending merchandise to new markets.

One early shipment was, within our context, especially noteworthy. In 1856, Bénédite related, Felix Bracquemond

*'discovered in the hands of the printer Delâtre a short volume of the Mangwa of Hokusai, which had been used as stuffing for a shipment of porcelain. . . . The little sketch book strongly impressed Bracquemond. He tried without success to buy it from its owner, and then eighteen months or two years later he succeeded in making a swap for it from its new owner, the engraver Lavielle. Bracquemond made it his breviary. He always carried it with him and showed it to everyone at every opportunity, enjoying the surprise, admiration, and curiosity it aroused.'[1]

Six years after he discovered this volume, containing 'wonderfully animated rapid sketches of humble occupations, of jugglers, dancers, children, landscapes, animals, insects, and flowers',[2] Bracquemond produced a 'Japanese etching', *Lapwings and Teal*, 'one of the earliest works to

evince an artist's conscious attempt to imitate Japanese modes of composition, delineation, and tonality'.[3] In this year of 1862 the rapidly growing French and British enthusiasm for Japanese art reached a climax with an exhibition and the opening of two celebrated shops.

In London, the International Exhibition included the largest display of Japanese works of art yet seen in the West, and when the show closed many objects went to Regent Street to be offered for sale by the newly opened import establishment, Farmer & Roger's Oriental Warehouse. Among the early customers were the Rossetti brothers, George Frederick Watts, Edward Burne-Jones, Frederick Leighton, John Everett Millais, Lawrence Alma-Tadema, Norman Shaw, Charles Keene, William Morris, John Ruskin, and James Whistler.

At about the same time in Paris, under the arcades of the Rue de Rivoli, a couple named De Soye, who had recently visited Japan and returned with miscellaneous works, opened what Bénédite called *'an exotic junkshop',[4] *La Porte Chinoise.* *'Without understanding their artistic value,' Bénédite said, 'they displayed embroidered materials, lacquered works, porcelains, and also the little albums which were used to pad them.' They had an immediate success. A typical recollection is that of Chesneau, who said that 'the enthusiasm took over all the shop with the rapidity of a flame running down a dust track. . . . We took the whole collection at relatively high prices.'[5] The De Soyes' first clients included Baudelaire, the Goncourt brothers, James Tissot, Bracquemond, Manet, Duret, Degas, Monet, Zola, Jules Champfleury, Phillipe Burty, and, naturally, Fantin-Latour and Whistler.

What caused this excitement in Regent Street and the Rue de Rivoli? Why were Whistler and his contemporaries captivated by Japanese art? The answers to these questions lie in the qualities of the works.

The art, in the first place, was devoid of realism and was conspicuous for suggestiveness. In the words of Richard Muther, Japanese painters 'express themselves by the scantiest means, shrink from saying too much, and aim only at a rapid and right expression of total effect, leaving to the imagination the task of supplementing and amplifying what is given'.[6] In depicting female figures, for example, 'a dexterous sweep of the brush was all that was necessary for the modelling, all that was wanted to summon the idea of the velvet softness of the flesh and firmness of the bosom'.[7] Japanese artists went to the heart of their subject and showed only what was essential.

The subjects of Japanese paintings were limited, but constantly repeated with new and different methods of treatment. 'In less skillful hands,' an early writer observed, 'these subjects would be worn threadbare, but a true Japanese draughtsman never fails to give fresh grace and beauty to even

the tritest motives. The treatment of cranes . . . is a wonderful instance of this. Almost every Japanese artist has painted them on the wing or on the ground, yet it is difficult to find two to be replicas.'[8]

Japanese pictures were non-literary and non-historical, appealing to the eye, not the intellect, as objects of beauty. The artists were, literally, impressionists, recording intuitive, spontaneous perceptions, including 'the most refined effects of light' such as 'illuminated bridges, dark firmaments, white sickles of the moon, glittering stars, bright and rosy blossoms of spring, dazzling snow as it falls on trim gardens'.[9]

Toward the end of his Parisian apprenticeship, Whistler had probably been introduced to Japanese art, and now he saw it all: the suggestiveness, the ability to penetrate a subject with a few details, the elimination of the irrelevant, the fresh and original ways of repeating a subject, the appeal to the eye rather than the mind, and the skilful treatment of nocturnal effects. His artistic vision would forever be affected by what he saw in Regent Street and the Rue du Rivoli.

Late in 1863 Whistler began his first 'Japanese' picture, which, he told Fantin in January 1864, *'depicts a porcelain salesman, a Chinese man, who is painting a pot'.[10] He confessed, *'It's hard, and I rub out so much. There are times when I think I've learned something, but sometimes I'm discouraged.' A few weeks later, Anna described it for Gamble: 'He is finishing a very beautiful picture for which he is to be paid one hundred guineas. . . . A girl is seated, as if intent upon painting a beautiful jar which she rests upon her lap – a quiet and easy attitude. She sits beside a shelf which is covered with matting, a buff color, upon which several pieces of china and a pretty fan are arranged, as if for purchasers; a Schinde rug carpets the floor.'[11] The man painting the jar had become a woman, who was not modelled by Jo, providing one reason for Whistler's continuing difficulties, and more evidence to support speculations on her pregnancy.

This picture was called *The Lange Leizen of the Six Marks*. The Dutch words 'Lange Leizen' refer to a type of pottery found in Delft and mean 'the long Elizas', alluding to the elongated figures on the jar; 'of the six marks' refers to the potter's signature and date. The porcelain, the carpet, the fan, and even the gown, were part of Whistler's steadily growing collection of orientalia. These excellently reproduced accessories give the painting a Japanese flavour. The harmony of design and colour moreover surpasses anything he had yet done and shows that he had profited from hours of poring over Japanese art. Yet except in superficialities *The Lange Leizen* is not Japanese. The compositional arrangement resembles that of several of Whistler's 1862 magazine illustrations, and the figure might have been a Victorian woman at a masquerade party. But in this initial venture done in the first flush of a newly aroused enthusiasm it

would have been unreasonable to expect a thorough assimilation of his subject.

The picture went to the Academy where it was accepted and well hung, and, since it was not something one could easily ignore, virtually every reviewer mentioned it. The Pre-Raphaelites, William Rossetti and F. G. Stephens, were eulogistic. In *Fraser's* Rossetti called it

'the most delightful piece of colour on the walls: the more you examine it, the more convinced you become that it will yield new pleasure on rein-spection. . . . Its harmonizing power is so entire that we find it a choice piece of orientalism, though conscious that there is not even an attempt at the Chinese cast of countenance.'

In the *Athenaeum*, Stephens said that Whistler

'appears with great force of characterization and superb colouring in a quaint subject. . . . The Chinese lady amuses herself by working, and she does it with a grace and spirit of expression that promise highly for the jar she decorates. The design does Mr Whistler great honour for his concep-tion of her character. This picture is among the finest pieces of colour in the Exhibition.'

Rossetti and Stephens were not alone. The *Morning Advertiser* said this painting of 'a German-looking woman painting jars, is wonderfully truth-ful and yet simple in its effect'. The *Evening News* after mentioning pictures by the Pre-Raphaelites Arthur Hughes, Henry Wallis, Robert Martineau, and Spencer Stanhope, said Whistler 'shows a finer sense [than they] of the necessity for considering that a picture is not merely an imitation of certain objects. In this there is decided originality and feeling for character and good colour.' The *Telegraph* said, 'In rich glow and tender brilliancy [Whistler's] figure-scene has no rival.'

Other reviewers generally qualified their praise. The *Builder* found it to be 'one of the most remarkable specimens of colour in the collection', and judged that it, along with *Wapping*, 'with all their eccentricity, exhibit very rare appreciation of colour, and though careless to a fault in drawing and execution, are wonderfully suggestive of reality'. The *Observer* called it 'a strange picture . . . less capable of explanation than its title' but acknowledged there is 'a sort of fascination about it'. Some writers displayed that irritation to which Whistler would grow accustomed. The *Times* said:

'We turn with impatience from him who attempts to win our notice by

doing everything unlike other people. Mr Whistler has so much power that it is a thousand pities to see it marred by fantastic tricks, such as have led him to invent the hideous forms we find in his Chinese vase-paintress in such exquisitely and subtly slovenliness of execution with the most carefully calculated choice and arrangement of hues; or when he can draw so well if he chooses, to give us an object as much out of perspective as the great blue vase . . .'

The *Art Journal* declared:

'The artist shows his versatility, not to say genius. . . . Mr Whistler in this singular but clever conceit affects the Chinese manner; the lady might herself have sat to a painter of the celestial empire; or she looks as if she had just stepped out from a china bowl, so stiff is she in bearing, and so redolent of colour is her attire. We may expect great things of Mr Whistler if he will but bring his talent under control of common sense.'

Whistler was not displeased with the response to his picture, and he was happy about its sale, not because of the price, one hundred guineas, good but unremarkable, but because of the purchaser, Ernest Gambart, the nation's best known art dealer, who four years earlier had paid £5,500 for Holman Hunt's *The Finding of Christ in the Temple*. Although Whistler probably hoped for bigger things from this premier buyer of pictures, *The Lange Leizen* would be his only sale to Gambart. This lack of interest in Whistler 'is not surprising', says Jeremy Maas, author of a recent biography of the dealer, 'because Gambart was first and foremost a print publisher and it would surely have occurred to him that Whistler was the least engraveable of artists! (That is the kind of engraving published, large popular prints after Landseer, Frith, R. Bonheur, etc.).'[12] In the mid-sixties *The Lange Leizen* was sold by Gambart to James Leathart.

While *Wapping* and *The Lange Leizen* were hanging in the Royal Academy, the British Institution presented an exhibition of old masters, with four works by Velasquez: three portraits – of Philip IV of Spain, his wife Isabella, and his Minister, Count-Duke Olivarez – and a sketch from *Las Meñinas*. Whistler, who had seen Velasquez paintings in the Louvre, in Manchester, and in the National Gallery, surely visited the show, and it would perhaps be opportune to take up the oft-discussed question of Velasquez and Whistler.

Frequently called 'the patron saint of modern painting', Velasquez was widely discussed and studied in the mid-century, and so Whistler must have been familiar with his work. He unquestionably saw the subtle colour harmonies, the advanced use of light and shade, the ability to

repeat a subject without being repetitive, the personal way of seeing and interpreting nature. Whistler learned from Velasquez, as from other painters. But when it comes to particularising, those who have linked Whistler to Velasquez have not been notably convincing. Bénédite, better than most commentators on Whistler, exemplified their difficulties. *'What we call the influence of one master on the other', he said, 'is most often a subtle and mysterious action which is not defined.' And 'between natures of the same essence, it is a type of magnetic appeal, an inexplicable attraction, a sympathetic ardent impulse.'[13] He had to conclude that 'doubtlessly Whistler took nothing directly from Velasquez's works'.

One might agree with Duret that Velasquez's alleged influence on Whistler has been greatly exaggerated, and also concur with the *Spectator*'s art critic who, writing on the 1864 Exhibition, said that 'it seems a mistake to compare [Whistler] with Velasquez. Some of the best works of that master have but little of the bold dashing manner the occasional use of which has caused the coupling of Mr Whistler's name with his.' Although overstated, Velasquez's influence was not non-existent, and its inception may perhaps be traced to the British Institution show of 1864, when, having been introduced to the harmonies of Japanese art, he was more sensitively appreciative of the subdued tones of the Spanish master. Indeed only in the later years, beyond the scope of this volume, did the Velasquez influence really take effect. As Bénédite acknowledged, *'the spell' of Velasquez 'did not work until long after [his youth], by reason of the simultaneous or successive trials through which this young, eager, curious intelligence [passed]'.[14]

Of one thing we may be sure: Whistler's indebtedness to Velasquez was not imitative. He once told Fantin, *'You know, this glorious painter can't be copied,' and then declared, 'Oh, how he must have worked.'[15] Here perhaps is the key to Velasquez's influence on Whistler. Like Hogarth, Velasquez was a highly original painter who worked independently of rules and formulae. From him Whistler learned, as from Hogarth, to be himself and not to be too much swayed by anyone, not even Velasquez. R. A. M. Stevenson said that 'of all painters, Velasquez was the one who tampered least with the integrity of his impression of the world'.[16] To what nineteenth-century artist does this more aptly apply than Whistler? Possibly a fear of being unduly influenced kept him forever from Madrid and the Prado.

Velasquez's influence on Whistler, to summarise, was indefinite, tenuous, and cumulative, manifesting itself most strongly later in his career. As to the immediacy of the other influence of which we have been speaking, there can be no doubts: before *The Lange Leizen* went on exhibit, Whistler had begun his second 'Japanese' picture.

Late in 1863 in the Ionides home, Whistler met Marie and Christine Spartali, the beautiful daughters of London's Greek Consul-General, and he persuaded Christine, the younger, to model for a picture he had already begun to sketch. (A few years later Marie would pose for one of the figures in Rossetti's *Dante's Dream*.) Through the winter of 1863–4, Christine went twice a week to Whistler's studio, standing sometimes for more than four hours, until finally, early in 1864, she collapsed from exhaustion. The picture for which she stood, *La Princesse du Pays de la Porcelaine*, presents a kimono-clad woman standing before a Japanese screen. As in *The Lange Leizen*, Japanese accessories surround a figure who is obviously occidental. The atmosphere, however, is more genuinely oriental than that of its predecessor. As a recent observer remarked, 'in this picture Whistler has begun to assimilate the lessons of the Japanese prints'.[17] *La Princesse* has reminded some people of certain pictures by Rossetti, especially those in which the model was Jane Morris. Whistler was in contact with Rossetti, and influences passed in both directions, but he could hardly have been affected by paintings of Jane Morris, who did not begin seriously to sit until 1868.

Although *La Princesse* was signed 'Whistler 1864', finishing touches were not applied until the following spring. (A smaller version, with a different model, done while planning the major work, hangs in the Worcester, Massachusetts, Art Museum.) Rossetti liked it and found a purchaser, who objected only to the oversized signature, which he wanted altered. Rossetti thought this was reasonable, but, the Pennells reported, 'Whistler was indignant. The request showed what manner of man such a patron was, one in whose possession he did not care to have any work of his, and that was the end of the bargain.'[18] The picture was sold to another Rossetti patron, the Liverpool shipping magnate Frederick Leyland.

Before completing *La Princesse*, Whistler started his third Japanese picture, *The Golden Screen*, with a readily recognisable figure, Joanna Hiffernan, again serving as his principal model.

The Golden Screen shows a woman in a richly embroidered Japanese robe seated on the floor looking at a colour print by Hiroshige. Again there are numerous Japanese accessories – the gown, the prints, the box, the vase, the flowers, and the screen – but now they are integrated into a unified whole. As a work of art *The Golden Screen* is inferior to its fore-runners, but of the three it is the most successfully realised 'Japanese' picture. It is dated '1864'; because of its mature 'Japanese' style and the apparent earlier unavailability of Jo, it was presumably painted late in the year. To be sure, Bénédite wrote: *"In February or the beginning of March, Whistler points out that he has "again done a little Japanese picture that is ravishing". This is the *Golden Screen*.'[19] If this is correct,

everything said about Jo's pregnancy is fit for a shredder. Bénédite, how-
ever, though knowledgeable, was not infallible, and here, it seems, he was
mistaken. In the letter from which he quotes, Whistler does not name the
picture; he merely calls it 'little'. *The Golden Screen*, measuring 31 by 20
inches, might perhaps be called 'little', but he was more likely referring to
a painting of which Bénédite knew nothing, the earlier, smaller version of
La Princesse, which was completed by early 1864.

Once back in London, Jo resumed her modelling in earnest, with no
chance of a conflict with Mrs Whistler, who, for reasons of health, had
moved to Torquay. Late in the year she began sitting for what would
become one of Whistler's most famous paintings, *The Little White Girl*.

The Little White Girl shows a red-haired woman in a white dress hold-
ing a fan and leaning against a fireplace below a reflecting mirror. The
'Japanese' features – the fan, porcelain, and flowers – unobtrusively fit
into the scene. Of all young Whistler's paintings, this second 'White Girl'
has been the most lavishly praised. Kenyon Cox, for example, called it 'an
almost unequivocal success . . . perfect in harmony of arrangement and
color'.[20] Bernard Sickert said, 'Every portion of the picture is flawless.
Look at the lovely arms and head resting on the mantelpiece. How lightly
it rests, and yet it is a woman's arm, round and solid under soft muslin.
Look at the azaleas in the foreground. Do other blossoms ever seem to be
growing by comparison? Was there ever such lightness of touch combined
with such sureness?'[21] The Pennells categorically deemed it 'the most
individual, the most complete, the most perfect he ever painted at any
period'.[22]

Whistler's friends raved about *The Little White Girl*, no one more so
than Swinburne, who was inspired by it to write a poem, 'Before the
Mirror'. He mentioned his poem and the painting in a letter to an acquaint-
ance, John Ruskin: '. . . whatever merit my song may have, it is not so
complete in beauty, in tenderness and significance, in exquisite execution
and delicate strength as Whistler's picture. . . . I am going to take Jones
[Burne-Jones] on Sunday to Whistler's studio. I wish you could accompany
us. Whistler . . . is of course desirous to meet you, and to let you see his
immediate work.' Ruskin did not accept the invitation, nor at any time in
the near future did he meet Whistler. One might wonder if Victorian art
history would have been changed had he gone with Swinburne and
Burne-Jones to Whistler's studio.

Swinburne's desire to introduce him to Ruskin was another effort by a
member of the Rossetti circle to help Whistler. He was doing well enough,
thanks partly to them, to be able to tell Fantin, late in the summer of 1864,
*'this year I have had my greatest success yet – and they now offer me
three times the price that I asked for last year.'[23] Some purchasers were

referred by Rossetti and his friends, but once they entered 7 Lindsey Row Whistler knew what to do. Luke Ionides recalled a typical incident:

'In 1864 ... when I happened one day to call upon Jimmy, he asked me if I had any money. I told him I had twelve and sixpence, and he said, "That's enough for my purpose. Let's go out and buy two chairs and some bottles of wine. I'm expecting a moneyed guest to-night, and you are going to dine with us."

'So we went out and bought two chairs at two shillings each, four bottles of claret, and four sticks of sealing-wax, one blue, one green, one yellow, and one red. When we got back we sealed the corks of the four bottles, each with a different colour.

'When we finished our soup, he gravely said to the maid, "Go down and bring a bottle with the yellow seal," which we had after the soup. After the next dish, he ordered a bottle with the red seal, and the others after the different courses. Whether the fact that the "moneyed guest" . . . bought a picture for a hundred pounds, was the result of the supposed different wines, I do not know!'[24]

Rossetti liked Whistler and his work, but there were limits to the friendship. Late in 1864 the house next to his became vacant, and on 27 December he told Leathart, 'I have just seen the house, and I think it would suit you very well. Whistler is after some other place, and *entre nous* I had rather have you for a neighbour than that dearest but most excitable of good fellows.'[25] Leathart did not move into the house, but neither did Whistler, depriving us of the spectacle of Dante Gabriel Rossetti and James Abbott Whistler as next-door neighbours.

Whistler's closeness to the Rossetti circle annoyed some of his older friends. On 11 November 1863, Du Maurier wrote to his brother:

'Jimmy & the Rossetti lot ... are as thick as thieves:

> Ces animaux vivent entre eux comme cousins;
> Cette Union si douce et presque fraternelle
> Enveloppe tous les voisins.

[These animals live among themselves like cousins/This union so sweet and almost fraternal/Envelops all their neighbors.]

Their noble contempt for everybody but themselves envelops me I know. . . . I think they are best left to themselves like all Societies for mutual admiration of which one is not a member.'[26]

Du Maurier's generalisation was not entirely correct. Certainly it did

not apply to Fantin-Latour, who continued as Whistler's principal confidant. *'I would like to talk to you about my painting,' Whistler wrote to him early in 1864. 'I am so discouraged – always the same thing – always such painful and uncertain work! When will I work more quickly? . . . I put out so little because I wipe off so much.'[27] He ended by saying, 'I never feel a complete confidence in the kindness of anyone but you.'

Soon Whistler would be able to speak with his friend face to face. As a tribute to Delacroix, dead for a year, Fantin planned an ambitious painting showing a number of young artistic figures gathered respectfully before a portrait of the departed master. The mourners would include Baudelaire, Manet, Bracquemond, Champfleury, and, Fantin hoped, Whistler. *'Your picture will be superb!' Whistler wrote in February. 'I can see the heads painted by you in a magnificent color. Perhaps the bust will be difficult to arrange, but I have the greatest confidence in you.'[28] Legros was also asked to sit, and Whistler responded:

*'Naturally . . . Legros and I will come to Paris to pose. . . . Save two good places for us – perhaps Rossetti as well – he told me that he would be very proud to sit for you. He has a fine head, and you will like him very much. . . . Fantin, your picture is going to be very beautiful – the great mass of light does awfully well – it is going to be very good for you, for it is a picture which will forcefully attract attention.'[29]

In answering Fantin's request to be in Paris on a certain day for a sitting, Whistler said:

*'You can count on me – if no sickness or accident prevents me – so keep my place for me. Rossetti, however, cannot promise – he told me to tell you how sorry he is and how happy he would have been to be in your picture, for he has the greatest admiration for your work, but understanding the importance of arriving in Paris at a fixed time, he told me that he could not commit himself, for if at the last minute he were prevented from leaving, he would never be able to forgive himself.'[30]

Rossetti gave a somewhat different reason for not going to Paris. Writing to his brother in November 1864, he said, 'I saw the picture and think it has a great deal of very able painting in parts, but is a great slovenly scrawl after all, like the rest of this incredible new French school – people painted with two eyes in one socket through merely being too lazy to efface the first.'[31]

At about the time that Ulysses S. Grant became President Lincoln's supreme general, James A. Whistler stood militarily in the most prominent position in the painting of Henri Fantin-Latour. He spent a fortnight in Paris, long enough to see the completed picture, but he left before the

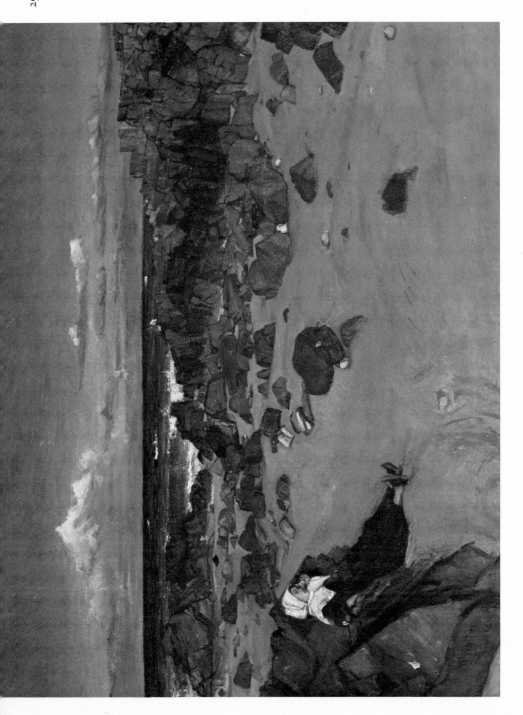

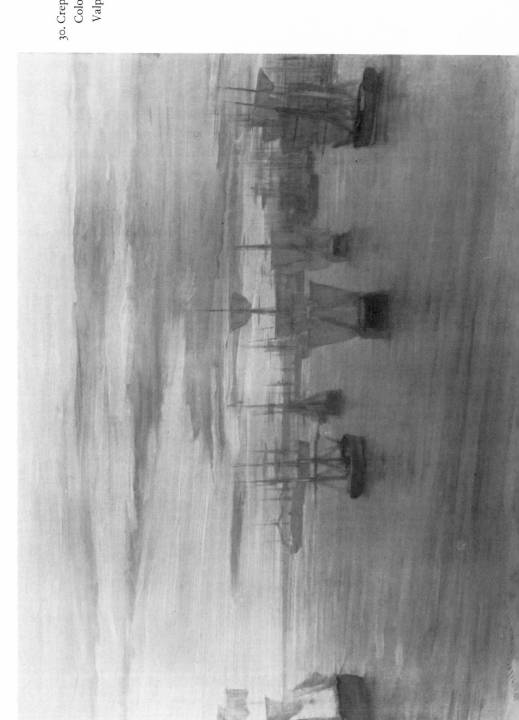

30. Crepuscule in Flesh
Colour and Green:
Valparaiso

opening of the Salon, where it was exhibited. Back in London, he wrote, *'I thought of your Hommage à Delacroix, and I saw the great step you have taken. There is in this picture (and the impression has indeed stayed with me) besides its beautiful qualities, a simplicity and a breadth and quite striking *individuality*. How charming it would have been to go to the Salon together to see your picture!'[32] The exhibition was a triumph for Fantin, and Whistler wrote, *'I wanted to be with you for your success – to see you finally take your place, which has been long overdue. I happily thought of everything we would have to say to each other, of those wonderful long talks at night, when we understand each other so well – you must have wanted to talk with me during the Salon – for I am happy to think that we need each other for this true exchange of sympathies which we cannot get from others.'[33]

Whistler had succeeded in gaining for his friend commissions from Greek patrons, mainly for pictures of flowers, which he mentioned in a letter of early 1864:

*'You must do more floral arrangements of the *same size* for Ionides – he will pay you 150 francs apiece. Do them right away and you will have the money immediately. Yesterday (upon receiving your letter) I wrote to Ionides and Dilberoglou asking them to send you the money, that is, 300 francs from one and 100 francs from the other. That makes 400 francs – you will get it tomorrow. Now let me tell you – don't go spoiling your business which is growing, as you see, by placing a small price on a big bouquet. Your starting point is easy now, 200 francs for the small ones (for we are going to ask that price after this order), then for the large ones you must ask for more. You must establish a price for each size. I suppose the large bouquets should be about 300 to 350 francs apiece. For the *Wedding Feast of Cana* – don't make it too big – about 1,000 francs. I have not yet let Dilberoglou know the size that you told me so that you can write to me once more. . . . Don't make it too big, [for] here the size counts for a lot in the price.'[34]

A letter of early April 1864 reveals that Whistler obtained for Fantin more than money:

*'I beg you, mon cher Fantin, don't let a word of this out to *anyone*. You do not know how much I am counting on it.

'I know something that will be delightful for you, and I shall tell you in secret, for it was confided to me with much caution. Sunday I spent the morning with my friend the Academician whom you know. We talked quite a lot, but it was understood that nothing was to be repeated. So

look out. Promise me that you will say nothing – it is more important than you think. I have already told you that I wrote to him concerning your two floral arrangements which the Greeks told him had been sent. Well, one of the first things he told me was "Fantin's bouquets are *ravishing*. I saw both of them, and they are really complete!" He has hung them as a pair, on both sides of a bigger picture, at shoulder level so it is just perfect. He spoke *a lot* about it and in an extremely friendly manner – he would like to see a big picture of yours, and then I told him about what you sent to the Salon.'[35]

As the letter indicates, Whistler had persuaded a Greek purchaser of Fantin's pictures to send two to the Royal Academy, and they were accepted and well hung. (This was not his R.A. debut: in 1862, also because of Whistler, another flower piece had been shown.)

Fantin saw his pictures in the Academy, for he had been induced by Whistler to visit London in July. Years later he told Joseph Pennell that Whistler *"introduced me to his friends, who bought some still lifes and florals. I lived with him on Lindsey Row. We were neighbors with Rossetti where we would spend evenings. . . . Those were happy days for me!'[36] Fantin's presence in London was good for Whistler also, especially because two other long-standing friendships had virtually ended.

'Jimmy and Legros are going to part company,' Du Maurier told Armstrong in November 1863, 'on account (I believe) of the extreme hatred with which the latter has managed to inspire the fiery Joe.'[37] If Jo was then pregnant, she was understandably agitated, but at no time did she like the non-English-speaking Legros, never less than when they both shared 7 Lindsey Row with Whistler. After Legros moved, early in 1864, he and Whistler seldom saw each other, but in October, Du Maurier wrote to his brother: 'I am told Whistler has quarrelled with Legros; money matters, but I don't know for certain what the particulars are. But Ridley said that if Legros' version of the affair was correct Jim had behaved very shabbily.'[38] The basic reason for the breach was more deep-rooted than Jo's feelings or 'money matters'. For some time Legros depended on Whistler, but eventually, even without learning the native language, he could get on quite well by himself. As his independence grew, he was increasingly reluctant to submit to domination by Whistler, who, except for Fantin, could not easily maintain a close friendship with an equal. The final blow was struck near the end of the year. On Christmas Day, Du Maurier told Armstrong:

'Legros . . . is married. He called here the other day & talked very bitterly of Jimmy, whom he says he can never see again. There has been some

money quarrel between them and according to Legros Jimmy's conduct has been most shabby. . . . He was especially bitter about Jimmy's conduct à propos of his (Legros') marriage, for it appears Master Jim chaffed him on all occasions in a very disagreeable manner.'39

Why did Whistler thus behave because of Legros's marriage? Because he could no longer control his friend? Or because he would no longer share intimate relations with Legros, which both shared with Fantin, thus introducing a new dimension into their Society of Three? These questions are more easily asked than answered.

Also in 1864, Whistler ended his friendship with Seymour Haden.

An early sign of an impending rupture with Haden appears in a letter to Fantin in January 1864 – six months before Haden was Fantin's gracious host in London. Whistler referred to

*'the quarrelsome feeling developed day by day between Haden and his devoted brother-in-law! We told each other little pleasant things! The opportunity was easy to find, and I fear that I did not let it slip away without using it completely! One day we dined at Sloane Street! nice discussion on art! Me, with an offhand manner without any reverence! I made a big deal about your fine copy of *The Wedding Feast* to a great idiot of a painter who was there. Little by little I had him talk about a figure, you know, the one Haden finds not dark enough. It was evident that he had done the picture for Haden. Then I aired all the derision possible! I spoke of the vulgar idea of "pushing back", how it was good enough for the Academicians (meaning Horsley) and absurd for the true master, etc., etc. Ah, if you had been present you would have been in a state. Finally I cauterized the wounds once more. I kept saying during the entire evening, "And what is Fantin doing for you now?" "Nothing at this time." "Ah, well what is the next copy he is to do for you?" "I don't know." "But he must be doing something else, isn't he? a Titian, I think?" "No, not now." "Oh, I thought he was." See! On leaving I invited Haden and his artist (a poor cousin of his family) to dine with me and Alphonse a week from Monday. They accepted. It was a ceremonious affair! We wished each other good night! Ah, now, Fantin, light your pipe.'40

Soon thereafter, when Haden was in Paris and shortly before he himself went there, Whistler wrote to Fantin: *'Haden must be making a show of himself! . . . Perhaps he is sounding off about wanting to buy your picture [Delacroix], but if it is not yet sold to Gambart, do not listen to him, or better yet, ask him for 300 pounds sterling right away (that makes 7,500 francs), for you could possibly sell it to Mr Winans here.'41

Two explanations have often been advanced to account for Whistler's changed feelings towards Haden and, ultimately, the break between them.

According to the first supposition, they quarrelled over Joanna Hiffernan. If they had a dispute over Jo, it reached a climax in January 1864. On the 23rd, Whistler told Fantin:

*'This is taking on a little of the turmoil of the Three Musketeers and "Twenty Years After." I shall try to unveil for you the panorama of this glorious war! . . . Here is the affair, more or less. The enemy opened the campaign by a volley shot into the middle of Lindsey Row in the form of a letter – insolent indeed – concerning the dinner to which they were invited. Suddenly they found they had scruples concerning Jo! and they boldly proposed that she not be at the feast. This dispatch had taken a week in composition, and, in its coarseness, it was quite successful. To the vigorous attack, I responded by bringing in the light cavalry! I deployed large reserves of amiable provocation and produced serious wounds, and my pleasantries reached such a point that the enemy lost his head and kicked me out of the house. After this pitiable stupidity on his part, the enemy continued his rapid decline in the esteem of the gallants by a series of stupid blunders – letters of impotent and comic rage – to which I answered nothing! Nothing! for what did the philosopher say, "Never write, never burn!" All of this quite interrupted the tranquil and peaceful life of our studio.'[42]

News of such an incident could hardly be kept from spreading, and early in February Du Maurier told his brother:

'Jimmy and Haden à couteaux tirés [with drawn knives]; quarrel about Joe, in which Haden seems to have behaved with unusual inconsistency & violence; for he turned Jimmy out of doors, literally, without his hat; Jimmy came in again, got his hat and said goodbye to his mother and sister. . . . It's a deuced unfortunate thing and there is little chance of ever a raccommodement.'[43]

Du Maurier heard about the affair from a third party, who in turn may have been informed by a fourth party. One may be sceptical about the particulars on Whistler's hat, and certainly he did not bid farewell to his mother, who was not yet in London.

A quarrel between Whistler and Haden undoubtedly occurred, although Whistler characteristically exaggerated its seriousness. But that Jo could

have caused the end of the friendship is inconceivable. In his letter, Du Maurier noted that 'Haden has dined there, painted there, treating Joe like an equal, travelled with them and so forth.' Haden had indeed always been on excellent terms with Jo, in Rotherhithe and on Lindsey Row. Why then did he create this scene? Because, it seems, Jo was in a state of obvious pregnancy, and Haden would have been embarrassed by her presence at a dinner with his relative. (This was presumably the dinner alluded to earlier, the one in which the guests would be Haden and his 'poor cousin'.) This might cause a temper tantrum but would not terminate a friendship, and in fact the brothers-in-law continued to see each other regularly. Several months later Whistler was Haden's guest when the event occurred which gave rise to the other alleged reason for the parting of the ways.

This second purported cause of the breach was a picture painted by Legros and owned by Haden. Again Whistler gave Fantin a full account of the episode, soon after he had been to Paris for the Delacroix picture:

*'Returned home and began work. An event which shook the Chelsea Colony! with indignation was the discovery of the brother-in-law's crime which had been hidden for so long, and for so long known only to the two of us, you and me! his retouching of *The Angelus*!!!! [a church interior painted by Legros and sold to Haden] Picture Legros in the anguish of the first moment! looking for the tones of the Turnerish sunset, those gray and calm tiles of his well-loved church!! I leave to your imagination his furious twitching and my small individual joy in thinking about the just vengeance of the gods.... The next day, after being very excited, we returned to Sloane Street and brought the Angelus back to Lindsey Row, and we spent the day removing, with benzene, knife and razor, all of Haden's beautiful corrections in the perspective. Soon after, Haden's return – and we waited for his visit! Two days later he comes. Him, with a cheery and eager appearance, and us, charming and gracious! A perfect reception. You can imagine how clever this was! Passions in check, for he perceived his strange position, he speaks joyously to us about his trip without seeming to see the picture which is staring him in the face. It was posed on its easel in its state of demolition! because Legros did not want to re-arrange it until he saw the damage! Finally, upon leaving, he says to Alphonse, "Ah, you have taken that away! Good! Do your best!" to which Alphonse answers calmly, "Yes!" Can you see it! Can you see the scene, the smiles, the good-day's, the politeness of the brother-in-law! my individual little rejoicing that I have already mentioned to you.'44

This report surely does not suggest that the incident could have caused a separation of the brothers-in-law. Some writers, however, have over-

looked this contemporaneous account, unpublished and written in French, and have relied on the published report of the affair, recounted by Whistler more than thirty years later:

'When Legros came with me to Haden's the first time [this was by no means Legros's first visit to Haden's home] . . . gradually Haden's work dawned upon him. That he could not stand. What was he to do? Run off with it, I suggested. We got it down, called a four-wheeler, and carried it away to the studio [and] cleaned off Haden's work. Haden, in a rage when he discovered it gone, hurried after us to the studio, but when he saw it on the easel, Legros repainting the perspective, well there was nothing to say.'[45]

The discrepancies between the versions are obvious, and yet people who should know better have unquestionably accepted the second story.

The incidents involving Jo and Legros are symptoms rather than causes, symptoms of Whistler's growing antagonism toward his brother-in-law. That the enmity was one-sided is demonstrated by a Haden etching of mid-1864, whose first impression was dedicated 'To Whistler'. This inscription, along with other signs of Haden's personality, should demolish another assigned reason for the discord, that it was inevitable because they were both dominating, inflexible individuals. Actually, Haden was easy to get along with; if anything, he was too accommodating. Writing in February 1864 to his brother, Du Maurier said: 'I wonder Jim cannot agree with Haden – I always get on capitally with him. I say with a deferential air and rather timidly: Mr Haden, doesn't it occur to you that snow in reality is of a fine jet black colour? And he answers heartily in the affirmative.'[46] Du Maurier's response is consistent with other accounts of Haden's personality.

The blame for the difficulties between the men may be divided between Whistler and certain members of Haden's family.

So long as Haden simply etched as a hobby, he was freely accepted by Whistler as an 'amateur'. But then, although he never neglected professional duties, Haden gradually gained recognition for his art work, culminating in 1864, when he was represented for the fifth time at the Academy, and also at the Salon, and he received more journalistic attention than ever before. In June, the *Gazette des Beaux-Arts* contained an article 'The Prints at the Salon', by Philippe Burty, the famed critic who first recognised Meryon's genius, and one long, glowing paragraph described the two entries of Haden. This was only the beginning. Burty wrote an essay, 'The Work of Francis Seymour Haden', covering twenty-eight pages of two issues of the *Gazette*, appearing in September and

October. It included a biography, a eulogistic critique of his work, and a wholly complimentary descriptive catalogue of fifty-four etchings. Contrast this with the most momentous notice Whistler had received in Paris for his etchings, two sentences that dealt more with the Thames than the pictures! It is hardly accidental that Whistler turned against Haden in 1864, his year of triumph.

Haden's success alone might not have ensured the end of his friendship with Whistler, and therefore might one mention his relatives, two in particular. Emma, Haden's elder sister, married Charles Bergeron and died without issue in 1858. Charles Sydenham, his only brother, married Mary Love Boott, a niece of 'the founder of Lowell', went into the Foreign Service, and played no role in Whistler's life. Seymour's remaining sibling was his sister Rosamund, Mrs John Calcott Horsley. Until recently one could only speculate on their attitude towards Whistler, upon which nothing specific has so far appeared in print. Conjectures are no longer necessary, for there is documentary evidence on this question, Rosamund's diaries, which, through the courtesy of her granddaughter, Mrs Nancy Strode, the author of this volume has examined. In 1864 J. C. Horsley exhibited his fifty-fourth and fifty-fifth pictures at the Exhibition and was elected a Royal Academician. Because of his position, Horsley and his wife were greatly involved in activities relating to the British art scene, and her diaries constantly mention artists, art events, and art organisations. Since her husband perennially participated, Rosamund never missed a Royal Academy Exhibition. Her entries for 1862 are typical. On 29 May she wrote, 'Took Annie to the Exhibition this afternoon.' Two days later she 'Went into town. Exhibition in afternoon.' On 4 July she came in for a third visit. As for personal matters, the diaries reveal Rosamund's fondness for Deborah, always called 'Dasha'. She repeatedly had tea with Dasha, shopped with Dasha, dined with Dasha and Seymour. And the Haden children are continually mentioned; Annie in particular was a favourite of Aunt Rosamund. None of these entries are surprising or remarkable. The diaries are less revealing for what they contain than for what they do *not* include.

A painstaking perusal of Rosamund Haden's diaries from 1855 to 1866 has uncovered not one reference, direct or indirect, to James Whistler. Not one syllable indicates that Dasha had a brother, that Seymour had a brother-in-law, that Annie had an American uncle. Whistler appeared at every Exhibition from 1859 to 1865, yet nothing in her diaries indicates that Rosamund Horsley saw even one of his twenty-six paintings and etchings that hung on the walls of the Academy during these years. Even in 1860 she did not mention *At the Piano*, bought by John Phillip, R.A., and depicting a Sloane Street parlour scene with Annie and Dasha. From the

diaries one would not infer that Whistler was detested or disliked by the Horsleys – he simply did not exist. He was a non-person.

Why did the Horsleys snub Whistler? In the first place, he was an American, reason enough to be ignored. Deborah was also an American, but she became a British subject, adjusted to life in Britain, and, like more than a few Yankees in London, cultivated an English way of speaking. Whistler, on the other hand, although he spent his entire adult life in Europe, always spoke and acted like an American. He was an American expatriate who flaunted his Americanism, a course of conduct not recommended for endearing oneself to residents of the British Isles. Then, too, he was ebullient, loud, and gesticulative, and this was not greatly appreciated by people who habitually practised restraint and understatement. But most reprehensible to the Horsleys was Whistler's personal behaviour. In France a painter could be unconventional, but in England, a Victorian critic noted, an artist was 'a man of business [and] must pose amongst his fellows, must be like prosperous people, and not indulge in the eccentricities proper to his craft'.[47] The 'dominant note of their lives', a more recent commentator observed, was 'always that of intense respectability. . . . Only the very successful were allowed to be eccentric to the point of notoriety'.[48] The immensely successful John Everett Millais was the model of what a British artist was supposed to be: he maintained a lavish town house on an eminently respectable street in Kensington; he had an equally luxurious and respectable country home; he dressed fashionably and entertained the 'right' people in the 'right' way; he hunted, fished, and played golf. Can anyone imagine James Whistler on a golf course! Horsley was as respectable as Millais, and for him and his wife Whistler was impossibly unconventional. How could they accept someone who lived in Rotherhithe and openly maintained a liaison with an Irish woman to whom he was not married? James Whistler was the black sheep of the family, and the proper way for an upper middle-class English family to deal with such a person is to pretend that he does not exist.

Although he professed to feel only contempt for the Horsleys, Whistler suffered from the slights he received, week after week, month after month, year after year. Finally the continued rebuffs, combined with Haden's success, proved too much to take, and, since he never saw the Horsleys, Whistler took out his resentment on the only accessible member of the family, Seymour Haden. Thus was the break between the two men inevitable.

It should be understandable now why Whistler felt as he did about Lowell: the town had been founded by someone related by marriage to the Hadens, who, moreover, had built the very church in which he was baptised.

By the end of the summer of 1864, Whistler ceased entirely to see Haden, leaving him with one regret, he later told Fantin. *'What was serious was the trouble that it caused my sister! We could see each other only rarely, at the homes of mutual friends. You know that we are very much attached to each other.'[49] Nothing could ever drive a barrier between James Whistler and his sister.

LONDON AND VALPARAISO
1865-6

In May 1865 Whistler wrote to Fantin: *'Naturally you will tell me about gossip at the Salon and the Café du Bade, and especially about your visit to the Japanese lady.'[1] The 'Japanese lady' was *La Princesse du Pays*, hanging at the Salon, and Fantin probably did not report fully on the response it evoked. Hardly any reviewers liked it. Paul Mantz, for example, writing in the *Gazette des Beaux-Arts*, called it *'a work of whim and fancy . . . a study of costume, and not the representation of a life-like figure', and he declared that he could 'in no way perceive in it anything of interest'. Jules Claretie, in *l'Artiste*, said merely, 'Its eccentricity is possible only if taken in small doses like a homoeopathist's pills.' The negative reaction to *La Princesse*, it has been said, led Whistler to his almost total boycott of French exhibitions for seventeen years. Actually it was this response along with Burty's eulogy of Haden that turned him away from Paris.

In London, Whistler fared better. Four of his pictures were hung at the Academy, *Old Battersea Bridge* – harkening back to an earlier period – and *The Scarf*, *The Golden Screen*, and *The Little White Girl* – representing his current phase.

Finished just before the show opened, *Old Battersea Bridge* was well received. In *Fraser's Magazine*, William Rossetti exclaimed that Whistler had reduced 'these simple materials to perfection, whether composition, tone, truth, or originality, is in demand', and he stated that 'not two men in a thousand could produce so precious a picture'. The *Telegraph*'s reviewer said:

'By far the most remarkable landscape in the Middle Room appears to us the "Old Battersea Bridge". Here the artist has condescended to employ his magical sense of touch on an English scene and . . . to combine unity of sentiment and meaning with what he never fails in, harmony of colour. The skill with which the boats, the bridge and the line of buildings on the river-side are so used as to give value to elements which separately would appear almost without pictorial capability, is not more

remarkable than the effect of air and space which has been breathed into this vividly true piece of English mist and greyness.'

The *Saturday Review* observed that Whistler 'has a landscape – all English gray and damp, in place of Oriental brightness – in which ... there seems little for his admirers to wish added. There is ... nothing equal to it in the Middle Room in its palpable and delightful truth of tone. It is, what every landscape should be, rather an inlet into nature through a frame than what we commonly mean by a picture.' The *Illustrated London News* said that Whistler 'shows his unrivalled power of matching subtle hues and gradations; and renders these with a breadth singularly suggestive'. The *Spectator* drew a favourable contrast with other recent work: 'Glimpses of power appear in ... "Old Battersea Bridge" which one would fain believe more natural to him than his ludicrous imitation of Japanese art.' Even a French critic, Charles Blanc of the *Gazette des Beaux-Arts*, acknowledged that it *'possesses strong harmonic qualities'.

Among Whistler's other entries, not much attention was given to *The Scarf* and *The Golden Screen*. Rossetti was the only principal British reviewer to mention both. They were, he said, 'unsurpassed in delicate aberrances and intricate haphazards of colour – but these hazards only happen to masters in their art. . . . A Japanese would applaud them, we think; and no nation knows better than the Japanese what to be at in invention, colour, and execution.' Charles Blanc's comments in the *Gazette des Beaux-Arts* might suggest that he and Rossetti had seen different paintings: *'[Whistler's] Japanese subjects have been justly called a hoax, and the members of the Academy . . . have shown themselves indeed possessed of wit and light-heartedness in exposing the two works to a discerning judgment by giving them excellent and choice places. These two "Japanese pictures" abound in false and washed-out tones . . . 'A few reviewers mentioned one or the other of the pictures. *The Saturday Review* said that among Whistler's entries *The Scarf* was 'beautiful . . . above all'. In the *Athenaeum*, Stephens spoke of *The Golden Screen* and was more critical than usual:

'A Japanese lady – whose hideous features seem, and probably are, specially designed to prevent our interest in the supreme colour of the picture being diverted – examines a picture, drawing, or fan, or whatever it may be. Behind her is a golden screen, so ineffably beautiful in its colour, and making such delightful harmony with the purple robe, red scarf, etc., of the woman, that we are glad to forgive the painter the ugliness of her face, which is not vulgar; we cannot, nevertheless, quite see that it was needful that Mr Whistler should dispense

with drawing and modelling forms in order to leave us alone with his colour and *chiaroscuro*.'

The Scarf and *The Golden Screen* were comparatively neglected because of the attention given to *Old Battersea Bridge* and, most particularly, *The Little White Girl*, which nobody ignored.

According to a popular myth, *The Little White Girl* was universally denounced. 'The critics', we are told in a typical comment, 'dealt with the picture in their most acidulous, fault-finding manner. They thought it strange, and bizarre, and their unanimity about its lack of good qualities was a blow to the artist.'[2] Let us now examine the record.

The *Art Journal* noted that among Whistler's pictures in the Exhibition ' "The Little White Girl" has obtained the largest number of admirers.' Although he was not one of them, the admirers included some of this writer's colleagues. Here, in part, is what the pace-setter, *The Times*, said:

'This picture, slightly finished as it seems – slovenly as many will think it – is of all the paintings in the exhibition the one most likely to impress itself deeply on the minds finely attuned to the delicate harmonies of colour and the subtlest suggestions of form. . . . The execution is of the broadest and least laboured kind, but its slightness is the result not of carelessness, but of careful calculation. How studied is the workmanship all through the picture is best proved by its exquisite effect as a whole when seen . . . from the opposite side of the room. Before this picture, even those who resent most strongly what we take leave to call Mr Whistler's freaks and impertinences – for his Japanese pictures, with all their delightfulness of colour and their cleverness in expression, *are* impertinences – must admit that he has power of the rarest kind. There is too much dross mixed with his gold to justify us as yet in calling that power genius. But it is a duty in Mr Whistler to turn his great and rare gifts to the best account.'

The *Telegraph*'s reviewer, after remarking that another painting 'requires a wall itself for a satisfactory study', wrote:

'On other grounds we are inclined to say the same in regard to Mr Whistler's "Little White Girl," by far the most interesting of the figure subjects contributed by this fantastic genius. Indeed this is the only one of them which in a human or at least a European sense is interesting; in the others the exquisite Japanese screens are so truly rivalled that Mr Whistler's art is altogether eliminated – the result, we presume, which the gifted

painter aimed at. No need to repeat our frequent former remarks on the harmony and subdued sweetness of Mr Whistler's colour; in this he is single and unrivalled. The management of the fireplace behind the girl, the sensible atmosphere between the screen she holds in her right hand and her dress behind it, are feats which appeal almost "beyond the range of art" till one sees them accomplished.'

In *Fraser's Magazine*, William Rossetti wrote:

'Of Mr Whistler's four contributions this year, two are perhaps the very best things he has yet exhibited; for charm, "The Little White Girl"; and for perfection according to his individual scheme of execution, the "Old Battersea Bridge." The exquisiteness of the "Little White Girl" is crucially tested by its proximity to the flashing white in Mr Millais's "Esther": it stands the test, retorting delicious harmony for daring force, and would shame any other contrast. The loveliness of the delicate carnations, especially of the hand which lies along the white dress, cannot be overpraised. The flame-yellow of the hair, black of the fireplace, the crimson-pink of the azaleas, contribute to a consummate whole.'

The *Saturday Review* said: 'There is nothing in the rooms, not even by Mr Millais, which stands its ground against the soft purity, the full under-tone of exquisite tint, in this sketchy picture. The tenderness, for instance, with which the girl's arm, as it were, warms the sleeve, is something that, as Mr Ruskin once said of Turner, can rather be felt than pointed out.'

There were other brief notes of praise. The *Spectator* said, 'For delicacy of colour nothing surpasses Mr Whistler's "Little White Girl".' The *Morning Advertiser* called it 'one of Mr Whistler's many specimens of his mastery over colour and his facility in drawing'. *The Observer* averred that 'There is a strange perversity of talent in Mr Whistler, as may be seen in his "Little White Girl".' And Charles Blanc of the *Gazette des Beaux-Arts*, who, we noted, did not like Whistler's more obviously Japanese pictures, said: *'Mr Whistler has marvellously attained his objective in this work. . . . All the features . . . are a total success.'

Need one say more in answer to the assertion that *The Little White Girl* was unanimously denounced? There were, to be sure, a few negative notices. The *Art Journal*, which characterised all of Whistler's current works as 'experiments and freaks', said *The Little White Girl* was what 'the Italians would call un capriccio' and was 'a mere "abozzo" or first "rubbing in" ' and concluded that 'no artist can play such pranks for long with impunity'. The *Evening News* judged the picture to be 'a more domesticated version of his fantastic figures neither Chinese, Japanese, nor

European. . . . The picture is an eccentric trifle, clever as far as it goes, but too much of the "bon-bon" style ever to lead to any worthiness in art.' And the *Illustrated London News* said that because of 'Chinese ugliness and most impertinent slovenliness' Whistler's works, including *The Little White Girl*, 'have a value scarely above that of curious articles of virtù or luxurious upholstery'.

In 1865 some notices contained retrospective comments on Whistler's work, a tribute to his stature, an indication that he had 'arrived' and was too important to be ignored.

Stephens, in the *Athenaeum*, was among the commentators:

'Mr Whistler may be called half a great artist. He has shown to perfection the power of drawing, and has shown it in many examples, wherein the objects of representation have been old houses, rigging of ships, water, trees, and what-not of that sort. His knowledge of form is so complete that it is possible for him to express more by a single touch than most painters contrive to do by many touches. The power of drawing, and its concomitant knowledge of form seem to desert him whenever the human figure becomes his subject. Given a woman, and Mr Whistler will produce the most *bizarre* of bipeds, he will disdain to draw any one of her limbs or features and exhibits a strange indifference as to how, or why, they are put together. This negligence is clearly a whim, of which it was hoped the last sign appeared last year at the Royal Academy, the exquisitely-coloured and subtly-toned Chinese painter of jars. Mr Whistler still disdains, however, to change this portion of his style, and gives us figures which are as quaint, ill-proportioned, and innocent of modelling as their predecessors have been. He does not, however, fail to give to these queer creations the same subtle beauty of colour, the same almost mystical delicacy of tone and admirable *chiaroscuro*.'

Stephens's admiration of Whistler's pictures, it would seem, was proportionate to the degree in which they embodied the principles of Pre-Raphaelism.

Other generalised comments emphasised Whistler's alleged eccentricities. *The Times* said:

'If we are told that the eccentricity of genius is what the world calls originality, we reply that sound criticism makes a great distinction between the two things, and that so long as it classes a man among eccentrics, it refuses him the palm of genius. Mr Whistler as yet has been content, in all that we have seen of his, except his etchings, the "Girl at the Piano", by which he first attracted notice, and this picture of the "Girl in White",

to be what we must call eccentric. In these pictures he deserves to be called original.'

The *Pall Mall Gazette* called him 'an artist of remarkable power, but so eccentric that he can hardly hope for popularity'. The *Spectator*, which, as we saw, liked *Old Battersea Bridge*, referred to his other recent work as 'ludicrous imitation of Japanese art' and asked 'When will Mr Whistler give up sensation-hunting and betake himself seriously to his work?' The *Examiner*, which hitherto had overlooked Whistler, said simply, 'Mr Edward Burne-Jones's works are as preposterous in affectation as the Japanese impertinences of Mr Whistler at the Academy.' Burne-Jones's paintings were hanging in the Old Water Colour Society, and in the light of their later feelings toward each other, this coupling of their names seems ironic.

For Whistler, the late spring of 1865 was memorable for the attention given to his work and also for the reunion, after a ten years' separation, with his brother.

William astonished James by arriving on a mission for the Confederacy. He had been granted a furlough of four months, after which he was to return to America. He told exciting tales of recent adventures, and by examining some of his later correspondence we may envisage what Whistler heard in 1865. On 12 October 1898 Robert R. Hemphill, of Asheville, South Carolina, wrote to James Whistler and inquired about the whereabouts of his brother, who had been attached to Hemphill's regiment. 'He was a fine surgeon,' Hemphill said, 'kind hearted and a very brave man. We all admired and respected him.'[3]

James forwarded the letter to William, who gave Hemphill a lengthy account of his experiences of early 1865. In February he reported to Richmond and received dispatches to deliver in England, which, he said,

'made my getting through the lines an anxious undertaking. I had arranged to run the blockade from Charleston. On reaching Columbia, however, I found myself stopped by Sherman's advance; and so I had to beat a very hasty retreat from there back again towards Richmond. . . . Sherman's camp fires were lighting up the night, just across the river, and the whole town was in a bustle and preparation. Every man was being ordered to immediate duty. . . . I saw at once that this was no moment for showing papers or entering into explanations.'[4]

He stowed away in an empty van of a Treasury Department train and 'climbed in the dark to an upper shelf just under the roof . . . in the bitter cold, for it was snowing'. Upon reaching his destination, he found it

impossible to run the blockade, and thus he could not escape by sea. He went on:

'The only course open to me was to get round Grant's lines as best I could, and make my way through Maryland. . . . The travelling suit, required for a disguise, cost me 1,400 dollars, and the bundle of notes needed to meet the expense was so bulky, that I got a darkey to tote it to the tailor. . . . It was not until the 4th of March that I got fairly off. I started in an ambulance waggon, having secured a place in it for 510 dollars. . . . I walked nearly all the way, owing to the state of the roads.'

In a Virginia home he

'cleaned up, shaved, etc. . . . then across Chesapeake Bay in a canoe – finally got on a train to Philadelphia, where I bought a ticket without challenge by two military sentries standing by a window in the depot – finally to New York where I was comparatively safe. I sailed under an assumed name on the *City of Manchester* to Liverpool and immediately delivered my dispatches to the Confederate Secret Service Agent in Liverpool.'

From Liverpool he went to London.

One week after William's arrival, news came of Lee's surrender, and 'after this', he told Hemphill, 'I had nothing to return to, so I remained here with my family'. (His childless wife had died in 1863.)

James Whistler did not find William's presence comforting. For some time he had erased the war from his mind, but now, with a hero in his home, there could not but have been a return of his feelings of guilt. Had the war continued, perhaps he would have returned with his brother to America, but Lee's signature at Appomatox ended for ever his chance to gain glory on the battlefield.

Whistler's lately controlled restlessness was now revived, and during the summer he briefly visited Cologne, and immediately upon returning left with Jo for Trouville to join Courbet, who seemed more interested in Jo than Jim. He painted a fine portrait of her, *La Belle Irlandaise*, also known as *The Woman in the Mirror*, of which at least four versions exist. One is reproduced here, providing an interesting contrast with Whistler's depictions of Jo.

Whistler did no major work in Trouville. The several pictures he painted are less interesting *per se* than as portents for the future. *Sea and Rain* and *The Beach at Selsey Bill* are transitional works which are neither realistic nor atmospheric. Outwardly this working seashore holiday was

pleasant and serene – he swam and exchanged stories with Courbet – but inwardly it was a period of turmoil. Part of the unrest came from a guilty conscience, but it was deeper than this. Whistler's conflict was less military than artistic. He was a dissatisfied painter. He had left the track of Courbet and realism but had not yet stepped solidly on to a new path. The Japanese had helped in details but not in providing a road on which to travel. He was not now confiding in Fantin, which intensified the issue. He had recently paused in Paris to appear in a Japanese robe in Fantin's second group picture, *l'Hommage à la Vérité*, also known as *Le Toast*. Displeased with this work, Fantin slashed it, preserving only three heads, including Whistler's (reproduced in this volume). Cutting the picture seemed like a symbolic gesture, for, although they would continue to correspond, their active friendship had ended. Unlike most of Whistler's other ruptured relationships, it terminated amicably, resulting only from views on art from which they had diverged.

Writing to Joseph Pennell after Whistler's death, Fantin mentioned the abortive *Le Toast* and said, *'At this time he was closely tied with A. Moore.'[5] Herein lies the crux of the matter, the ferment in Trouville and the break with Fantin: Whistler had fallen under the influence of a new force, that of Albert Moore.

Twenty-four years old in 1865, the precocious Moore had exhibited five landscapes at the R.A. in 1857, 1858, and 1859, and four Biblical paintings in 1861 and 1862 – Pre-Raphaelite work reminiscent of Madox Brown and Holman Hunt. In 1862–3 he visited Rome and discovered classical Greek art. Immediately, he eliminated narrative elements from his work and concentrated on decorative arrangements of figures in classical drapery. Soon afterwards, Moore, like everyone else, was exposed to the Japanese, and, as Muther explained, he effected a unique mixture: 'From the Greeks he learnt the combination of noble lines, the charm of dignity and quietude, while the Japanese gave him the feeling for harmonies of colour, for soft, delicate, blended tones. By a capricious union of both of these elements he formed his refined and exquisite style.'[6]

The 'new Moore' first appeared publicly at the R.A. Exhibition of 1865 with *The Marble Seat*, which simply shows three Grecian-dressed women sitting on a bench, surrounded by trees and flowers, while a nude young man stands by pouring wine into a cup. *The Marble Seat* established the principle that Moore would adhere to thenceforth: art's sole function is to create beauty through lines and colours, and paintings are harmonies of tone and colour in which the subject is of no importance.

At the Exhibition of 1865, Whistler was transfixed by *The Marble Seat*: this was what he had been trying to do since *The White Girl*. He went to

the artist's home at 14 Russell Place and found Moore to be even more shy and withdrawn than Fantin. Totally dedicated to art, he was aloof to everything else and lived almost as a recluse. Again captivating by charm, Whistler at once struck up a friendship and wrote to Fantin suggesting that Moore replace Legros in the Society of Three. He did not pursue this thought, for both Legros and Fantin would be supplanted by Moore. For Whistler, Albert Moore symbolised a new artist's life. His arrival meant the liquidation of earlier associations, those of his youth and apprentice-ship – obviously Courbet, but also Fantin-Latour.

Whistler probably pondered these matters at Trouville. It was not easy to break with Fantin, nor to adopt at once the principles of Moore. To paint non-subject pictures successfully, it was essential to have an excellent technique, and he may have regretted neglecting this while studying in Paris. He may have wondered if he had the capacity to realise his conceptions. He returned to London late in the year immersed in thought.

On 10 January 1866 Charles Keene wrote to Edwin Edwards, 'Have you been to Gambart's exhibition? . . . I hear Whistler's Paris picture is hung there.'[7] Gambart was holding a small show in his gallery, which included not *La Princesse*, the 'Paris picture', but its artistic cousin, *The Lange Leizen*. Whistler may not have known that Gambart was exhibiting one of his pictures. In January of 1866 he was engrossed in more serious matters.

On the final day of the month he signed his 'last will and testament', wherein he declared: 'I devise and bequeath all the Real and Personal Estate to which I shall be entitled at the time of my decease unto Joanna Hiffernan of No. 7 Lindsey Row.'[8] Also on 31 January, Whistler wrote to the Manager of the Bank of London:

'I request you will . . . consider Miss Joanna Hiffernan as fully empowered for me, and on my behalf, to draw Cheques; to negotiate for and take Discounts, Loans, on my account, and take or deposit any species of security for the repayment of such loans; and generally, in all dealings and transactions between me and you, to act as fully and effectually for all intents and purposes as I could if personally present acting in the matters and transactions aforesaid.'[9]

Whistler's confidence in Jo's judgement was reinforced by another paper of late January. His solicitor, Anderson Rose, was empowered to negotiate for the Thames etchings, but otherwise Jo had the authority to deal as she saw fit with all 'pictures in his possession and any he may send from abroad'.[10]

The preamble to the power of attorney document gives the reason for these papers. Whistler was 'about to proceed to America'. Although in fact America encompasses everything from the northernmost Canadian island to Cape Horn, almost every English person regards 'America' as synonymous with the United States of America. Whistler encouraged his English friends to think that he had gone to the United States, and he even gave them a precise destination. In February, Swinburne wrote to an unknown recipient that Whistler 'really was off to California', and a few days later Keene remarked to Edwards, 'That was a rum stunt of Jemmy Whistler bolting to California was it not?'[11]

Why he had gone to California was a mystery, one that would not soon be solved, for no one heard from him during 1866. And no one could have received a letter from him postmarked California, for James Whistler never was in California. In February 1866 he left for America, but not the United States of America. He went to South America, specifically Valparaiso, Chile.

For many writers on Whistler, the trip to Chile is unexplainable, and more than one biographer has suggested that perhaps he never made the journey. Elizabeth Pennell, than whom no one knew Whistler better in his later life, said the voyage 'always struck Joseph Pennell and myself as the most inexplicable incident of his life. We were unable anywhere to find even the suggestion of a special necessity for him to leave London at this time.'[12] The usually perceptive Mrs Pennell was too close to her subject in the mid-nineties to perceive that thirty years earlier Whistler had two excellent reasons for journeying somewhere, if not to Valparaiso. He probably felt, in the first place, a need to be alone, away from a familiar environment, in order to resolve his artistic conflicts. Secondly, because he continued to be embarrassed by the recent American Civil War, Chile was a fitting country to visit, for in 1866, along with Peru, it was at war with Spain.

In October 1865, following a Spanish blockade of its coast, Chile declared war, and on 25 November the *Illustrated London News* reported from Valparaiso: 'The enthusiasm is great, all from the highest to the lowest being anxious to take up arms and offering their services to the Government. . . . The spirit of 1810 is again awake, and the Chilians, not deterred by the immediate sacrifice, are prepared to fight the war of independence again.' This was made to order for Whistler, and, given his current state of mind, his adventure is far from inexplicable.

Whistler spent most of 1866 in Valparaiso but never said much about it, and nothing at all for thirty years. He arrived in time for one flare of hostilities, the Spanish bombardment on 31 March. An officer on a nearby British warship described the attack in a letter published in the *Illustrated London News*:

'. . . at about nine a.m., the Spanish fleet . . . began to fire on the town. They continued the bombardment until the town was in flames in one place, and the custom-house also. . . . I saw shells bursting amongst the poor people's houses; and one went close to a whole lot of cattle and men, congregated, as they fancied, out of range. One old donkey I saw hit, and also a shell exploded within ten yards of an old woman. . . . Today I was on shore, and I was surprised at the very trivial effect the bombardment has had on the town. . . . I could not find out if any were killed, but I think not. . . . During the whole bombardment the Chilieans did not return a shot.'

The only military engagement that James Whistler ever saw or heard was this three-hour shelling of Valparaiso.

If militarily the trip to Chile was a fiasco, personally and artistically it was of the greatest importance.

Except for the 1862 episode with a Parisian plasterer, Whistler had never been pugnacious, nor had he shown signs of a temper. Late in the autumn of 1866 a ship travelling from Valparaiso to London gave birth to the 'new Whistler'. 'On the return voyage,' Boyce wrote in his diary, 'he got into a shindy with a swell Marquis-Nigger, whom he took exception to and whose head he punched, for which he was put under arrest. . . . He subsequently had a row with the mail agent, who gave him a black eye.' When Whistler spoke of the incident, thirty years later, he recalled 'a nigger from Hayti, made obnoxious to me, by nothing in particular except his swagger and his colour. And, one day, I kicked him across the deck to the top of the companion way and there sat a lady who provided an obstacle for a moment. But I just picked up the Marquis de Marmalade, dropped him down on the steps below her, and finished kicking him down stairs.'[13]

Upon reaching London, Whistler became involved in an episode in the station which, the Pennells noted, remained clouded in obscurity. 'The final adventure Whistler never told us, but everybody else says that when he got out the train . . . someone besides his friends was waiting: whether the captain of the ship, or relations of the Marquis, or an old enemy, really makes little difference. Somebody got a thrashing.'[14]

In November a new man arrived in London, and also a new artist. The quantity of work Whistler had with him was hardly overwhelming. 'He has brought back', Boyce wrote, 'but two oil sea-sketches with shipping, both are near Valparaiso, both though slight, effective, artistic, and true in tone.' In the mid-nineties Whistler told the Pennells that he had painted two other pictures in Chile, which were stolen by the ship's purser, and on the return voyage 'a tidal wave met the ship and swept off

purser, cabin, and Whistlers'.[15] This story should be taken with several grains of salt and was probably invented to explain why he had not accomplished more in Chile. The only pictures that may be safely assigned to Valparaiso are *Nocturne in Blue and Gold: Valparaiso* (in the Freer Gallery) and *Crepuscule in Flesh Colour and Green: Valparaiso* (reproduced in this volume). Neither is a great work of art, but they are prophetically important. They show that Whistler had worked out his problems, and, by absorbing and combining the Japanese and Albert Moore, had created something new and original. As *The French Set* was seminal for the career of the young Whistler, these Valparaiso paintings signal the beginning of a new, mature artistic life.

Unlike his Thames pictures, Whistler's Chilean paintings have no details of 'local colour'. Indeed they have few readily identifiable details of any kind. As Frederick Sweet pointed out, they 'reveal an increasing preoccupation with fleeting effects of light and atmosphere ... and thereby achieve significance as the direct ancestors of the Nocturnes of the '70s'.[16]

Whistler spent less than a year in Chile and returned with only two pictures, but it would be difficult to overestimate this interval. To quote one of the more delightful commentators on his work, it was 'the splendid moment of his career. This change of scene ... seems to have made a marvellous impression on the man. It was in this year that he drew completely away from tradition and the achievement of his own and former ages – it was in this year that he found himself. His hand becomes bolder; his spirit frees itself from the ages; he rises above the schooling of tradition; and his confidence is justified and supreme.'[17] It was in this year that one may write 'finis' to the life of the young Whistler.

NOTES
BIBLIOGRAPHY
INDEX

Notes

CHAPTER I

1 Frederick Wedmore, 'British Etching', *Magazine of Art*, vol. 16 (1893), p. 884.
2 Ernest Knaufft, 'James A. McNeill Whistler', *Review of Reviews*, vol. 28 (1903), p. 95.
3 Léonce Bénédite, 'Artistes Contemporains: Whistler', *Gazette des Beaux-Arts*, vol. 33 (1905), p. 403.
4 H. Granville Fell, 'Memories of Whistler', *Connoisseur*, vol. 95 (1935), p. 21.
5 'Whistler's Birthplace', New York *Sun*, 18 April 1936, p. 22.
6 Bénédite, p. 403.
7 Elizabeth and Joseph Pennell, *The Life of James McNeill Whistler* (Philadelphia, Lippincott, 1908), vol. I, pp. 1–2.
8 From an unpublished letter in the Freer Gallery of Art.
9 Nathan Appleton, *The Origin of Lowell* (Lowell, Massachusetts, B. H. Penhallow, 1858), p. 19.
10 John Warner Barber, *Historical Collections Relating to the History and Antiquity of Every Town in Massachusetts* (Worcester, Massachusetts, Dorr, Howland, and Company, 1841), p. 406.
11 *American Guide Series: Massachusetts* (Boston, Houghton Mifflin, 1937), p. 261.
12 'A Day at Lowell', *Western Monthly Magazine and Literary Journal*, vol. 5 (1936), p. 72.
13 Hannah Josephson, *The Golden Threads* (New York, Duell, Sloan, and Pearce, 1949), p. 4.
14 Michel Chevalier, *Society, Manners and Politics in the United States* (Gloucester, Massachusetts, Peter Smith, 1967), p. 129.
15 ibid., p. 142.
16 Charles Dickens, *American Notes*, Chapter 4.
17 ibid.
18 Chevalier, p. 133.
19 Carlisle Allen, 'The Husband of Mrs Whistler', New York *Herald Tribune*, 6 May 1934, p. 5.
20 John L. Hobbs, 'The Boott and Haden Families and the Founding of Lowell', *Derbyshire Archaeological and Natural History Society Journal*, vol. 66 (1946), p. 59.
21 Appleton, p. 36.
22 Lawrence F. Whittemore, *Old Stonington in Connecticut* (New York, The Newcomen Society, 1949), p. 17.
23 ibid.
24 For an account of the Battle of Stonington, see Henry Robinson Palmer, *Stonington by the Sea* (Stonington, Connecticut, Palmer Press, 1913). pp. 34–41.
25 Henry Robinson Palmer, *Stonington by the Sea* (Stonington, Connecticut, 1913), pp. 75–6.
26 George L. Vose, *The Life and Works of George W. Whistler* (Boston, Lee & Shepard, 1887), p. 13.
27 From an unpublished letter in the Massachusetts Historical Society.
28 For a reproduction of the drawing see Pennell, *Life*, vol. I, facing p. 10.
29 Nancy Dorfman Pressly, 'Whistler in America', *Metropolitan Museum Journal*, vol. 5 (1972), p. 127.
30 Albert Parry, *Whistler's Father* (Indianapolis, Bobbs-Merrill, 1939), p. ix.

31 ibid.

32 This unpublished letter is in the Library of Congress.

33 From a letter of 1899 to William Heinemann, in the Library of Congress.

34 From I. B. Davenport's unpublished interview with Whistler, in the New York Public Library.

35 From an unpublished letter, undated, to Otto Goldschmidt, in the Library of Congress.

36 Michael Frisch, *Town Into City* (Cambridge, Massachusetts, Harvard University Press, 1972), pp. 31, 33.

37 'Springfield Sixty Years Ago', *Progressive Springfield*, vol. 1 (1891), p. 73.

38 Frisch, p. 34.

39 Oramel S. Senter, 'Springfield as It Was and Is', *Potter's American Monthly*, vol 9 (1877), p. 245.

40 See the map of Springfield in Mason A. Green, *Springfield, History of Town and City* (Springfield, C. A. Nichols, 1888), p. 438.

41 Senter, p. 247.

42 ibid., p. 246

43 Vose, p. 25.

44 Richard M. Haywood, *The Beginnings of Railway Development in Russia* (Durham, North Carolina, Duke University Press, 1969), p. 229.

45 Mumford, p. 56.

CHAPTER 2

1 'St. Petersburg and Its Inhabitants in 1843', *Colburn's New Monthly Magazine*, vol. 69 (1843), p. 241.

2 John S. Maxwell, *The Czar, His Court and People* (New York, Scribner's, 1854), p. 105.

3 'Winter at St. Petersburg', *The Times*, 12 January 1842, p. 3.

4 J. G. Kohl, *Russia* (London, Chapman and Hall, 1844), p. 47.

5 Maxwell, p. 137.

6 'Sketches in St. Petersburg', *Illustrated London News*, 26 October 1856, p. 419.

7 Maxwell, p. 180.

8 J. N. Westwood, *A History of Russian Railways* (London, Allen & Unwin, 1964), p. 30.

9 Maxwell, p. 162.

10 Constantine de Grunwald, *Tsar Nicholas I* (New York, Macmillan, 1955), p. 133.

11 Maxwell, p. 119.

12 Robert Sears, *An Illustrated Description of the Russian Empire* (New York, Sears, 1855), p. 477.

13 'Sketches in St. Petersburg', p. 419.

14 Elizabeth and Joseph Pennell, *The Life of James McNeill Whistler*, vol. I, p. 17.

15 Kohl, p. 105.

16 Marquis de Custine, *Russia* (New York, Appleton, 1854), p. 57.

17 'St. Petersburg and Its Inhabitants', p. 248.

18 Custine, p. 249.

19 ibid., p. 141.

20 ibid., p. 41.

21 'A Winter at St. Petersburg', *London Society*, vol. 11 (1867), p. 147.

22 Maxwell, p. 45.

23 [Frederick Hardman], 'Pictures from St. Petebrsurg', *Blackwood's Magazine*, vol. 70 (August 1851), p. 156.

24 'St. Petersburg and Its Inhabitants', p. 246.

25 Maxwell, p. 101.

26 George A. Sala, 'St. Petersburg as It Is', *Illustrated London News*, 28 April 1877, p. 406.

27 Custine, p. 71.

28 Kohl, p. 47.

29 Westwood, p. 32.

30 Custine, p. 72.

31 ibid., p. 77.

32 'Pictures from St. Petersburg', p. 155.

33 Custine, p. 52.

34 Francis Bouvier, *The Czar and the Sultan* (New York, Harper, 1853), p. 32.

35 Grunwald, p. 147.

36 Gardner C. Teall, 'Whistler's Father', *New England Magazine*, vol. 29 n.s. (1903), p. 238.

37 'Gigantic Railway Plan in Russia', *The Times*, 4 June 1844, p. 6.

38 'Reynolds and the Portrait Painters of the Past Century', *Blackwood's Magazine*, vol. 102 (1867), p. 584.

39 Mary Chamot, *Russian Painting and Sculpture* (New York, Macmillan, 1963), p. 19.

40 Richard Hare, *The Art and Artists of Russia* (London, Methuen, 1965), p. 207.

41 ibid.

42 Elizabeth and Joseph Pennell, *The Whistler Journal* (Philadelphia, Lippincott, 1921), p. 182.

CHAPTER 3

1 All quotations from Mr Whistler's letters are from his unpublished correspondence in the University of Glasgow Library.

2 These letters of Seymour Haden are in the University of Glasgow Library.

3 From an unpublished letter in the University of Glasgow Library.

4 John Sandberg, 'Whistler Studies', *Art Bulletin*, vol. 50 (March 1968), pp. 47–8.

5 George L. Vose, *The Life and Works of George W. Whistler* (Boston, Lee & Shepard, 1887), p. 36.

6 From an unpublished letter in the University of Glasgow.

CHAPTER 4

1 'Common School System of Connecticut', *New York Review*, vol. 10 (1842), pp. 340–1.

2 'Common Schools in Connecticut', *American Journal of Education*, vol. 11 (1862), p. 311.

3 Darius Mathewson, 'Reminiscences of Pomfret', in *Pomfret Old Home Festival* (Pomfret, Connecticut, Pomfret Neighborhood Association, 1915), p. 60.

4 Elizabeth and Joseph Pennell, *The Life of James McNeill Whistler* (Philadelphia. Lippincott, 1908), vol. I, pp. 25–7.

5 ibid., p. 26.

6 ibid., p. 28.

7 ibid., p. 27.

8 A. J. Bloor, 'Whistler's Boyhood', *The Critic*, vol. 43 (1903), p. 250.

9 Pennell, vol. I, p. 28.

10 Bloor, p. 250.

11 Nancy Dorfman Pressly, 'Whistler in America', *Metropolitan Museum Journal*, vol. 5 (1972), p. 129.

12 *Regulations of the Military Academy* (New York, Wiley and Putnam, 1839).

13 Morris Schaff, *The Spirit of Old West Point* (Boston, Houghton Mifflin, 1907), p. 2.

14 ibid., p. 80.

15 Stephen E. Ambrose, *Duty, Honor, Country* (Baltimore, Johns Hopkins University Press, 1966), p. 129.

16 ibid.

17 K. Bruce Galloway and Robert Bowie Johnson Jr, *West Point* (New York, Simon and Schuster, 1973), p. 141.

CHAPTER 5

1 'Academy at West Point', *American Quarterly Review*, vol. 16 (1834), p. 362.

2 Charles Dickens, *American Notes*, Chapter 15.

3 Morris Schaff, *The Spirit of Old West Point* (Boston, Houghton Mifflin, 1907), p. 38.

4 Stephen E. Ambrose, *Duty, Honor, Country* (Baltimore, Johns Hopkins University Press, 1966), p. 120.

5 ibid., p. 128.

6 Schaff, p. 38.

7 ibid., p. 22.

8 'Academy at West Point', p. 362.

9 Stephen E. Ambrose, *Crazy Horse and Custer* (New York, Doubleday,1975), p. 93.

10 Schaff, p. 82.

11 'Military Academy', *North American Review*, vol. 34 (1832), p. 258.

12 *Regulations of the Military Academy* (New York, Wiley and Putnam, 1839), p. 31.

13 H. M. Lazelle, 'Whistler at West Point', *The Century Magazine*, vol. 90 (1915), p. 710.

14 Thomas Wilson, 'Whistler at West Point', *The Book-Buyer*, vol. 17 (1898), p. 113.

15 Edward C. Boynton, *Guide to West Point* (New York, Van Nostrand, 1867), p. 66.

16 Lazelle, p. 710.

17 Elizabeth and Joseph Pennell, *The Life of James McNeill Whistler* (Philadelphia, Lippincott, 1908), vol. I, p. 34–5.

18 *Regulations of the Military Academy*, p. 40.

19 Joseph B. James, 'Life at West Point One Hundred Years Ago', *Mississippi Valley Historical Review*, vol. 31 (1944), p. 26.

20 E.M. Hunt, 'West Point and Cadet Life', *Putnam's Monthly Magazine*, vol. 4 (1854), p. 193.

21 Ambrose, *Crazy Horse and Custer*, p. 95.

22 Peter S. Michie, *Life and Letters of Henry Upton* (New York, Appleton, 1885), p. 12.

23 Ambrose, *Crazy Horse and Custer*, p. 96.

24 James, p. 23.

25 Julian Hawthorne, 'A Champion of Art', *The Independent*, vol. 51 (1899), p. 384.

26 From an unpublished letter in the University of Glasgow.

27 Lazelle, p. 710.

28 ibid.

29 ibid.

30 Gamaliel Bradford, 'James McNeill Whistler', *Atlantic Monthly*, vol. 127 (1921), p. 512.

31 Luke Ionides, 'Memories', *Transatlantic Review*, vol. 1 (1924), p. 52.

32 Mortimer Menpes, *Whistler as I Knew Him* (London, Adam and Charles Black, 1904), p. 65.

33 ibid., p. 128.

34 Gustav Kobbé, 'Whistler at West Point', *The Chap-Book*, vol. 8 (1898), p. 442.

35 Kenneth W. Rapp, 'Whistler in Cadet Gray', *Assembly*, vol. 29 (1971), p. 12.

36 Lazelle, p. 710.

37 Wilson, p. 114.

38 Pennell, vol. I, p. 55.

39 Kobbé, p. 440.

40 Extracted from the *Official Register of Officers and Cadets, U.S.M.A.*, 1851–1858.

41 Hunt, p. 202.

42 General Joseph Wheeler, 'West Point Fifty Years Ago', *The Golden Age* (1906), p. 68.

43 Herman Herst Jr, 'Manuscripts Gone Forever ?' *Manuscripts*, vol. 17 (1965), p. 4.

44 Kenneth W. Rapp, 'More About Whistler and Lee', *Manuscripts* (1966), p. 17.

45 Sir J. E. Alexander, 'United States Military Academy', *Colburn's United Service Magazine*, vol. 3 (1854), p. 13.

46 ibid., p. 10.

47 Irene Weir, *Robert W. Weir* (New York, Doubleday, 1947), pp. 70, 72.

48 *Regulations of the Military Academy*, p. 12.

49 Weir, p. 66.

50 *Centennial of United States Military Academy at West Point* (Washington, Government Printing Office, 1904), p. 302.

51 Wilson, p. 114.

52 Kobbé, p. 440.

53 Wilson, p. 114.

54 Day Allen Willey, 'Whistler's West Point Drawings', *Book News Monthly*, vol. 30 (1912), p. 637.

55 Kobbé, p. 442.

56 Wilson, p. 113.

57 Kobbé, p. 442.

58 Joseph William C. Carr, *Some Eminent Victorians* (London, Duckworth, 1908), p. 137.

59 Mortimer Menpes, 'Reminiscences of Whistler', *The Studio*, vol. 29 (1903), p. 65.

60 West Point Superintendent's Letterbook, Number 3, p. 29.

61 Rapp, 'More About Whistler and Lee', p. 15.

62 *Regulations of the Military Academy*, pp. 13–14.

63 Weir, p. 66.

64 Columbia College Catalogue, 1853–4.

65 Kobbé, pp. 441–2.

66 Discovered in 1925, the three pages, along with three humorous drawings, are owned by the Metropolitan Museum of Art.

67 William H. Baumer, *Not All Warriors* (New York, Smith and Durrell, 1941), p. 228.

68 Lazelle, p. 710.

69 Boynton, p. 84.

70 Ambrose, *Crazy Horse and Custer*, p. 105.

71 From an unpublished letter in the University of Glasgow.

72 *Regulations of the Military Academy*, p. 21.

73 Lazelle, p. 710.

74 From an unpublished letter in the University of Glasgow.

75 Douglas Southall Freeman, *Robert E. Lee* (New York, Scribner's, 1934), vol. I, p. 337.

76 Elizabeth Pennell, *The Art of Whistler* (New York, The Modern Library, 1928), p. 112.

CHAPTER 6

1 Elizabeth and Joseph Pennell, *The Life of James McNeill Whistler* (Philadelphia, Lippincott, 1908), vol. I, p. 36.

2 Elizabeth Mumford, *Whistler's Mother* (Boston, Little, Brown, 1939), p. 202.

3 From an unpublished letter in the University of Glasgow.

4 ibid.

5 Thomas Winans's unpublished journal is included in the Winans Papers, in the library of the Maryland Historical Society, Baltimore.

6 John G. Gobright, *Baltimore as It Is* (Baltimore, John Woods, 1857), pp. 9–10.

7 Pennell, vol. I, p. 39.

8 *American Guide Series: Maryland* (Oxford University Press, 1940), p. 210.

9 J. D. B. DeBow, *The Compendium of the Seventh Census* (Washington, U.S. Census Office, 1854), p. 240.

10 Nancy Dorfman Pressly, 'Whistler in America', *Metropolitan Museum Journal*, vol. 5 (1972), p. 134.

11 *The United States Coast Survey* (New York, Dix and Edwards, 1855), p. 12.

12 Henry S. Pritchett, unpublished letter to Howard Mansfield, 8 May 1900, in the Manuscript Division, New York Public Library.

13 John Ross Key, 'Recollections of Whistler', *Century Magazine*, vol. 75 (1908), p. 929.

14 Theodore Duret, *Whistler* (Philadelphia, Lippincott, 1917), p. 14.

15 Gustav Kobbé, 'Whistler in the U.S. Coast Survey', *The Chap-Book*, vol. 8 (1898), pp. 479–80.

16 Key, p. 931.
17 From an unpublished letter in the University of Glasgow.
18 Pritchett.
19 Key, p. 929.
20 ibid.
21 From an unpublished memorandum by a colleague of Whistler at the Coast Survey, in the Manuscript Division, New York Public Library.
22 ibid.
23 Kobbé, p. 480.
24 Key, p. 931.
25 ibid., pp. 932–3.
26 Pennell, vol. I, p. 42.
27 ibid.
28 Kobbé, p. 480.
29 See note 21 above.
30 Key, p. 932.
31 ibid.
32 Pressly, p. 134.
33 Constance McLaughlin Green, *Washington, Village and Capital, 1800–1878* (Princeton, New Jersey, Princeton University Press, 1962), p. 215.
34 ibid., p. 189.
35 ibid., p. 182.
36 Pressly, p. 135.

CHAPTER 7

1 From an unpublished letter in the University of Glasgow.
2 'Student Life in Paris', *Household Words*, vol. 3 (1851), p. 286.
3 Thomas Armstrong, *A Memoir* (London, Martin Secker, 1912), p. 116.
4 *Bogue's Guides for Travellers, Paris and Its Environs* (London, David Bogue, 1885), p. 15.
5 Armstrong, p. 116.
6 Lawrence and Elizabeth Hansen, *Impressionism: the Golden Decade* (New York, Holt, Rinehart & Winston, 1961), p. 454.
7 John Rewald, *The History of Impressionism* (New York, The Museum of Modern Art, 1961), p. 20.
8 Hansen, p. 17.
9 ibid., p. 12.
10 Charles Baudelaire, *Art In Paris, 1845–1862* (London, Phaidon Press, 1965), p. 217.
11 John Canaday, *Main Streams of Modern Art* (New York, Holt, Rinehart & Winston, 1959), p. 154.
12 Ernst Scheyer, 'Far Eastern Art and French Impressionism', *Art Quarterly*, vol. 6 (1943), p. 59.
13 Rewald, p. 28.
14 ibid.
15 Joseph C. Sloane, *French Painting Between the Past and the Present* (Princeton, New Jersey, Princeton University Press, 1951), p. 128.
16 Marcel Zahar, *Courbet* (London, Longmans, Green & Co., 1950), p. 8.
17 Sloane, p. 48.
18 Albert Ludovici, *An Artist's Life in London and Paris* (New York, Minton, Batch & Co., 1926), p. 138.
19 Albert Boime, *The Academy and French Painting in the Nineteenth Century* (London, Phaidon, 1971), p. 68.
20 Rewald, p. 70.

21 François Fournel, *Les Artistes Français Contemporains* (Tours, Alfred Mame et Fils, 1884), p. 222.

22 ibid., p. 223.

23 Boime, p. 61.

24 Ambroise Vollard, *Auguste Renoir* (New York, Knopf, 1934), p. 26.

25 Rewald, p. 73.

26 Vollard, p. 26.

27 Rewald, p. 73.

28 Boime, p. 60.

29 ibid., p. 63.

30 Rewald, p. 62.

31 S. G. W. Benjamin, 'Art in Contemporary France', *Harper's Magazine*, vol. 54 (1877), p. 487.

32 Elizabeth and Joseph Pennell, *The Whistler Journal* (Philadelphia, Lippincott, 1921), p. 172.

33 Boime, p. 61.

34 Val Prinsep, 'A Student's Life in Paris in 1859', *Magazine of Art* (1904), p. 339.

35 Elizabeth and Joseph Pennell, *The Life of James McNeill Whistler* (Philadelphia, Lippincott, 1908), vol. I, p. 51.

36 G. H. Boughton, 'A Few of the Various Whistlers I Have Known', *Studio*, vol. 30 (1903), p. 211.

37 Theodore Duret, *Whistler* (Philadelphia, Lippincott, 1917), p. 99.

38 *Bogue's Guides*, p. 38.

39 'The Quartier Latin', *Galaxy*, vol. 1 (1866), p. 610.

40 Jules Janin, 'The Grisette', in *Pictures of the French* (London, Wm. S. Orr and Co., 1840).

41 Luke Ionides, 'Memories', *Transatlantic Review*, vol. 1 (1924), p. 38.

42 Mrs Russell Barrington, *Life, Letters and Work of Frederick Leighton* (London, George Allen, 1906), vol. I, p. 236.

43 Pennell, *Life*, vol. I, p. 55.

44 Arsène Alexander, 'J. McNeill Whistler', *Les Arts* (1903), p. 4.

45 Pennell, *Life*, vol. I, p. 38.

46 Malcolm Easton, *Artists and Writers in Paris* (New York, St Martin's Press, 1964), p. 173.

47 Armstrong, p. 174.

48 Pascal Forthuny, 'Notes sur James Whistler', *Gazette des Beaux-Arts*, vol. 30 (1903), p. 390.

49 From an unpublished letter in the Library of Congress.

50 Elizabeth Pennell, 'Whistler Makes a Will', *The Colyphon* (1934) [unnumbered pages].

51 Armstrong, p. 140.

52 ibid., p. 121.

53 *Nocturnal London* (London, S. E. Stanesby, 1890), p. 269.

54 Armstrong, p. 93.

55 Leonée Ormond, *George Du Maurier* (Pittsburgh, University of Pittsburgh Press, 1969), pp. 45–6.

56 Dougald S. MacColl, 'The Industrious and Idle Prentices', *Saturday Review*, vol. 96 (1903), p. 608.

CHAPTER 8

1 Albert Boime, *The Academy and French Painting in the Nineteenth Century* (London, Phaidon, 1971), p. 52.

2 Lawrence and Elizabeth Hansen, *Impressionism: the Golden Decade* (New York, Holt, Rinehart & Winston, 1961), p. 9.

3 Alfred Stevens, *A Painter's Philosophy* (London, Elkin Mathews, 1904), section ccxv.

4 ibid., section xxxviii.

5 Malcolm Easton, *Artists and Writers in Paris* (New York, St Martin's Press, 1964), p. 105.

6 François Fournel, *Les Artistes Français Contemporains* (Tours, Alfred Mame et Fils, 1884), p. 224.

7 John Rewald, 'Auguste Renoir and His Brother', *Gazette des Beaux-Arts*, vol. 27 (1945), p. 179.

8 Elizabeth and Joseph Pennell, *The Life of James McNeill Whistler* (Philadelphia, Lippincott, 1908), vol. I, p. 67.

9 Thomas Armstrong, *A Memoir* (London, Martin Secker, 1912), p. 188.

10 John Rewald, *The History of Impressionism* (New York, The Museum of Modern Art, 1961), p. 75.

11 Richard A. Muther, *The History of Modern Painting* (London, Henry & Co., 1895), vol. 3, p. 395.

12 Stevens, section cli.

13 Léonce Bénédite, 'Artistes Contemporains: Whistler', *Gazette des Beaux-Arts*, vol. 33 (1905), p. 406.

14 Armstrong, p. 178.

15 Pennell, p. 61.

16 Bénédite, p. 406.

17 Rewald, *Impressionism*, p. 76.

18 Frank Gibson, *The Art of Henri Fantin-Latour* (London, Diane's Ltd, 1924), p. 289.

19 Bénédite, p. 404.

20 From an unpublished letter in the Library of Congress.

21 Stevens, section xv.

22 Gerstle Mack, *Gustave Courbet* (New York, Knopf, 1951), p. 92.

23 Fournel, p. 356.

24 Mack, p. 93.

25 'Gustave Courbet', *Temple Bar*, vol. 42 (1874), p. 311.

26 Fournel, p. 354.

27 ibid., p. 350.

28 ibid., pp. 354–5.

29 ibid., p. 355.

30 Elizabeth Pennell, *Whistler the Friend* (Philadelphia, Lippincott, 1930), p. 91.

31 Edmund Wuerpel, 'Whistler the Man', *American Magazine of Art*, vol. 27 (1935), p. 132.

32 Pennell, *Whistler the Friend*, p. 46.

33 ibid.

34 Lecoq de Boisbaudran, *The Training of Memory in Art* (London, Macmillan, 1911), p. 4.

35 ibid., p. 15.

36 ibid., p. 16.

37 ibid., p. 21.

38 Frederick Wedmore, *Meryon and Meryon's Paris* (London, Thibaudeau, 1879), p. 21.

39 William Howe Downes, 'Whistler the Etcher', Boston *Evening Transcript* (1904). [Taken from book of cuttings in Library of Congress.]

40 ibid.

41 Charles H. Caffin, *American Masters of Painting* (New York, Doubleday, Page, & Co., 1902), p. 47.

42 Armstrong, p. 146.

43 Pennell, *Life*, vol. I, p. 66.

44 Campbell Dodgson, *The Etchings of James McNeill Whistler* (London, Geoffrey Holme, 1922), p. 10.

45 Theodore Duret, 'James Whistler', *Gazette des Beaux-Arts*, vol. 23 (1881), p. 369.

46 From an unpublished letter in the Library of Congress.

47 Pennell, *Life*, vol. I, pp. 62–3.

48 ibid., p. 63.

49 Armstrong, p. 190.

50 Elizabeth Pennell, *The Art of Whistler* (New York, Modern Library), p. 61.
51 From an unpublished letter in the Library of Congress.
52 From an unpublished letter in the University of Glasgow.
53 'The Lady of the Portrait', *Atlantic Monthly*, vol. 136 (1925), p. 322.
54 Theodore Duret, *Whistler* (Philadelphia, Lippincott, 1917), p. 25.
55 Stevens, section cxxvi.
56 Sheldon W. Chaney, *The Story of Modern Art* (New York, Viking Press, 1941), p. 150.
57 Rewald, *Impressionism*, p. 20.
58 John Canaday, *Main Streams of Modern Art* (New York, Holt, Rinehart & Winston, 1959), p. 140.
59 Rewald, *Impressionism*, p. 32.
60 Charles Baudelaire, *Art in Paris* (London, Phaidon, 1965), p. 146.
61 Bénédite, p. 409.
62 Pennell, *Life*, vol. I, p. 69.
63 Armstrong, p. 211.

CHAPTER 9

1 James Whistler, *The Gentle Art of Making Enemies*, p. 331.
2 'The Lady of the Portrait', *Atlantic Monthly*, vol. 136 (1925), p. 323.
3 From an unpublished letter in the University of Glasgow.
4 Malcolm C. Salaman, *Sir Francis Seymour Haden* (London, The Studio, 1926), p. 2.
5 'The Lady of the Portrait', p. 322.
6 Aaron Sheon, 'French Art and Science in the Mid-Nineteenth Century', *Art Quarterly*, vol. 34 (1971), p. 439.
7 Tom Taylor, 'English Painting in 1862', *Fine Arts Quarterly Review*, vol. 1 (1863), p. 3.
8 ibid.
9 A. Paul Oppé, 'Art', in G. M. Young's *Early Victorian England* (Oxford University Press, 1934), vol. 2, pp. 115–16.
10 ibid.
11 William Rossetti, *Fine Art* (London, Macmillan, 1867), p. 97.
12 'Art and the Royal Academy', *Fraser's Magazine*, vol. 46 (1852), p. 230.
13 ibid.
14 'The Art Exhibition of 1859', *Bentley's Quarterly Review*, vol. 1 (1859), pp. 585–6.
15 Daphne Du Maurier, *The Young George Du Maurier: A Selection of His Letters* (London, Peter Davies, 1951), p. 6.
16 G. H. Boughton, 'A Few of the Various Whistlers I Have Known', *Studio*, vol. 30 (1903), p. 87.
17 Pennell, vol. I, p. 79.
18 Du Maurier, p. 7.
19 Albert Ludovici, *An Artist's Life in London and Paris* (New York, Minton, Batch & Co., 1926), p. 78.
20 Du Maurier, p. 66.
21 From an unpublished letter in the Library of Congress.
22 Frank Gibson, *The Art of Henri Fantin-Latour* (London, Diane's Ltd, 1924), p. 36.
23 Du Maurier, p. 27.
24 Edward Beck, *Memorials to Serve for a History of Rotherhithe* (Cambridge University Press, 1907), p. 1.
25 'The Turner Gallery', *Art Journal*, n.s. vol. 1 (1862), p. 155.
26 Nathaniel Hawthorne, 'Up the Thames', *Atlantic Monthly*, vol. 11 (1863), p. 599.
27 Henry Mayhew, *London Labour and London Poor* (London, Griffin, Bohn, & Co., 1861), vol. 3, pp. 302–3.
28 Gustave Doré and Blanchard Jerrold, *London a Pilgrimage* (London, Grant and Co., 1872), pp. 21, 23.

29 Alfred Stevens, *A Painter's Philosophy* (London, Elkin Mathews, 1904), section xci.
30 Léonce Bénédite, 'Artistes Contemporains: Whistler', *Gazette des Beaux-Arts*, vol. 33 (1905), p. 496.
31 'London Pictures', *Builder*, vol. 18 (1860), p. 348.
32 Du Maurier, p. 38.
33 William Holman Hunt, *Pre-Raphaelitism and the Pre-Raphaelite Brotherhood*, vol. I, p. 361.
34 Rossetti, p. 272.
35 Malcolm C. Salaman, *Modern Masters of Etching* (London, The Studio Ltd, 1927), vol. I, p. 8.
36 Du Maurier, p. 27.
37 ibid.
38 Pennell, vol. I, p. 84.
39 Bénédite, p. 496.
40 Du Maurier, p. 118.
41 Malcolm Salaman, *The Etchings of Sir Francis Haden* (London, Halton & Truscott, 1923), p. 5.
42 Kenyon Cox, 'The Art of Whistler', *Architectural Record*, vol. 15 (1904), p. 473.
43 William Howe Downes, 'Whistler the Colorist', Boston *Evening Transcript* (1904). [Taken from book of cuttings in Library of Congress.]
44 Pennell, vol. I, p. 90.
45 [Margaret Oliphant], 'The Royal Academy', *Blackwood's Magazine*, vol. 119 (1876), pp. 753-4.
46 Armstrong, p. 203.
47 Ionides, p. 40.
48 Hunt, vol. I, p. 360.
49 Du Maurier, p. 4.
50 Pennell, vol I, p. 82.
51 Boughton, p. 112.
52 Du Maurier, p. 4.
53 Walter Thornbury, *The May Exhibition: A Guide to the Pictures in the Royal Academy* (London, James Virtue, 1860), p. 10.
54 Pennell, vol. I, p. 82.
55 Rossetti, p. 2.
56 Thomas Armstrong, *A Memoir* (London. Martin Secker, 1912), p. 203.
57 Boughton, p. 112.
58 Du Maurier, p. 38.
59 James Laver, *Whistler* (London, Faber and Faber, 1930), p. 340.
60 Edward G. Kennedy, *The Etched Work of Whistler* (New York, The Grolier Club, 1910), p. 24.
61 Denys Sutton, *Nocturne* (London, Country Life, 1963), p. 340.
62 Pennell, vol. I, p. 89.

CHAPTER 10

1 Daphne Du Maurier, *The Young George Du Maurier: A Selection of His Letters* (London, Peter Davies, 1951), p. 38.
2 C. J. Holmes, ''Whistler and Modern Painting', *Burlington Magazine*, vol. 14 (1909), p. 204.
3 Du Maurier, p. 105.
4 From an unpublished letter in the New York Public Library.
5 From an unpublished letter in the University of Glasgow.
6 Du Maurier, p. 118.
7 ibid.
8 ibid., p. 104.
9 From an unpublished letter in the Fitzwilliam Museum.

10 DuMaurier, p. 105.

11 ibid., p. 139.

12 Elizabeth and Joseph Pennell, *The Life of James McNeill Whistler* (Philadelphia, Lippincott, 1908), vol. I, p. 98.

13 John A. Mahey, 'The Letters of James McNeill Whistler to George A. Lucas', *Art Bulletin*, vol. 49 (1967), p. 416.

14 Alfred Stevens, *A Painter's Philosophy* (London, Elkin Mathews, 1904), section ccxlv.

15 Charles Baudelaire, *Art in Paris* (London, Phaidon, 1965), p. 225.

16 From an unpublished letter in the Library of Congress.

17 Elizabeth Pennell, *Whistler the Friend* (Philadelphia, Lippincott, 1930), pp. 93-4.

18 From an unpublished letter in the Fitzwilliam Museum.

19 Campbell Dodgson, *The Etchings of James McNeill Whistler* (London, Geoffrey Holme, 1922), p. 9.

20 Bénédite, p. 502.

21 ibid.

22 All of Whistler's quotations from Biarritz are from unpublished letters in the Library of Congress.

23 Bénédite, p. 499.

24 From an unpublished letter in the Library of Congress.

25 Pennell, *Life*, vol. I, p. 101.

CHAPTER II

1 Thomas Burke, *Nights in Town* (New York, Henry Holt & Co., 1916), p. 363.

2 Thea Holme, *Chelsea* (New York, Taplinger Publishing Co., 1971), p. 154.

3 From an unpublished letter in the Bodleian Library.

4 *The Greaves Brothers and Victorian Chelsea* (Libraries Committee of Royal Borough of Kensington and Chelsea, 1968), p. 1.

5 'Stray Notes on Chelsea', *London Society*, vol. 20 (1871), p. 342.

6 William Gaunt, *Chelsea* (London, B. T. Batsford Ltd, 1954), p. 176.

7 Arthur Ransome, *Bohemia in London* (London, Chapman & Hall, 1907), p. 40.

8 Burke, p. 364.

9 Gerald Cumberland, *Set Down in Malice* (London, Grant Richards, 1919), p. 166.

10 Burke, p. 364.

11 'Stray Notes on Chelsea', p. 343.

12 Ford Madox Hueffer, *Memories and Impressions* (New York, Harper and Bros, 1911), p. 33.

13 From an unpublished letter in the University of British Columbia Library.

14 From an unpublished letter in the Library of Congress.

15 Léonce Bénédite, 'Artistes Contemporains: Whistler', *Gazette des Beaux-Arts*, vol. 33 (1905), p. 508.

16 From an unpublished letter in the Library of Congress.

17 Henry Holiday, *Reminiscences of My Life* (London, Heinemann, 1914), p. 95.

18 ibid., p. 96.

19 Daphne Du Maurier, *The Young George Du Maurier: A Selection of His Letters* (London, Peter Davies, 1951), p. 105.

20 From an unpublished letter in the Library of Congress.

21 John Rewald, *The History of Impressionism* (New York, The Museum of Modern Art, 1961), p. 80.

22 From an unpublished letter in the Library of Congress.

23 Philip G. Hamerton, 'The Salon of 1863', *Fine Arts Quarterly Review*, vol. 1 (1863), p. 260.

24 Rewald, p. 84.

25 ibid.

26 Hamerton, p. 261.

27 Louis Étienne, *Le Jury et Les Exposants. Salon des Refusés* (Paris, Dentu, 1863), p. 30.

28 From an unpublished letter in the Library of Congress.

29 Bénédite, p. 508.

30 From an unpublished letter in the Library of Congress.

31 Theodore Duret, 'James Whistler', *Gazette des Beaux-Arts*, vol. 23 (1881), p. 366.

32 Duret, *Whistler* (Philadelphia, Lippincott, 1917), p. 24.

33 ibid.

34 J. K. Huysmans, *Certains* (Paris, Tresse & Stock, 1889), p. 345.

35 Paul Mantz, 'Salon de 1863', *Gazette des Beaux-Arts*, vol. 15 (1863), pp. 60–1.

36 Étienne, p. 30.

37 Bénédite, p. 509.

38 From an unpublished letter in the Library of Congress.

39 'The Lady of the Portrait', *Atlantic Monthly*, vol. 136 (1925), p. 325.

40 John K. M. Rothenstein, *The Artists of the 1890's* (London, Routledge, 1928), p. 127.

41 ibid., p. 128.

42 Elizabeth and Joseph Pennell, *The Life of James McNeill Whistler* (Philadelphia, Lippincott, 1908), vol. I, p. 107.

43 Tom Pocock, *Chelsea Reach* (London, Hodder & Stoughton, 1970), p. 72.

44 Elizabeth and Joseph Pennell, *The Whistler Journal* (Philadelphia, Lippincott, 1921), p. 124.

45 ibid., p. 120.

46 Du Maurier, p. 106.

47 Pocock, p. 57.

48 Du Maurier, p. 227.

49 'The Lady of the Portrait', p. 324.

50 From an unpublished letter in the Library of Congress.

51 Pennell, *Journal*, pp. 124, 163.

52 Du Maurier, p. 227.

53 Pennell, *Journal*, p. 124.

54 'The Lady of the Portrait', p. 322.

55 *The Times*, 18 February 1870.

56 *Golden Guide to London* (London, Sampson Low, 1875), quoting a French critic, p. 62.

57 George Bryan, *Chelsea in the Olden and Present Times* (London, George Bryan, 1869), p. 39.

58 Katharine S. Macquoid, 'Old Battersea Bridge', *Art Journal*, vol. 33 (1881), p. 35.

59 These letters to Leathart are in the manuscript collection of the University of British Columbia Library.

CHAPTER 12

1 Léonce Bénédite, 'Artistes Contemporains: Whistler', *Gazette des Beaux-Arts*, vol. 33 (1905), p. 442.

2 Bénédite, 'Felix Bracquemond l'Animalier', *Art et Décoration*, vol. 17 (1905), p. 39.

3 J. M. Cloner, *The Influence of Japanese Prints on Manet and Gauguin*, unpublished Ph.D. dissertation, Columbia University, 1968, p. 39.

4 Bénédite, 'Artistes', p. 442.

5 ibid.

6 Richard Muther, *The History of Modern Painting* (London, Henry & Co.), vol. 3, p. 91.

7 ibid.

8 [R. K. Douglas] 'The Pictorial Art of Japan', *Blackwood's Magazine*, vol. 141 (1887), p. 190.

9 Muther, vol. 3, p. 94.

10 Bénédite, 'Artistes', p. 148.

11 'The Lady of the Portrait', *Atlantic Monthly*, vol. 136 (1925), p. 503.

12 Quoted from Jeremy Maas's letter to author.

13 Bénédite, 'Artistes', p. 502.
14 ibid.
15 ibid.
16 R. A. M. Stevenson, *Velasquez* (London, Bell, 1902), p. 94.
17 John Sandberg, ' "Japonisme" and Whistler', *Burlington Magazine*, vol. 106 (1964), p. 504.
18 Elizabeth and Joseph Pennell, *The Life of James McNeill Whistler* (Philadelphia, Lippincott, 1908), vol. I, p. 124.
19 Bénédite, 'Artistes', p. 148.
20 Kenyon Cox, 'The Whistler Memorial Exhibition', *The Nation*, vol. 78 (1904), p. 167.
21 Bernard Sickert, *Whistler* (London, Duckworth, 1908), p. 12.
22 Pennell, vol. I, p. 127.
23 From an unpublished letter in the Library of Congress.
24 Luke Ionides, 'Memories', *Transatlantic Review*, vol. I (1924), p. 42.
25 From an unpublished letter in the University of British Columbia Library.
26 Daphne Du Maurier, *The Young George Du Maurier* (London, Peter Davies, 1951), p. 216.
27 From an unpublished letter in the Library of Congress.
28 ibid.
29 ibid.
30 ibid.
31 Dante Gabriel Rossetti, *Collected Letters* (Oxford, Clarendon Press), vol. 2, p. 526.
32 From an unpublished letter in the Library of Congress.
33 ibid.
34 ibid.
35 ibid.
36 ibid.
37 Du Maurier, pp. 218–19.
38 ibid., p. 244.
39 ibid., p. 248.
40 From an unpublished letter in the Library of Congress.
41 ibid.
42 ibid.
43 Du Maurier, p. 227.
44 From an unpublished letter in the Library of Congress.
45 Elizabeth Pennell, *Whistler the Friend* (Philadelphia, Lippincott, 1930), p. 80.
46 Du Maurier, p. 227.
47 From a review of Society of British Artists Exhibition, *Magazine of Art* (1886), p. 109.
48 A. Paul Oppé, 'Art', in G. M. Young's *Early Victorian England* (Oxford University Press 1934), vol. 2, p. 129.
49 From an unpublished letter in the Library of Congress.

CHAPTER 13

1 From an unpublished letter in the Library of Congress.
2 William H. Baumer, *Not All Warriors* (New York, Smith and Durrell, 1941), p. 248.
3 From an unpublished letter in the University of Glasgow.
4 ibid.
5 From an unpublished letter in the Library of Congress.
6 Richard Muther, *The History of Modern Painting* (London, Henry & Co., 1895), vol. 3, p. 353.
7 From an unpublished manuscript in the Fitzwilliam Museum.
8 Elizabeth Pennell, 'Whistler Makes a Will', *The Colyphon* (1934) [unnumbered pages].
9 ibid.
10 ibid.
11 From an unpublished letter in the Fitzwilliam Museum.

12 Pennell, 'Whistler Makes a Will'.

13 Elizabeth and Joseph Pennell, *The Whistler Journal* (Philadelphia, Lippincott, 1921), p. 43.

14 Elizabeth and Joseph Pennell, *The Life of James McNeill Whistler* (Philadelphia, Lippincott, 1908), vol. I, p. 135.

15 Pennell, *Journal*, p. 43.

16 Frederick A. Sweet, *Sargent, Whistler, and Mary Cassatt* (Chicago Art Institute, 1954), p. 12.

17 Haldane MacFall, *Whistler* (Boston, John Luce, 1905), p. 29.

Bibliography

A. MANUSCRIPT COLLECTIONS

Archives of American Art, Washington. Miscellaneous letters pertaining to Whistler.

Bodleian Library, Oxford. F. G. Stephens Papers, including letters by D. G. Rossetti and Holman Hunt.

Fitzwilliam Museum, Cambridge. Letters pertaining to Whistler, by Whistler and others to Edwin Edwards.

Freer Gallery of Art, Washington. Letters to and from Whistler.

Library of Congress, Washington. Pennell Papers. The largest collection of documents pertaining to Whistler, his family, and friends.

Louvre Archives, Paris. Records of copyists in the Louvre.

Maryland Historical Society, Baltimore. Winans Papers, including journal of Thomas Winans.

Massachusetts Historical Society, Boston. Arthur Livermore Papers, with miscellaneous references to Whistler.

Metropolitan Museum of Art, New York. Whistler's West Point diary.

New York City Public Library. The third largest collection of documents pertaining to Whistler, his family, and friends, including Anna Whistler's St Petersburg diary.

Pierpont Morgan Library, New York. Documents pertaining to Whistler, including full record of quarrel with George Du Maurier.

Strode, Mrs Nancy, Amersham, England. Documents pertaining to Seymour Haden family, including diaries of Rosamund Haden Horsley.

United States Military Academy Archives, West Point. Documents pertaining to Whistler's career at West Point.

University of British Columbia, Vancouver. Letters pertaining to Whistler, by D. G. Rossetti and others, to James Leathart.

University of Glasgow. Birnie Phillip Papers and Revillon Papers, the second largest collection of documents pertaining to Whistler, his family, and friends.

Victoria and Albert Museum, London. J. Smith's 1834 Memoranda of Pictures in the Hermitage Museum.

B. PUBLISHED SOURCES

À Beckett, Gilbert A. and Arthur W. *Comic Guide to the Royal Academy, 1864* (London, John Nichols, 1864).

'Academy at West Point', *American Quarterly Review*, vol. 16 (December 1834), 358–73.

Alexander, Arsene. 'J. McNeill Whistler', *Les Arts* (No. 21, September 1903), 22–32.

Alexander, Sir J. E. 'United States Military Academy at West Point', *Colburn's United Service Magazine*, vol. 3 (September 1854), 7–23.

Allen, Carlisle. 'The Husband of Mrs Whistler', New York *Herald Tribune*, 6 May 1934, p. 5.

Ambrose, Stephen E. *Crazy Horse and Custer* (New York, Doubleday, 1975).

Ambrose, Stephen E. *Duty, Honor, Country. A History of West Point* (Baltimore, Johns Hopkins University Press, 1966).

Americans in Paris (New York, 1972).

'Anecdotes from the Personal Whistler', *Bookman*, vol. 35 (June 1912), 342–3.

Appleton, Nathan. *The Origin of Lowell* (Lowell, Massachusetts, B. H. Penhallow, 1858).

Armstrong, Thomas. *A Memoir*, ed. L. M. Lamont (London, Martin Secker, 1912).

'Art and Artists', *Morning Post*, 20 July 1903.

'Art and the Royal Academy', *Fraser's Magazine*, vol. 46 (August 1852), 228–36.

'The Art Exhibition of 1859', *Bentley's Quarterly Review*, vol. 1 (July 1859), 7–59.

Aslin, Elizabeth, 'E. W. Godwin and the Japanese Taste', *Apollo*, vol. 76 (December 1962), 779–84.

Atherton, Gertrude. *Adventures of a Novelist* (New York, Liveright, Inc., 1932).

At the Piano (New York, Scott and Fowles, n.d.).

Bacon, Henry. *Parisian Art and Artists* (Boston, James Osgood, 1883).

Baldry, Alfred. *Albert Moore* (London, D. Bell & Sons, 1904).

Baldwin, Elbert F. 'Memories of Whistler', *The Outlook*, vol. 91 (1909), 479–89.

Banister, E. W. 'Fate and Whistler', *The Pointer*, vol. 23, no. 15 (March 1946), 9, 32.

Barber, John Warner. *Historical Collections Relating to the History and Antiquity of Every Town in Massachusetts* (Worcester, Dorr, Howland, & Co., 1841).

Bernard, Henry. 'Common Schools in Connecticut', *American Journal of Education*, vol. 5 (June 1858).

Barrington, Mrs Russell. *Life, Letters and Work of Frederick Leighton* (London, George Allen, 1906).

Baudelaire, Charles. *Art in Paris, 1845–52*, transl. and ed. by Jonathan Mayne (London, Phaidon, 1965).

Baumer, William H. *Not All Warriors* (New York, Smith and Durrell, 1941).

Beaver, Alfred. *Memorials of Old Chelsea* (London, Elliot Stock, 1892).

Beck, Edward Josselyn. *Memorials to Serve for a History of the Parish of St. Mary Rotherhithe* (Cambridge University Press, 1907).

Becker, George J. and Edith Phillips. *Paris and the Arts, 1851–1896: From the Goncourt Journal* (Cornell University Press, 1971).

Bell, Mrs Arthur (Nancy). *James McNeill Whistler* (London, George Bell & Sons, 1904).

Bell, Quentin. *Victorian Artists* (Harvard University Press, 1967).

Bénédite, Léonce, 'Artistes Contemporains: Whistler', *Gazette des Beaux-Arts*, vol. 33 (1905), 403–10, 496–511, vol. 34 (1905), 142–58, 231–46.

Bénédite, Léonce, 'Felix Bracquemond l'Animalier', *Art et Décoration*, vol. 17 (1905).

Benjamin, S. J. W. 'Art in Contemporary England', *Harper's Magazine*, vol. 54 (January 1877), 161–79.

Benjamin, S. J. W. 'Art in Contemporary France', *Harper's Magazine*, vol. 54 (March 1877), 481–503.

Bizardel, Yvon. *American Painters in Paris* (New York, Macmillan, 1960).

Blake, Charles E. 'Springfield, Massachusetts', *New Englander Magazine*, n.s. vol. 9 (January 1894), 574–99.

Blanche, Jacques-Émile. *Portraits of a Lifetime* (London, Dent, 1937).

Bloor, A. J. 'The Beginnings of James McNeill Whistler', *The Critic*, vol. 48 (1906), 123–35.

Bloor, A. J. 'Whistler's Boyhood', *The Critic*, vol. 43 (1903), 247–54.

Blunt, Reginald (ed.). *The Crown & Anchor: A Chelsea Quarto* (London, The Chelsea Publishing Co., 1925).

Blunt, Reginald. *An Illustrated Historical Handbook to the Parish of Chelsea* (London, Lamley & Co., 1900).

Boas, George. 'Courbet and the Naturalistic Movement', *Parnassus*, vol. 10 (April 1938), 10–11.

Boisbaudran, Lecoq de. *The Training of Memory in Art*, transl. by L. D. Luard (London, Macmillan, 1911).

Bogue's Guides for Travellers. Paris and Its Environs (London, David Bogue, 1885).

Boime, Albert. *The Academy and French Painting in the Nineteenth Century* (London, Phaidon, 1971).

Boime, Albert. 'The Salon des Refusés and the Evolution of Modern Art', *Art Quarterly*, vol. 32 (1969), 411–26.

Boughton, G. H. 'A Few of the Various Whistlers I Have Known', *Studio*, vol. 30 (1903), 208–18.

Boyce, George. *Diary*. Included in *The Old Water Colour Society's Nineteenth Annual Volume*, ed. Randall Davies (London, Old Water Colour Society, 1941).

Boynton, Edward C. *Guide to West Point* (New York, D. Van Nostrand, 1867).

Boynton, Edward C. *History of West Point* (New York, D. Van Nostrand, 1864).

Bradford, Gamaliel. *American Portraits* (Boston, Houghton Mifflin, 1922).

Bradford, Gamaliel. 'James McNeill Whistler', *Atlantic Monthly*, vol. 1927 (April 1921), 512–24.

Braham, Allan. *Velasquez* (London, The National Gallery, 1972).

Brinton, Christian. *Walter Greaves* (New York, Cottier & Co., 1912).

Brinton, Christian. 'Whistler and Inconsequence', *The Critic*, vol. 38 (1901), 32–3.

Brinton, Christian. 'Whistler from Within', *Munsey's Magazine*, vol. 36 (1906), 6–20.

Brownell, W. C. 'Whistler in Painting and Etching', *Scribner's Monthly Magazine*, vol. 18 (August 1879), 481–95.

Bryan, George. *Chelsea in the Olden and Present Times* (London, George Bryan, 1869).

Caffin, Charles H. *American Masters of Painting* (New York, Doubleday, Page, & Co., 1902)

Caffin, Charles H. *The Story of French Painting* (New York, The Century Company, 1910).

Canaday, John. *Main Streams of Modern Art* (New York, Holt, Rinehart & Winston, 1959).

Cargill, Oscar. *Intellectual America* (New York, Macmillan, 1919).

Cary, Elizabeth. 'French Influences in Whistler's Art', *The Scrip*, vol. 1 (July 1906), 312–26.

Cary, Elizabeth. *The Works of James McNeill Whistler* (New York, Moffat, Yard, and Company, 1907).

Centennial of the United States Military Academy at West Point (Washington, Government Printing Office, 1904).

Chamot, Mary. *Russian Painting and Sculpture* (New York, Macmillan, 1963).

Chase, William M. 'The Two Whistlers', *Century Magazine*, vol. 80 (1910), 218–26.

Chevalier, Michael. *Society, Manners, and Politics in the United States* (Gloucester, Massachusetts, Peter Smith, 1967, revision of 1839 edition of Weeks, Jordan, and Co., Boston).

Clayton, Susan. 'Kitty's Whistlers', *The Atlantic Advocate*, vol. 50 (September 1959), 40–5.

Cloner, J. M. *The Influence of Japanese Prints on Manet and Gauguin* (Columbia University Ph.D. Dissertation, 1968).

The Coast and Geodetic Survey, 1807–1957 (Washington, Government Printing Office, 1957).

Coburn, Frederick W. 'The Whistler Memorial Exhibition', *Brush and Pencil*, vol. 13 (March 1904), 436–49.

Colvin, Sidney. 'Albert Moore', *Portfolio*, vol. 1 (1870), 4–8.

'Common School System of Connecticut', *New York Review*, vol. 10 (April 1842), 331–47.

'Common Schools in Connecticut', *American Journal of Education*, vol. 11 (March 1862), 303–44.

Connecticut. American Guide Series (Boston, Houghton Mifflin, 1938).

Cortissoz, Royal. *American Artists* (New York, Scribners, 1923).

Cortissoz, Royal. 'Whistler', *Atlantic Monthly*, vol. 92 (December 1902), 826–38.

Cox, Kenyon. 'The Art of Whistler', *Architectural Record*, vol. 15 (1904), 467–81.

Cox, Kenyon. 'The Whistler Memorial Exhibition', *The Nation*, vol. 78 (1904), 166–9.

Cumberland, Gerald. *Set Down in Malice* (London, Grant Richards, 1919).

Custine, Marquis de. *Russia* (New York, D. Appleton and Co., 1854).

'A Day at Lowell', *Western Monthly Magazine and Literary Journal*, vol. 5 (February 1836), 72–8.

Delacroix, Eugène. *Journal*. Ed. by Hubert Wellington (London, Phaidon, 1951).

Dodgson, Campbell. *The Etchings of James McNeill Whistler* (London, Geoffrey Holme, 1922).

Doré, Gustave, and Blanchard Jerrold. *London, A Pilgrimage* (London: Dent & Company, 1872).

[Douglas, R. K.] 'The Pictorial Art of Japan', vol. 141 (February 1887), 281–90.

Du Maurier, Daphne. *The Young George Du Maurier: A Selection of Letters* (London, Peter Davies, 1951).

Du Maurier, George. 'Trilby', *Harper's Magazine*, vols. 27–8 (January–July 1894).

Duret, Theodore. 'James Whistler', *Gazette des Beaux-Arts*, vol. 23 (1881), 365–9.

Duret, Theodore. *Whistler* (Philadelphia, Lippincott, 1917).

Duret, Theodore. 'Whistler and His Work', Art and Letters, vol. 1 (1888), 215–26.

Easton, Malcolm. *Artists and Writers in Paris* (New York, St Martin's Press, 1964).

Étienne, Louis. *Le Jury et Les Exposants. Salon des Refusés* (Paris, Dentu, 1863).

Fell, H. Granville, 'Memories of Whistler', *Connoisseur*, vol. 95 (1935), 21–4.

Fitzgerald, Percy H. *Picturesque London* (London, Ward & Downey, 1890).

Forsyth, Walter G. and Harrison J. le R. *Guide to the Study of James A. McNeill Whistler* (Albany, State College of New York, 1895).

Forthuny, Pascal. 'Notes sur James Whistler', *Gazette des Beaux-Arts*, vol. 30 (1903), 381–91.

Fournel, François. *Les Artistes Français Contemporains* (Tours, Alfred Mame et Fils, 1884).

Freeman, Douglas Southall. *Robert E. Lee* (New York, Scribner's, 1934).

Frisch, Michael. *Town into City* (Harvard University Press, 1972).

Furness, Harry, *Royal Academy Antics* (London, Cassell & Co., 1890).

Furst, Herbert. *Original Engraving and Etching* (London, T. Nelson & Sons, 1931).

Gallet, Louis. *Salon de 1865* (Paris, Le Bailly, 1865).

Galloway, K. Bruce and Robert Bowie Johnson, Jr. *West Point* (New York, Simon & Schuster, 1973).

Gaunt, William, *Chelsea* (London, B.T. Batsford Ltd, 1954).

Gaunt, William. *The Restless Century* (London, Phaidon, 1972).

Gibson, Frank. *The Art of Henri Fantin-Latour* (London, Diane's Ltd, 1924).

Gobright, John G. *Baltimore as It Is* (Baltimore, John W. Woods, 1857).

Godson, William F. H. *The History of West Point, 1852–1902* (Temple University Ph.D. Dissertation, 1934).

Golden Guide to London (London, Sampson Low, 1875).

Gosse, Edmund. *Life of Algernon Charles Swinburne* (London, Macmillan, 1917).

Gray, Basil. ' "Japonisme" and Whistler', *Burlington Magazine*, vol. 107 (June 1965), p. 324.

The Greaves Brothers and Victorian Chelsea (Chelsea Libraries Committee of Royal Borough of Kensington and Chelsea, 1868).

Green, Constance McLaughlin. *Washington, Village and Capital, 1800–78* (Princeton University Press, 1962).

Green, Mason A. *Springfield, History of Town and City* (Springfield, C. A. Nichols & Co., 1888).

Gregory, Horace. *The World of James McNeill Whistler* (New York, Nelson, 1959).

Grieve, Alastair. 'Whistler and the Pre-Raphaelites', *Art Quarterly*, vol. 34 (summer 1971), 219–28.

Grunwald, Constantine de. *Tsar Nicholas I*, transl. by Brigit Patmore (New York, Macmillan, 1955).

'Gustave Courbet', *Temple Bar*, vol. 42 (1874), 305–35.

Hadley, Samuel P. and Mabel Hill. 'Lowell: A Character Sketch of the City', *New England Magazine*, n.s. vol. 19 (January 1899), 625–46.

Hamerton, Philip G. 'The Artistic Spirit', *Fortnightly Review*, vol. 1 (June 1865), 332–65.

Hamerton, Philip G. *Etchings and Etchers* (London, Macmillan, 1868).

Hamerton, Philip G. 'The Salon of 1863', *Fine Arts Quarterly Review*, vol. 1 (October 1863), 225–61.

Hamilton, George Heard. *The Art and Architecture of Russia* (London, Penguin Books, 1954).

[Hardman, Frederick], 'Letters and Impressions of Paris', *Blackwood's Magazine*, vol. 60 (October 1846).

[Hardman, Frederick]. 'Pictures from St. Petersburg', *Blackwood's Magazine*, vol. 70 (August 1851).

Hare, Richard. *The Art and Artists of Russia* (London, Methuen, 1965).

Harris, Frank. 'Whistler, Artist and Bantam', *Forum*, vol. 52 (1914), 338–55.

Harris, Neil. *The Artist in American Society* (New York, George Braziller, 1966).

Hartmann, Sadakichi. *History of American Art* (Boston, L. C. Page & Co., 1903).

Hartmann, Sadakichi. *The Whistler Book* (Boston, L. C. Page & Co., 1910).

'Has a New and Greater Whistler Been Discovered?' *Current Literature*, vol. 51 (July 1911), 91–3.

Hawthorne, Nathaniel. 'Up the Thames', *Atlantic Monthly*, vol. 11 (May 1863), 598–614.

Haywood, Richard M. *The Beginnings of Railway Development in Russia* (Durham, North Carolina, Duke University Press, 1969).

Herst, Herman, Jr. 'Manuscripts Gone Forever?' *Manuscripts*, vol. 17 (Summer 1965), 3–5.

Hind, Arthur M. *A History of Engraving and Etching* (London, Constable, 1923).

Hinshaw, Ida Clifton. 'Whistler's First Drawings', *Century Magazine*, vol. 80 (September 1910), 736–41.

Hobbs, John L. 'The Boott and Haden Families and the Founding of Lowell', *Derbyshire Archaeological & Natural History Society Journal*, vol. 66 (1946), 59–74.

Holden, Donald. *Whistler's Landscapes and Seascapes* (New York, Watson-Guptill Publications, 1969).

Holiday, Henry. *Reminiscences of My Life* (London, Heinemann, 1914).

Holme, Thea. *Chelsea* (New York, Taplinger Publishing Company, 1971).

Holmes, Sir Charles. *The Royal Academy: Its Origin and History* (London, The Studio, 1914).

Holmes, Sir Charles. 'Whistler and Modern Painting', Burlington Magazine, vol. 14 (1909), 204–6.

Honour, Hugh. *Chinoiserie* (London, John Murray, 1961).

Howard, Oliver O. *Autobiography* (New York, Baker & Taylor, 1907).

Howard, W. Stanton. 'The Music Room', *Harper's Magazine*, vol. 119 (August 1909), 424–5.

Hubbard, Hesketh. *A Hundred Years of British Painting* (London, Longmans, Green & Co., 1951).

Hubbard, Hesketh. *Some Victorian Draughtmen* (Cambridge University Press, 1944).

Hueffer, Ford Madox. *Memories and Impressions* (New York, Harper's, 1911).

[Hunt, E. M.]. 'West Point and Cadet Life', *Putnam's Monthly Magazine*, vol. 4 (August 1854), 192–203.

Hunt, William Holman. *Pre-Raphaelitism and the Pre-Raphaelite Brotherhood* (London, Chapman and Hall, 1913).

Hutchinson, Sidney. *History of the Royal Academy* (London, Chapman & Hall, 1968).

Huysmans, J. K. *Certains* (Paris, Tresse & Stock, 1889).

Ingamells, J. 'Greaves and Whistler', *Apollo*, vol. 89 (March 1969), 224–5.

Ionides, Luke. 'Memories', *Transatlantic Review*, vol. 1 (January 1924), 37–52.

'James A. McNeill Whistler', *Current Literature*, vol. 35 (1903), 310–15.

James, Joseph B. 'Life at West Point One Hundred Years Ago', *Mississippi Valley Historical Review*, vol. 31 (June 1944), 21–38.

Jameson, Anna Brownell. *Memoirs of the Early Italian Painters* (London, Charles Knight & Co., 1845).

Josephson, Hannah, *The Golden Threads* (New York, Duell, Sloan, and Pearce, 1949).

Josephson, Matthew. *Portrait of the Artist as an American* (New York, Harcourt Brace, 1930).

Kennedy, Edward G. *The Etched Work of Whistler* (New York, The Grolier Club, 1910).

Keppel, Frederick. 'Whistler as an Etcher', *Outlook*, vol. 85 (1907), 962–77.

Key, John Ross. 'Recollections of Whistler', *Century Magazine*, vol. 75 (1908), 928–32.

Knaufft, Ernest. 'James A. McNeill Whistler', *Review of Reviews*, vol. 28 (1903), 173–6.

Kobbé, Gustav. 'Whistler at West Point', *The Chap-Book*, vol. 8 (1898), 439–42.

Kobbé, Gustav. 'Whistler in the U.S. Coast Survey', *The Chap-Book*, vol. 8 (1898), 479–80.

Kohl, J. G. *Russia* (London, Chapman & Hall, 1844).

'The Lady of the Portrait. Letters of Whistler's Mother', *Atlantic Monthly*, vol. 136 (1925), 310–28.

Larned, Charles W. 'Whistler at West Point', *Illustrated London News*, vol. 132 (25 January 1908), 120–1.

Larned, Charles W. 'Whistler's Cadet Drawings', *Army and Navy Life and the United Service*, vol. 12 (January 1908), 76–82.

Laver, James. *Whistler* (London, Faber & Faber, 1930).

Lazelle, H. M. 'Whistler at West Point', *Century Magazine*, vol. 90 (1915), 710.

'Lectures on Etching', *The Times*, 2 April 1879, 5–6.

Leslie, Charles Robert. 'Lectures on Painting', *Athenaeum* (17 February–10 March 1848).

Leslie, George Dunlop. *The Inner Life of the Royal Academy* (London, John Murray, 1914).

L'Estrange, A. G. *The Village of Palaces*, vol. 2 (London, Hurst & Blackett, 1880).

London & Its Environs (Edinburgh, Adam & Black, 1862).

London as It Is Today (London, H. G. Clarke, 1851).

'London Pictures', *Builder*, vol. 18 (2 June 1860), 348.

Losee, William F. 'James McNeill Whistler, the Painter', *Brush and Pencil*, vol. 12 (August 1903), 319–33.

Ludovici, Albert. *An Artist's Life in London and Paris* (New York, Minton, Batch & Co., 1926).

Lumsden, E. S. *The Art of Etching* (New York, Dover Publications, 1962).

Maas, Jeremy. *Victorian Painters* (New York, Putnam's, 1969).

MacColl, Dougald S. 'The Industrious and Idle Prentices', *Saturday Review*, vol. 96 (November 1903), 608–9.

MacFall, Haldane. *Whistler: Butterfly, Wasp, Wit, Master of the Arts* (Boston, John Luce, 1905).

Mack, Gerstle. *Gustave Courbet* (New York, Knopf, 1951).

McMullen, Roy. *Victorian Outsider* (New York, E. P. Dutton & Co., 1973).

Macquoid, Katharine S. 'Old Battersea Bridge', *Art Journal*, vol. 33 (1881), 33–6.

Mahey, John A. 'The Letters of James McNeill Whistler to George A. Lucas', *Art Bulletin*, vol. 49 (September 1967), 247–57.

Mansfield, Howard. *A Descriptive Catalogue of the Etchings and Drypoints of James Abbott Whistler* (Chicago, The Caxton Club, 1909).

Mansfield, Howard. Introduction to *A Whistler Centenary* (New York, Knoedler, 1934).

Martin, Benjamin Ellis. *Old Chelsea* (London, T. Fisher Unwin, 1889).

Maryland: American Guide Series (Oxford U. Press, 1940).

Mathewson, Darius. 'Reminiscences of Pomfret', in *Pomfret Old Home Festival* (Pomfret, Connecticut: Pomfret Neighborhood Association, 1915).

Mayhew, Henry, *London Labour and London Poor* (London).

Meier-Graefe, Julius. *Modern Art*, vol. 2 (London, Heinemann, 1908).

Michey, Peter S. *Life and Letters of Emory Upton* (New York, Appleton, 1885).

'The Military Academy', *North American Review*, vol. 57 (October 1843), 269–92.

Mitchell, Peter. *Alfred Emile Leopold Stevens* (London, John Mitchell & Sons, 1973).

Monkhouse, Cosmo. *British Contemporary Artists* (New York, Scribner's, 1899).

Morris, Thomas. *Handbook to the Exhibition of the U.K.'s Art Treasures at Manchester, 1857* (London, Houston and Wright, 1857).

Morton, Frederick. 'James McNeill Whistler, the Etcher', *Brush and Pencil*, vol. 12 (August 1903), 305–19.

Moss, Arthur, and Evalyn Marvel. *The Legend of the Latin Quarter* (New York, The Beechhurst Press, 1946).

Mowat, Robert B. *Americans in England* (Boston, Houghton Mifflin, 1935).

'Modern Painters', *Fraser's Magazine*, vol. 33 (March 1846), 358–68.

Mumford, Elizabeth. *Whistler's Mother* (Boston, Little, Brown, 1939).

Murray's Handbook for Travellers in Russia (London, John Murray, 1863).

Muther, Richard. The History of Modern Painting, vol. 3 (London, Henry & Co., 1895).

'New Light on the Whistler-Greaves Mystery', *Arts and Decoration*, vol. 16 (January 1922), 206–7.

Nocturnal London (London, S. E. Stanesby, 1890).

[Oliphant, Margaret]. 'The Royal Academy', *Blackwood's Magazine*, vol. 119 (June 1876), 753-9.

Oppé, A. Paul. 'Art', in G. M. Young's *Early Victorian England*, vol. 2 (Oxford University Press, 1934).

Ormond, Leonée. *George Du Maurier* (University of Pittsburgh Press, 1969).

Palmer, Henry Robinson. *Stonington by the Sea* (Stonington, Connecticut, Palmer Press, 1913).

Palmer, Marlene. 'Whistler and the U.S. Coast and Geodetic Survey', *Journal of the West*, vol. 8 (October 1969), 559-77.

'Paris and London: Points of Contrast', *Builder*, vol. 19 (16 February 1861).

Parker, Margaret Terrell. *Lowell* (New York, Macmillan, 1940).

Parry, Albert. *Whistler's Father* (Indianapolis, Bobbs-Merrill, 1939).

Payne, George Henry, 'A Living Old Master', *Saturday Evening Post*, vol. 171 (25 February 1899), 552-3.

Pearson, Hesketh. *The Man Whistler* (New York, Harper & Bros., 1952).

Pennell, Elizabeth. *The Art of Whistler* (New York, The Modern Library, 1928).

Pennell, Elizabeth. 'Whistler Makes a Will', *The Colyphon*, part 17, no. 4 (1934).

Pennell, Elizabeth. *Whistler the Friend* (Philadelphia, Lippincott, 1930).

Pennell, Elizabeth and Joseph. *The Life of James McNeill Whistler* (Philadelphia, Lippincott, 1908).

Pennell, Elizabeth and Joseph. *The Whistler Journal* (Philadelphia, Lippincott, 1921).

Pennell, Joseph. 'James McNeill Whistler', *North American Review*, vol. 177 (1903), 378-84.

Pennell, Joseph. 'The Whistler Legend', *Bookman*, vol. 36 (October 1912), 109-12.

Pevsner, Nikolaus. *Academies of Art, Past and Present* (Cambridge University Press, 1940).

Pevsner, Nikolaus. 'Whistler's *Valparaiso Harbour* at the Tate Gallery', *Burlington Magazine*, vol. 79 (1941), 115-20.

Phythian, John E. *Fifty Years of Modern Painting* (London, Grant Richards, 1908).

'Pictures from St. Petersburg', *Blackwood's Magazine*, vol. 70 (August 1851), 154-72.

Pocock, Tom. *Chelsea Reach* (London, Hodder and Stoughton, 1970).

Pressly, Nancy Dorfman. 'Whistler in America: An Album of Early Drawings', *Metropolitan Museum Journal*, vol. 5 (1972), 125-54.

Prideaux, Tom. *The World of Whistler* (New York, Time-Life Books, 1970).

Prinsep, Val. 'James A. McNeill Whistler', *Magazine of Art*, vol. 27 (1903), 577-80.

Prinsep, Val. 'A Student's Life in Paris in 1859', *Magazine of Art*, vol. 28 (February 1904), 338-42.

'The Quartier Latin', *Galaxy*, vol. 1 (1866), 608-12.

Raleigh, Walter A. *In Memoriam, James McNeill Whistler* (London, Heinemann, 1905).

Ransome, Arthur. *Bohemia in London* (London, Chapman & Hall, 1907).

Rapp, Kenneth W. 'More about Whistler and Lee', *Manuscripts* (Summer 1966), 12-17.

Rapp, Kenneth W. 'Whistler in Cadet Gray', *Assembly*, vol. 29 (Winter 1971), 10-11, 40-1.

'The Real Whistler', *Current Literature*, vol. 46 (January 1909), 49-55.

Reff, Theodore, 'Copyists in the Louvre, 1850-70', *Art Bulletin*, vol. 46 (December 1964), 552-9.

Regulations of the Military Academy (New York, Wiley & Putnam, 1839).

'Residences and Domestic Arrangements in Paris and in London', *Builder*, vol. 19 (26 October 1861).

Rewald, John. 'Auguste Renoir and His Brother', *Gazette des Beaux-Arts*, vol. 27 March 1965), 171-88.

Rewald, John. *The History of Impressionism*, Revised edition (New York, Museum of Modern Art, 1961).

Ritchie, A. I. 'Chelsea, Cheyne Walk', *Art Journal*, vol. 34 (1882), 340-1.

Ritchie, Leitch. *A Journey to St. Petersburg and Moscow* (London, Longman, Orme, Brown, 1836).

Root, J. A. 'Common Schools of Connecticut', *New Englander*, vol. 4 (October 1846), 522–32.

Rossetti, Dante Gabriel. *Collected Letters*, ed. by Oswald Doughty and John Robert Wahl, vols 1–2 (Oxford University Press, 1965).

Rossetti, William. *Fine Art, Chiefly Contemporary* (London, Macmillan, 1867).

Rothenstein, John K. M. *The Artists of the 1890's* (London, Routledge, 1928).

Rutter, Frank. *James McNeill Whistler* (London, Grant Richards, 1911).

Sabin, Ralph. 'A Survey of the Past', in *Pomfret Old Home Festival* (Pomfret, Connecticut, Pomfret Neighborhood Association, 1915).

'St Petersburg and Its Inhabitants in 1843', *Colburn's New Monthly Magazine*, vol. 69 (1843), 241–59.

Salaman, Malcolm C. *The Etchings of Sir Francis Haden* (London, Halton & Truscott, 1923).

Salaman, Malcolm C. *Modern Masters of Etching* (London, The Studio Ltd, 1927).

Salaman, Malcolm C. *Sir Francis Seymour Haden* (London, The Studio Ltd, 1926).

Sandberg, John. ' "Japonisme" and Whistler', *Burlington Magazine*, vol. 106 (November 1964), 500–5.

Sandberg, John. 'Whistler's Early Work In America', *Art Quarterly*, vol. 29, no. 1 (1966), 46–59.

Schaff, Morris. *The Spirit of Old West Point* (Boston, Houghton Mifflin, 1907).

Scheyer, Ernst. 'Far Eastern Art and French Impressionism', *Art Quarterly*, vol. 6 (1943), 117–42.

Sears, Robert. *An Illustrated Description of the Russian Empire* (New York, Robert Sears, 1855).

Seitz, Don Carlos. *Uncommon Americans* (New York, Bobbs-Merrill, 1925).

Seitz, Don Carlos. *Whistler Stories* (New York, Harper's, 1913).

Sheon, Aaron. 'French Art and Science in the Mid-Nineteenth Century', *Art Quarterly*, vol. 34 (Winter 1971), 434–54.

Sickert, Bernard. *Whistler* (London, Duckworth, 1908).

Sickert, Walter. 'L'Affaire Greaves', The New Age, vol. 9 (15 June 1911), 159–60.

Siple, Walter H. 'Cincinnati's Whistler', [*At the Piano*], *Art Digest*, vol. 19 (1 December 1944), 16, 30.

Sloane, Joseph C. *French Painting Between the Past and the Present* (Princeton University Press, 1951).

Spielmann, Marion H. 'Whistler the Man and the Artist', *Magazine of Art*, vol. 27 (1903), 580–4, vol. 28 (1903), 8–16.

Stevens, Alfred. *A Painter's Philosophy* (London, Elkin Mathews, 1914).

Stevenson, R. A. M. *Velasquez* (London, George Bell & Sons, 1902).

'Stray Notes on Chelsea', *London Society*, vol. 20 (October 1871), 342–4.

Stubbs, Burns. *James McNeill Whistler* (Washington, Freer Gallery of Art, 1950).

'Student Life in Paris', *Household Words*, vol. 3 (14 June 1851), 286–8.

Sutton, Denys. *James McNeill Whistler* (London, Phaidon, 1966).

Sutton, Denys. *Nocturne: The Art of James McNeill Whistler* (London, Country Life, 1963).

Sweet, Frederick A. *Sargent, Whistler, and Mary Cassatt* (Chicago Art Institute, 1954).

The Swinburne Letters, ed. Cecil Y. Lang, vol. 1 (Yale University Press, 1959).

Taylor, Tom. 'English Painting in 1862', *Fine Arts Quarterly Review*, vol. 1 (May 1863), 1–26.

'Teaching at the Royal Academy', *Athenaeum*, 30 August 1862, p. 281.

Teall, Gardner C. 'Whistler's Father', *New England Magazine*, vol. 29 n.s. (1903), 235–9.

The Thames in Art, introduction by Katharine Kinnear (London, Arts Council, 1967).

Thornbury, George Walter and Edward Walford. *Old and New London* (London, Cassell, Petter, & Galpin, 1879–85).

Topas, Jan. 'Fantin-Latour', *Art in America*, vol. 17 (December 1928), 25–30.

The U. S. Coast Survey (New York, Dix and Edwards, 1855).

Vose, George L. *The Life and Works of George W. Whistler* (Boston, Lee and Shepard, 1887).

Way, Thomas R. and Walter G. Bell. *The Thames* (London, John Lane, 1897).

Way, Thomas R. and G. R. Dennis. *The Art of James McNeill Whistler* (London, Bell, 1903).

Weber, Gustavus A. *The Coast and Geodetic Sruvey* (Baltimore, Johns Hopkins University Press, 1953).

Wedmore, Frederick. *Etching in England* (London, George Bell & Sons, 1895).

Wedmore, Frederick. 'The Place of Whistler', *Nineteenth Century*, vol. 55 (1904), 665–75.

Wedmore, Frederick. *Whistler's Etchings* (London, George Bell & Sons, 1896).

A Week in London (London, T. M. Craddock, 1847).

Weintraub, Stanley. *Whistler* (New York, Weybright and Talley, 1974).

Weir, Irene. *Robert W. Weir* (New York, House of Field-Doubleday, Inc., 1947).

Weisberg, Gabriel P. 'Felix Bracquemond and Japonisme', *Art Quarterly*, vol. 32 (Spring 1969), 57–60, 67–8.

Westwood, J. N. *A History of Russian Railways* (London, Allen & Unwin, 1964).

Wheatley, H. W. and T. R. Way. *Thames Side and South Suburban Reliques of Old* (London, George Bell & Sons, 1904).

Wheeler, General Joseph. 'West Point Fifty Years Ago', *The Golden Age*, February 1906, 66–70.

'Whistler's *Last of Old Westminster*', *Connoisseur*, vol. 117 (March 1946), 45–6.

White, Gleeson. *Letters to Living Artists* (London, Elkin Matthews, 1891).

Whittemore, Lawrence F. *Old Stonington in Connecticut* (New York, The Newcomen Society, 1949).

'Why Whistler Lost His Job', *Literary Digest*, vol. 110 (4 July 1931), 21.

Willey, Day Allen. 'Whistler's West Point Drawings', *Book News Monthly*, vol. 30 (May 1912), 634–8.

Wilson, Thomas. 'Whistler at West Point', *The Book-Buyer*, vol. 17 (1898), 113–15.

'A Winter at St Petersburg', *London Society*, vol. 11 (February 1867), 145–55.

The Work of the Coast and Geodetic Survey (Washington, Government Printing Office, 1909).

The World's Guide to London in 1862 (London, Darton & Hodge, 1862).

Wright, Harold J. Introduction to Catalogue for London Arts Council Exhibition of Etchings, Dry-Points and Lithographs (London, The Arts Council, 1954).

Wuerpel, Edmund H. 'My Friend Whistler', *Independent*, vol. 56 (1904), 131–6.

Young, Andrew McLaren. Introduction to Catalogue for Whistler Exhibition at Arts Council (London, The Arts Council, 1960).

Young, Dorothy Weir. *The Life and Letters of J. Alden Weir* (New Haven, Yale University Press, 1960).

Zahar, Marcel. *Courbet* (London, Longmans, Green & Co., 1950).

Index